IN PLENTY AND IN TIME OF NEED

CRITICAL CARIBBEAN STUDIES

Series Editors: Yolanda Martínez-San Miguel, Carter Mathes, and Kathleen López

Focused particularly in the twentieth and twenty-first centuries, although attentive to the context of earlier eras, this series encourages interdisciplinary approaches and methods and is open to scholarship in a variety of areas, including anthropology, cultural studies, diaspora and transnational studies, environmental studies, gender and sexuality studies, history, and sociology. The series pays particular attention to the four main research clusters of Critical Caribbean Studies at Rutgers University, where the co-editors serve as members of the executive board: Caribbean Critical Studies Theory and the Disciplines; Archipelagic Studies and Creolization; Caribbean Aesthetics, Poetics, and Politics; and Caribbean Colonialities.

IN PLENTY AND IN TIME OF NEED

Popular Culture and the Remapping of Barbadian Identity

LIA T. BASCOMB

RUTGERS UNIVERSITY PRESS
New Brunswick, Camden, and Newark, New Jersey, and London

Library of Congress Cataloging-in-Publication Data

Names: Bascomb, Lia T., author.
Title: In plenty and in time of need: popular culture and the remapping of
 Barbadian identity / Lia T. Bascomb.
Other titles: In plenty and in time of need (Rutgers University Press)
Description: New Brunswick: Rutgers University Press, 2019. |
Series: Critical Caribbean studies | Based on the author's thesis
 (doctoral)—University of California, Berkeley, 2013, of the same title. |
 Includes bibliographical references and index.
Identifiers: LCCN 2019010438 | ISBN 9781978803947 (pbk.: alk. paper)
Subjects: LCSH: Nationalism and the arts—Barbados. | Postcolonialism and the
 arts—Barbados. | Popular culture—Barbados. | Gender expression—Barbados.
Classification: LCC NX180.N38 B37 2019 | DDC 700/.4581—dc23
LC record available at https://lccn.loc.gov/2019010438

A British Cataloging-in-Publication record for this book is available from the British
Library.

♾ The paper used in this publication meets the requirements of the American National
Standard for Information Sciences—Permanence of Paper for Printed Library
Materials, ANSI Z39.48-1992.

Copyright information for song lyrics can be found in the Permissions section.

www.rutgersuniversitypress.org

Manufactured in the United States of America

For Ricardo Agard

CONTENTS

IN PLENTY AND IN TIME OF NEED

INTRODUCTION

I don't think there has been anything in human history quite like the
meeting of Africa, Asia, and Europe in this American archipelago we call the
Caribbean. But it is so recent since we assumed responsibility for our own
destiny, that the antagonistic weight of the past is felt as an inhibiting
menace. And that is the most urgent task and the greatest intellectual
challenge: how to control the burden of this history and incorporate it into
our collective sense of the future.

—George Lamming, *Coming, Coming Home*

On November 30, 1966, the 166-square-mile island of Barbados became
an independent nation-state. This was only four years after Jamaica and Trinidad
and Tobago gained independence, and months after Guyana. Each territory had
its own distinct history, including variations on economic structures, racial demo-
graphics, and political visions, but each had been claimed by the British Empire.
Like the Spanish, French, and Dutch empires that had also profoundly affected
the region, the British Empire left its mark on the Caribbean, one that continued
to be felt after its colonies became independent nation-states. In considering the
weight of those relationships, Barbadian literary artist George Lamming posits
several questions regarding Caribbean identity in the latter half of the twentieth
century: What visions could be imagined with such a hefty past behind us? Can
it be said that the past was behind us when so many in the region had been edu-
cated in colonial ways, if not in colonial metropoles? What forms of self-definition
and self-making were possible? Who would make them possible, and how? Build-
ing on the visions offered in Barbados's independent national symbols, *In Plenty
and in Time of Need* traces the myths, songs, stories, and performances that have
been offered, refused, and remade by state actors, cultural representatives, and
larger populations. As a pivotal point in the Atlantic slave trade of the seventeenth
and eighteenth centuries, one of Britain's most prized colonies well into the
mid-twentieth century, and, since 1966, one of the most stable postcolonial
nation-states in the Western Hemisphere, Barbados is an extremely important
site of Caribbean, postcolonial, and world history.

This book focuses on the cultural arena and the fluid boundaries of Barbadian identity, the ways that migration and return help to define national visions, and how musical artists use regional influences and African diasporic resources to create, maintain, and remix definitions of Barbadian identity. It reorients the burden of Barbadian history by mapping Barbadian identity beyond geographical or nation-state boundaries, using the popular cultural narratives told and lived by Barbadian people.

Based within African diaspora studies, *In Plenty and in Time of Need* provides a history of representations of national identity formation within independent Barbados. It focuses on cultural representations to show the ways in which migration, regionalism, transnationalism, and diaspora have helped to shape both an ideal national identity and a number of Barbadian realities. It is an interdisciplinary study of postindependence Barbados that analyzes performances of its culture and representations of gender and sexuality. By reading novels, performances, videos, and digital media as primary sources, *In Plenty and in Time of Need* uses representation to engage in the cultural discourses of what it means to be Barbadian. The book uses archival research, interviews, visual analysis, performance analysis, literary analysis, new media, and ethnography, while also relying on economic, historical, sociological, literary, and anthropological secondary sources.

Focusing on prominent musical artists including calypsonians the Mighty Gabby and the Merrymen, soca artists Alison Hinds and Rupert "Rupee" Clarke, and pop artist Robyn Rihanna Fenty, the book uses the language of performance studies and engages with various strands of performance theory. *In Plenty and in Time of Need* puts the stage performances of Barbadian artists in conversation with quotidian performances and literary representations of identity. In looking at the performances of arguably the most internationally recognizable Barbadian musical artists of the twenty-first century, this book explores how they came to have the authority to represent the nation on a global stage. Both the stage performances of Barbadian artists and the quotidian performances of Barbadian identity have various audiences: visiting tourists, the nation itself, and communities abroad. Each performer has a role to play. The stage roles of "Soca Queen" Alison Hinds, "Reluctant Romeo" Rupee, and "Good Girl Gone Bad" Rihanna are in conversation with but different from the roles of mother, daughter, father, son, woman, man, celebrity, and Barbadian citizen.[1]

While there is a wealth of scholarly work and government and agency reports on Barbados, much of the existing scholarship focuses on Barbadian history and politics. Although this book focuses on postindependence Barbados, it also shows how a historical grounding is important in understanding the ways in which gendered, raced, and classed identities have formed over the centuries. The history also provides context for the ideological shifts on the island and the many different ways the nation of Barbados was imagined long before it became an independent nation-state. The historical record also illuminates the differences within the

national identity, including the gendered relationship between the state and nation-building projects, as well as the treatment of gender and sexuality in popular culture. In the past thirty years, there has been a growing field of historical research on gender and sexuality both on the island and throughout the English-speaking Caribbean.[2] This focus on gender provides the historical context for my analysis of how popular artists represent gendered identities in Barbados. There is also a growing body of work on Caribbean sexualities.[3] By drawing on this emerging scholarship, *In Plenty and in Time of Need* places older colonial myths of the eroticized Caribbean in conversation with the lived realities of contemporary Caribbean populations.

Popular culture studies on Caribbean music in the English-speaking Caribbean have focused on Jamaica and Trinidad.[4] Curwen Best is one of very few to track the history of Barbadian popular culture and aesthetics in single-author monographs, and, throughout many of his texts, he laments the fact that Barbados makes such scant appearances in the study of Caribbean popular culture. Drawing on this earlier work, I hope to further the field of Caribbean cultural studies by showing how important Barbados is to the Caribbean music scene, and, in turn, how that arena is transforming Barbadian identity.

In Plenty and in Time of Need also echoes cultural studies scholars' assertions that the popular imagination and popular culture have the power to subvert official cultural institutions, and it claims that popular culture is both a means to unite diasporically and a site of social construction.[5] The cultural influences of the island have drawn on various African diasporic traditions, and the performances of musicians such as Rihanna and a growing crop of newer artists who have signed to U.S.- and U.K.-based labels[6] are in conversation with national performances of modernity, development, and transnational relations. There are very few monographs that focus on the contemporary relationships between Barbados and concepts of diaspora. This book identifies an African diasporic consciousness as one of the many forces shaping Barbadian identity.

By drawing together the theories of postcolonial studies, performance studies, visual culture, diaspora studies, and new media, *In Plenty and in Time of Need* makes key theoretical interventions. This text examines constructions of the "real" through representations as varied as memoirs, novels, social media, and advertisements by using Stuart Hall's theories of representation and Jean Baudrillard's definitions of hyperreality. By applying these analyses to the works of the Barbados nation-state and the artists who represent it, this text questions what such theories can do for our understandings of nation building within global economic and ideological markets. Furthermore, in investigating different understandings of a "real" national identity, this text draws on the works of Lionel Trilling and John L. Jackson Jr., who both debate the relative meanings and usefulness of authenticity and sincerity. Building on Jackson's notion of racial sincerity, *In Plenty and in Time of Need* offers the theoretical framework of national sincerity as one

way to understand the raced, classed, gendered, and sexualized performances of Barbadians and Barbadian musical artists.

In Plenty and in Time of Need begins with representations of cultural ideals and their relationship to political and economic realities, and it uses the popular culture arena to illuminate the state of Barbadian identity, as well as the directions it is taking. The Barbadian cultural arena is emblematic of the island's complex international relationships and how they manifest in the construction of a national identity. The book begins with the literature of one of the island's most well-known literary artists, George Lamming, and the speeches of the nation-state's first prime minister, Errol Barrow, before moving to the musical arena and focusing on calypsonians the Merrymen and the Mighty Gabby. As music and musical performance are some of the most widespread manifestations of social commentary, the book focuses on them in order to analyze the competing ideals and realities of Barbadian national culture. The final three chapters focus on soca artists Alison Hinds and Rupee, and pop artist Rihanna in order to shed light on the ways femininity, masculinity, and sexuality have been used to represent a national identity within a global popular culture market. The main goal of the book is to provide a historically grounded analysis of the relations between gender, sexuality, transnationalism, and diaspora in Barbadian national identity formation. *In Plenty and in Time of Need* reveals how an analysis of Barbadian identity constructions can demonstrate the ways in which nationalism, regionalism, popular culture, and diasporic consciousness interact in the postcolonial world.[7]

A BRIEF HISTORY

Barbados is the easternmost island in the Caribbean archipelago of the Lesser Antilles. Portuguese explorers arrived on the island in 1536.[8] By the time the ship *William and John* landed in what is now Holetown with a group of English settlers in 1627,[9] all of the first-nations indigenous populations had migrated to other islands or to the mainland of South America.[10] The early settler population consisted largely of members of the lower aristocracy seeking to make a name for themselves and return to England, who were shortly thereafter joined by Irish and Scottish prisoners, indentured servants, and debtors.[11] Within decades of the first English settlement, sugarcane had come to dominate the geographic and economic landscape and the Atlantic slave trade had transformed the population.[12] The plantation system on the island colored power relations for centuries and was central to the political structures of the island.[13]

Barbados boasts one of the oldest parliamentary bodies in the Western Hemisphere, beginning as the General Assembly in 1639.[14] The General Assembly of Barbados proved to be cantankerous as early as 1651. The island served as an outpost for dissidents and others looking to avoid the turmoil of the English Civil War from 1642 to 1651.[15] In 1650, as the English Parliament regained power in

Europe, it sought to establish order abroad and curtailed the trade of England's colonies.[16] The planters and merchants in Barbados (which was the population from which the legislative body was chosen) refused to curtail their trade, and those in favor of ruling themselves contemplated joining with Bermuda to outright defy the order.[17] The General Assembly's defiance of English ruling bodies in 1651 "came as close to a declaration of independence as any English colony was to come before 1776."[18] This group of privileged landholding men consistently tried to assert their rights as freeborn Englishmen in the seventeenth century and repeatedly refused to submit as colonials. In January 1652, the governing bodies of the island signed articles of agreement in which "it was recognized that Englishmen in the Colonies expected to have and ought to have all the rights of Englishmen who live in England."[19] These articles made up the Charter of Barbados, which solidified the rights of those Englishmen on the island and formally acknowledged and clarified the governing structure of the island. Throughout Barbados's history, the elite classes (those who were male, white, propertied, and wealthy) practiced greater self-rule than elsewhere in the region,[20] and even after most of the British Caribbean reverted to Crown colony status in the late 1800s, Barbados kept its representative body.[21] This history of self-governance over the centuries became one of many arguments for Barbadian independence in the 1960s.[22]

The foundations of Barbadian society were built on the racialized international trades of sugarcane and enslaved labor, and the plantation system colored the social, political, and economic power dynamics for centuries after the island's settlement.[23] Before Emancipation in 1838, the free populations of color espoused both their connection to the British Crown and a diasporic consciousness through interest, support, and involvement in schemes for Afro-Barbadian emigration to Africa.[24] After Emancipation, a politically diverse cadre of Afro-Barbadian politicians began to emerge. In the early twentieth century, Garveyism swept the region. Barbados's first chapter of the Universal Negro Improvement Association (UNIA) was formed in 1919, and the organization's presence grew from six to eleven chapters on the island between the 1920s and 1940s.[25] Marcus Garvey made a one-day visit to the island in October 1937.[26] Organized Pan-Africanist efforts, as well as the international experiences of World War I (specifically the politicization and organization of the British West Indies Regiment), led to a movement toward labor organizing that came to its height on the island on July 26, 1937.[27] World War II had similar effects in terms of international and local organizing, and Barbadians were key to the efforts to organize the West Indies Federation, which came to fruition in the late 1950s.[28] By the time of independence in 1966, Barbadians were active in a growing African diasporic discourse,[29] while maintaining the global networks, diversity, and local specificity that had been at the foundation of the island's settlement.[30]

In Plenty and in Time of Need focuses largely on Afro-Barbadian culture. This is not to dismiss the diversity of the nation's population, but it does nod toward

the dominant imaginaries and representations of the nation. That being said, three of the main artists examined in this study exist in somewhat racially ambiguous spaces. In her live performances, Alison Hinds has repeatedly offered herself as a "caramel" alternative between her "chocolate" and "vanilla" dancers.[31] She clearly expresses her sense of African heritage while also acknowledging the varied privileges of skin tone. Rupee is a mixed-race man of Afro-Barbadian and German parentage. His rise in popularity across the region and across the globe mirrored that of artists with similar skin tones, such as Jamaican artists Red Rat and Sean Paul. And Rihanna's skin tone, Irish heritage, and green eyes have been celebrated in magazines and derided on playgrounds.[32] In their racial ambiguity and globality, these Barbadian artists are both representative and exceptional.

The cultural texts considered in this book simultaneously exist and are produced at home and abroad. Errol Barrow's speeches were given on both sides of the Atlantic, and Lamming's work is very distinctly about Barbados, but he himself says that it could only have been produced after he left the island. He entered into a network of migrants who were economically, culturally, and politically active. The support for the West Indies Federation was a diasporic organizational effort across continents and islands. Migration and travel were central to the careers of some of Barbados's most well-known calypsonians. The twenty-first-century musical texts, too, are inherently stretched between home and away. The book looks at Alison Hinds's representation of Barbados while performing in Trinidad and her collaboration with Jamaican reggae artist Richie Spice. While tracing Rupee's growth as a performer on the island, chapter 4 also situates his international debut within an early twenty-first-century dancehall craze and examines the ways his HIV/AIDS activism is a means to both represent Barbados and contribute to a global effort of awareness. Rihanna's stardom and her relationship to the Barbadian state are based squarely in her international popularity. Decades of independence have produced a national identity that is always in the making, and the process of that identity formation is and has been integrally tied to international flows and the migrations and returns of Barbadian peoples. These cultural analyses remap Barbadian identity as inherently global even while it is tied to the locality of the island.

NATIONAL SINCERITY

Popular culture not only expresses but also acts or induces action.[33] Not unlike Judith Butler's theorization of gender performativity, popular culture "is performatively constituted by the very 'expressions' that are said to be its results."[34] It is performative in that it implies its own construction of meaning.[35] Representations of Barbadian popular culture rely on and resist mythic histories of the region. The artists and actors who produce these representations present the culture of the nation as they know it and signify the desires of what they hope to

see realized. Through their performative popular work, they create imaginaries of nationhood.

Similarly, belonging to a nation is ongoing performative work, much like gender, race, and other forms of identity. The imaginaries that form the basis of nationhood can shift over time, and thus, despite official structures of state citizenship, there is rarely, if ever, any one accurate test of nationhood. *In Plenty and in Time of Need* analyzes performances of Barbadian national identity through a theoretical lens of national sincerity. Based on the arguments of Édouard Glissant and Stuart Hall, who think of identity as a set of processes, and the work of literary scholar Lionel Trilling and anthropologist John L. Jackson Jr. on sincerity and authenticity, I argue that national identity is performative and that it exists through its ongoing expressions.

The performativity of national identity is best understood through the tension between sincerity and authenticity, wherein sincerity indicates a performative becoming and authenticity implies an inherent essence. Trilling's examination of the antagonism between sincerity and authenticity relies heavily on art and literature. He finds that notions of sincerity and authenticity, and how they relate to understandings of the self, change and grow throughout different artistic periods. He argues that both in the modern epoch and in the period of modern art, authenticity takes precedence over sincerity. Art's purpose, Trilling argues, is to tell its audience who they are, to give them the tools to see their inauthenticity, to provide them with the barometers against which to measure their "true" selves.[36] Not unlike sociologist Erving Goffman,[37] Trilling sees a sincere performance of self as an effortful endeavor. He says that "if sincerity is the avoidance of being false to any man through being true to one's own self, we can see that this state of personal existence is not to be attained without the most arduous effort."[38] Trilling argues for a teleological trajectory where sincerity was held in high regard until a more "modern" judgment exposed sincerity's flaws.[39] For him, authenticity suggests "a more strenuous moral experience than 'sincerity' does, a more exigent conception of the self and what being true to it consists in, a wider reference to the universe and man's place in it, and a less acceptant and genial view of the social circumstances of life."[40]

Jackson adapts Trilling's concept of sincerity and authenticity in order to understand how academic and colloquial conversations about racial "authenticity" can be better understood through the lens of racial "sincerity." Echoing Trilling, Jackson notes how "sincerity demands its performance" and "wallows in unfalsifiability, ephemerality, partiality, and social vulnerability."[41] Authenticity, on the other hand, privileges structure and requires hard proof, often relegating the authenticated to object status as it is verified.[42] Jackson asserts, "Sincerity presumes a liaison *between subjects.* . . . Questions of sincerity imply social interlocutors who presume one another's humanity, interiority, and subjectivity."[43] In assuming another's humanity, sincerity allows for a mutual recognition that begins to relocate power

in exchanges of identification, especially for populations who have been objectified by hegemonic discourses of the modern.

Jackson prefers sincerity as a means of analyzing identity, because sincerity is both performance and performative.[44] It exists because of its constant performance, and its performance proves its existence. This is not unlike Hall's assertion of identity as ongoing process.[45] While Trilling argues that one cannot trust sincerity, Jackson contends that sincerity's subjectivity is just as valid and perhaps more telling in analyzing the production and policing of racialized identities and communities. In looking at the ways in which populations of the late twentieth century define "self" especially in relation to "society," Jackson finds that it is precisely the fluidity of sincerity and the untestable nature of it that makes it more appropriate for examining racial identity formations. Jackson goes on to note that "where authenticity lauds content, sincerity privileges intent."[46] While Trilling privileges authenticity and an authentic self that one either performs or does not, Jackson's theory of racial sincerity privileges the intentional effort of an ongoing performance of self. He notes that in recognizing another's humanity and interiority, one also recognizes the inevitability of personal ambiguity. Jackson's theoretical offering acknowledges and to some degree celebrates the skepticism, doubt, and uncertainty of sincerity, especially for those populations who have been objectified and "overdetermined from without."[47] Jackson concludes, "Whatever else sincerity is, it should be described as tactical rather than strategic," part of an ongoing set of struggles around identification, definition, and belonging.[48]

Expanding Jackson's conversation beyond the United States and extending his concept beyond racial identity, I posit that Barbadian national cultural identity is performed through national sincerity. As Barbados moved toward becoming an independent nation-state, the messy work of forming and defining the national identity found structure in the national motto of Pride and Industry. Performances of this national pride varied drastically and were virtually unverifiable. But the constant idealization of a national performance of pride supports a national sincerity that gives an ideological and poetic home to all of the many cultural habits, political histories, and social realities that Barbadians experienced. This national sincerity, not unlike Jackson's racial sincerity, is tactical. Even with drastically different power dynamics, the populations who settled in Barbados had been othered by political strife and war in Europe, the Atlantic slave trade, and various social and working conditions throughout the region and across the globe. A theory of national sincerity allows for variation across class, race, and color such that each individual can perform Barbadian nationhood, and yet it is very difficult to say exactly what the script of that role is.

The differences between these two scholars' interpretations of authenticity and sincerity stem from their different intellectual subjectivities. Trilling is working from the perspective of 1970s literary criticism and using that discipline to explicate literary and philosophical discourses of European culture. Trilling uses the

term *national sincerity* to explain a specifically English character espoused by Ralph Waldo Emerson, among others. For Emerson, Trilling argues, an English national sincerity is "the basis of the English national moral style" and the basis of the practical power (read as superiority) of the English.[49] Trilling still privileges authenticity and uses the concept of national sincerity as a means to analyze specific writers' understandings of the "character" of specific European nations. Jackson is working from the perspective of anthropological discourse, one that is highly informed by black studies in a U.S. context. He revels in the marginal spaces, privileging sincerity over authenticity to study identities and peoples who have been objectified by authenticity discourses and who have been othered within many discourses of modern nationhood. Here, I use their work in an interdisciplinary project that (1) reclaims the term *national sincerity* as a performative practice rather than a specific national character, (2) offers national sincerity as a performative practice that is informed by performances and discourses of diaspora and is in keeping with anticolonial discourses that disrupt hegemonic margin-center perspectives, and (3) uses national sincerity to build on a history of anthropology of Afro-Caribbean cultures while placing it in discourses beyond anthropological cultural studies.

NATIONAL CULTURE

Any understanding of Barbados is implicitly tied to the history of the region, global markets of trade, migrations, and the many networks that these phenomena have produced. By the turn of the twentieth century, Barbados could boast a centuries-old democratic Parliament structured after the British Westminster model and more informal social governance that was informed mainly by African and European cultures. Its economic trade had reached across continents and significantly influenced the racial and class distinctions on the island. Efforts at a larger West Indian nation-state had been attempted and were beginning to form again. The cultural practices of the people were constantly informed by the influences of their earlier homelands, as well as the institutions and practices that they created on the island and across networks of Barbadian migration. Barbadian identity, then, is inherently linked to the relations between populations, structures, and movements that have influenced the island and all who lay claim to it.

In the mid-1600s when Barbados was first colonized, the meanings of what it meant to be English were in flux and were debated between Royalists and Parliamentarians. In the next century, "English" identity became intertwined with that of the more encompassing term *British*, and even this identity was complicated by British colonists and the populations that they colonized across the world. These kinds of power relationships between populations, state structures, and ideologies of belonging created revolutions, which in turn created new national identities. And these identities were created as a challenge to the totalitarian structures

that defined what it meant to be a subject of empire, what it meant to be modern, what it meant to be Human, and so forth. Édouard Glissant offers a theory of relational identity as opposed to rooted identity because he understands the ways that identity is fluid—too fluid, in fact, to be easily authenticated. He offers identity as a system of Relation, one that presents itself as a form of violence against totalitarian structures;[50] he uses the notion of the rhizome as an epistemological tool. He writes, "Rhizomatic thought is the principle behind what I call the Poetics of Relation, in which each and every identity is extended through a relationship with the Other."[51] In thinking of identity as a system of Relation, Glissant implicates the Caribbean, believing that the region is one of the places where Relation is most visible in the world.[52] The unique history(ies) of the Caribbean region serve as an ideal example of why identity should be viewed through a Poetics of Relation.

Glissant's Relation is a part of and in response to discourses of diaspora. While the Jewish, Greek, and Armenian examples of diaspora relied heavily on a homeland-hostland model, by the 1970s scholars had begun to question the notion of identity being "rooted" in a homeland.[53] Glissant's rhizomatic paradigm offers a way of analyzing diasporic identities that does not erase a sense of rootedness but also challenges ideas of a totalitarian root.[54] If identity is formed through Relation and does violence to totalitarian structures, then one's "roots" cannot be the only indicator of one's identity. The scholarship of Caribbean creolization and hybridity, as well as the field of cultural studies, supports such a reading.

Since the late seventeenth century, the Barbadian population has been overwhelmingly of African descent, but it also includes statistically smaller communities of European, East and South Asian, Middle Eastern, and first-nation indigenous descent. The migration patterns that the island nation is a part of have also created a Caribbean diaspora across the world. In describing "what makes Afro-Caribbean people already people of a diaspora," Stuart Hall is careful to define exactly what he means by the term. His understanding of diaspora is one of heterogeneity. He says diaspora experience is defined "by a conception of 'identity' which lives with and through, not despite, difference; by *hybridity*. Diaspora identities are those which are constantly producing and reproducing themselves anew, through transformation and difference. One can only think here of what is uniquely—'essentially'—Caribbean."[55] Hall notes how the hybridity of Caribbean discourse implicates and is implicated by rhizomatic forms of diaspora. In using a relational, always in process, definition of identity, he ironically calls on "essentialism" to define the ongoing processes of Caribbean identity formation through an already implied diasporic Relation.[56] Contemporary African diaspora theorists describe difference as a constitutive part of diaspora, reject totalitarian "essences" of identity, and implicate the Caribbean as part of diasporic discourse. In light of this, Barbadian identity cannot be understood through simple essentialism, and its reliance on regionalism and diaspora is not an effort at essentialist sameness

but is used, rather, to help to build and define a national identity and produce a national culture.

Any Barbadian national culture, then, is built through and implicated within the concepts and material practices of nation, state, diaspora, and cultural process. A national culture is constituted by the body of efforts made by a people to describe, produce, praise, critique, and defend their collective body.[57] In analyzing the ongoing formations of a Barbadian national culture, one must take into account the ways it also exists within and is distinct from a West Indian culture, a Caribbean culture, and multiple diasporic cultures. Both "nation" and "culture" are built on ideological imaginaries and produced through sets of practices informed by these imaginaries that a collective assigns meaning to.[58] Michel-Rolph Trouillot argues that the state is "a set of processes."[59] If "culture," "nation," and "state" are all sets of ongoing processes that inform and interact with one another, how does one tell them apart, and what meaning does a term like *national culture* conjure up, especially in globalized and diasporic contexts?

The Barbadian nation has been constituted by the processes of interaction between multiple populations over centuries. Those who live, have lived, and/or have affective ties to the island create an imagined community that is then expressed through cultural practices. The nation-state of Barbados, then, grew out of the process of defining a national identity and achieving a level of self-determination on and against a history of British colonialism. In examining the formation of a Barbadian national identity, Hall's caution is useful. He writes, "We should think . . . of identity as a 'production' which is never complete, always in process, and always constituted within, not outside, representation."[60] Barbadian identity is constantly being produced through the quotidian performances and spectacular representations of those who identify as Barbadian. The meanings assigned to these performances and thus to the identity(ies) that they produce are therefore themselves ongoing productions.

If identity is a production whose meanings are constantly being made, then it is quite difficult to pinpoint any one singular "truth" within identity. Hall cautions that meaning is less about claims of "accuracy" and "truth" and more about translation, about effective communication, and that this view recognizes persistent power differentials between those communicating.[61] Arjun Appadurai, in his 1990s analysis of a "new" global economy of the late twentieth century, identifies five dimensions to the global flow of culture: ethnoscapes, technoscapes, financescapes, mediascapes, and ideoscapes.[62] These scapes describe global flows and exchanges of goods, peoples, and ideas that disrupt any simplistic notion of a margin and a center. For artists such as Alison Hinds, Rupee, and Rihanna whose careers depend on the global travel of their images and who have strong ties to their specific "home" of Barbados, such global scapes characterize both their sense of home and the routes they take in representing it. The relations among these five scapes—the ways in which ethnoscapes often rely on technoscapes that fuel

mediascapes that depend on financescapes and ideoscapes—have particular resonance with popular culture artists who in many ways are an important part of today's global cultural flows. For artists such as Alison Hinds and Rupee who were born in Europe yet strongly identify Barbados as home and clearly declare that they represent Barbadian culture, these scapes are at the core of their representations of self and community. In the twenty-first century, these artists, along with Rihanna, have demonstrated the ways these scapes inform, circulate, and create popular culture while representing their nation.

Meaning is made through the conversations, performances, representations, and discourses of Barbadian national identity. The actors within this meaning-making process stand on unequal footing, and these differences in power are both supported by state structures and resisted by nonstate actors. The artists who work within and seek to represent Barbadian culture tell the stories of Barbadian identity. It is largely through their work that one can begin to conceive of identity as an ongoing achievement, as something that has been formed (even if still in formation). Glissant notes, "Identity will be achieved when communities attempt to legitimate their right to possession of a territory through myth or revealed word."[63] Literature, song, dance, and accompanying visuals rewrite the myths of Barbadian identity. Within these representations, artists performatively re-create Barbados, since, as Glissant notes, "to declare one's own identity is to write the world into existence."[64]

MYTH, REPRESENTATION, AND THE POPULAR

Barbados is implicated in historical myths of the Caribbean as exotic leisure paradise and historical realities of the region that include sickness, struggle, and strife. Roland Barthes defines myth as a second-order semiotic system,[65] one wherein the original signified is obscured and lost. Myth takes a referent (a reality) and turns it into a form, a way of signifying rather than any one concept, idea, or materiality to be signified. Myth, then, is a form of communication.[66] Like a copy of a copy of a copy, the meanings associated with mythic signs are continuously resignified. In this way, "what is invested in the concept [of myth] is less reality than a certain knowledge of reality; in passing from the meaning to the form, the image loses some knowledge: the better to receive the knowledge in the concept."[67] The mythic signs of Barbadian identity become a way of signifying Barbadianness. They serve as a means of effective and affective exchange, as a performative way of communicating an ever-changing national identity.

As a form of communication, myth is not bound by a sense of accuracy, "authenticity," or even "truth." As a way of communicating, it has no loyalties to what is being communicated. Because of this, "myth hides nothing and flaunts nothing: it distorts; myth is neither lie nor confession: it is an inflexion."[68] As a system of communication, myth is neutral, meaning "myths can be manipulated for good

or for ill because they are just that, myths."[69] Barbados's history is full of myth. Those myths begin with the larger historical myths of the Caribbean as exotic paradise. They move through the myths of colonization, the most notable being the mythic discourse of Barbados as "Little England." After independence and into the twenty-first century, those older myths never quite went away, but newer myths feed Barbados's nationalism and its tourist economy. What people believe about Barbados is based in these mythic forms of communication because "in reality (as both history and semiotics demonstrate), the investment of believing passes from one myth to another, from one ideology to another, or from statement to statement. Thus, belief withdraws from myth and leaves it almost intact, but without any role, transformed into a document."[70] *In Plenty and in Time of Need* begins with mythic representations of Barbadian national identity. It starts with two powerful forms of communicating Barbadianness (namely, the concept of "Little England" and a masculine-imagined black nationalism) and the specific events and materialities that use these forms. Representations of these myths, however, produce affective ties and thus real-life effects. Marita Sturken and Lisa Cartwright define *representation* as "the use of language and images to create meaning about the world around us."[71] They make a distinction between a mimetic view of representation that simply mirrors back a part of the world that already exists, and a social constructionist view of representation where meaning making only happens within systems of representation, where readings of representations create meaning.[72] This book focuses on a constructionist discursive view of representation, wherein "representation is thus a process through which we construct the world around us . . . and make meaning from it."[73] Representation, then, is both a re-presentation and a site of creation. All representations, as René Magritte and Michel Foucault have shown, exist outside the "real" they purport to represent.[74] The drawing of a smoking pipe is not a pipe. The political speech is not (yet) the policy. The tourist poster is not the actual beach. The mythic representations of Barbados serve to create a hyperreal wherein mimetic and discursive understandings of representations collapse on themselves.

Such mythic representations are not unlike Baudrillard's reading of Borges's fable.[75] The short fable tells the story of a cartography so perfect that the map of the Empire met the Empire on a one-to-one scale. Subsequent generations, less interested in cartography, found this useless and let the map decay. The map frayed, revealing bits of the territory it was meant to represent beneath it. Subsequent generations were left to wonder whether it was bits of the territory or bits of the map that they were looking at. In Baudrillard's usage, this tale illustrates what he calls the hyperreal. The hyperreal is what happens when the map and the territory are indistinguishable; it is "the generation by models of a real without origin or reality."[76] Hyperreal representations "substitut[e] the signs of the real for the real,"[77] not unlike myth. Whereas myth is a form of communication, incessantly neutral in that it can communicate anything and anything can become mythic, the hyperreal

stands in for a signified, one that may never have been but is assumed to exist. Hyperreal communication is achieved when the representation is more real than the real itself.[78] The myths of Barbadian identity display this hyperreality. One need only look to the racist assertions of Barbadians as "English rustics in black skin" who are more British than the British or postcards of Cannibal Canal as examples.[79]

In Baudrillard's assessment, there is a distinct difference between representation and simulation. For him, representation is mimetic. It is based in a utopian idea that the sign equals the real. He writes, "Whereas representation attempts to absorb simulation by interpreting it as a false representation, simulation envelops the whole edifice of representation itself as a simulacrum."[80] In this mimetic view, representation as a concept is meant to have some truth-value that simulation is false to. Even in its most idealistic iterations, there is an assumption that a representation is a sign that accurately presents a reality. Simulation and hyperreality privilege the sign over the real that representation says it represents.

In Caribbean discourse, such simulations often fall into the realm of the romantic.[81] The Caribbean is romantically represented by beaches, coconuts, palm trees, and warm sunsets. Societies with tourist-dependent economies rely on such romantic, hyperreal representations. The construction of a Caribbean imaginary in the seventeenth and eighteenth centuries paved the way for the construction of a consumable Caribbean that is reimagined and reconstructed in the twentieth and twenty-first centuries.[82] The map and the territory become indistinguishable; they converge and disperse over and again. Representation and simulation collapse on one another in attempts to sell a mythic "real" Caribbean, an "authentic" experience based on a nostalgic past and an idealistic future. Images, narratives, and myths of Caribbean romance (whether it be an interpersonal romance or falling in love with the region) are familiar signs whose referents are irrelevant. They are myths that have effective and affective power because of how they are communicated rather than what is communicated. And they rely on a notion that fantasy can be made real.

What Baudrillard calls hyperreal, Caribbean discourse has termed myth-reality. Ian Strachan uses this term to describe the relationship between Bahamian lived experience and tourist representations of that island nation and the larger Caribbean region. In *Paradise and Plantation*, he details the rise of paradise discourse, how the concept of paradise influences imperialism, colonialism, tourism, and ideologies that Anglophone Caribbean populations hold about themselves and their place in the world. For Strachan, "Caribbean discourse, then, is customarily [but not entirely] shaped by an underlying economy: the imperialist-colonial economy of wealth extraction and exploitation and an often anti-imperialist counter-economy, one that concerns self-worth."[83] In Strachan's estimation, the myth of the Caribbean as paradise becomes a myth-reality through the performances of tourism. From Christopher Columbus's brutality in the region, through

the discourse of convalescence (the Caribbean as healing), and into the twentieth-century tourist market, Strachan tracks the ways representations informed ideologies that produced (hyper)realities. The map preceded the territory. The region was represented as a paradise, and centuries later it is still being turned into paradise (for those who can afford the experience).

The dependence on a tourist economy means that the state is complicit in the myth-reality. Strachan writes, "Notwithstanding the contradictions between an imaginary paradise and the lived experience of most Bahamians in a society so dominated by tourism, independent sources of community identity must contend with a state-sanctioned and -financed, industrially packaged brochure myth-reality."[84] In Baudrillard's terms, the Bahamas (and wider Anglo-Caribbean) materially does what every society does in a consumer-driven world: it continually attempts "to restore the real that escapes it." It materially (through hotels, land-scaping, golf courses, etc.) produces the hyperreal.[85] Tourism industries mimic the mythic narratives of Caribbean paradise that began when the region was colonized, sustaining a hyperreal with no original referent.

Homi Bhabha theorizes the use of mimicry within colonial contexts in two ways. First, colonizers encourage mimicry rather than assimilation. This view posits that the act of mimicking marks one as "other," because one can never really become the colonizing subject. Such a use reinforces hegemony. Second, the colonized can also appropriate acts of mimicry for their own use. Because colonial mimicry relies on ambivalence, its "doubleness" allows for a challenge to its authority.[86] Derek Walcott draws on this second sense of mimicry and takes it further, arguing for mimicry as a site of creation. He says, "Anyone in the Caribbean . . . is fated to unoriginality," but there is something to be done with that fate.[87] Artists and performers, in particular, have the power to reinvent the roles they mimic, not becoming the original but creating a new original in the process. They are able to use an oppositional form of appropriation[88] to resignify the mythic representations of the Caribbean and its peoples. Those who were supposedly more British than the British become modern, developed Barbadians (with all of the connotations of those contested terms). And they can simultaneously mimic the premodern exoticism of mythic representations of the region. Walcott posits that it is the liminality of Caribbean subjects that allows for this process.

Caribbean subjects have been able to mimic the mythic narratives that have been circulated about the region and re-create them in and outside tourist economies. As Angelique V. Nixon notes, "The site is now a sight. . . . The paradise is now both myth and material good."[89] She draws on the work of Strachan, who notes that, "like the plantation that gave birth to it, Caribbean tourism is rooted in export, the export of paradise to North America and Europe."[90] The historical myths of the region, then, are tied to the international market of goods and ideologies, and these ties have continued for centuries. Similarly, in his tracing of the etymology of *paradise* and its applications to the Caribbean region, Lyndon K.

Gill beautifully expresses the hyperreal/myth-reality of a Caribbean imaginary. He writes, "And so the Antilles remain, *a there* that is not ever there completely, but shifting perpetually like an uneasy spirit between the material world and a fetishistic longing. Quite literally, these islands are called upon to stand in for that which is desired and immaterial (a disappeared Antilia, the elusive Indies), essentially that which they are not and yet still forced to become."[91] Strachan further genders this dynamic when he writes, "The Caribbean then, is a whore paid to play the virgin, in the sense that its virginity and deflowering is re-created and reenacted advertisement after advertisement, for the benefit of a male consumer who is invited to be the first to take her maidenhead, on land or underwater. The female tourist, in turn, is invited to play the role of the exotic, the licentious virgin. She is summoned to become the object of desire. She is invited to be as wild and unrepressed, as sensual and mysterious as the land itself."[92] The gendered and sexualized nature of these accounts deserves some attention. In hegemonic myths of the Caribbean region, the land is feminized, licentious, unrepressed, and available to be penetrated or consumed.[93] She is available to both male and female visitors, and century after century, they will always be her first, fixing her in time and inexperience. She will teach men how to be men by taming women while at the same time teaching women to be untamed. This is the fetishistic longing that Gill writes of. It is a myth that tourism encourages Caribbean peoples to mimic. And Caribbean people mimic it *and* reject it with nuance in their performances of tourism and in their performances of national and regional identities. Gender and sexual performance become another site of self-definition.

Gender and sexual performance has been a site to further explicate Caribbean discourses of self-making and creolization. In her introduction to the edited collection *Sex and the Citizen*, Faith Smith writes against an overarching notion of Caribbean creolization and hybridity as an inherently liberating force of self-definition. She writes that postcolonial liberation celebrates autonomy, but it celebrates a "wholesome" heteronormative sexual autonomy that is part and parcel of Caribbean sovereignty and thus offered as the only correct way to be Caribbean.[94] In noting the ways that such discourses have been used to create heteronormative state ideals, she brings attention to the nonheterosexual peoples, practices, and impulses throughout the region. Her introduction (and the larger edited collection) works to make the multitude of Caribbean sexualities a constitutive part of discussions of Caribbean citizenship.[95] The collection shows how myths of Caribbean availability, of erotic exoticism, must be dealt with in the postcolonial world, and dealing with them cannot mean simply replacing them with equally restrictive expectations of "wholesome, normative, straight" ideals. The burden of history asserts itself again and again as Caribbean populations seek a sovereignty that negotiates the differences (racial, gendered, and sexual) within each territory and each nation-state. According to Smith, it is in the realm of per-

formance that "sexual desires are given a wider range and reign than they are in other areas of life."[96]

In Plenty and in Time of Need focuses on representations and performances of popular culture, in terms of both secular music culture and, to a lesser degree, popular cultural practices. The text also uses theories of performativity to analyze national, gender, and sexual identities.[97] Given the history of myths of an erotic and exotic Caribbean and the reliance on these myths in many tourism markets, gender and sexuality are important lenses in analyzing how popular musical performers represent the nation.

The "popular" is built on representations in both the mimetic and the constructivist discursive senses. On the one hand, as Stuart Hall observes, "Popular culture always has its base in the experiences, the pleasures, the memories, the traditions of the people. It has connections with local hopes and local aspirations, local tragedies and local scenarios that are the everyday practices and the everyday experiences of ordinary folk."[98] It reflects the values and practices of the people, the populace, from which it comes. And yet it also reflects their aspirations. Hall continues, "Popular culture, commodified, and stereotyped as it often is, is not at all, as we sometimes think of it, the arena where we find who we really are, the truth of our experience. It is an arena that is *profoundly* mythic. It is a theater of popular desires, a theater of popular fantasies. It is where we discover and play with the identifications of ourselves, where we are imagined, where we are represented, not only to the audiences out there who do not get the message, but to ourselves for the first time."[99] In this second sense, popular culture provides the means for both maintaining and creating a collective identity. It is mythic. It communicates desire and (re)produces imaginaries and knowledge structures. Those desires are both sexual and chaste; they are wild and innocent; and they bear the burdens of the Caribbean region's eroticized mythic history. Kamala Kempadoo's work shows how "the Caribbean has long been portrayed in the global imagination as an exotic, resource-filled region of the world." The region was a playground and "sex haven for the colonial elite," it is visited by sex tourists, among others, and the tourist economies rely on this racialized and sexualized myth.[100]

The popular culture of the region mimics these earlier myths in both of Bhabha's definitions of the word. *In Plenty and in Time of Need* reads popular artists and their representations of Barbados through their gendered and sexualized bodies. Alison Hinds's understanding of herself as Soca Queen cannot exist without the gendered nature of the queen trope and what it means in a larger African diasporic discourse. Rupee's "love you all" aesthetic is in contrast to the images projected by many of the other Afro-Caribbean artists who were being signed to major labels in the early twenty-first century, and his performances of masculinity are central to his representations of Barbadian culture. Representations of Rihanna's

sexuality have been conflated with representations of the island nation in celebrity media. These artists and their audiences play with sexualized expectations of the region and reassign their own meanings, both supporting and resisting earlier tropes of Caribbean sexuality, Caribbean availability, and Caribbean subjectivity.

CHAPTER SUMMARY

Chapter 1, "England's Child, the People's Nation: Myths of Barbadian National Identity," begins by tracing the origins and uses of the myth of Little England before showing how that myth has both endured and been resisted. Through Curdella Forbes's "man of speech" discourse, the chapter concentrates on two prominent Barbadian men in literature and politics. Using the works of George Lamming, one of the most heralded Barbadian literary artists, and Errol Barrow, a consummate West Indian statesman and the first prime minister of Barbados, the chapter looks at how Barbadian independence grew out of, interacted with, and butted up against efforts of Anglophone Caribbean regionalism, African diasporic networking, multiple eras of black (inter)nationalism, and the growing need to move beyond older sociopolitical structures of the island.

Chapter 2, "Performing National Identity," looks at the ways that the myths of Barbadian national identity were rebuffed by the realities of Barbadian culture and specifically through the creativity of Barbadian cultural producers. Using a musical form that is indigenous to the island, tuk, as a metaphor for how English, African, and Caribbean cultural influences competed to form the cultural foundations of an independent Barbados, the chapter examines the careers of popular calypsonians such as the Merrymen and the Mighty Gabby, and the central role that migration and return have had in quotidian performances of "Barbadian personality."[101] Theoretically, this chapter offers national sincerity as a more useful discourse than cultural authenticity as it analyzes Barbadian performances across differing racial and class statuses. Finally, it looks at how cultural performance became entrenched in the economic, political, and ideological understandings of the Barbadian nation-state through the construction of a tourism brand, a turn to cultural industries, and the revival of the Crop Over Festival.

Chapter 3, "Caribbean Queen: Afro-Barbadian Femininity and Alison Hinds Performing the Erotic at Home and Abroad," gives a historical account of Afro-Barbadian women in the public domain and the shifts in discourse that occurred throughout the 1960s and 1970s before focusing on soca artist Alison Hinds and her performance as "Soca/Caribbean Queen." Hinds's use of the African queen trope as a diasporic resource allows her to navigate definitions of respectability, femininity, and power across audiences while representing Caribbean women to a global audience. Through her public performances (on stage, in music videos, and through her use of internet technology to connect with fans), the chapter lays out how she uses Afro-Barbadian femininity as a national and diasporic resource.

Chapter 4, "'Love You All': Rupee, Afro-Barbadian Masculinity, Activism, and the Temptations of a Global Pop Market," uses Chela Sandoval's notion of the neorhetoric of love in order to analyze the performance of Afro-Barbadian masculinity that soca artist Rupee offers on a global stage. By examining his public presentation of himself, his AIDS activism, and his affectionate, inclusive performance aesthetic (best articulated in his signature saying, "love you all"), I argue that Rupee represents a generation of Caribbean men whose definition of masculinity is rooted in a sense of responsibility. This chapter traces definitions and performances of Barbadian masculinity using sociological studies, memoirs, performances, and interviews in order to demonstrate the changes that happened in the first independent generation of Barbadian men.

Chapter 5, "Rihanna: Where Celebrity and Tourism Meet at a Dangerous Crossroads of Representation," analyzes the relationship between Rihanna, the Barbadian government, and both her Barbadian and larger global audiences. It traces a changing same of representation by connecting historical myths of the erotic and exotic Caribbean to blogs, music videos, and augmented-reality advertisements. Using key performance moments and the reactions to them in the press and social media, the chapter examines the role that sexuality plays in representations of Rihanna as a global celebrity and of Barbados as a Caribbean tourist destination. Ultimately, this chapter explores the partnerships, tensions, and possibilities between Rihanna's celebrity brand and Barbados's national tourism brand.

A FINAL HELLO

In 2016, the prime minister of Barbados, Freundel Stuart, issued his message to the nation on the occasion of the fiftieth anniversary of independence. In it he said, "The pursuit and achievement of nationhood was never intended to be an end in itself. It was not just a search for psychic satisfaction. We pursued nationhood in order that we might take our destiny into our own hands and mould that destiny in such a way as would develop to the fullest extent possible the hidden potential of our people."[102] He tasked each Barbadian with the responsibilities of independence, and in line with the familiar ideal of Barbadian pride and excellence, he stated that "there is just no room in the Barbados of today or the Barbados of tomorrow for mediocrity in any area of our lives."[103] Stuart's message continues a tradition of Barbadian and Caribbean idealist political entreaties that ask populations to accept the burdens and hardships of self-determination in order to achieve the promise of self-government and maintain a vision of possibilities for better times. He delivered this speech while in the midst of criticism of his own performance as prime minister and his government's performance overall.[104] One of his duties as prime minister was to perform a nationhood that, ostensibly, Barbadians would want to support, but he was also tasked with articulating a future

that the population would believe he could help to achieve. Stuart's message to the nation was his representation of a future vision, but his assessment of the present omitted the economic, social, and cultural fears that were circulating at the time and the critiques of his own performance. The independence celebrations were an opportunity to commemorate past achievements and to assess the present. It was a moment that laid bare the "presence of all the absences (memories, lessons, promises) to whose rhythm History becomes both intelligible and desirable."[105] Stuart's speech to the nation after fifty years of independence was a pregnant moment—pregnant with possibility and yet still carrying the burdens of history.

In the twenty-first century, economic hardships, cultural debates, and political battles have continued to provide an ever-shifting foundation on which to continue to build Barbadian pride. The Barbadian nation continues to move away from old myths and create and re-create new ones through changing performances of a national ideal, such that the boundaries between ideal and real have become hyperreal. A world without such boundaries can be scary and uncertain, but it is likewise filled with possibilities. Just as the history of Barbados has been recorded through the voices of its artists, the future lies in new melodies. That initial meeting of Africa, Asia, the Americas, and Europe that created the Caribbean is still at the heart of struggles for self-identification and self-governance in the region. But the local and international success of individual artists, and the ways in which they have been able to represent the region and the nation, provides hope that new identities may yet be able to bear the weight of their histories. Barbados's history is a complex and heavy one, but the innovation of its artists is inspiring, and as Barbadian poet, cultural critic, and theorist Kamau Brathwaite once wrote,

sun coming up
and the drummers are praising me

out of the dark
and the dumb gods are raising me

up
up
up

and the music is saving me[106]

1 · ENGLAND'S CHILD, THE PEOPLE'S NATION
Myths of Barbadian National Identity

Three hundred years, more than memory could hold, Big England had met and held Little England and Little England like a sensible child accepted. Three hundred years, and never in that time did any other nation dare interfere with these two. Barbados or Little England was the oldest and purest of England's children,[1] and may it always be so.
—George Lamming, *In the Castle of My Skin*

It's the third day of January 2012, and a small group of people are liming[2] in a shop in Speightstown. It's an old port city on the northern shores of Barbados, one that holds its history even as its hustle and bustle has slowly waned with time. Some folks are regulars; a few have stopped in for the first time. Pensioners drink with working-age folks, though only a handful are under forty. The debate starts when the men see a pretty woman pass. She has just come out of the sea and is wearing a beach towel with a map of New York to cover her bathing suit as she walks down the road. The men begin to talk, still watching the woman disappear up the street. One woman in the shop, a Bajan woman home for holiday from England, begins to talk about how poorly Bajans live in New York City. Then she says black people have a place in England but not here, not in Barbados. An elderly man two seats away says England was designed for everybody and eagerly sings praises, thankful for everything England has done for him. I do not agree with them and say so. But the elderly man's statement has already started something in the shop, and that's when the young man on the other end of the bar jumps in and explains that just because you benefit from something doesn't mean it was designed for your benefit. I agree with him and feel a little sad that so many of the older generation in the room are so adamant in praising England and crying down Bim[3] with statements like, "I will never deny England. England is the best place on earth." The shop erupts into debate. The younger folks tell the stories of their grandparents' struggles. The old folks stake claim to their own experiences.

The middle-aged folks are largely silent on the sidelines. It feels paradoxical. I speak with the woman on holiday about the nuances of affirmative action in the United States and the pushback against it. We talk of infrastructure and varying senses of belonging in the United Kingdom. We don't speak much of Barbados. Both of us are Bajan. Neither of us lives on the island. She admits that maybe black people's place in the world is more complicated than she had thought. By now the two loudest of the men have agreed to disagree, hugged it out, and bought a drink. The shop quiets into its usual banter that spans everything from gardening to sex, knot tying, parenting, and reminiscing. The space's soundtrack of laughs and grumbles resumes as more bottles open.

As I leave and walk off down the street, the young man at the center of the debate pulls his truck up beside me. He had stopped to buy his friend a drink after work and now asks me what I thought about the whole conversation and why I was so quiet. He says, "It would have been nice to have some backup." I repeat what I had said to the group and what I had said one on one. I was on his side, but he hadn't heard me at all; he hadn't heard any of the women in the shop. He pulls away, not entirely convinced I had been in the conversation. I keep walking on, still a little dazed that such a conversation persists forty-six years after independence.

This chapter uses literature and political rhetoric to explore the changing myths of Barbadian nationality, arguing that the myth of Barbados's exceptionality as "Little England" outgrows its usefulness as a growing cadre of mostly male intellectuals throughout the Caribbean region push a more attractive myth of nationalism in the mid-twentieth century. I argue that Barbadian national identity is constituted through migration and return; social, political, cultural, and economic relations between the island and its Caribbean neighbors; and the changing place of the colonial myth of Little England in Barbadian discourse. Barbadian identity achieved a sense of exceptionalism and modernity with its association with the English and then the British Empire, but that exceptionalism was almost always limited to an elite white planter-merchant class, and throughout the mid-twentieth century the colonial relationship would mark the nation as outside modernity. In the decades surrounding independence in 1966, representations of Barbados negotiated the contradictions of the island's colonial past, a growing yet still uneasy regionalism, and a nuanced black nationalist reclamation of African heritage in order to both discover and create a unique Caribbean nation-state ideal.[4] The language of Barbadian public discourse reflected this shift.

An analysis of some of the most well-known works of Barbadian literary giant George Lamming and the official speeches of the nation's first prime minister, Errol Barrow, demonstrates Barbados's complicated culturo-political heritage, and the ways in which the colonial and state governments worked in and through the complexity to construct a mythic ideal of Barbadian national identity. Lamming and Barrow, as writer and politician, respectively, fit squarely within the discourse

of "men of speech," one wherein "the iconic face of the nation was uncompromis-
ingly masculine and male."[5] Their representations of Barbados continue the dis-
courses of historical texts, academic dialogues, and public platforms that privi-
leged male voices.[6] Both Lamming in his novels, and Barrow in his speeches, call
for Barbados to be "something bigger" and "something more" than it was imagined
to be in the time of their writing. They speak of ways of life, a changing sense of
community, and a remapping of the island's identity that includes its many his-
torical influences, as well as diasporic communities. Using both the discourses of
fiction and those of more formal political arenas, this chapter charts the growth
of these competing mythic ideals of colonial child and self-governing entity.

In 1953 Lamming released *In the Castle of My Skin* and began a career that would
earn him a reputation as one of Barbados's most heralded literary talents. The text
is a coming-of-age story of both a boy who grows into a young man and a colony
growing toward more self-government. Using autobiographical fiction, Lamming
details his upbringing with delicate attention to the specificities of gender, color,
class, and status. In the voice of a nine-year-old narrator named G., he tenderly
explains his mother's pain and how, as her child, he had come to embody her hopes
in the absence of his "father[,] who had only fathered the idea of [him]."[7] G.'s per-
sonal narrative resembles that of the island's relation to "Big England."[8] Just as G.
outgrows his village and sets his sights on opportunities abroad, Barbados out-
grew its colonial position and was beginning to explore its overlapping options
of regionalism, nationalism, and independence.

In the Castle of My Skin is a text primarily about Barbados and its mythic iden-
tity as Little England. Offering one of the most explicit and salient examples of
the sociopolitical ethos of its 1950s moment, it satirically depicts a pride that com-
mon village folk felt for being a part of such a "great," "proper," and modern Brit-
ish empire. Lamming illustrates how English settlers brought their culture, their
habits, and their English characteristics to the island, turning Barbados into Little
England. In Lamming's telling, these English settlers, landlords, and English
descendants used this title "with the pride of the villager who thought the name
carried with it a certain honourable distinction."[9] In the text, Barbados is a smaller
version of England, and as Little England it replicates the same social structures.
In the first half of the novel, the young characters present the notion that Barba-
dos is Little England as something fixed, ahistorical, and affecting their entire out-
look on the world. England and the British Empire stand in for the world outside
Barbados's shores. After sneaking into the white landlord's yard to watch the land-
lord's family entertain visiting sailors one evening, the boys of the village sit con-
templating the difference between their lives and the "big life" of the landlord:

> "That's what Mr. Slime say he goin' to change," said Boy Blue. "He say time an'
> again there ain't no reason why everybody shouldn't have the big life."
> "He won't change what is," said Trumper. "'Tis a question of what is."[10]

For Trumper, what has always been, including race, class, and gender inequities, will always be. For him and the rest of the children, it is not a question so much of the history of the island or the ways in which its people built a unique identity but rather a question of what *is*; and in their moment, from their perspective, Barbados *is* Little England. They do not question how the island of Barbados came to be associated with England, but they do dwell on this association as a source of pride. They are proud to be a part of Little England, even if their own racial and class position in society does not afford them any other privileges than that pride. And this is how the myth had operated as a Barbadian imaginary. Lamming explains, "This is what I mean by the *myth*. It has little to do with lack of intelligence. It has nothing to do with one's origins or class. It is deeper and more natural."[11] The myth of Little England, though it changed over centuries, was based on a singular perspective that profoundly affected the experiences of many. In *In the Castle of My Skin*, this myth is troubled when more and more characters gain different perspectives through travel and return, and as those who stay in the village begin to have experiences that don't match the myth.

At the end of the novel, the sale of the village land to the growing, rootless middle class brings sweeping social change to the lives of the villagers, and the only certainty is that something has to give. G. is growing up, and the village is as well. "English civility" unravels into labor unrest, and migration and return to the United States bring different perspectives to the village. As the plot unfolds, the reader can see how the people of the village and the island are moving to own their own land, to break through the boundaries of social status, to exercise more civic rights, and to control their own destinies, while some just want things to stay as they have always been. There is a comfortable familiarity in the way that the community has endured its disadvantaged position, and change threatens that collective refuge. Lamming paints this change as inevitable. The story begins with the question of what *is*, but it ends with the question of what's *gotta be*.

In his 1960 *Pleasures of Exile*, Lamming echoes many of his colleagues in making the claim that West Indian writers had to leave the Caribbean in order to write. He offers the text as one man's way of seeing and centers his remarks on the importance of perspective.[12] From his point of view, in the 1950s a West Indian writer could not exist in the West Indies, simply because the ubiquitous colonial perspective could not imagine such a being existing.[13] Instead, dozens of West Indian novels were released by West Indian migrants, marking the 1950s as an important literary era. The form of the novel itself drew on British modernism even while the content of these novels was distinctly anticolonial.[14] While Lamming notes that his first novel was beginning to be taught in West Indian schools, *Pleasures of Exile* is about the freedom of travel and how getting away from his home shaped his perspective as a writer, as a West Indian, and as a diasporic subject. As Sandra Pouchet Paquet writes, "His dissenting voice is personal and collective. As colo-

nial subject, Lamming offers himself as a representative text to be read and as a privileged interpreter of his own historical moment."[15] Both his autobiographical novel and this collection of autobiographical essays set him apart as an icon, a subject through which greater phenomena can be read. *Pleasures of Exile* traces Lamming's journeys through London, Ghana, the elite spaces of Harlem, and the more modest homes of the U.S. South, marking the differences and similarities of blackness in each. Yet, "despite the complexity of the text, resistance and liberation are an exclusively male enterprise in *The Pleasures of Exile*."[16] That same year, Lamming published *Season of Adventure*. The novel takes place on a fictional Caribbean island, and its protagonist is a young girl growing into womanhood as her community grows into its own. While the protagonist, Fola, is the driving force of the novel, her story is not necessarily what drives the community's transformation, and her narrative of growth does not necessarily parallel that of her community's. As Curdella Forbes writes, "The 1960 novel *Season of Adventure*, through whose female protagonist is figured the Oedipal crisis of the nation growing towards 'masculinity,' is a remarkable example of Lamming's developing sense of West Indian gender realities. Here Lamming comes close to dismantling the masculinist figuration of nationhood, even though his representations are ultimately circumscribed by that figuration."[17] Though Lamming writes gender carefully, his perspective is distinctly male, and in both his autobiographical and fictional works, it is men who lead the charge of sociopolitical action.

By the 1960s, from a colonial perspective, Barbados had been Little England for too long, and it was time for it to grow up. Small as the island was, the people's regional efforts of federation and diasporic consciousness placed them firmly in an anticolonial movement that aspired toward something greater than what European empires had achieved. As Frantz Fanon urges in the conclusion to his 1961 *Wretched of the Earth*, "It is a question of the Third World starting a new history of Man," one that does "not pay tribute to Europe by creating states, institutions and societies which draw their inspiration from her. Humanity is waiting for something other from us than such an imitation, which would be almost an obscene caricature."[18] For Barbados, this "something other" meant representing itself as something more than Little England, and this something more would ostensibly represent black working-class Barbadians. This vision was most loudly offered by the cadre of men coming to power through an increasingly vocal labor movement, men who had already experienced migration and return to the island, and whose political vision was both regional and national in many ways. It would be a new myth to strive toward, and a new ideal to measure oneself against.

In 1962, four years before national independence, Errol Barrow made his attitude toward the British Empire clear in the following statement addressed to Parliament: "I am sure that honourable members would forgive me and other members of the Cabinet if, as West Indians and if as persons who are looking forward

to the eventual emancipation of the area from imperial rule under which we have suffered so long—and I make no apologies for stating unequivocally that I am anti-imperialist; as a matter of fact, even the leaders of the Conservative Party in the United Kingdom are anti-imperialists in their declaration when we see the rapidity with which they are dissolving the British Empire."[19] Barbados had already achieved self-governance by the time that Barrow spoke these words,[20] but in a linguistic twist, he politely assumed forgiveness and then interrupted himself, making no apologies. Indeed, from the 1940s to the 1960s, the end of colonialism in the British West Indies was growing increasingly near in the minds of many. During these decades, in particular, the myth of Little England had outgrown any connotations of modernity. Barrow's "was the gospel of self-reliance, self-esteem, and independence. He always sought an opportunity to remind the people of the Caribbean of their own capacity to solve their problems."[21] Colonial status represented a disadvantaged position in the world order, and it was time for the region to raise its status.

By the 1960s it had become increasingly clear that the British Empire was changing, and its relationship with the West Indies would be bound to change as well. Emigration and the nationalistic ideas that emigrants returned with, the rising middle class and the power they began to exert, and the changing attitudes of British colonial powers that had previously seen Barbados, to some extent, as their responsibility all factored into a growing social expectation. This expectation fed off political, economic, and cultural changes that occurred on the island, in the rest of the world, and in the island's relationship to that world. Anticolonial movements throughout Asia, the United States, the Caribbean, and Africa brought a new political solidarity to the struggles of individual colonies and populations. The Bandung Conference of 1955 set the foundations for a new political imaginary, a Third World that would organize its own destiny in the midst of post–World War II internationalism and the growing Cold War between the United States and the Soviet Union. Colonialism was changing. Regionalism throughout the Anglophone Caribbean focused on a collective effort at greater self-government, if not outright independence. Economically, Barbados (and much of the Caribbean) was developing a stronger tourist and service economy to replace the waning monocrop agricultural model that had supported the island for centuries. Because the societal and political structure was so deeply tied to the monocrop plantation economy, this economic change brought sweeping sociopolitical effects. It would be inaccurate to say that a unified monolithic national ethos formed, but it would be just as misleading to deny the growing, if indeterminate, fervor for change. Not unlike the debate in the Speightstown shop so many years later, this change would be a spirited, gendered discussion of the relationships between an English colonial past, a black diasporic world, and Barbadians' capability to determine their own future.

THE LITTLE ENGLAND THAT COULD

> Generations had lived and died in this remote corner of a small British
> colony, the oldest and least adulterated of British colonies: Barbados, or
> Little England as it was called in the local school texts.
> —George Lamming, *In the Castle of My Skin*

Barbadian national identity is built around a changing mythic ideal.[22] Barbados
is the most easterly island in the Antillean archipelago of the Caribbean Sea. This
coral landmass of 166 square miles currently supports a population of approxi-
mately 276,500 people.[23] Indigenous peoples such as the Barrancoid, the Arawaks,
and the Caribs all inhabited and left the island at different points before it was
"discovered" by European travelers. The Portuguese and the Spanish visited the
island in the 1500s before the first English ship landed on its shores on May 14,
1625.[24] Barbados soon became one of the most treasured British colonies. Its east-
ern position made it an important post for the British Atlantic slave trade, as well
as a key location for administering Britain's colonial policy throughout the Carib-
bean region. Throughout the next few centuries, Barbados never changed colo-
nial hands, and it became known as an island fortress, a nickname encouraged by
the presence of militia and at times the strong backing of the British navy. By the
1650s the island had already earned its most popular nickname: Little England.[25]

But Little England is a myth.[26] The myth is centuries old and multifaceted. In
1887 N. Darnell Davis claimed that the English colonists in Barbados in the 1650s
used this phrase freely. He writes that "Englishmen who emigrate to the Colonies
remain Englishmen still; and, so it was with the Cavaliers and Roundheads of
Little England, as Barbados is boastingly called by her Islanders."[27] As he details
the effects of the English Civil War on the growing colony in the Caribbean, he
casually refers to the island as "Little England" four times, not including the two
chapter titles "Declaring for the King in Little England" and "Troubles in Little
England." Nearly a century later, Sidney Greenfield's 1966 *English Rustics in Black
Skin* similarly assumes the myth of Barbados as Little England. In introducing his
social science study, he writes, "The island is popularly referred to as 'Bimshire'
or 'Little England' by natives and visitors alike, and it is even reported to be more
similar to the English countryside in appearance that [*sic*] it is to its West Indian
neighbors."[28] Greenfield's attempt at entry into the debate over the rupture or
retention of the culture of African-descended populations in the New World leads
him to the racist conclusion that Barbadians are just underdeveloped English
people. He concludes his analysis on family structures by stating that "Barbados
is truly 'Little England,' in its cultural tradition." He continues, "Barbados, though
inhabited by the descendants of Africans, is English in culture. . . . The English
influence ties the island and its institutions to another cultural tradition. Within
that tradition, Barbados and the behavior of its inhabitants are both explicable and

understandable."[29] For centuries, then, the moniker of Little England has been applied to the island, first as a source of pride for elite English colonists and later as a means of explaining the behavior of the largely African-descended population. British colonialism continued this myth by teaching it in schools. Fiction writers, such as George Lamming, relate how prevalent the myth has been. Social scientists like Greenfield use it as their starting point to enter into larger academic debates, and they are aided by colonial officials and local politicians (including Barrow) in their work.[30] Colonial Britain proffered the myth of Little England as a source of pride. Barbados could be inextricably tied to the great British Empire. And yet in building an independent national identity, the myth of Little England would need to be exposed, as it became a source of shame. In 1960 Lamming wrote that "one of the most wounding attacks you can make on a West Indian is to accuse him of being a little colonial stooge."[31] Given this, who would want to claim an identity as a subject of Little England?

The myth was useful, although it communicated an inaccuracy. It provided the foundation for a Barbadian exceptionalism, and it distinguished a small, outlying island from the rest of the Caribbean region and the colonies of the New World. This exceptionalism stems from the fact that, unlike its neighbors, Barbados never changed colonial hands. Barbadian exceptionalism is partly built on the unique and complex history of its monocrop plantation system, which simultaneously made it a valuable colony (when sugar was good) and kept it from developing a more diverse economy, work force, and political structure.[32] The island enjoyed privileges that other colonies in the Caribbean could not. Throughout Barbados's history, the elite classes, those who were propertied and wealthy, practiced greater self-rule than elsewhere in the region, as demonstrated when "in the constitutional reorganization of the British Caribbean in the later part of the nineteenth century, only Barbados managed to retain its representative Assembly."[33] Only months before independence, Barrow, then premiere of Barbados, boasted, "Right from the beginning and long before some of these territories were discovered or settled, the relationship between the people of this country and the government of the United Kingdom, had been a relationship of contract and not a relationship of status. That is what has probably distinguished Barbados from any other Westindian [sic] island. Its approach has always been a contractual approach and not an approach of status."[34] Thus the myth of Little England, built on a history of political exceptionality, positions Barbadian history as modern. Even as a colony, Barbados was able to take part in the kind of cultural and political practices that linked it to an English modern tradition; and yet, even in the 1650s, though English settlers on the island saw themselves as English citizens and fought to maintain their rights, they did not see Barbados as a smaller version of England.[35] Rather, many saw it as a space to make their fortunes before returning to England.[36] Others saw it as a place of refuge during the English Civil War.[37] And still others experienced

Barbados as a punishment they would make the best of, as Scottish prisoners of war and many other prisoners were sent to the island as colonists.[38] By 1700 the plantation system had become firmly entrenched in every aspect of the island. Its singular focus on sugar and profit meant that the plantocracy held the political power (with suffrage dictated by race and wealth), which allowed them to largely determine the economic opportunities for everyone else by limiting the ability of workers to negotiate for the best wages and attempting to curtail emigration. The racial stratification between the white plantocracy and largely black laboring population, coupled with the pervasiveness of the single-crop plantation system, made Barbados dependent on England for foodstuffs, trade, supplies, and a military force—since, by then, most of the population was unfree and had little reason to be loyal—and this would have a far-reaching impact on the social, political, economic, and cultural growth of the island.[39]

After Emancipation in the 1830s, those in power on the island were of English descent. One needed to be white and wealthy in order to vote. Planters went to great pains to keep the largely black working class in "their place," even instituting the Masters and Servants Act in 1840, which tied workers to the plantations where they worked.[40] The newly freed workers were encouraged to take on the liberal ideals of the Enlightenment, but it was almost impossible to do so given the sociopolitical structures of the island.[41] The colony of Barbados inherited the social expectations of specific gender performances modeled after those of the English gentleman and lady. In the decades after Emancipation, Barbadians reconstructed their society under a colonial model in which government, educational, and religious institutions worked to place newly freed black women in the domestic sphere and to define "proper" men as productive workers and the heads of their households.[42] This model was rarely achievable in light of the material realities of the island, where jobs that could support whole families were scarce for men and most women were engaged in some form of the market economy. Such realities often led men (specifically) to migrate to find work that would enable them to fulfill the role of breadwinner. Thus, based on a limited degree of political autonomy and the imposition of "modern" English cultural norms, a colonial ideal of Barbadian identity became inextricably tied to England and later Britain, and that ideal became mythologized within the discourse of Barbados as Little England.

"Little England" was more than a nickname. As a myth, it had cultural, political, and social implications. British colonialism imposed impossible ideals for Barbadians, obscuring the histories that simultaneously constructed the ideals and made them unachievable for most colonial subjects. The elite British ideals of gender, class, race, and ultimately empire are at the heart of the myth of Little England. In fashioning a Barbadian identity, subsequent Barbadian governments have relied on the island's connection to England, most of the population's

African heritage, and a tenuous regionalism. These histories have been reshaped within national discourses in order to present a tidy and idyllic image of a modern Barbados to its own people and to the rest of the world. Creating such tidy ideals meant negotiating through, against, and around this historical myth of Little England. As anticolonial efforts grew worldwide, regional collaborations were attempted, and nationalism (whether Barbadian, West Indian, or black) made inroads on the island, it increasingly became embarrassing to be referred to as Little England. While the pride associated with the earliest iterations of that myth has become a central part of Barbadian identity, that pride has been redefined. Lamming asserted it clearly in 1960, writing, "The Barbadian is proud, for reasons that have an exact parallel in England. It is not correct to say that the Barbadian is very English; for that is to make English a criterion of what, in the case of the Barbadian, is a universal quality. I would say that the Barbadian has much the same relation to Barbados which the Englishman has to England. They both have an inordinate pride in the feel and look of the land they call theirs."[43] As Barbadians began to claim more sociopolitical rights, as they migrated as laborers and intellectuals, this Bajan pride became tied to a sense of nationalism rather than the myth of Little England.

RACE, NATION, AND DIASPORA: ORGANIZING COLLECTIVE IDENTITIES

> "'Tain't no joke," the shoemaker said; "if you tell half of them that work in those places they have somethin' to do with Africa they'd piss straight in your face."
>
> … "'Tis true," said Bob's father, "no man like to know he black."
>
> —George Lamming, *In the Castle of My Skin*

> Every child in the village had a stock response for the colour, black. We had taken in like our daily bread a kind of infectious amusement about the colour, black. There was no extreme comparison. No black boy wanted to be white, but it was also true that no black boy liked the idea of being black.
>
> —George Lamming, *In the Castle of My Skin*

The characters of Lamming's *In the Castle of My Skin* fictionally display Barbadians' complex relations to race. As Barbados moved away from a colonial identity, a pride in blackness became entrenched in ideas of nationhood. The gradual shift from colony to nation-state happened in tandem with a shift in the racial ideologies of the island. Such a shift was by no means all encompassing, but a number of organizations and events subtly and overtly recast the connotations of blackness on the island. This shift was influenced largely by

Barbadians' efforts of regionalism and their interactions with the rest of the African diaspora.

While the white elite had a stranglehold on the politics and economics of the island in the first two centuries of its settlement, shifts in race and class structures slowly began to emerge in the early to mid-nineteenth century. The enslaved black working population revolted in one of Barbados's few direct and violent actions, a slave revolt on Easter Day in 1816. A growing black and brown middle class began to challenge the white elite,[44] though they were not a monolithic group. Those who had fought in the militia that ultimately quashed the 1816 rebellion earned themselves special status, including the ability to testify in court.[45] As members of the laboring population continued to work to organize themselves through the approved channels and, more often, through other means, "the democratic hopes of the disenfranchised majority were ultimately dashed by the combined efforts of white and non-white elites."[46] A small number of radicals began to permeate the political sphere, first through the press and then through more "legitimate" means with the election of Samuel Jackman Prescod in 1842, the first representative of color in the House of Assembly.[47] These parallel political spaces (formal political assemblies and popular open-air meetings and presses) would continue to provide Barbados with a training ground for oratory and intellectualism. Prescod's election was momentous, but not revolutionary. Elites of color also found a cause in African colonization. Barbadians had been involved in Liberian settlements as early 1816, and in 1865 another 346 made the trip across the Atlantic.[48] Ultimately, "by accepting a few elite men of colour into the political fold without also being forced to make fundamental socio-political changes, the imperial and colonial regimes were able to absorb and deflect mass discontent while reaffirming the exclusion of the majority from public life."[49] The disenfranchised majority on the island would find other ways to change their circumstances.

By the 1880s the sugar industry was in major decline, and migration provided one solution to many of the urgent social issues of the island. The island lost roughly 50 percent of its population in 1881, and Barbados became one of the major sources of Caribbean emigration in the late nineteenth and early twentieth centuries.[50] At the turn of the century, masses of Barbadians went to Panama to work in the Canal Zone. While the work was hard and dangerous and the racial tensions in the zone were fed by the U.S. administrators in charge of the project, the wages, coupled with a lack of opportunity at home, made the journey attractive.[51] The migration to Panama changed the socioeconomic landscape in Barbados, as many workers sent remittances home and more and more of the population was able to buy land. As historian Winston James writes, "The escape to Panama was the next best thing to revolution in Barbados. And the revolution would not come."[52] Once the project was finished in 1914, the United States became a popular destination for migration.

Two events of the 1910s would shape a growing internationalism and a grow-ing black radicalism among West Indians at home and abroad. When Marcus and Amy Ashwood Garvey founded the Universal Negro Improvement Association (UNIA) in 1914, they built a vehicle that would grow to extraordinary proportions, touching millions of black people around the world[53] and providing "a gigantic beacon of hope promising to bring to an end the long night of their oppression. And this counted."[54] The same year as the founding of the UNIA and two years before it reached the United States and began its phenomenal growth, the assas-sination of Archduke Ferdinand set off a train of events that led to the Great War. Barbadians, and West Indians in general, fought under the British Crown. Their experiences in this war would shape radical sentiments that would turn into labor movements, anticolonialism, and diasporic organizing for decades afterward.

The migration of people within and outside the Caribbean brought more defi-ant racial ideologies to Barbados. In 1919 John Beckles and Israel Lovell estab-lished Barbados's first branch of the UNIA, whose "platform was largely concen-trated on teaching the virtues of black solidarity, black history and Pan-Africanism. The local Garveyites recognized that black unity was an imperative in the quest to transform their wretched, degraded conditions."[55] Mary Chamberlain notes that "as elsewhere in the African diasporic world, Garvey's message had enthusi-astic support in Barbados. In the heyday of the UNIA, in the 1920s, Bridgetown alone could support two branches which met in Carrington Village and the UNIA Hall in Westbury Road, respectively. There were branches in St. Lucy and St. Peter."[56] As racial and class tensions increased within Barbados's limited econ-omy, the UNIA would grow to include eleven branches on the island by the 1940s.[57] Notably, it was "ex-servicemen [who] were among the earliest converts to Garveyism," and many of them continued to migrate through and away from the Caribbean.[58]

The experiences of West Indian servicemen in World War I (and later World War II) provided a window into the changing potency of the Little England myth and a measure of the successes and failures of colonial ideologies. British colo-nial schools had been teaching their students that they were a part of Britain, even as their educations sought to keep them in a subordinated place within the empire. Lamming relates this in *In the Castle of My Skin* through a school inspector, an Englishman, who, after telling the students about the war in Abyssinia, assures them of their country's allegiance to England, enthusiastically saying, "Barbados is truly Little England!"[59] James writes, "As a part of Empire, they were defined as British and thus central, but by the very same token—as colonies—they were, by definition, marginal, paradigmatically other. This was the fundamental and inherent tension of the Imperial Idea."[60] As Barbadian statesman and World War II veteran Errol Barrow put it, Barbadians fought on the side of the British Crown, where colonial rhetoric had told them they belonged. He said, "West Indians were not reluctant in answering the call, whether in the armed services or in factories

or on the beaches. . . . Where the conflict was being waged the West Indians were there."[61] Unfortunately, many found that they were not wanted. When West Indians began to enlist to fight for the British in World War I, the War Office organized them into the British West Indies Regiment (BWIR)and tried to figure out what to do with them. The idea of black colonial men killing white Europeans, even enemies, was simply unacceptable to colonial authorities and the War Office alike, and this was reflected in the poor assignments, lodging, food, and health care that the BWIR received. Such treatment "was predetermined by the fact that the British War Office did not want them in the first place. Being good colonials, however, thousands throughout the archipelago volunteered to fight for Britain, which they believed was their country too."[62] These men had families back home. When the general population heard of the treatment of the BWIR soldiers, it effectively radicalized everyone to a degree. It was a slap in the face to be treated with such hostility, and it killed the illusion that black colonial populations were British, giving new meaning to their blackness. James notes, "First is the fact this inequality was noticed and resented openly by the men. . . . Second, and perhaps more significantly, is the fact that the men possessed an unbroken dignity, despite three centuries of British colonial rule."[63] This dignity would turn into radicalism. James continues, "Through the commingling of men from different parts of the archipelago and their bonding through common suffering, a pan-Caribbean identity had emerged out of the crucible of war."[64] These ex-servicemen would be central not only to the UNIA but also to black nationalist, West Indian nationalist, and diasporic organizing for decades to come.[65]

Many of these ex-servicemen had felt emasculated by their experiences of war, and by colonialism in general. Colonialism proffered gendered ideals of masculinity, but in the colonies most men did not have the material resources to perform those ideals, and masculine practices were shaped by a need to assert control within a colonial context. Often these practices included exerting control over and displaying aggression toward women as a means for men to define themselves as men. Aviston D. Downes, in his study of constructs of masculinity within Barbados, notes how "by 1920 many West Indian black men, influenced by the ideology of black nationalism, had begun to intensify their quest for human dignity rooted in racial integrity, social justice and economic enfranchisement. They were (and perhaps still are) far from fully disavowing constructs of masculinity predicated on aggression and the subjection of women but, ideologically, they had started to grow up."[66] Such growth, however, was still couched in the patriarchal notions of some early black nationalism, and it was influenced by the precepts of war and the roles of man as soldier and protector. With few exceptions, "women[,] . . . excluded from all positions of leadership or authority, have tended to be invisible in both the records and the rhetoric."[67] Although black Barbadians were questioning their "Englishness" within the contexts and experiences of World War I, the disruption of their English identity did not necessarily disrupt

the gendered constructs within that identity. The public face of self-definition in the form of a national identity was still shaped by the idea that men were "natural" rulers.

Different iterations of nationalism and class consciousness grew broader and more urgently in the years between World War I and World War II.[68] In 1924 Charles Duncan O'Neal and Clennell Wickham formed Barbados's first political party, the Democratic League.[69] O'Neal continued this work by setting up an industrial wing of the new party called the Workingmen's Association with two economic offshoots: the Barbados Workers' Union Cooperation and the Workingmen's Loans and Friendly Investment Society.[70] While support for Garveyism on the island spanned the class spectrum, it was the liberal, middle-class, socialist Garveyites who supported the Workingmen's Association.[71] Outside the formal political arena of the House of Assembly, the informal public networks of the press and public speakers continued to be influential and grew more radical. It was Wickham, "an ex-serviceman radicalised by his war time experiences, and a socialist by persuasion," who edited the Barbados Herald, a mouthpiece for the working class.[72] Wynter Crawford, who would be central to the foundation of at least two more political parties on the island, was the editor of the Barbados Observer throughout the 1930s.[73] Much like their predecessors, these men used their public venues to open up areas of self-determination for more of the island's population. Their work was part of a diasporic tradition of the radical press, whose members were often in conversation with one another across different locales. It was an era of black nationalism, and there was a parallel and sometimes overlapping black socialism among Caribbean intellectuals in the region and abroad. Those networks of migration continued to be important, as "whether black nationalism, black socialism, or black Marxism, these ideas were tailored by the African diasporic community and communicated through the same diasporic channels. With the return of remittances, and the exchange of letters, came the return, and exchange, of ideas and experiences."[74]

The growing economic and sociopolitical strains on West Indian nations resulted in a tumultuous decade. There was major social unrest in British Honduras (Belize) in 1934, in Saint Kitts and Saint Vincent in 1935, in Saint Lucia in 1936, and in Trinidad from 1934 to 1937.[75] Barbados was not exempt. The unrest grew from poor local conditions and through the existing migratory networks. While Barbadians had a (rather undeserved) reputation for political conservatism and were "confined and politically inhibited at home, . . . the children of Barbadians living elsewhere in the Caribbean (especially in Trinidad and Guyana) are over-represented among the archipelago's most distinguished radical intellectuals," including Henry Sylvester Williams, George Padmore, C.L.R. James, and Clement Payne.[76]

On March 26, 1937, Payne arrived in Barbados, and on the immigration forms, he said he was born on the island.[77] He had been invited by the Negro Welfare

Cultural and Social Association, a Marxist group, and he also worked with UNIA leaders such as Israel Lovell to organize the workers. Trade unions were still illegal at the time, but his message, disseminated through the informal public networks of public speaking and press, reached the laboring population. The rallying cry of the workers' rights movement was "Educate, agitate, but do not violate!," reflecting the movement's strategy of radicalism that works through a moral notion of each person getting his or her fair due.[78] Payne was arrested for false declaration of place of birth, and "on 22 July he was tried, defended by the young and ambitious lawyer, Grantley Adams, but convicted and fined." He appealed and won, but authorities refused to release him.[79] When the news leaked that he had been secretly deported from the island, the unrest began. The largely white-owned business district of Bridgetown became a target of property damage.[80] The uprising was swift, and the crackdown was brutal and indiscriminate.[81] Fourteen were killed, forty-seven were wounded, and three hundred were given prison sentences of up to ten years, yet "in the commissioners' view . . . only wide-scale emigration could begin to alleviate Barbados' problem."[82] Like many movements throughout the African diaspora, the events of 1937 live on in Barbados's popular memory, although it was a relatively small percentage of the population who participated. And although Payne's deportation was the tipping point, "the riots themselves were neither orchestrated nor co-ordinated. They appeared to be spontaneous. But once begun, they were remarkable for the consensus of support which they developed and which continued throughout the 1940s and 1950s in regular strikes and stoppages."[83]

This history is reflected fictionally in Lamming's *In the Castle of My Skin*. Throughout the text, the waterfront workers are beginning to organize through work strikes that are negotiated through a former teacher. In chapter 9 the strike turns into something else entirely, and as the villagers wait to hear news from town, there is a growing anxiety. The workers go to the governor's house for advice, but they are violently turned away. The violence continues and spreads into the city. The workers throw bottles and break windows. They focus on property damage, refusing to loot or steal anything. The police crackdown is swift and brutal, and Lamming details the impact through the voice of a mother, a woman who everyone in the village knows gets drunk every Friday night, mourning her son who was shot down by police while hiding in a tree. The police force the workers out of the city and into the villages. Creighton Village is confused. Some of the men had participated in earlier work strikes. The young boys had gone into town to see what was happening and came back scared and faint. Most of the villagers do not know that the same man who owns the village land is a partner in the company they have been striking against. The activity is focused on the men, with a few women in supporting roles. The drunk mother has the largest female role as the narrative unfolds. As workers come stealthily into the village armed with bottles, the villagers feel uneasy about strangers among them, regardless of their

intentions. The chapter ends with a standoff between the workers and the land-owner, with a middle-class politician between them. The standoff fizzles, and the village can hear the police cars heading toward the boundary of Belleville, where the white people live.

The social conditions on the island and throughout the region became tin-der that would periodically be sparked by black nationalist, black Marxist, and social justice movements that existed as part of a regional and global network of intellectuals, activists, and workers. This was affirmed by both the Deane and the Moyne Reports commissioned by the British government to under-stand the unrest in Barbados and in the region, respectively. It was this unrest that would ultimately galvanize support for formal efforts of self-determination on the island and in the region, support that was both buoyed and troubled by ever-changing meanings of race in the region and abroad. Chamberlain writes that "the riots and other aspects of social disorder, stimulated both by poverty and by the assault upon the dignity and the right to decent lives of Barbadians, together constituted a serious insurrection from which the end of empire in the region was ultimately to flow."[84]

These growing movements of black nationalism, class consciousness, and infor-mal public networks that led to expressions of social unrest are depicted in Lam-ming's *In the Castle of My Skin* most poignantly in the character of Mr. Slime. As a schoolteacher turned politician, he brings new ideologies. He is contrasted with the school inspector, an Englishman who teaches the assembled students that they are a part of England, which is always on the side of peace, and with the head teacher, a middle-class, well-respected drunk who feels impotent even in his revered position. Mr. Slime is disruptive: he may or may not have slept with the head teacher's wife, and after losing his job because of it, he turns to electoral poli-tics, where he looks to disrupt the social order with ideas of wealth redistribution. He is a young, masculine threat to the social order. When Mr. Slime leaves the school, he becomes a politician and a central force of the burgeoning labor move-ment that culminates in social unrest that rocks the village. He is the politician left standing between the angry workers and the landlord before the unrest fiz-zles away. Lamming paints him with the contradictions of the era the book por-trays. He is a young upstart, brash, seemingly unafraid, with notions of bettering the lives of the workers. But he is part of a middle class that ultimately displaces the poorer villagers. His ideas have the air of moral virtue, but he is a man with his own faults. He seems to take the village by storm, but once the villagers begin to take action, he slowly fades into the shadows. The villagers love him, support him, and revere him as Black Moses and Black Jesus, but when the shoemaker, Mr. Foster, and Pa are forced out of the village, they suspect him and realize that although he may have had nice dreams for everyone, like any politician, he's "a blasted liar."[85] Their reaction demonstrates the ways that, for the black working class of Barbados, a change seemed promising, but also dangerous. It disrupted

the power structures, but also the communal structures that held people together and kept them healthy, safe.

As the region was rocked by social unrest throughout the 1930s and connected to various movements and events around the globe, efforts toward self-determination and improving social conditions often relied strategically on different definitions of community. Activists often belonged to more than one organization. Migrants moved in and through communities, sometimes forming new identities as they sought to hold on to or adapt older ones. Whether Barbadians were simply looking for a means of survival or actively pushing for social change, they had to define their "people." These social negotiations were reflected in the growing number of West Indian novels in the 1950s, including Lamming's *In the Castle of My Skin*. Toward the beginning of the novel, Lamming describes the sentiments of the folk in the village, the divisions in the community, and their complicated allegiances. In presenting the perspective of the middle classes, those in society's liminal spaces, such as the black overseer, that middleman between the respectable white landlords and the common village folk, or the educated civil servants striving to leave behind their humble origins, Lamming shows "the image of the enemy," and, as the narrator states, "The enemy was My People. My people are low-down nigger people. My people don't like to see their people get on. The language of the overseer. The language of the civil servant. The myth had eaten through their consciousness like moths through the pages of ageing documents. Not taking chances with you people, my people. They always let you down."[86] Although the "people" weren't to be trusted, in an era just after the indigéniste movement, an era of négritude, and a burgeoning West Indian novelist movement to which this text belongs, the speaker still identifies them as *his* people. The class consciousness abuts, but does not negate, the race consciousness of the statement. And the distrust is sown through colonial structures that privilege a few who master European ways of thinking and cultural expression. The poor white communities in Barbados, as well as all of the small communities who could not easily be placed on a black-brown-white spectrum (the first-nation indigenous, Asian, and Middle Eastern minorities), continued to exist on the island, though they were not at the forefront of the sociopolitical changes of this era. While colonial schools had taught Barbadians that they were Little England, that they were a part of a great British empire, the experiences of World War I, World War II, and colonial policy told black Barbadians in particular that the British may not be their "people." From the 1930s through the 1960s, "for the West Indian colonies, the claim of being one of the oldest parts of the empire increasingly became a 'scarlet letter' rather than a badge of honor."[87] Over these three decades, understanding and defining one's self as a Barbadian and as a West Indian, building identities through, against, and across race, class, gender, and geography, became an exercise in finding, forming, and strategically maintaining one's people. Much of this work is tied to diasporic collaborations and experiences.

The Barbadian and larger West Indian communities abroad have impacted the islands from which they come. Migration has brought together local and diasporic communities, shaping how individuals, families, formal organizations, and informal social groups define themselves. It is important to understand that "there has scarcely been a Barbadian family who has not been touched, and shaped, by migration and its absences, at a literal, metaphysical, cultural and historical level."[88] In this way migration, exile, and return are an integral part of Barbadians' lives. Migration has shaped family structures, gender roles, and notions of community, but it has wider implications as well. As Chamberlain explains, "The migration narratives of the Caribbean ran parallel with the rhetorical metaphors of nation-state and Empire, and have helped to shape, and continue to shape, the culture of the Caribbean at home and abroad. Indeed, the story of modernity is one of several, *unfinished* migrations, which began in the Caribbean, and which continue."[89] Such a phenomenon flows two ways. The experiences that emigrants have in Barbados shape how they enter into the rest of the world. The socioeconomic restrictions of the island inhibited many from social activism, while "exile made it easier for many of these young migrants to embrace radical ideas precisely because the social pressures abroad were not as great as they were at home."[90] Younger migrants and their children are among the most radical, having experienced both a Barbadian upbringing and the social expectations and pressures of their host lands.

For those in relatively small migrant communities in large metropolises, island distinctions lost some of their currency, and many Barbadians interacted with Jamaicans, Trinidadians, and others to form West Indian communities abroad. As Lamming notes, in his own experience, "no Barbadian, no Trinidadian, no St. Lucian, no islander from the West Indies sees himself as a West Indian until he encounters another islander in foreign territory."[91] Politicized by their surroundings, they formed lasting bonds with multiple communities. In a 1962 statement to Parliament, Errol Barrow, while acknowledging the radicals of the region, stated plainly that "there is one group of Westindians [*sic*], quite apart from the students who were studying in the United States of America, Canada and the United Kingdom. This group of persons existed in the areas of New York, Boston, and Chicago; those persons had been brought together by the events in the Westindies [*sic*] of 1937 and have stuck together right through the dim period of the Second World War, taking a very active interest in every political development in the British Caribbean area and, indeed, in a wider context, in the Caribbean as a whole."[92] In fact, in 1937, Reginald Pierrepointe, a Barbadian who worked as a reporter for the *New York Amsterdam News*, founded the West Indian Defense Committee and sent appeals to the Crown to help striking workers throughout the Caribbean.[93] The unrest of the 1930s had lasting effects. Efforts around those events went beyond each island where they occurred and beyond the region. Individuals and organizations used whatever resources they could muster, crossing community boundaries. West Indians used the resources of the British Crown

strategically in order to get what they needed, but as British attitudes about the sustainability of a colonial empire and West Indian attitudes toward self-determination and survival changed, West Indians relied on older practices of community support. Barrow went on to explain that while Barbados had never depended on the British or U.S. government for funding, the remittances of West Indians abroad sustained the island, especially in the period between World War I and World War II.[94]

Lamming illustrates the ways migration and return worked to change ideologies of race through his character Trumper. As one of the oldest of the boys in the neighborhood, Trumper's words and attitudes had always carried extra weight with his companions. By the end of the novel, "Trumper had emigrated to America and no one could tell what he would become. Most people who went to America in such circumstances usually came back changed. They had not only acquired a new idiom but their whole concept of the way life should be lived was altered."[95] Out of all the boys in the story, "Trumper was what we called fair skin, or light skin, or, best of all, clear skin,"[96] but his exposure to American racism teaches him his blackness and redefines his notion of his "people." Upon his return to the island, this change in consciousness is the first thing the village notices and is partly reflected in the rebellious uniform of a zoot suit. The same young boy who had only years earlier confidently asserted that no one could "change what is" has a new lesson to teach.[97] After listening to Trumper's favorite song, Paul Robeson's rendition of "Go Down Moses," the narrator, G., receives his first explicit lesson in racial identity, in an understanding of "blackness." As he listens to Trumper speak of his "people," he admits, "He knew I was puzzled. This bewilderment about Trumper's people was real. At first I thought he meant the village. [But] this allegiance was something bigger."[98] Trumper attempts to explain:

> "If there be one thing I thank America for, she teach me who my race was. Now I'm never goin' to lose it. Never never."
>
> "There are black people here too," I said. I hadn't quite understood him.
>
> "I know," said Trumper, "but it ain't the same. It ain't the same at all. 'Tis a different thing altogether. 'Course the blacks here are my people too, but they don't know it yet. You don't know it yourself. None o' you here on this islan' know what it mean to fin' race. An' the white people you have to deal with won't ever let you know."[99]

Trumper is not claiming Americanness. He is Barbadian. That is still recognizable, but Trumper is different now. He claims a life knowledge he learned as a black man in the United States. He claims the pain that taught him the knowledge. It gives him a noticeable assuredness. Knowing his race in that context has made him bigger than the island he belongs to. In bringing this attitude, this knowledge, back to Barbados, back to Creighton Village, he makes the idea of Barbados

bigger than it used to be. G. reflects on their conversation, thinking, "I under-stood my island. This was more impersonal, less immediate, but not altogether outside my claims. I spoke of my island. But this new entity was different. The race. The people."[100] Things had changed in the village, and things had changed in the world. Through the character of Trumper, the village could plainly see how these changes were interrelated. The "people" was an entity now defined by a racial consciousness. Trumper's understanding of his "people" was a new imagi-nary, a new community, a wider black nation that he could call on as a young man in the midst of a changing Barbados. The interactions between Trumper, G., and G.'s mother show the ways in which the gendered story of migration shapes this new imaginary. Trumper's young masculinity is essential to his understand-ing of change, while G.'s mother is represented as slightly confused but happy to see him return, and G. is caught in the middle, listening to new ideas with one foot out of the door toward his own migration to be a teacher in Trinidad. Lis-tening to Paul Robeson, Trumper has found the language to demand that what has always been be no more. He carries that voice with him in a little music box, periodically listening to it sing, "Let my people go."

FEDERATION, INDEPENDENCE, AND DEFINING NATIONAL IDENTITIES

> Any West Indian who has any reservations about the absolute necessity of independence—any colonial for that matter—is a slave, and should not be allowed the privileges of a free man at a time when the entire world is agreed on the moral difference between the two states of existence.
> —George Lamming, Pleasures of Exile

Throughout the 1940s the labor strikes and stoppages that characterized the 1930s continued, as did diasporic organizing.[101] World War II put the stark realities of humanity and modernity at the center of an urgent global conflict. As they did thirty years before, West Indian and colonial populations aided in the Allies' efforts. West Indian politicians and activists pushed to find the best routes for social reform and self-determination. Organizations founded by migrants abroad would be central to these efforts. In 1947 the West Indies National Council "invited Norman Manley [of Jamaica] and Grantley Adams [of Barbados], along with Paul Robeson [of the United States], to address a series of meetings and fundraise for Federation, with the objective of enlisting the political and economic muscle of the diaspora to push for reform at home."[102] Efforts such as these relied on inte-grating audiences that were pushing for social justice and self-determination in their homes (Jamaica, Barbados, and the United States in this instance) and who were also interested in diasporic and wider anticolonial efforts.[103]

Central to these discourses of self-determination were debates on how best to achieve it. Should Britain be tasked with reversing the centuries of colonialism it inflicted? Should it be required to bankroll the independence of its Caribbean colonies, and if so, how much, if any, say would it have in the political structures its money would fund? Should each colony become its own nation-state, or would a collective West Indian nation be a better solution? These were hotly contested issues with no simple answers, and the debates were influenced by West Indians' self-image. In order to imagine any form of independent English-speaking post-colony in the Caribbean, West Indians needed to have the confidence that they had something of their own, something beyond what colonialism had gifted and forced on them; "it is not surprising therefore that, conterminous with political debate, was increasing interests in *culture* in order to resolve the conundrums of West Indian nationhood."[104] The era of West Indian migration in the 1940s and 1950s produced something slightly different from what earlier movements did. Between 1948 and 1958 around a dozen novelists from the British Caribbean published nearly fifty novels, primarily from abroad.[105] This era produced a concentrated proliferation of West Indian novels that would reflect West Indian culture as experienced by the working class, the peasants, told through the voice of "colonials" who were imagining themselves as much more.[106]

More than poetry, essays, or dramatic plays, the novel marked a form of West Indian modernity.[107] Novelists such as Lamming were able to paint the picture of colonialism's effects. He and his contemporaries showed the ideals of colonialism and how they had shaped and were at odds with the lived realities of colonial subjects. They did this through ordinary language, spoken by familiar characters whose lives were in conversation with different classes of West Indian people. Of this phenomenon Lamming says, "For the first time the West Indian peasant became other than a cheap source of labour. He became, through the novelist's eye, a living existence, living in silence and joy and fear, involved in riot and carnival. It is the West Indian novel that has restored the West Indian peasant to his true and original state of personality."[108] Still, these novels were, by and large, published outside the Caribbean. Their West Indian audience was painfully slow to grow, but the concepts of owning, creating, and promoting one's own culture as one step of many toward self-definition and self-determination were important.

By the time Lamming returned to the Caribbean in 1956, *In the Castle of My Skin* was being taught in the schools. He left an aspiring writer and returned to speak to the youth after having made a name for himself.[109] A year later, in 1957, the Barbados Arts Council was formed. While the Barbados Cultural Society, founded in 1943, had aspired to bequeath Barbadians with British culture,[110] the Barbados Arts Council was the first direct link between the government and the arts.[111] A number of other important outlets had formed throughout the 1940s and 1950s, including Frank Collymore's literary journal *Bim*, Speightstown art

classes, and the beginnings of local art in the Barbados Museum. These latter efforts showed that Barbadians had a culture of their own outside of the myth of Little England, one that did not simply mimic British culture. Through the arts, and specifically through Windrush-era novels, West Indians countered the myths of colonialism that painted them as expendable labor without culture, without identity, without modernity, and without value. In their novels, they wrote new ways of thinking into existence by taking old realities of colonial life and coupling them with the political efforts of their moment both locally and internationally. Building on previous histories, they wrote new myths, hoping to create blueprints for a future reality. As Curdella Forbes notes, this "project of speaking oneself into being then necessitates both the creation of myth as truth larger than and beyond historical fact and inventions of self which are in effect experiments in perfor-mance."[112] These self-making performative acts would occur in the political and cultural arenas of the 1950s as long-standing debates of federation and indepen-dence became more urgent amid Britain's growing disinterest in maintaining its empire and the anticolonial movements of the Caribbean and the rest of the world.

In the late nineteenth century, colonial powers and the white elite in the Brit-ish Caribbean islands offered federation as a way to consolidate power and gov-ern more easily. Throughout this period and into the early twentieth century, the idea was co-opted by burgeoning West Indian nationalists and labor organizers.[113] Each effort varied in the support it received, but these efforts would lay the foun-dations for the organizing of the 1950s. Migration and diasporic networks were important to the efforts behind federation and the ongoing debates as to what it should look like. Chamberlain notes that "the idea of Federation was born in the transnational belongings and dreams of West Indians overseas and soon acquired status as a kind of mythical homeland. Federation was as much a part of diasporic yearning as was the dream of an African state."[114] While it is true that the cam-paign for a West Indian federation proffered it as a black nationalist state among black nationalists internationally, the ideas around race and federation were com-plicated, and it may be unfair to say that the idea began outside the Caribbean. Federation was an old idea that became more urgent in the 1950s. During World War II the rhetoric of fighting for democracy was deployed in tandem with nego-tiations between world powers and their empires. Britain was financially devas-tated by the war, and the U.S. economy bounced back from the Depression through its war industries. The British West Indies were caught in between, and in the fall of 1940 the two superpowers signed the Destroyers for Bases deal. The British got destroyers, and in return the United States got ninety-nine-year leases on bases throughout the Caribbean. This flew in the face of black West Indian efforts of self-determination, as they were not consulted in the transactions, though white populations in Newfoundland and Bermuda were.[115]

Through speaking engagements in the United States, Jamaica's Norman Man-ley "undoubtedly convinced many in Black America of the significance of a Carib-

bean federation not only for the West Indies but for black peoples across the globe. And he did so through an explicitly racialized portrayal of federation as primarily a black nation-building project."[116] As the federation began to take shape, however, spaces with large East Indian populations, such as Trinidad, had to work through their understandings of the project and the different racial communities. East Indians had been portrayed as separatists in Trinidadian political campaigns such as the 1958 campaign between the People's National Movement and the Democratic Labour Party. Some in the community were invested in nation building, but not if it meant assimilating into an Afro-Caribbean ideal.[117] At the same time, "in both local and regional organizations, some West Indian activists, including Afro-Caribbeans, deemphasized race through the presentation of their efforts as transracial or multiracial movements of 'British citizens' seeking the same colonial advancement they observed in other areas of the empire."[118] Federation reinforced complex relations of race in the West Indies, where, on the one hand, a connection to a larger African diaspora was useful and desirable but, on the other hand, negotiating the many racial communities of the region and the differing definitions and manifestations of race was also important.

The importance of self-determination made federation an urgent issue. A West Indian nation could be stronger together than apart.[119] But negotiating what federation would like for each island proved to be difficult. Over decades, federation was debated at a number of conferences and congresses throughout the Caribbean and Britain. By September 1947, "in spite of these sometimes contentious debates, by the close of the Montego Bay Conference, all the colonial representations except British Guiana's delegation accepted the principle of a federation in which each unit would retain control over all matters not specifically given to the federal government."[120] On August 2, 1956, the British Parliament passed the British Caribbean Federation Act, establishing "a federation incorporating ten territories: Antigua, Barbados, Dominica, Grenada, Jamaica, Montserrat, St. Kitts-Nevis-Anguilla, St. Lucia, St. Vincent, and Trinidad and Tobago. Thereafter, in August 1957, Parliament approved an order-in-council establishing the newly named West Indies Federation, which would be formally established in 1958."[121] The details would have to wait. The federation had become a reality.

Hopes of a West Indian identity didn't quite result in any concrete definitions. On the one hand, the ten territories had a shared (transracial) experience of British colonialism that could provide a mixed-salad diversity model for the world. On the other hand, federation had also been touted as a black nationalist project.[122] As the West Indies Federation moved forward, debates over whether and when it would be independent from the British Crown abounded. Without independence, federation could be seen as a step down for players like Barbados. Internally, the big three (Manley representing Jamaica, Eric Williams representing Trinidad, and Grantley Adams representing Barbados and serving as federation prime minister) were often stuck between a rock and a hard place, negotiating

between federation and island politics. Issues of representation, immigration, and trade were foremost. Smaller territories were afraid that if representation were based on population, they would be at the whim of the big islands, Jamaica especially. The ease of immigration and trade among the federated territories was also a concern, with populations on the big islands not wanting to have to economically support smaller territories or have their labor markets glutted with "foreigners." Manley was dealing with a tight political race in Jamaica and a growing sense among Jamaicans that they would be footing the bill for the federation. Williams was dealing with a large and anxious East Indian population who, although not necessarily against federation, saw it as a black nationalist project. Of the big three, Adams was the only one who could say yes without too much commotion, and even he was dealing with his own growing unpopularity in politics at home.

The West Indies Federation became official on January 3, 1958, and the federal legislature was inaugurated months later in April.[123] While those outside the Caribbean celebrated, West Indian leaders continued to negotiate the terms of the federation and what its independence and governance would look like. There were balls and banquets in Chicago, Boston, Baltimore, and Washington, D.C., celebrating the new federation, and many events in New York City. The West Indies Federation came on the heels of Ghana's 1957 independence, and for those who saw the federation as a diasporic effort, it "may not have been the federation that many had envisioned and worked for since the late nineteenth century, but it was celebrated nonetheless."[124] Meanwhile some of the key players (Manley and Williams in particular) were still facing island politics while negotiating their territory's place in the federation. Adams had become the prime minister of the federation, but though he was once a young upstart, his impact on Barbadian politics was beginning to wane, and historians would remember him in this era as both a visionary and an opportunist. In Jamaica, as the rival Jamaica Labour Party, led by Alexander Bustamante, began to gain support, federation became a partisan issue, forcing Manley to call for a referendum, where, against his hopes, Jamaicans voted to leave the West Indies Federation.[125] Within a few months, Trinidad and Tobago had also left the federation, leaving eight smaller territories to figure things out.[126]

In Barbados's 1961 election, the fairly new Democratic Labour Party (DLP), led by Errol Barrow, ran on a platform that promised education, health, maternity care and leave, school meals, social security, and a focus on independence.[127] Adams may have been the prime minister of the West Indies Federation, but back home in Barbados his limelight was beginning to fade as the DLP swept into power. With the two largest territories out, the West Indies Federation failed and was officially dissolved on May 31, 1962, the same day its independence from the British Crown was meant to go into effect.[128] A smaller federation of the "Little Eight" was debated, and Barbados would have been the biggest economic power

in such a union.[129] In 1962 Barrow spoke to the sociopolitical conditions that such unity would be based on:

> There has been little communication culturally between one island and another but when you look at the broad masses of people in the Westindies [sic], they do have a common affinity, although in individual islands they have their own way of looking at things. We are, therefore, bound together by some ties of consanguinity, it is true, but we are bound together by similar conditions and similar economic background more than anything else. We are bound together because we believe that most of us were displaced from some part of Africa, some may have come from Dahomey, some from Uganda, some from Gambia, some from the Ebou nation, some from Mozambique, some from Dakar, and from all parts of the continent our ancestors may have been brought against their wishes. But when you look at a country like Barbados and you realise that the average Barbadian is completely detribalised and has more cultural standing and is allied more closely to those people in western industrial nations, one cannot really go on with that nebulous affinity in order to prove we have a common destiny.[130]

Barrow espoused a kind of black nationalism that was class oriented, geared toward the black working class of Barbados and the region. But he was not a politician who believed in racial unity above all else. Hilbourne A. Watson notes, "Barrow's charismatic appeal helped to undermine black working class solidarity, for he used his charisma for the populist end of appealing to the mass over class, and by treating black working class grassroots nationalism as something at odds with democracy."[131] Barrow's statement that "the average Barbadian . . . has more cultural standing and is allied more closely to those people in western industrial nations" also aligns with the kind of Barbadian exceptionalism that posits Barbados as modern and that was at the heart of the Little England myth. His sense of regionalism and nationalism was based on specific commonalities of heritage. His vision of an independent West Indies and an independent Barbados sat at the meeting point of two competing myths of national identity. He posited ancestry as important, but the common condition of colonialism was what really bound the region together in his rhetoric, and moving past that condition would be the way in which the region as a whole would come to define its future.

This is the attitude that found its way into Parliamentary debate in the early 1960s. After the 1961 elections and the demise of the West Indies Federation in early 1962, Barbados was still left to define its place in a changing world. The minority classes that opposed independence, and the rising middle classes, which had been taught to aspire to a colonial ideal, were still a force in politics and society. But with a racialized consciousness, Barrow espoused the cause of the black workers of Barbados in a populist-nationalist way.[132] In his political rhetoric, not

unlike in Lamming's essays, it was an insult to be associated with anyone who openly reinforced the centuries-old racial inferiority complexes, and he used this as a political tool against his opposition, stating, "We talk of psychological injuries that have been done to our young people by instilling in them a sense of inferiority. There are people in this House who have said they would never employ a black man before they employ a white man."[133] As previously noted, his politics were racialized, and his promotion of the black working class was central, but he also resented opposition attempts to use racial rhetoric to denounce his vision for the nation, stating in the same speech that "people of this country try to set white people against black people. Some members over there would rally members of European descent in this population and tell them that Barrow intends to do so and so."[134] He reassured everyone that Barbados had been a democracy for centuries (conveniently omitting that before universal adult suffrage in 1951, participation in the democratic process was severely curtailed to anyone who was not a white elite man), that the laws existed and would be adhered to, but that independence was still an absolute necessity. His assurances were meant to allay fears that the black majority would forcefully take over the island in a way that was dangerous to the other racial minorities. These are the same fears that Lamming shows in the governor's response to the striking workers at his gate in *In the Castle of My Skin*. In that instance, the fear creates the very violence the fear is based on. Barrow presented a certainty in the necessity of independence, but he did so while at the same time adhering to Barbados's image as a peaceful, law-abiding place. In critiquing his opponents, he strongly asserted that "they underestimate the intelligence of the masses of this country, because the masses of this country want independence. The masses of this country have too much sense to aspire to get into company which is intellectually inferior to the African heritage; but we have a bunch of humbugs in this country whose only ambition is to identify themselves with the hegemony, the presiding power, and, if they get into their company, they feel that some of this prestige will rub off on them."[135] Under the myth of Little England, Barbados had been governed by an elite few who were firmly entrenched in British culture and British social structures and who had exercised their power to protect their privilege. But throughout the twentieth century, new ideologies of racial and class consciousness gave the majority of Barbadians a new impetus toward self-determination. Barrow distinctly marked this new impetus as part of an African diasporic politics, one that posited African intellectual heritage as superior to that of the European imperial discourses that had ruled for so long. A few months later, he was also careful to make class distinctions. He said, "The real solid basis of Westindian [*sic*] advancement, [is] something which is based on the struggles of the masses of the Westindies [*sic*], and not on the political leadership of the Westindies [*sic*]. I want to make it clear, and that goes also for this or any other government in Barbados, that any advancement which we have attained has been due to the demonstration of the submerged tenths of the populations and not any-

thing that a leader has condescended to give up to the people of the Westindies [*sic*]."[136] Drawing on W.E.B. Du Bois's notion of the talented tenth, as he often did in this era, allying himself, his nation, and the anticolonial world with the submerged nine-tenths, Barrow posited the masses as the "real" leaders of change. It was their efforts that led to the island's advancement. Lamming portrays similar sentiments years earlier in *In the Castle of My Skin*, where it is the poor people's money, the village's Penny Bank, that provides the foundation for the middle class to invest and buy the village land, ultimately displacing the poor villagers, whose efforts were at the heart of the community's feeling of improvement.

The colonial system had clearly worked in the interest of the largely white merchant elite and old plantocracy class. A broad-based nationalism was a threat to the elite's economic and social hegemony, but the middle-class intelligentsia of color was also tied to colonial structures. Barbadian psychiatrist Ezra E. H. Griffith demonstrates this relationship in his memoir, *I'm Your Father, Boy*, where he relates a 1950s conversation between the men of the village and one of their educated peers, nicknamed Professor:

> "Gentlemen," he intoned seriously, "you are offering an hypothesis, upon which we are clearly not agreed. Furthermore, there is clearly little logic to your claims."
>
> "Professor, as usual, you talking down to we. But you en mek nuh blasted point yet. British politicians and the Colonial Office don' give two shites 'bout black people in Barbados. An' you know dat is a fact."
>
> "My god man, there is no need to resort to obscene language to make your point. There is virginal youth in our midst."
>
> "You tink dis boy never heard a curse word? You trying to change the subject. De British colonize yuh ass, and you talking like dem. But deh don' want yuh."[137]

Professor's command of the colonial language did not give substance to what he had to say. He was a recognizable individual in the village, a part of the community, but his educated status placed him outside the world in which the majority of the villagers lived. Professor's choice to use "proper" English displayed an affinity for the colonial structure that, by the 1950s, the rest of the men had grown to resent. The people of Road View both appreciated Professor's command of language and found his constant use of it arrogant. His position exemplifies what the intelligentsia had to lose in a broad-based national movement. This autobiographical example mirrors Lamming's autobiographical fiction, where one of the middle-class new landlords opines, "These were days when the better educated had to go easy with the poor since the latter's will could now be felt, and no one could tell whether he might not be called upon at some time to represent that will."[138] The middle class was still liminal, and the precariousness of their social space was keenly represented in the literature. People like the Professor and the middle-class landowner may have learned Prospero's tools, but the common folk

remained unimpressed. Leadership aside, the nationalist movement in Barbados gained its support from the working class, whose members had been actively agitating for change since the 1930s. It was to them that any nationalism would need to be directed.

The narratives of Barbadian nationalism focus almost exclusively on male leadership in both the political rhetoric and literary representations. Michelle A. Stephens argues that this is partly a result of the gender politics of the movements that such nationalism grew out of. The organizing of the late nineteenth century in particular often relied on visions of Ethiopianist utopias, worldwide black empires. In such a framework (based on Psalms 68:31), it is the *princes* who shall come out of Egypt, and Ethiopia will stretch *her* hands unto God.[139] Within this discourse, men are the actors and women are the symbols. This partly explains why regionally and diasporically, political women's organizations such as the Women's International League for Peace and Freedom are not as prominent in the narratives of nationalism, diaspora, and independence as the male voices. As these movements worked diasporically, the nineteenth-century visions of black empire began to give way to twentieth-century efforts toward nationhood. Stephens argues that within this shift, in "leaving behind the language of Africa as motherland, that black imperial politics would also leave little place for the symbolic woman of color."[140] In the literary realm, "women's articulations of their historical experiences were marginalized because they did not reflect the agendas of nationalist politics."[141]

Lamming's *In the Castle of My Skin* relates this history on the social level. The village includes a shoemaker, teachers, domestic servants, children, and a long-retired elderly couple known only as Ma and Pa. Ma is terrified and outraged by the false report that the village boys had attempted to rape the landlord's daughter. She is the figure of sexual morality that is tied to older structures of power in the village, to "*what is.*" It is her audience with the landlord that makes the change coming to the village real. She had heard his fears with her own two ears. And ultimately, her death marks a point of transition in the village. She symbolizes the safety of community life rooted in the unequal power dynamics of the village's history, the collective efforts of survival, and the community social structures that aid them. Hers is not a story of transformation, and thus she cannot be present as the village undergoes sweeping change. Similarly, narratives of West Indian and Barbadian nationalism are gendered masculine and based on the silences and absences of women's voices in the idealized history. Lamming notes, "This unconscious treatment of the female as an invisible presence, that is, made absent when she is most present, is a continuing factor in the under-development of our societies."[142]

The picture Lamming presents is not unlike that of Griffith's memoir: specific in the portrayal of the idiosyncrasies of a community, yet typical in its depiction of Barbadian life. Both depict a close-knit community with various connections

to a world marked as outside their daily lives. By characterizing *In the Castle of My Skin* as autobiographical fiction, Lamming is able to wed the authority of an autobiography with the creative license of fictional writing. Because the story spans several years, the voice of the narrator grows as the plot progresses. Lamming's character G. grows from a boy to a man while witnessing Barbados shift away from colony and toward nation-state.[143] This text has become a classic in Caribbean literature, and its reception speaks both to the talent of the author and the embrace of local culture. The story of an average young man from a working-class background in a typical Barbadian village became an iconic representation of Barbados in the 1950s. *In the Castle of My Skin* is able to do this largely because it gives a gendered, racialized, and classed depiction of Barbados from the social perspective of the members of the working class who were pushing for change.

In August 1965 Barrow submitted a white paper on independence without any conversation with the majority of voters, claiming a referendum was unnecessary since the people had spoken with their votes for the DLP, which had clearly made independence a priority.[144] Younger, politically active citizens held public meetings in Queen's Park that were very well attended. Support for independence in Barbados looked much different from the lukewarm support for federation across the region because "the levels of public debate, and controversy, had succeeded in raising a general awareness about independence, about being a West Indian, and also about being a Barbadian in ways that Federation had not."[145] By 1966, change was imperative for the majority of the island's population. Speaking at the Barbados Constitutional Conference in London in July 1966, Barrow made it plain: "In our view, there can be no question whether Barbados is ripe and ready for independence. Three centuries of history answer that question in the affirmative. You have never had to shore up our finances; you have never had to maintain or preserve public order among us. Even now, without the help of thousands of our best citizens, your own hospital and transport system would be in jeopardy."[146] Barrow related Barbados's readiness based on its unique history as a British colony. Barrow's vision of Barbadian independence relied on the fact that Barbados had never changed colonial hands and had a centuries-old Parliament. Independence would be a continuation of parliamentary rule, even if that political history had been largely exclusive to white elites.[147] Barrow co-opted the Little England myth, offering it in the 1960s as a foundational history for black nationalist populist self-determination.

The urgency of the moment was conveyed in Barrow's increasingly strong tone throughout the mid-1960s. The West Indies Federation had represented a West Indian nation. Its failure had been attributed to poor leadership, island factionalism, and, for some, a sense that even after decades of pushing for it, the collective West Indies were not ready. In Barrow's representation, Barbados had long since been ready; its population was exceptionally modern, as demonstrated through its governance and the fact that the labor of its migrants had become key to British

modernity, with heavy impacts on the transportation and health of the United Kingdom. Change meant confusion for some and pride for others, but whether or not any individual's faith in the nation's readiness faltered, change was certain. Just as it does for the boys sitting on the beach in Lamming's novel, it became a question of what's *gotta be*. As Trumper notes, "We all get a feelin' inside that certain things got to be, an' it make no difference what is, or what's not, that particular thing gottabe."[148] In the novel, this sentiment is used to express both a faith in what has always been and a growing urge for something different. As Barrow had warned in January 1966, "No one is going to be contented to be treated as second class citizens in perpetuity."[149] In his address to the Barbados Constitutional Conference that July, Barrow made it quite clear that the time for independence had come, and he gave his guarantee: "My Government, I assure you, Sir, will not be found loitering on colonial premises after closing time."[150]

INDEPENDENCE AND FREEDOM

> "I was thinkin'," he said, "how the Independence would change all that wipin' out, change everythin' that confuse."
>
> Powell's pride had been aroused. His voice came loud and fretful.
>
> "Change my arse," he shouted, "is Independence what it is? One day in July you say you want to be that there thing, an' one day in a next July the law say all right, from now you's what you askin' for. What change that can change? Might as well call your dog a cat an' hope to hear him meow. Is only words an' names what don' signify nothin'."
>
> The politics of freedom had always haunted Powell's imagination.
>
> —George Lamming, *Season of Adventure*

> Free is how you is from the start, an' when it look different you got to move, just move, an' when you movin' say that is a natural freedom make you move. You can't move to freedom, Crim, 'cause freedom is what you is, an' where you start, an' where you always got to stand.
>
> —George Lamming, *Season of Adventure*

Released in 1960, Lamming's *Season of Adventure* presents a character so obsessed with the meanings of freedom that all else seems irrelevant. Setting the novel on the fictional Caribbean island of San Cristobal, Lamming presents the character of Powell as an everyman with an attitude of distrust, paranoia, and an intense yearning for control of his own destiny. In an unconventional author's note that interrupts the latter chapters of the novel, Lamming writes, "By historians and analysts, [Powell] is presented as a man who saw freedom as an absolute, and pure. . . . To the novelists and poets . . . Powell has become in their work the purest example of a man for whom nostalgia was an absolute."[151] Powell yearns for

older days while inherently critiquing the lack of freedom of the past and present. Lamming would later say of the conversation quoted at the beginning of this section, "This nationalism that these two characters are speaking about; this sense of nation which is both political and cultural; I am suggesting to you that it does not exist in this region."[152] The natural freedom that Powell was so adamant about was still a dream to be realized in Lamming's view.

Lamming's autobiographical book of essays *The Pleasures of Exile* was also published in 1960. In it he details his ideas of freedom, the restrictions of colonialism, and the many different experiences of blackness he encounters around the world. Six years later, on November 30, 1966, the British Union Jack came down and, replacing it, Barbados's own national flag waved in the wind. When leading the nation toward independence, Errol Barrow was very clear that the country was not looking for handouts. Barbados was not asking for independence. Barrow insisted the island had been independent for some time, or at the very least had dutifully carried out the responsibilities of an independent if not sovereign nation (democratic process, economic survival, international trade, cultural and social reproduction). Still, independence was a little more than a sociopolitical formality. The officialdom of Barbados looked much different, and "at independence the complexion of the political, legal and judicial executive had become definitively and irrevocably black. Within barely a decade there had been a revolution in the symbols of state and authority (even if economic power remained in the hands of those who had traditionally held it)."[153] Both *Season of Adventure* and *The Pleasures of Exile* depict the difference between a change in circumstances and a feeling of change only years before Barbados would officially embark on a struggle to translate political independence into a feeling of freedom. Supposedly, independence from colonial powers would consequently lead to freedom, but this was not guaranteed, and definitions of what freedom would look like, or how average people would experience it, often got lost in the movement away from colonialism.

The relationship between independence and freedom, between a change in circumstances and a feeling of change, between internal affairs and foreign relations, began to play out in Barrow's representations of Barbados shortly after independence. Independence allowed Barbados to pursue its own economic goals, and, as evidenced in its joining the United Nations only a month after formal independence, it allowed the nation to define itself internationally. Whereas before, colonial authorities and fictional school inspectors told Barbadians that their place on the world stage was the place of England, of the British Empire, which was always on the side of peace, two world wars and many other internal and international conflicts had taught Barbadians otherwise. Lamming identified political freedom as "the recognition of the demand to be collectively responsible."[154] And in his first speech to the UN in December 1966, Barrow expressed a similar sentiment. After thanking those nations who sponsored Barbados's entry and assuring those present that Barbados made no distinction between its internal and

external affairs, he detailed what that meant to him. His vision of the poorer classes being the foundation of change extended beyond the shores of Barbados, and he tied the notions of world peace to the eradication of poverty. Only twenty-one years after the atom bomb signaled the beginning of the end of World War II and the beginning of a cold war, he said, "Two-thirds of the world's people do not fear a nuclear holocaust because they literally have nothing to live for. The irony of their situation is that they hold the key to the world's prosperity, but that the doors are bolted against them by the participants of prosperity."[155] He firmly placed Barbados within international struggles, noting that "it [Barbados] belongs to the submerged two-thirds of the world."[156] He called on the UN to fulfill Frantz Fanon's plea to create a new history of Man.[157] He stated that Barbados would do its part, acknowledging the military might of larger powers and the necessity of bringing the voices of the less powerful to the forefront. And he asserted Barbados's position in an idealistic phrase that he would reuse time and time again: "We will be friends of all, satellites of none."[158]

The high social expectations surrounding Barbadian independence are evident in the national symbols, which present a beautiful ideal. These symbols ostensibly came from the Barbadian public, having been chosen through competitions (figures 1 and 2). This meant that "the public . . . felt a sense of involvement in the construction of important symbols of the national imaginary."[159] The Fiftieth Anniversary of Independence National Monument states that "the Barbados Flag, designed by Grantley W. Prescod, was chosen from an open competition of over a thousand entries." It features "Neptune's Broken Trident[, which] connotes the bold break from a colonial past." The trident symbolizes the history of the island's relationship to Britain, and its prominent placement demonstrates how central the history of that relationship has been to Barbadian identity. Yet the trident is broken and surrounded by the bright cerulean blue and golden yellow that stand for the sky, sand, and sea, Barbados's most abundant natural resources.[160] The national motto, Pride and Industry, relies on the reputation that Barbadians earned throughout the Caribbean and in other sites of migration. Known to be extremely hardworking, dignified, and proud almost to the point of haughtiness,[161] Barbadians distinguished themselves with the sentiments of pride and industry. According to the monument, seven years after independence, "the choice of the National Pledge [was] announced in 1973, with Mr. Lester Vaughan [a schoolteacher] emerging victorious in a competition of 167 entries." The last line of Barbados's Pledge of Allegiance, "to do credit to my nation, wherever I go," posits the ideal that one would always be Barbadian, while acknowledging that migration and movement are a constitutive part of the national identity. The national anthem gives the most salient representation of the wishes of an independent Barbadian nation-state. The music was written by Roland Edwards, a music teacher from Speightstown, and the lyrics were written by Irving Burgie, a Brooklyn-born descendant of Barbadians who had achieved great success writing songs for Harry

FIGURE 1. Barbados National Flag, Fiftieth Anniversary of Independence National Monument, the Garrison, Barbados. Taisha Carrington, artist. Photographed by the author.

Belafonte, including what would become island classics such as "Day-O" and "Island in the Sun." The national symbols and the people behind them share the history of the nation's road to independence, as Edwards was both a respected musician and teacher in Speightstown and had been a workers' rights activist before World War II,[162] and Burgie's personal history demonstrated the centrality of migration and return and diasporic politics. Burgie says he was inspired by the civil rights movement in the United States, and when he wrote the lyrics to the anthem, he was already well known on the island, having vacationed regularly in his mother's homeland for years.[163] The anthem's declaration that "these fields and hills . . . are now our very own" and "upward and onward we shall go, inspiring, exulting, free" give voice to the "natural freedom of movement" Lamming's *Season of Adventure* character Powell speaks of. Living up to the expectations these symbols portray would prove much harder than constructing them.

In achieving independence, Barbados (and much of the rest of the West Indies) was still dependent on liberal political ideology, the same gendered ideology

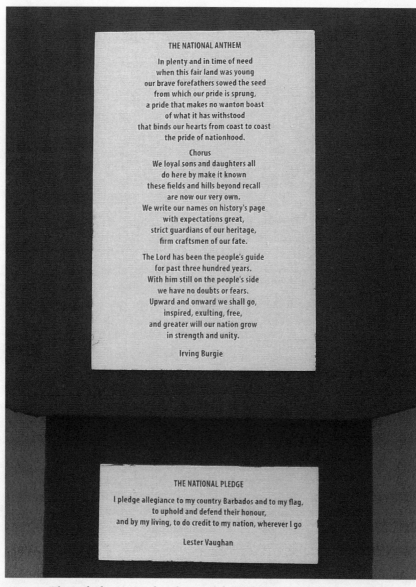

FIGURE 2. The Barbados National Anthem and the Barbados Pledge of Allegiance, Fiftieth Anniversary of Independence National Monument, the Garrison, Barbados. Taisha Carrington, artist. Photographed by the author.

prevalent after Emancipation. This ideology sought to confine women to the domestic sphere while men operated in public spaces. Writing in 1998, V. Eudine Barriteau suggests that "we should deconstruct the foundational assumptions of liberal political ideology to reveal its gendered construction of citizenship."[164] Such a deconstruction would have proved difficult in the decades after independence, since throughout the West Indies, "discussions on gender were women's business. Discussions about race and class were everybody's business."[165] In Lamming's work, "he associates women with domesticity."[166] In the decades preceding independence, men had seemingly fathered the idea of a Barbadian nation-state because, according to the liberal political ideology and "men of speech" traditions, such discourses were the domain of men. Even after independence, "the political leaders, formally educated or not, were male. The mantle of political leadership passed from white males to black males."[167] Not unlike the spirited discussion in the Speightstown pub in 2012, it was not necessarily that women were not present or active, but they were not imagined as part of a publicly political discourse of nationalism. Their voices did not enter the memory of independence discourse. In the move toward freedom, this was one arena where, as Lamming's character Powell might say, "you might as well call your dog a cat an' hope to hear him meow";[168] little had changed.

The group that made this new independence precarious, however, would be the growing black and brown middle-class intelligentsia.[169] Their understandings of Barbadian society far outdid those of the colonial powers or the white elite. Their climb up the social ladder had been a treacherous and earnest one that only grew in intensity in the decades before independence, and as black and brown people, they racially fit the ideal of the new nation. In *In the Castle of My Skin*, Lamming represents this class as both central to notions of change and usurpers of a proffered dream. It is Mr. Slime who brings about labor reforms and offers the village the dream of owning land, but in the end, though their money is central to the changes, the villagers are the ones displaced, and "Mr. Slime had become suspect."[170] In analyzing another Barbadian author's novel of this era, Aaron Kamugisha lays out the changing social conditions on the island, stating, "The post-colonial state was, in part, a gift of the British to the Caribbean middle class, who were seen as possessing the social and cultural capital that made them fit to rule."[171] The attitudes that led them to their tenuous social position were rooted in a colonial past. As Lamming's *Season of Adventure* character Powell explains, "They harsh an' cruel 'cause they think that freedom is a gift they can't afford to lose. Is bad that thinkin', is the nearest any man come to killin' what he is. Take it from me, Crim, you can take it from me. If I ever give you freedom, Crim, then all your future is mine, 'cause whatever you do in freedom name is what I make happen. Seein' that way is a blindness from the start."[172] Powell's disdain for the middle class illustrates the ideological slippages between freedom and independence, between social expectation and sociopolitical reality. Independence is not

synonymous with freedom. In the literary realm, sociopolitical freedom is represented as an individual and collective feeling of self-determination.[173] Independence is a political act that presents new psychological, economic, and cultural challenges.[174] In order for Barbados's citizens to honestly confront those challenges, they would have to work with, through, or around the middle-class intelligentsia.

The political leaders of the era were from such a group. Many of them had been educated, gone abroad, and worked as lawyers or in the press before becoming politicians. Although they had strong ties to the working class and many purported to represent it, their educational success and political aspirations also defined them as middle class. The new prime minister, Barrow, fit this profile. As a self-proclaimed "penniless politician" who wanted the children of his servants to have just as much confidence as his own children, Barrow created the illusion of uplift in his own moral expressions.[175] He was both "an old-fashioned benevolent aristocrat" and "at home and totally comfortable in the lowest echelons of society."[176] In reality, Barrow was for the people, but he was also a part of the plantocracy,[177] and such a position ultimately shaped the way in which he viewed social power. While Barrow was consistently radical on international issues such as anti-imperialism, African independence movements, and antiapartheid,[178] he was not outwardly against the "economic stranglehold that the white elite held over the country."[179] Barrow had made his political career speaking as a man for the people, and now, as prime minister, he would still have to demonstrate his commitment to the working class.

The working class and the middle class had different socioeconomic goals and different sets of expectations that the new nation-state would have to marry in order to appease both sectors of society. The working class had specific social and economic needs, and its members had engaged in the rhetoric surrounding independence that promised to put control over the nation's destiny in the hands of "the people." Yet the middle class, educated in both colonial and local structures, was prepared and expected to take the reins of leadership. As Lamming reflects in a 1995 essay, "Education had made this class a serious obstacle to development, and a hostile enemy against any struggle for cultural authenticity, for the compiling of the native territory."[180] Yet, as Kamugisha notes, "Anglophone Caribbean independence was not just a transfer from the colonial office to the West Indian middle classes; it represented the genuine aspirations for self-determination held by so many Caribbean people. While the limited character of that independence and conservative nature of the new governing elites was clear, independence was something Caribbean people could not *not* want."[181] The social need to create and maintain an independent national identity was threatened by the middle class's ties to the colonial ideologies in which its members had been educated and through which they had gained their social status. At the same time, it was bol-

stered by their ability to create and sustain avenues for a new national culture to thrive.

To a large extent, the two classes shared space and were interconnected. They were demarcated by education, career choice, and opportunity, as well as actual and perceived wealth. The appeasement of both was aided by the fact that Prime Minister Barrow had no intention of restructuring the socioeconomic landscape of the new nation-state. He believed that governments had the responsibility to improve the conditions of the poor, materially and socially, but he was not inclined to give them direct power.[182] Historian Hilary Beckles explains that because Barrow was "unable to implement structural changes in the ownership of productive resources and the social organization of the plantation-based formation, Barrow resorted to radical social policies that carried the potential for long-term transformations."[183] These policies expanded on the platform the DLP ran on in 1961 and included free education through the tertiary level, national insurance, incentives to small black businesses, and a cohesive national health policy. While the largely silent elite continued to enjoy their privileged position, the nation-state focused on appeasing the middle and working classes.[184] Such a platform continued the work the DLP had promised in 1961 and offered the newly independent nation-state a vision, since "there was neither any other real opposition to Barrow nor popular demands beyond independence itself."[185]

Although, as Barrow repeatedly remarked, Barbados had always enjoyed a representative government and, in the early 1960s, full internal self-government, the island was still protected by the legacy, if not the diplomacy, of the British Empire. As political scientist Gordon Lewis notes,

> West Indians have been made to feel, frequently to their own satisfaction, that with paramount responsibility resting with London, Britain would always look after things, would always guarantee their safety. . . . There was lacking the one single incentive, the knowledge that they were on their own in an uncertain and frequently hostile world, calculated to nurture that capacity. That incentive is now there. The real problem of independence is whether the West Indian society can respond creatively to that challenge or will react negatively, seeking in typical colonial fashion to find alibis for inaction or even deliberate evasion of responsibility.[186]

England and the English descendants of the Barbadian plantocracy had a responsibility to Barbados and its working class. They felt that responsibility, as represented in the novels of the era and the British Parliament's continued paternalistic discussions of how to end colonialism. Independence may not have brought an automatic sense of freedom, but it did formally begin to sever the political ties of responsibility. Barrow, as a leader, was both fervently wedded to change and solidly content with some of the old social structures. He relied on black nationalist

discourse while undercutting black nationalist organizing on the island.[187] He staunchly worked toward the betterment of all, but not necessarily the empowerment of all.[188] Lamming writes that in traveling to England, Barrow "caught a glimpse of those who had made the rules by which his own childhood had been indoctrinated. The next stage was inevitable. He would become the colonial in revolt. If he did not wish to be a revolutionary, it is also true that he did not degenerate into that status we call conservative."[189] Independence meant that Barbados was entering into an entirely new set of circumstances, and many saw Errol Barrow as a man destined to lead the way.[190]

As Lewis notes, with political independence, "a new sense of personal responsibility, of personal involvement, must grow up, for much of what passes for a new national spirit is frequently a sterile anti-colonial prejudice."[191] He goes on to say that "it is not enough, with independence, to be merely against something, however justifiably. One must be for something."[192] An independent Barbadian national identity would have to be more than an anticolonial stance.[193] Within this new nationalism, in order to align with the nation's motto, Pride and Industry, it was necessary to find an arena that the collective nation could find pride in and build an industry around—to find something to be for. The cultural arena satisfied this need.[194]

As a colony, Barbados had been wedded in one way or another to the myth of Little England. As an independent nation-state, basing the island's cultural identity on its history as Little England seemed antithetical to independence. To remain culturally in the shadow of Great Britain would be to face in the wrong direction on the path toward that ever-elusive freedom. After political independence, in order to make the next step, "the overpowering cultural image of Britain, reinforced by the West Indian mimetic process, and which permeates nearly every nook and cranny of West Indian social psychology, must give way to new concepts of national and even personal identity rooted in West Indian experience itself."[195] In the late 1960s Barbados would have to assert its own cultural identity in the midst of its British past and the growing North American influence. Many West Indians understood that independence required not only national symbols but also a change in the ways they imagined themselves, and they knew that change was a matter of psychological survival.[196]

The old and new myths of Barbadian nationalism have come to a head in some of the monuments and discourses around them on the island. Two prominent statues have been at the center of these debates. In the capital city of Bridgetown stands a monument to Lord Horatio Nelson, an admiral in the British navy who has been credited with winning the Battle of Trafalgar in 1805, thus checking the French naval threat to Britain's interest in the Caribbean and preserving slavery in the British West Indies for three more decades. The monument was erected by white Barbadians in 1813 in Barbados's own Trafalgar Square twenty-seven years before Britain erected its own monument to him.[197] In 1999 the Barbados Labour

Party government renamed Trafalgar Square National Heroes Square.[198] Owen
Arthur's Barbados Labour Party government also established the National Heroes
Square and Gallery Development Committee, which held three town hall meet-
ings before producing a report including recommendations for the removal of the
Nelson statue to an alternate site where its history would be preserved without
the implication that Nelson was a Barbadian hero. The recommendations were
not acted on.[199] Since 2007, just across the careenage stands a monument to Bar-
row, the first and only statue in Independence Square.[200] On one side of the water
stands a history of Little England, and on the other an imagined future of the
people's nation. While Barrow's place in Bridgetown seems rather secure, the
debate over what to do with this earlier myth of Little England, the debate con-
cerning the factual history of Lord Nelson's relation to Barbados versus the col-
loquial memory of his presence (the man, the statue, and the legend), signals a
larger debate about what role symbols of an earlier colonial history should play
in an independent nation-state. These debates have gone on for decades and seem
to be nowhere near conclusion. Not unlike earlier sociopolitical debates, they play
out in formal and informal spaces: in public meetings, in political discourses
around Independence Day and election time, in the calypsos, and in the editorial
pages of the press. Digital spaces such as the *Barbados Underground* blog position
the debate about Lord Nelson within partisan politics and national self-definition.
An article from 2008 on the site lauds Arthur's Barbados Labour Party for estab-
lishing the Pan-African Commission, erecting the statue of Barrow in the new
Independence Square, and changing the name of the square that holds Lord Nel-
son's statue from Trafalgar Square to National Heroes Square. The article, not
unlike the earlier recommendations and like many current debates about monu-
ments to undesirable histories the world over, calls for the statue to be moved else-
where, for the history to be remembered, but for Lord Nelson's place (physically
and metaphorically) to be less prominently displayed in Barbados.[201] These
debates are largely (though not wholly) continued through "men of speech" dis-
courses where mostly male politicians and academics debate publicly in their offi-
cial roles and as concerned citizens in various presses and other public spaces. As
the comments to this article and others note,[202] the significance of the presence
of the Lord Nelson monument in National Heroes Square varies drastically from
individual to individual. The historical events happened, but what they mean to
the notion of an independent and "free" Barbadian future is still very much under
debate. And so the two statues stand (figures 3 and 4), decades after independence,
the two heroes of different eras symbolizing the tensions of Barbados's history in
its present independence.

　　While attempting to repair the fissures that threatened the nation's psychologi-
cal survival, Barbados also needed to think about its economic survival. The
rebuilding of the cultural image of the new nation would also need to be an eco-
nomically viable pursuit. As Barbados is an island with few natural resources, the

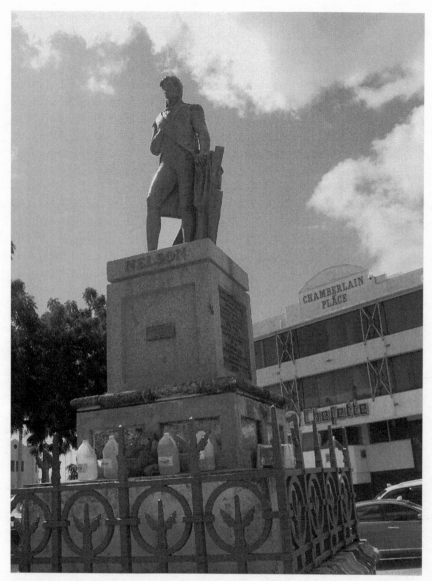

FIGURE 3. Lord Nelson in National Heroes Square, Bridgetown, Barbados. Photographed by the author.

tourism industry coupled the pursuits of economic survival and the building of a new national identity around Barbadian culture in the decades after independence. As the economy moved away from a monocrop agricultural model and more substantially toward tourism and more service-oriented industry in the late 1950s and early 1960s, representing Barbados in the most favorable light became very

FIGURE 4. Errol Barrow in Independence Square, Bridgetown, Barbados. Photographed by the author.

important.[203] In many ways, it was not only a nation that tourists were being presented with but also an island. Beaches, the then few but inviting golf courses, and high-class yet quaint hotels overshadowed the images of people who served as servants and accessories to a tourist experience in advertisements. The market colored representations of the character of the nation, so much so that in his 1964

version of *The Barbados Book*, Barbadian politician and former mayor of Bridgetown Louis Lynch reports that "Barbadians are urbane and most hospitable to visitors to the island. . . . They seem to look upon it as part of their duty, to whatever social stratum they may happen to belong, to be as kind and welcoming as possible in their attitude to visitors."[204] In preceding decades Barbados's regionalism had been based on a shared colonial identity and on the economic and political goals of the nation and its neighbors. Now more than before, that regionalism became a blanket representation in the way that Mimi Sheller describes when she writes, "In an endless simulacrum, earlier literary and visual representations of the 'Paradise Isles' have been mapped into the collective tourist unconscious before they have ever set foot there. The 'real' Caribbean is always a performance of the vivid Caribbean of the imagination."[205] Barbados was a part of the imagined Caribbean that already existed in the minds of its visitors, and it would take great pains to live up to that imagined image. In order to set itself apart in a growing tourist market, Barbados would have to present something unique, and the specifics of an imagined Barbados lie in the historical myth it was leaving behind, in the image of Little England, with a safe, respectable, and inviting population.

The representation of Barbados as unique, complete with its mythic history as Little England, presented a challenge to the creation of a new cultural nationalism and the self-determination that so many had worked so long to achieve. But there was little else to grasp on to, since, as Lewis notes of the West Indies as a whole, "there is little left of the original culture in which to take pride, save for a few scattered artifacts."[206] In 1966 the specific cultural history of the island had just barely begun to be mined by academics and cultural workers who, in the next four decades, would offer different perspectives of Barbadian culture, some by shedding light on African retentions and other cultural practices that had been formed on and were thus indigenous to the island. One alternative to the Little England myth of old was the acknowledgment of most of the population's African heritage. A reclamation of African origins suited the black nationalism of the time period, but such nationalism was not unquestionably attractive to all Barbadians. This reclamation of African heritage did not necessarily equate to an indiscriminate solidarity with the multiple forms of black nationalism expressed across the world in the 1960s. And Barbadian politicians such as Barrow made rhetorical space for themselves in promoting an African heritage tied to a previously derided past, while still asserting and defining what that might mean in the newly postcolonial present. Any images of a modern black nationalism might also alienate the largely European and North American tourists who, as part of the leisure class, enjoyed the benefits of capitalism that many facets of black nationalism critiqued.[207] Visitors, whether they belonged to the leisure class or were working-class people who had saved up, came to the shores of Barbados looking for an idyllic tropical image complete with a welcoming population. But as Sheller notes,

"the 'untouched' Caribbean of tourist fantasy must be held in place behind walls, gates, and service smiles in order to afford the tourist the experience of getting close to it."[208] How could Barbadians hold in place the fantasy that would come to fuel their economy while asserting a new cultural nationalism that proudly marked a difference from the stereotype of happy subservience informed by the not so distant colonial past? Such a task was not necessarily impossible, but executing it would require embracing the cultural complexity that had always existed on the island. Barbadians have a sociopolitical history that Beckles calls "respectable radicalism."[209] He suggests that Barbadian politicians such as Samuel Jackman Prescod, Charles Duncan O'Neal, and Conrad Reeves all pushed for radical (not revolutionary) change within the strict political confines of respectability, with the idea being to bring timely change through nonthreatening means. This strategy would have to translate into the cultural arena if the new independent national identity (and economy) were to survive.

This radical but not necessarily revolutionary change is still occurring in the minds of some Barbadians. The role of the symbols of history in Barbados's future as an independent nation-state and in marketing the island within tourist markets is still contested and complex. Only a few blocks away from the home of Roland Edwards, the composer of the national anthem; in the same city where Lester Vaughan, the author of the Pledge of Allegiance, used to teach; and only about a kilometer away from that shop where the men and women debated black Barbadians' relationship to England and their place in the world stand two signs introducing the city. One spans an entire street corner and, etched into a large stone that gives it a nostalgic modern permanency, boldly states the name of the city: Speightstown. The other one is smaller. Attached to wooden posts that can no longer hold it up, it rests against a tin paling and announces the city's history as Little Bristol.[210] That history exists as a living ghost, a duppy who is at home among the living.[211] Lamming's *Season of Adventure* offers Powell as the one who contemplates freedom. But it is the young protagonist, Fola, who thinks in even bigger terms. Her personal story is intertwined with the traditions of the drums and the ceremonies of the dead. The novel begins with the Ceremony of the Souls, where the men of the village play their drums, living up to their reputation as the best village band, and they eye Fola, who is one of them but whose class and education mark her as different. She stands next to her teacher, a white anthropologist who has come to teach her of her own culture. Soon the rhythms will call the spirits of the dead to come and make confession through a chosen priest. Throughout the text, this haunting continues. The past is never really dead. And the anticipation of its presence affects the living, who have ordered themselves by gender, class, education, and feeling. Fola searches for her personal history, but the collective past, the people who come from the dead to tell the village's story, which she witnesses at the Ceremony of the Souls, gives her pause. And in contemplating these, "she had begun to realise what was the ultimate punishment of the dead.

She thought she saw the limitation in each corpse which had returned to tell its history. It was this obvious and overwhelming fact: *they had no future they could choose*. Memory was their last and only privilege."[212] The novel ends with the tradition of drums that call these spirits to bear witness, but much has changed in the village, and rather than describing a ceremony, the last pages tell of teaching the next generation that "the drums must guard the day."[213] The historical myth of Little England haunts the present. It lurks in National Heroes Square, and it lingers on the streets of Speightstown. Its rhythms refuse to be forgotten, but it has no power to choose. Instead, it is the ideal of nationalism that holds the choices of Barbados's future.

2 · PERFORMING NATIONAL IDENTITY

The image of Barbados as merely "Little England" has joined the ranks of debunked myths from a colonial past.
—Trevor G. Marshall and Elizabeth F. Watson, "Barbados"

In such cases one experience—in this case Barbadian—becomes at once unique and universal through the creativity of its inhabitants and extended community.
—Trevor G. Marshall and Elizabeth F. Watson, "Barbados"

It's a Thursday afternoon in early January 2011. My cousins, family friends, and I go out drinking on East Coast Road. There are banners for Stag Beer all across the shop. "A Man's Beer." The repeated declarations in the visual advertisements seem almost comical. No one drinks Stag to be a man. Folks drink what they like (which is Carib Beer's slogan). Neither of these is owned or produced in Barbados, but the signs are ever present alongside ones for Heineken and Banks, the latter of which has long advertised itself as the beer of Barbados.[1] Going to Martin's Bay on a Thursday is a quintessentially "authentic" Barbadian experience. It's popular for the big plates of food, including whole fried snapper fresh from the water. Folks who drink can drink. It's a shop, so you order by the bottle and take your time. Folks who smoke can smoke. It's open air, so the cigarette and cigar smoke just floats out toward the shore. It's a waterside nonbeach thing along East Coast Road with the Atlantic crashing against the island only yards away. I have no idea why we come on Thursdays, but that is the day of the week reserved for Martin's Bay. We may be home by five o'clock in the evening, but more likely it will be closer to eleven or midnight. And as in any other rum shop, indoor or outdoor, we sit, we eat, we take our time, and, a few cups in, we talk deep thoughts and bare shite all rolled into one.

We ate early and I ate a second dinner just because. The others have phoned my cousin to show that I've out-eaten him and to tease him for missing out, for not being on the island just now. The sun has set, and we're finishing the second

flask of white rum between us. We get into our debate for the evening. At some point my cousin picks up my camera, ever the documentarian. A family friend, Hasan,[2] and I are deep in debate about Barbadian culture, what makes something Barbadian, what is foreign, and how that may or may not change. The sounds of nearby laughs and other conversations mix with his annoyed declarations of "cultural penetration." The camera picks up snippets here and there.

"That is their way. Their way is to continually colonize you," says Hasan. I argue for appropriation as a means of resistance, saying it's possible for people to adopt foreign influences and make them their own. The night stretches on as we agree that a fight against coloniality is at the heart of Barbadian identity. We are arguing the same side but not at all saying the same thing. I believe that culture inevitably changes over generations and that those changes do not make it false, do not necessarily represent a loss in this colonial fight. He disagrees. He sees any appropriation as failure. He deems it all cultural penetration, whether it be British colonial or North American neocolonial, and says, "Oftentimes we're not in a position to fight against it. We try, but we lose and that is why the Kentuckys [KFCs] come and dominate. It is not because we want to embrace it. It is because we can't fight against it." The insistence on cultural *penetration* amid all the manliness of "A Man's Beer" signs, banners, and umbrellas makes his point clear: Barbados is constantly being fucked.

Everyone is fully present in the conversation, but Hasan's and my voices are central. The others listen, actively lending their support and giving their two cents when and where they see fit.

"Macaroni pie ent Bajan."

"Wha!" My cousin's Jamaican Brit partner is astounded. She looks forward to having macaroni pie on their yearly trips to Barbados, and we've just dashed her version of "authentic" Bajan cuisine. I find myself arguing that things can be made Barbadian, can become Barbadian. Hasan (and some of the others) are arguing that no, "it ent gon become," but there will be a time when something has so completely penetrated and eroded "true" Barbadian culture that it will seem to become Barbadian. I insist that a five-year-old won't know that macaroni pie isn't Barbadian. To them it is Barbadian, and over a generation it becomes Barbadian. For Hasan, this is a failure of society. He says, "Culture is something that is passed on from generation to generation. Right? It's passed on. If you have a generation of people who are not able to pass it on, then you leave a void and anything can fill that void. And that's basically what happens to small societies." We talk of warri and dominoes. The debate goes on, but the video ends. My cousin puts the camera down as the conversation gets unintelligible (from the noise in the background and maybe also from the rum).

Around the same time next year, we will do it all again. The cast will be the same, with a few additions: my uncle, my aunt, that one woman my mum had a fight with in school decades ago. We'll sit at the same shop but across the road, a

little closer to the water, next time. And only weeks after that lime, one of us will be dead, will "have a fit" on the way home. And because he had kept his epilepsy a secret from most, it will come as a surprise. It's a performance of dangerous privacy in the midst of so much openness. I had been sitting next to him, drinking, only weeks before. I haven't been back to Martin's Bay on a Thursday since.

This is a singular moment that reoccurs with slight variation in rum shops, at kitchen tables, and at social gatherings across Barbados. In each site, "local" and "foreign" products are advertised and consumed. The cast changes based on who is home on "de Rock" and who is currently abroad. But what it means to be Barbadian is overtly and covertly discussed, performed, and enacted over and over again. The health of the nation depends on such negotiations of identity, depends on distinguishing between "progress" and cultural imperialism, between Bajans growing and doing for themselves and mimicking others.

This chapter explores the monumental question: What does it mean to be Barbadian? Without hazarding any singular answer, the chapter offers a means for defining national identity through the popular performances and common narratives offered by official and unofficial representatives of the nation. Beginning with a musical metaphor, the chapter goes on to trace musical, political, and quotidian performances of Barbadian identity. It explores the ways that migration and return have always been a constitutive part of what it means to be Barbadian, and ends by showing how the national revival of the Crop Over Festival seeks to offer a salable, attractive narrative of Barbadian culture. Anthropologist John L. Jackson explores how racial identity is defined and performed through sincerity. This chapter proposes that similar arguments can be made for national identities, and that these identities are often tied much more closely to the imagined community of a nation than to the official structure of a nation-state. There are characteristics, common experiences, and at times stereotypical representations that are offered by the nation and by the state as integral to identifying and defining what is means to be Barbadian. Sometimes this assumed Barbadian identity is referred to idyllically as the "Barbadian personality," and while that nomenclature can be useful in galvanizing national sentiment, it falls short of a definition of Barbadian identity. Martinican scholar Édouard Glissant writes that "identity is no longer just permanence; it is a capacity for variation, yes, a variable—either under control or wildly fluctuating."[3] He dispels the idea of identity as only one's roots by showing that relations are just as important. In doing so, he argues against the fixity of identity and offers a definition of identity as a system of Relation that is a form of violence against totalitarian structures.[4] Because identities interact across geographic and ideological spaces, the relations across identities resist attempts to fix any one identity's boundaries. I agree with Richard L. W. Clarke that "the *idea* of a cohesive Barbadian national identity is in the process of being constituted as the object of postindependence discourse of Barbadian nationalism,"[5] and

I argue that it must always be in process. As on that night in 2011, I argue that Barbadian national identity is constantly in the making; there is a multiplicity to any Barbadian experience that transcends any seemingly singular national narrative or national myth. To be Barbadian is what "we" say it is, and the power of defining that "we" is something that is in flux but based in performing a sense of national sincerity.

TUK AS NATIONAL METAPHOR

Drawing on the aesthetics of a specific cultural history, rhythms, histories, melodies, and voices all coalesce into something that is both a response and a creation: tuk music. A penny whistle sings in the highest register. Its melody notes the intricacies of the debate on culture. The bass drum beats low, providing the foundation for the space to share with one another. The kettledrum provides a polyrhythm in the middle range. It's both steady and improvised. And sometimes a cowbell or triangle chimes in for emphasis like the slamming of a domino or the spontaneous shouted approval in a debate. Tuk reverberates in the rhythmic sway of the bodies that remember and re-create traditions passed down through generations and in the sound of feet marching softly, turning sharply through a history of polyrhythmic movements, simple and complex. Tuk is one of Barbados's few acknowledged indigenous traditions.[6] Like the waves of the Atlantic Ocean meeting the Caribbean Sea, the moving sound is regular and unpredictable as it meets the land, laying the soundtrack to a history both celebrated and denied. The music, its associated practices, its history, and its celebration are a metaphor of the amalgamated complexities of Barbadian culture.

Tuk bands have their origins on the plantations of Barbados. At the end of the crop season, workers feasted and celebrated to the sounds of fife and kettledrum groups accompanied by local singers and masquerade bands including various dancers and characters. Such celebrations came to be known as the Crop Over Festival.[7] The festival began with a parade of donkey carts, each decorated with hibiscus, bougainvillea, oleander, and bright cloth. The first cart was led by a woman in all white, and the whole procession would parade around two or three times so that everyone had the chance to see each cart. At one point in time, an effigy of "Mr. Harding" was used to symbolize the cruelty of overseers. Common dancers and characters included stilt walkers, Donkeyman (who wore a donkey suit), Shaggy Bear (outfitted in plantain leaves to accent the animated movements of his dance),[8] and Mother Sally, who wore an exaggerated bust and buxom to exaggerate her movements, which were located mainly in the hips.[9] The fife and kettledrum groups created a distinct sound that melded the military melodies of British sailors with the rhythms of West Africa. According to cultural scholar Curwen Best, "It is the African-derived sense of performance, with its supposed

accent or emphasis on rhythms, which is responsible and accounts for the ideo-phonic name given to this phenomenon: *tuk*."[10] Other interpretations define the term as a derivation of the Scottish word *touk*, meaning "to beat a drum."[11] Both the sounds and the differing histories of the music sit squarely between African and European traditions adapted to and innovated within a Caribbean context; "thus, creole musical signatures define the sonic ethos of Barbados."[12] Best writes that "[it] is this process of active appropriation and accommodation that marks tuk as more than a musical phenomenon. Tuk culture is therefore defined in its early manifestation as having to do with survival, adaptation, and dynamic nego-tiation. Tuk therefore symbolizes the continuation of African musical expression in the 'New World,' but it also represents the ability of a people to find creative ways to make sense of their changing circumstances."[13]

Tuk bands are commonly associated with the Landship, a friendly society, or "susu,"[14] founded in Barbados in the 1860s, although the music of tuk "predates the Landship by at least a century."[15] As performed by the Landship, tuk rhythms fol-low the warm-up and running of a ship engine, combining the discipline of the mili-tary sound with the spirituality of its African influences, especially when the movement and the rhythm align in an almost trancelike state.[16] Because of the Landship members' military-style dress and discipline, some Barbadians critiqued them as mimics of the British. Marcia P. A. Burrowes's work offers a more nuanced reading, positing that "as a cultural form the Landship demonstrates one of the ways labouring-class Barbadians coped with colonisation in the post-emancipation period. What was interpreted as mimicry was instead a form of cultural camou-flage that enabled Landship members to manoeuvre within the constraints of plantation society. By adopting the clothes of the colonial master, they devised ways of creating pockets of resistance within colonial space."[17] By appearing to "act" British, Landship members maintained the practice of West African rhythms, skirted public noise ordinances, and entered into public spaces that were normally barred to the working class.[18] While the Landship's practices, including tuk, may have appeared to be a form of British cultural imperialism, Burrowes argues that they were more likely a form of masquerade, a cultural appropriation that allowed working-class members to innovatively transgress the social norms of their time, retain African cultural practices, and align themselves with burgeoning African diasporic movements that differed from those that favored the more elite classes in the period just after Emancipation.[19] Throughout the late nineteenth and early twentieth centuries, cultural practices such as tuk and Crop Over were still per-formed by the working class, but they were often frowned upon by the elites. Brit-ish imperialists were not fond of these cultural practices, but it was the "internal colonialists" who were most vehemently against them.[20]

Like many folk traditions, tuk went "underground" during the interwar period.[21] Tuk bands survived in the rural areas of the island, "mainly in the hilly

Scotland District parishes of St. Andrew, St. Joseph, St. Peter and St. Thomas."[22] The bands became associated with holidays, traveling musicians, and rum shops, and the middle classes often looked down on them.[23] In a society that prided itself on the industriousness of its people, traveling musicians had to fight the stigma of laziness and "wutlessness" in order to practice their craft. It was not until the nation began to assert itself socially, politically, and culturally in the 1960s that indigenous forms such as tuk began to receive their due across classed audiences, and even since then it has been a long fight.[24] In 1962, after more than two hundred years of the musical form's existence, a tuk band performed on a formal stage for the first time at the Civic Theatre.[25]

While tuk went underground in the 1940s, Trinidadian calypso began making inroads on the Barbadian landscape along with European folk songs, hymns and ballads, North American cowboy songs, and black American spirituals and minstrels. Calypsonians remember listening to European classical music such as Brahms and black American singers such as Ella Fitzgerald when radio first reached the island in the 1950s.[26] Barbadian audiences viewed these other musical styles as "serious" music, while Barbadian calypsonians and tuk bands were seen as comic relief. A few brave Barbadian calypsonians, such as DaCosta Allamby, Frank Taylor, and the Mighty Charmer, vied against Trinidadian calypsonians for the attention of Barbadian audiences and struggled to be recognized as legitimate artists.[27] Without Crop Over celebrations and with these other styles dominating other outlets, in the 1940s and 1950s few forums existed for Barbadian calypsonians to practice their craft. From 1958 to 1964 a small Trinidadian-style carnival was held at Kensington Oval.[28] This carnival was sponsored by the Junior Chamber of Commerce. It was not very popular, as it was organized by and for a small, white, elite audience.[29] The Yoruba Foundation, a Pan-Africanist organization founded by Elombe Mottley, also attempted to revive Crop Over in 1972, but potential supporters were put off by the organization's overt association with Africa and African cultures.[30] Barbadian calypso struggled to find a foothold on the island, and the efforts to provide space for it in the cultural landscape failed because they were rooted too strongly either in a white upper-class audience or in an overtly "African" organization.

Many who were frustrated with the limited opportunities for Barbadian calypsonians and still seeking to carve out a niche within the world of music turned to spouge. Created by Jackie Opel (also known as Dalton "Manface" Bishop),[31] spouge, like tuk, is an indigenous Barbadian form that relies on innovation and borrowing and reflects the ways in which Barbadian cultural practices are a unique mosaic of the island's cultural influences. Opel was born in Barbados, but he made his name as a ska singer in Jamaica, working with the famed Skatalites.[32] As Opel's fame rose in the 1960s, he began to tour throughout the Caribbean and the United Kingdom, eventually returning home to Barbados and creating a new sound. He

merged Jamaican ska and Trinidadian calypso into a Barbadian rhythm. Spouge features a syncopated drum pattern, consistent guitar, cowbell, and a "lazy" bass, all creating a distinctive rhythmic sound.[33] This sound epitomizes Caribbean innovation.

Spouge was gaining in popularity, but it all but disappeared after Opel's sudden death in a car crash in 1970[34] and competition from other genres overshadowed it on the growing musical landscape.[35] At the time of spouge's creation, Barbados had rich cultural forms and practices, but very few formal cultural institutions to support them. According to cultural scholar Curwen Best, spouge was short-lived because it had no ideological base. He argues it was a part of the independence moment, which, since it changed very little, was largely symbolic.[36] Both tuk and spouge are indigenous traditions that faced strong competition from other genres invading the island in the mid-twentieth century while the nation of Barbados was struggling to define an independent national culture.

In the twenty-first century, tuk can be found mixed into the soca rhythms of contemporary musicians and more overtly in celebrations of the Landship society and in the lobbies of expensive hotels.[37] Wayne "Poonka" Willock is a calypsonian and tuk bandleader who has been instrumental in keeping the form alive by teaching it in Barbadian schools and performing during Bridgetown Market, the main market of the Crop Over Festival.[38] Contemporary tuk bands include a bass drum, a snare or kettledrum, a penny whistle or flute, and a percussive instrument, usually the triangle.[39] Like steel bands, they have come to accommodate a number of genres and perform European classics, Negro spirituals, popular *Billboard* tracks, and a wide range of indigenous Caribbean music.[40] And as an indigenous cultural form, tuk has more cultural currency now that the island's economy is focused on (high-end) tourism.[41] Tuk serves as an active metaphor for Barbadian cultural identity. Throughout the centuries of its performance, it has been criticized as too foreign, celebrated as a form indigenous to Barbados, derided as low class, and performed in expensive hotels. While located most firmly in African-descended working-class communities, its influences and performances cross racial and, to a lesser degree, class boundaries. It borrows from multiple traditions even as it is acclaimed as "authentically" Barbadian. In the twenty-first century, it endures as a distinct tradition by adapting and adopting other musical forms. Its survival as a tradition is based in conventional modes of passing down culture and innovation in performance and venues. It is a distinctly Bajan thing, founded with Bajan audiences in mind, but its survival is now linked to the global economics of tourism that privileges distinct folk cultures. Like the ever-elusive "true" Bajan identity, tuk is a specifically Barbadian example of cultural forms that continue to exist by virtue of their ability to meld tradition and innovation within ever-changing circumstances.

MIGRATIONS: REPRESENTING BIM, IMAGINING A NATION

> ...because the origin of the Caribbean started with the Diaspora; it's
> nothing new.
> —Kamau Brathwaite, "Golokwati Conversations"

> In most respects there is no typical West Indian or Barbadian migrant story.
> —George Gmelch, *Double Passage*

Barbados's indigenous musical forms, tuk and spouge, display the global and regional flows that provide the foundation for discourses on Barbadian identity, and their presence in the twenty-first century is tied to the international tourist market. Mary Chamberlain writes, "Barbados was created out of a rootlessness."[42] The first-nation indigenous populations that settled on the island at least a thousand years before the Portuguese named the island in 1536 had largely moved on to other islands and the mainland before the English settled and colonized Barbados in 1627.[43] Drawing on Michel-Rolph Trouillot's work, Chamberlain asserts that the Africans and Asians brought to the New World were brought into an epistemological vacuum.[44] As Homi Bhabha explains, in the modern world, "the nation [then] fills the void left in the uprooting of communities and kin, and turns that loss into the language of metaphor."[45] According to Benedict Anderson's definition of *nation* as an "imagined community ... imagined as both inherently limited and sovereign,"[46] those who had been uprooted could reimagine themselves, not entirely leaving behind earlier ties, practices, or communal understandings but building a new national imaginary based on similar though varied conditions of being and similar though varied histories. The English, Scottish, Irish, West and Central African, and mainland first-nation indigenous peoples who came to the island of Barbados in the seventeenth century had vastly different life conditions and reasons for arriving on the island's shores. And yet their coexistence in the space over generations, with all of its inequities, built an imagined community. These migrations to the island may be the foundation for later understandings of a Barbadian nation, but so too are the myriad migrations away from the island.

Migration is integral to the history of the Caribbean region. As one of the most densely populated islands in the world, for Barbados in particular, emigration was one way to alleviate social strains created by "overpopulation."[47] After Emancipation in 1838, the planter classes feared that the island's labor force would migrate away, but once levels of poverty started to rise on the island, they began to gently encourage the poorer classes to migrate away permanently. In 1889 the government formed a commission to investigate migration as a possible remedy to the perceived population crisis. Such efforts allowed the upper classes to hold on to the idea of a surplus labor force and control wages on the island accordingly. The

idea of surplus labor was meant to keep workers complacent with the knowledge that someone else would be ready and willing to step into their positions. In this way, the largely white merchant and planter classes sought to control the means of production and the elements that determined the opportunities available to the larger labor force.[48]

Migration, however, did not necessarily happen in the ways in which the planter class wished. Ideally, poor families would migrate permanently, but "the difficulty for the Barbados Government was not that Barbadians were reluctant to migrate, but that the wrong people migrated, for the wrong reasons, for the wrong period of time."[49] Most emigrants left the island with short-term plans of finding economic stability and returning home with enough wealth to sustain themselves and their families.[50] The largely African-descended working classes found and produced their own employment opportunities. While the upper classes attempted to use migration as a means of control, migration allowed members of the working class to negotiate and expand their employment opportunities on and off the island.[51] One major example of this is the building of the Panama Canal at the turn of the twentieth century. Barbadians represented 44 percent of the non-U.S. contract laborers who arrived in Panama to do the heavy lifting of the canal's construction.[52] These laborers returned to Barbados with "Panama money," which boosted the local economy and made some impact on social status, class positioning, and local politics, thus threatening the upper classes' hold on these arenas in ways they did not anticipate when they initially promoted emigration.[53]

Such strategies for control and self-determination were developed in a period of burgeoning activism, labor organizing, and racial consciousness. Migration across the region, to Central America, North America, and the United Kingdom, allowed for wider economic, social, ideological, and political networks of opportunity. Only years after the opening of the Panama Canal in 1914, Garveyism and labor organizing swept the region and were most visible in the 1937 actions that have been characterized by some as labor "riots"[54] and by others as a "revolution."[55] Many of the earliest political organizations within Barbados sprang from organized labor, and their power and social clout can be traced to their economic successes abroad and the social networks built through migration.[56]

Barbadian migration took on different characteristics in the 1960s independence era. In the 1940s war period and throughout the 1950s, the United Kingdom was the major site for Barbadian migrants because of the cultural and political ties between the colony and its colonial power, as well as economic initiatives with London's Transport Board and nursing programs that provided gendered employment opportunities to West Indian migrants. In the 1960s migration paths began to shift from the United Kingdom toward the United States after the 1962 Commonwealth Immigrants Act placed restrictions on the number of colonials entering the United Kingdom.[57] New York in particular saw a surge of West Indian immigrants in 1965 that lasted well throughout the 1980s.[58] In these few decades,

West Indian communities began to form outside Harlem, producing their own publications, businesses, and private education under an ethnic banner of West Indianness that separated them from black Americans but subsumed (to some extent) national differences.[59]

Even within these new communities, "where West Indians from different islands live[d] side by side, Barbadians [were] commonly thought of as being 'smug,' 'prideful,' and 'know-it-alls.'"[60] Barbadian author, musician, and former cultural officer P. Antonio "Boo" Rudder suggests that such characterizations stem from an empty performance of pride. According to him, Barbadians are proud of their identity, but when they display pride without knowing exactly what they are proud of, it often translates as "arrogance rather than self-assurance."[61] Other stereotypes emerged. Black Americans used terms such as *black Jews, middlemen,* and *ghetto entrepreneurs* to describe West Indians in general.[62] Such terms marked West Indians as foreigners within New York's black communities, positioning them precariously as potential exploiters and/or as potential economic models.

Throughout most of the twentieth century, the gendered structure of Barbadian society informed Barbadian migration patterns and how migrants structured their own narratives. Gmelch notes of Caribbean migration in the mid-1960s that women outnumbered men as North American migrants and worked mainly as nurses and domestic laborers (producing the common image of the West Indian au pair), in contrast to the patterns of migration to Britain, where men moved in higher numbers than their female counterparts. When the need for domestics diminished, the gender ratio of migrants began to even out.[63] In her account of how Barbadian migrants remember and narrate their experiences, Chamberlain finds that the women were "not truly autonomous agents. Neither [were] the men. But whereas the men present[ed] themselves autonomously, the women present[ed] themselves within a set of family relationships, as part of a larger picture and process."[64]

Those who ventured abroad as children inherited a complicated sense of Barbadian identity. Their struggles to place themselves exemplified diasporic sensibilities. Their "roots" lay in their personal histories, their parents, and all they knew about life on "de Rock," but they also related (in varying degrees) to black America and other West Indian immigrants. Glissant's concept of relational identity is useful here. He says, "When identity is determined by a root, the emigrant is condemned (especially in the second generation) to being split and flattened."[65] But when taking into account relations between different sites and populations, one can see how identity is not always or only rooted in anything as seemingly permanent as geography but rather can be experienced and expressed across multiple "homes" that relate to one another, across "a capacity for variation."[66] Trouillot similarly looks at institutions and identifying concepts relationally when he writes, "We gain greater knowledge of the nation, the state, the tribe, modernity,

or globalization itself when we approach them as sets of relations and processes rather than as ahistorical essences."[67]

Often these "West Indians [found] themselves caught between powerful cross-pressures of ethnic separatism and racial identification."[68] Mary C. Waters's study of black Anglophone Caribbean immigrants in New York seeks to explain some of these identity formations. She argues that "black immigrants from the Caribbean come to the United States with a particular identity/culture/world-view that reflects their unique history and experiences."[69] Barbadian-born psychiatrist and professor Ezra E. H. Griffith explains in talking about his father, "When I talk about him and the West Indian island of Barbados, I am talking about me, about my persona that is grounded in the history and geography of Barbados, about me linked to a father I could never extract from that island."[70] Griffith's move to the United States as a child and subsequent life in the States has been distinctly undergirded by his relationship to his "home," as expressed through his recollections of the personal relationships he formed there. Even without a desire to return, his understandings of himself are intricately linked to "that island." Even in becoming (or deciding whether to become) citizens of a host land, immigrants and their children have a perspective on identity formation that blends their own specific island experiences with a history of interisland migration and, in the 1960s in particular, a new sense of nation building.[71]

Woven into the men's and women's narratives of Chamberlain's text is a general sentiment that "our people love to travel." While Antonio Benítez-Rojo notes this of Antilleans in general,[72] in Chamberlain's text the social, political, and economic impetuses and histories of migration and return are expressed as a part of Barbadian culture. There is a collective sentiment that those on the island love to leave, for various reasons and lengths of time, but they still identify as Barbadian. In fact, "in much of the Anglophone Caribbean, migration has become a normal and expected part of the normal adult life cycle, a virtual rite of passage."[73]

For one of the stalwarts of Barbadian music, the Mighty Gabby, migration was not just a rite of passage but an exploration that ultimately mapped the possibilities of his life course. Raised in the neighborhood of Emmerton in the parish of Saint Michael, Barbados, Anthony "Gabby" Carter began his singing career as a stand-in for a sick child singing in the Chapman Lane Choir at a primary school singing competition when he was six years old.[74] He took his musical moniker from one of his most distinguishing character traits: the gift of gab. By the age of ten, he had written his first song, "Vote for Mottley and Get Free Cakee," about then mayor of the capital city of Bridgetown, Ernest Deighton Mottley, who "wielded tremendous power."[75] Even at such a young age, Gabby melded his curiosity and his musical ability with his own commentary on the politics and culture of his home. By the late 1960s calypso had become competitive, and in 1968, at the age of nineteen, Gabby became the island's youngest Calypso Monarch. This

was the beginning of a long list of musical and cultural achievements, but before all of the acclaim, Gabby was a twentysomething musician performing on yachts for tourists and earning two dollars a day.[76] Hearing of Canada and the United States, he wanted to see what all the talk was about and vowed to leave the island for five years, setting sail for New York in 1971. He was a young man hoping to expand his horizons before accepting his role as a fully responsible adult within Barbadian society. His wish to migrate included a desire to return and settle into adult life in Barbados while still in his twenties.

As Gabby was beginning his career and mapping his adult life, a group of Barbadian calypsonians were gaining acclaim at home and abroad. Dominant opinions of folk music made a crucial shift in 1962 when a group of white Barbadian men named the Merrymen brought a level of respectability to Barbadian folk music and calypso. Founded by Emile Straker, Stephen Fields, and Robin Hunte, the Merrymen played Barbadian and other Caribbean folk songs over a calypso rhythm that they termed "Caribbeat."[77] Between the years of 1965 and 1967 (the height of independence) the Merrymen toured Canada, England, and the Caribbean, often playing in front of record-breaking audiences. Much of their touring was a joint venture between the group and the Barbados Board of Tourism wherein each party paid 50 percent of the tour expenses.[78] The Merrymen's popularity grew drastically while they promoted Barbados across continents, and they came to be the "country's first musical ambassadors."[79] Their popularity spread at the same time that the Beatles were sweeping the airwaves around the world. Both groups worked with producer George Martin and recorded at Abbey Road Studio in London.[80] Back at home in Barbados, the Merrymen played at sold-out venues and young children debated who was better, the Merrymen or the Beatles.

The Merrymen reached success when other Barbadian calypsonians struggled greatly to gain even a precarious foothold within the "established" (or well-funded) music arena. Ironically, this white group was able to do this in a time of international black nationalism and decolonization. In his history of Barbadian calypso, Trevor G. Marshall explains, "The key to the success of the Merrymen as opposed to the frustrating experiences of the generality of Black calypsonians lies largely in the difference in social status and membership of a 'shade' grouping. In Barbadian society, in which European colonisation and religion had successfully instilled the notion of the superiority of the white cultural force, this factor alone would have gone a long way in assuring their acceptance by the public, and, therefore, the frequent well-paid engagements which they attracted in the period 1965–1985."[81] The Merrymen performed Caribbean folk music, much of which had previously been associated with the black working class, but it was their white skin that allowed them to bring legitimacy to those same cultural forms. Best notes that the Merrymen's whiteness allowed them access that their Afro-Barbadian colleagues did not enjoy, but their reception was both celebrated and rife with accusations of exploiting Afro-Barbadian cultural spaces and not living up to white

middle-class respectability.[82] While a number of other forms of music competed on the island, the Merrymen continued to play calypso and folk. Marshall describes the band as the most well known and dedicated; when many others turned to funk, reggae, and spouge, the Merrymen were busy "saving" Barbadian calypso from "extinction."[83] Taking into account the context of the moment of their success, the Merrymen's performance of Barbadian folk culture in a time of independence is also a performance of allegiance to the nation of Barbados and the Caribbean region rather than to a colonizer. This performance is reliant on "national sincerity."

In the 1960s and 1970s, Barbadians were still in the process of defining an independent national identity. When keeping in mind Stuart Hall's notion that cultural identity is a production, one that is always in process and constituted through representation,[84] one can see how the national identity of an independent Barbados would be shaped in no small part by those cultural representatives who repeatedly performed Barbadian culture on and off the island. The histories of the many populations on the island, their migrations to and away, and their varied daily experiences were the materials with which to build and rebuild this identity; they served as the muse for an ever-in-process performative script of nationhood. Homi Bhabha says, "The scraps, patches and rags of daily life must be repeatedly turned into the signs of a coherent national culture, while the very act of the narrative performance interpellates a growing circle of national subjects. In the production of the nation as narration there is a split between the continuist, accumulative temporality of the pedagogical, and the repetitious, recursive strategy of the performative. It is through this process of splitting that the conceptual ambivalence of modern society becomes the site of *writing the nation*."[85] National identity, then, is a performative that is also continually being taught and being rewritten by those who are interpellated as Barbadian. Like the scraps of English military melodies, West African rhythms, and Caribbean experience that come together in the consistent yet improvisatory sounds of tuk music, Barbadian national identity is consistently being made by those with the performative authority to write the nation. The imaginary that defines the Barbadian community is the Relation between these varied experiences on the island and with the larger world. Such a Relation cannot be easily authenticated because it is constantly in flux. But it can be sincerely and repeatedly performed. Like tuk music, the Merrymen's performance of Barbadian calypso and folk music relies on a multiplicity of racialized, classed, and gendered experiences and defines that multiplicity as Barbadian through the lens of the Merrymen's specific Barbadian experience. Because of the performativity of identity, their repeated performances of Barbadian culture serve to define, in part, what Barbadian culture is.

The fact that the Merrymen worked within folk culture is one proof of the sincerity of their performance as Barbadians. They believed themselves to be Barbadians, to be folk singers, and to be capable of representing Barbadian culture, and

they performed in a way that conveyed this belief to their audiences at home and abroad.[86] Simultaneously, the Merrymen's racial privilege allowed them to perform Barbadian cultural forms in larger arenas than either the independent myth of a black nation or the colonial myth of Little England would allow. They successfully moved beyond the mythic ideals to create a reality through performance. Serving both the hegemonic and colonial ideology that whiteness is better and a nationalistic ideology that privileged folk culture, the Merrymen's social and racial status allowed them to perform their national sincerity on the island and spread its seeds across continents without engaging in authenticity tests of black nationalism, British colonialism, or "Little Englandness." For over a decade after their initial appearance on stage, the Merrymen were the most well-known Barbadian calypsonians.

Gabby's experience of migration politicized him. He left the island with dreams of material wealth. Working within the garment district in New York, he was exposed to unions in a way that he had not been in Barbados.[87] He met with other Barbadians from different class backgrounds and eventually joined the Barbados Theater Workshop in New York. He read James Baldwin and *The Autobiography of Malcolm X* and studied Marcus Garvey and Harry Belafonte, countering his British colonial education, which had told him "that we had no history—that our history was just the slave thing and that it wasn't worth knowing."[88] He returned to Barbados with a vastly different outlook, one that was still very much Barbadian but was immersed in a wider world. The idea of a rooted identity is clear in Gabby's famous calypso "Jack," in which he asserts his Barbadian identity in the lyric, "My navel string is buried here,"[89] but his Barbadian identity was formed through his experiences on *and* off the island. His understanding of himself as Barbadian was a Relational identity built on migration and return, on his relationship to diasporic subjects and his national relationships. He came home with the intention of returning to New York and playing Madison Square Garden, enacting "an expectation and a pattern of return, albeit one . . . of coming and going."[90] When he returned to Barbados, that dream changed. His vision of life was no longer focused on material gain. He said, "Now I think about doing what I can for the Caribbean, not just for myself."[91] This is the same ethos that characterizes tuk. The movement of the sea, the coming and going, that tuk emulates serves a collective performance and a collective identity with cultural and economic effects. For Gabby, the experience of migration and return helped to foster a sense of collectivity and community inherent within the expression of a national and regional identity. He expresses this attitude most poignantly in his music.

Gabby returned to Barbados in 1976, only ten years into independence, and two years after the official revival of Crop Over. By the 1980s, Barbadian calypsonians had entered into the wider calypso arena throughout the Caribbean and the West Indian diaspora with Gabby at the forefront. He had a strong personality, and this, coupled with his musical talent, allowed him to easily say, "You were

either my fan or not, but never again would you ignore me."[92] His most famous works are deeply rooted in Barbadian contexts but are strongly influenced by his time abroad. With social satires and political commentaries such as "Jack" (1982), "Hit It" (1983), and "Boots" (1984), Gabby was leading the pack.[93] He says, "A lot of what I sing comes out of my experience of having lived in the States. . . . My aim is to paint a picture of my experience, of the West Indian experience. I want people to understand why they are the way they are."[94] Instead of looking for money, he became more passionate about his craft and how it could be put in the service of his national culture. He explains, "I have always felt that the music was first. And if you do it right, then everything else should and would fall into place."[95] And things did fall into place. Making his mark on the calypso stage, Gabby did eventually play Madison Square Garden in 1982.[96] His success in promoting local culture and changing Barbadian social traditions was largely informed by and fueled by his migration experience. Singing of the West Indies, of Barbados, and of his own neighborhood of Emmerton, Gabby asserts himself strongly as a Barbadian who is part of a larger world network but born of the soil of the island.

Gabby connects calypso to wider traditions of philosophical thought, oral and literary traditions, and historical narrative. In approaching his music, he wants his audience to understand the origins of the tradition and the possibilities for its future. He says, "So, you see, you gotta understand that when you're dealing with calypso, for me, I deal with it in the widest sense of how it behaves, or how it should behave, or what it says, and what it means. And that's why I tell people, well this competition, this winning and losing, it looks so minute to me, that, that, it's like an ant that I can just crush in my han' like dat. That is not important. What is important is knowing what it is, what it stands for, where it comes from, where it is, where it's going, [and] where it can go in a global setting."[97] Gabby understands calypso as part of a Pan-Africanist tradition that is in conversation with the greatest artists and philosophers from across the globe, whose work transcends any one historical time period. The global possibilities he sees are often founded within, although hardly limited to, regional and diasporic connections. And for him, the role of an artist, the role of a cultural worker, the role of any Barbadian privileged enough to have an audience, is to represent the nation. In 2009 he declared, "I always feel that I am representing my nation. . . . I'm going to Costa Rica on Tuesday. . . . I feel I'm breaking new ground for Barbados. Barbados is not known to much of the Latin countries or calypso, and if they know calypso at all the one they know is Trinidad. They're bringing a band from Panama to play for me. Costa Rica. I feel honored. And on the several occasions I went to Cuba I always knew I was representing Barbados, because the Cubans didn't know too much about the Barbados artists."[98] Beyond the impressive list of titles he has collected, he sees the chance to represent the nation of Barbados using the music he loves as one of his greatest privileges. And in doing so he is able to bring together various nationalities and musical traditions that can relate to one another musically, historically, and diasporically.

Gabby claims to be the most banned Barbadian calypsonian in history.[99] His wit and attention to sociopolitical concerns have struck some politicians as too strong at times, but they have also come to define his career and are central to his understanding of the role of a calypsonian within Barbadian society. Gabby's music has led to libel suits, including one filed by Barbadian prime minister Tom Adams. In relating his run-in with the prime minister over the song "Cadavers" (1984), Gabby explains the role of the calypsonian in Barbadian society at length:

What the role? In here!? Crucial! . . . Calypsonians CAN bring down governments. Calypsonians CAN put governments in power. . . . Let me put it this way: There isn't a politician in the world that can make a speech in five minutes that will have the impact of a five-minute calypso. . . . I remember distinctly in the early days when I was sued for "Cadavers," Eddy Grant and me. I can see the morning like now. The man came about 6:15 and knock on my door. I was living in Collymore Rock at the time. I open. "Are you Anthony Nicholas George Carter?" "Yes." "You are hereby served [this writ from Prime Minister Adams]" So I started to laugh. The man said, "This is no laughing matter." But I say, "For me it is." And he said, "What do you mean?" I said, "This fluffing that you brought here isn't worth the paper it is written on." And now he's like cafuffled. He was bemused. He was like bamboozled. He was like, "How dare you," you know, "tell me that my prime minister is sending a" some habeas corpus something or other a lot of fancy colorful language. I said, "But you don't understand. It may seem arrogant to you, but I equate myself with Bill." "Bill? Who the hell is Bill?" I said, "Some of us call him William Shakespeare. For me, his name is Bill. You understand? And when Bill was alive, you had kings, queens, princes, princesses, duchesses, dukes, lords, countesses, and counts. You had all the so-called gentry. And they all felt superior to him, and they treated him as such. But the day came when they died, and so did he. And the day is coming when Tom Adams will die, and so will me. But, my friend, no part of the world including Barbados will anybody play his speeches like they play my songs. He will never live long enough to be as important to this country as me. And I'm not being arrogant, I'm being truthful. . . . If Tom Adams makes a speech today he has two chances. One, it could make headline, or it could make headline and front page. Today. By tomorrow evening Miss Bess will be wrapping fish with it in de market. It cannot be that important. But my songs will play all the time once they are recorded. Which one of us you think will go down in history as being more important?"[100]

Gabby defines the role of a calypsonian as that of an agent of social change, a teacher, a chronicler, and a historian. He understands the power of well-crafted music within current sociopolitical debates and within social, political, and cul-

tural history.[101] Gabby subscribes to the kind of Pan-Africanism that privileges "the people" over appointed authority figures and uses the cultural arena to hold authorities accountable to the larger population. The song "Cadavers" criticizes Prime Minister Adams's decision to allow the importation of dead bodies from the United States (purportedly for medical research). Gabby manages to critique the state of the medical industry; question the judgment of the prime minister, who sought to bring foreign exchange with the decision; and, with the only lyric repeated in the chorus, comment on the sovereignty of the nation. The repetition of the line "them importing Dracula" uses metaphor to suggest that the prime minister's decisions to import U.S. commodities and cater to foreign interests above those of Barbadians are sucking the life out of the independent nation. The fact that Adams found offense even in such a craftily veiled critique and sued for libel only helped to boost Gabby's popularity and his audience's interest in the song. Gabby's response to the suit demonstrates that even postindependence, the "official" authority of the prime minister, in Gabby's opinion, is no match for the national sincerity of a Barbadian artist.

Gabby's social work is rooted in his role as an entertainer. George Gmelch explains how "migrants often return home with lofty ideas about changes that they would like to see made in Barbados, but few are in a position to be innovators. Most of them simply lack the position or authority to put their ideas into practice, and some become discouraged by the resistance of local people to change."[102] Gabby's desire to travel and his ability to negotiate local resistance to change upon his return were both tied to his profession as a musician. Tales of the United States reached him in the conversations he had while performing on cruise ships in Barbados. He honed his craft in New York with other Barbadians. His experiences abroad gave him the tools to proclaim his West Indianness and Barbadian pride back home. Migration provided the space for him to define and perform a local identity using the influences of the larger world. Travel provided the space for his national performance. Much like tuk, each site provided a sounding board, and what echoed back was something distinctly Barbadian.

Both the Merrymen and Gabby are celebrated fixtures within Barbadian music. Each has represented Barbadian culture through calypso, folk music, and other genres. And for each, the status of national culture representative has been built on and expressed through travel, migration, and return. Each has taken the varied experiences on the island and within Barbadians' relations to the rest of the world and turned them into something named Barbadian culture. Like tuk, their music has "roots" in several spaces and traditions outside the island, but they have reworked those influences through the Relation of racialized and classed identities on the island into something that is representative of a national culture, a culture built on the relationships that could only form between the unique mix of influences and experiences that characterize Barbadian history.

THE REBIRTH OF CROP OVER

One of the most pivotal events in the history of promoting Barbadian culture was the 1974 government-sponsored revival of Crop Over.[103] In the late 1960s the turn toward tourism as a path to economic growth and independence provided a means for Crop Over to return, bringing an audience that would include tourists from other nations, Barbadian nationals living abroad, and Barbadians on the island. The festival's revival was meant to both fuel the Barbadian economy by boosting tourism in the summer season and promote national pride in Barbados's cultural heritage. The underground folk practices of old would be put on full display, and those hidden transcripts would become the cultural and economic representations of the nation.[104]

The timing of the contemporary Crop Over is based on that of the older celebration, but in practice, its structure resembles the Trinidad Carnival that many tourists are already familiar with.[105] The festival is designed to both promote the island to tourists and celebrate, revive, and reclaim an idyllic Barbadian heritage, yet many of the earlier characters that had begun to disappear are now being revived in the twenty-first century with less ceremony than their previous incarnations received. The contemporary Crop Over has been an extremely important venue for Barbadian talent. It incorporates all areas of the arts, although music is most distinctly at the forefront. The festival features several music performances and competitions, including Pic-o-de-Crop, a calypso competition known for its social commentary; Soca Royale, a two-part competition for the best and sweetest party songs of the season; Road Monarch, awarded to the singer of the most played song on the road during the road march called Kadooment; and Cohobblopot, a concert featuring various Barbadian artists and usually an invited guest from another island.[106] Many of Barbados's most well-known artists began their performance careers in the contemporary Crop Over tradition, and with junior competitions for youths, the festival continues to nurture local talent.[107]

The revival of Crop Over married two important endeavors: defining, reclaiming, and celebrating a recognizably national culture and promoting the island on the regional and international tourist markets. With music at the forefront of the celebration, such a government-sponsored initiative displays what Thomas Turino terms "musical nationalism," "the conscious use of any preexisting or newly created music in the service of a political nationalist movement, be it in the initial nation-building stage, during the militant moment of maneuver, or during and after the moment of arrival to build and buttress the relationship between the general population and the state."[108] Crop Over's official resurgence certainly presents such a "conscious use of preexisting [and] newly created music." Tuk has been kept alive, largely through the efforts of Wayne "Poonka" Willock, and incorporated into the festival as an indigenous Barbadian practice. Best laments, however, that "since the advent of Barbados' Crop Over Festival as a government spon-

sored celebration in the mid-1970s, there has been a growing acceptance of the tuk band by the establishment. But there has not been an understanding of its socio-historical and cultural purpose as an indigenous entity."[109] In this way, Crop Over has fueled a conversation about Barbadian cultural practices, but its link to commercial tourism and political uses sometimes overshadows the historical and cultural value of those same practices.

The links between political, cultural, and economic purposes expose the collaborations and fissures between a national Barbadian identity and a wider West Indian or regional identity. Louis Regis writes that "it was fitting that the calypsonian be the herald of independence [in Trinidad] because he had long championed the national forces and movements agitating for self-rule and statehood. Over the following 25 years, and beyond, he continued commenting on happenings in the political domain, communicating his views about politics, politicians and power sharing."[110] Regis genders calypsonians as male in his comments, supporting the narrative of "men of speech" and the common understanding that their voices purportedly speak for the majority of a population. While Barbadian calypsonians have certainly played a similar role, that of "the people's newspaper," an outlet for the working class to speak back to state and economic power, they were not nearly as popular at home or abroad at the time of independence in Barbados. The switch in festival structure from Barbados's earlier, decentralized Crop Over to a more internationally familiar Trinidadian style has raised questions around how best to promote Barbadian culture on national and international stages. Mike Alleyne notes that "a central concern of most small cultures is the assimilation and utilization of foreign influences without distorting the content and representation of the local."[111] In 1983 an act of Parliament created the National Cultural Foundation (NCF), which was tasked with playing a "developmental and commercial" role in "oversee[ing] the cultural landscape of Barbados."[112] The NCF produces both the Crop Over Festival and the National Independence Festival of Creative Arts. The nation-state has made efforts to promote the specific histories of the island throughout Crop Over, but the musical focus and the tensions concerning funding and promotions have continued conversations on how best to reach the widest audiences while still being "true" to an "authentic" Barbadian culture within a tourist market.

In the late 1980s the Barbadian nation-state shifted once again between its two main political parties, the Barbados Labour Party and the Democratic Labour Party. Errol Barrow had led the nation as the first prime minister from 1966 to 1976, but Tom Adams had assumed the position for the next ten years. In 1986, twelve years after the official Crop Over revival, Barrow was running for the position of prime minister again, and he sought to galvanize his constituents by painting an image of Barbados that they could see themselves in. In his "Mirror Image" speech, he began by asking the audience how they saw themselves. He was quite direct in asking, "Do you really like yourselves?"[113] This was how he set up his argument

that the government of Barbados must reflect the people, and thus that the people must require their government to act in accordance with how they imagine their nation. Doing so requires them to conceptualize a national identity and to hold the state accountable for protecting it. In criticizing his political opponents, he also leveled accusations at the audience, saying, "If there are corrupt ministers in Barbados tonight, you have made them corrupt."[114] He criticized the population's wish to emigrate and announced his own national pride and commitment. He said that each time he traveled, he returned because he "believe[d] that [he was] as much Barbadian as they [his political opponents] are."[115] He came back to Barbados because he wanted to shape it. He offered his party's vision for the nation-state, saying, "The Democratic Labour Party has an image that the people of Barbados would be able to run their own affairs, to pay for the cost of running their own country, to have an education system which is as good as what can be obtained in any industrialised country, anywhere in the world,"[116] before exposing the nation-state's business. He talked of political bribes, who allowed guns and drugs onto the island, and who was known for forging signatures, being quite specific without naming any names. He critiqued the labor conditions for the women in the sugarcane fields and the men on the docks, asking his audience why they would allow such things. He compared Barbados with Singapore, laying out the small difference in land mass and the drastic difference in population size, offering up this other island nation's situation as a contrast to the current circumstances of Barbados in anticipation of the coming election. He said, "They have a mirror image of themselves. They have self-respect."[117] He lambasted the current labor, political, and ideological conditions in Barbados, providing a vision for something else, urging the people to want something better, and presenting his Democratic Labour Party as heralding a more favorable image of the nation-state. And he ended his speech in classic Barbadian idiom with, "Anyhow, ladies and gentlemen, I done."[118] In this speech Barrow performed a national sincerity that did not rely on any quantifiable, testable notion of authenticity. He was a Barbadian because he envisioned himself as one and acted accordingly, and he asked his audience to imagine the nation in the same way he did. After presenting a self-reliant, capable, and proud imaginary for the people of Barbados to get behind, Barrow was voted back into the office of prime minister, and the Democratic Labour Party won twenty-four out of twenty-seven seats in the House of Assembly.[119]

Barrow's famous "Mirror Image" speech in 1986 built on earlier stereotypes and understandings of what it meant to be Barbadian. It set out a framework for national identity that would come to be known as the "Barbadian personality," a term used by the NCF in the late 1980s and one that Prime Minister Owen Arthur later took up in the late 1990s. Richard L. W. Clarke argues that politicians, popular musicians, and literary artists articulate the Barbadian personality through the metaphorical language of Caribbean unity, pride in both a "roots culture" and modern sophistication, and a reclamation of African heritage and connection to

the broader African diaspora.[120] These ideas are widely disseminated through cultural forms, social interactions, and political rhetoric, so much so that "Barbadians 'intuitively' know what an Arthur or a Barrow is speaking about, not because the discourse of nationalism has merely held up a mirror to Barbadians in which they can find their reflection but because Barbadians have been encouraged to reflect the images found in the discourse of nationalism and from which they have derived their sense of identity."[121] In this way, the Barbadian personality is a performative ideal. Those from the most rural areas of the northernmost parish of Saint Lucy to the most urban of southern Saint Michael, men and women, the upper class and the working class, of every race and color, are encouraged to strive toward an ideal identity: proud Barbadian. Barrow used his mirror-image metaphor to spur his constituents in a direction rather than a destination. And he did so by assuming that there was some form of consensus about what it meant to be Barbadian, a consensus that the nation-state in 1986 had strayed from. His critiques of the nation call attention to how it has strayed from the path leading to this constructed ideal. The ideal of the Barbadian personality, then, is an assumption whose open-endedness allows it to constantly be redefined by those who perform it. Thus, in representing the national ideal, one is also creating it.[122]

Although the realities of Barbadians make it hard to pin down a concrete definition of Barbadian identity, an amorphous ideal of what it means to be a Barbadian still carries weight. It is solid enough for Jamaican prime minister Michael Manley to assert that the fact that his friend "Errol Barrow was a deep, passionate and unwavering Barbadian is impatient of debate. He was unapologetically Barbadian as any person one could ever hope to meet."[123] Manley leaves any details of what it might mean to be "unapologetically Barbadian" open for interpretation, or, more accurately, open to assumption. In a young nation-state where everyone supposedly knows what is *not* Barbadian and thus articulating what *is* Barbadian becomes unnecessary, where every Barbadian instinctively knows what is meant by "Barbadian personality,"[124] so much so that the structures for authenticating Barbadianness are virtually nonexistent, the performance of a sincere national identity is about as close as one can come to "authenticating" a Barbadian personality.

Performing the Barbadian personality requires sincerity, then, because the "real" and "authentic" are too unstable to prove and are built on an idealized past that may or may not have ever existed. Jean Baudrillard writes, "When the real is no longer what it was, nostalgia assumes its full meaning."[125] The promotion of an idealized past allows one to look at high unemployment rates and forget that unemployment and underemployment have long been a part of Barbadian reality. It allows critics to lament an indiscriminate embrace of Jamaican dub culture, Trinidadian sponsorship, and U.S. and U.K. hip-hop and pop music while forgetting the historical influence of Trinidadian calypso, roots reggae, and U.S. soul. And it allowed Barrow to idealize his earlier achievements as prime minister by

packaging them as a hyperreal past when Barbadians had something to be proud of. This political strategy allowed Barbadians to vote for the good old days and the better days to come by returning Barrow to office. The hyperreal reflects, creates, and promotes an "authentic" Barbadian context, one that may or may not have ever existed. Baudrillard explains, "Whence the characteristic hysteria of our times: that of the production and reproduction of the real. The other production, that of values and commodities, that of the belle epoque of political economy, has for a long time had no specific meaning. What every society looks for in continuing to reproduce, and to overproduce, is to restore the real that escapes it. That is why *today this 'material' production is that of the hyperreal itself.*"[126] For the Caribbean region in particular, such invention and material production have a long history. Krista Thompson shows how "colonial representations were frequently not just reflective of colonial views but became constitutive and iconic parts of the colonies' landscape."[127] Since the seventeenth century, the material reality of the Caribbean has been invented for a raced and classed elite to enjoy, while the larger populations have worked to both find and maintain an elusive ideal of paradise. Thompson goes on to show how marketing the Caribbean as a premodern paradise established modern tourism as a development scheme, creating a delicate balance between modern amenities for some and the preservation of the picturesque that relied on, policed, and excluded most others.[128] The ideals of material consumption and the Caribbean imaginary that they are based on both search for "the real that escapes" them.[129]

In the 1950s the promotion of an "authentic" paradise had been codified into Barbados's growing tourist industry. Tourism in Barbados dates back to the eighteenth century, but "it was not until the introduction of the Hotel Aids Act in 1956 and the establishment of the Barbados Tourism Authority . . . in 1958 that tourism in Barbados was formalized."[130] While early tourism would characterize Barbados as a leisure destination for the wealthy,[131] the tourist population diversified, and by 1969 tourism had eclipsed agriculture in the Barbadian economy.[132] In the next three decades, the Barbadian state worked to distinguish Barbados as unique while exploiting the already existing images of "islands" in the regional and international tourist market. This is the same time period during which a national culture was burgeoning into an economic industry. Culture—whether it be organized festivals or traditional practices—would become a key selling point in developing "brand Barbados" for the tourism markets. Hilary Beckles describes "the emergence of 'brand Barbados' [as] an attempt to globalize national identity around images of corporate integrity, diplomatic sophistication, financial flexibility and other such assets befitting a centre of Western capitalism."[133] This brand, coupled with a national culture, provides a modernist image of Barbados that is rooted in premodern stereotypes. Like the Barbadian personality, it collapses tangible materialities and intangible ideologies to present an assumed definition of Barbados, one that is attractive and salable on the tourist market.

The tourism industry and the nation-state's economic reliance on it, then, produce, reproduce, and represent paradise. In her analysis of Caribbean tourism and resistance to the tropes and stereotypes of "paradise" imagery, Angelique V. Nixon notes that in the region, "Caribbean people and bodies are being commodified in the production of cultural performance and local/tourist interactions, where the racialized and sexualized other is desired for both culture and sex. These relationships and exchanges are complicated because such representations can be taken as 'authentic' or 'real' Caribbean exotic experience, and then can directly alter and shape contemporary and evolving Caribbean identities."[134] Tourist representations of the Caribbean as a paradise, then, are hyperreal. With tourism as a crucial part of the Barbadian economy, the "paradise" image must be turned into a reality, producing an "authentic" experience. Barbadian culture and the bodies of Barbadians become consumable through tourist advertisements. The material realities and experiences of Barbadians, then, are implicated within and affected by the tourism promotions. By the twenty-first century, the official promotional tagline for Barbadian tourism was "Experience the Authentic Caribbean."[135] Crop Over serves as an "authentic" cultural experience that is specific to Barbados while fitting larger tourist imaginaries of the Caribbean. Its marketing, directed at tourists and Barbadians alike, collapses the distance between foreigner and local, allowing each to create, participate, and consume Barbadian culture.

The contemporary Crop Over tradition uses a piece of Barbadian cultural history and transforms it using Trinidadian influences in order to market the island to foreigners and nationals and nurture local talent. A 1988 Barbadian editorial promotes Crop Over as "steeped in history and tradition with a distinctive character all its own. It is a cultural expression of the Barbadian personality, combining his experiences of yesterday with his achievements of today and his aspirations for tomorrow."[136] The writer clearly imagines the Barbadian personality as male while lamenting the lack of Barbadian participation in the Crop Over Festival, noting that too many Barbadians are watching on the sidelines instead of joining this "expression of the Barbadian personality." Through the 1974 revival of Crop Over, the Barbadian state posited an ideal national culture that was celebratory, talented, rooted in history but defined by innovation, and reflecting a formal education that can be expressed with acumen through local traditions; but the fissure between the ideal and the reality of Barbadian life is evident in the fact that many Barbadians still see themselves as a part of *and* apart from the cultural expressions that are meant to represent the nation.[137]

In the decades since the official revival of Crop Over, the festival has become an extremely important economic asset, but it has not yet managed to encompass, delineate, or promote any singular Barbadian culture. Or perhaps the Barbadian culture it promotes is just as varied and diverse as it was in the moment of independence. The Barbadian personality that Crop Over is meant to express is still an assumed ideal that is difficult to concretely define or authenticate. This is partly

a result of the dual objectives of Crop Over (and the Barbadian culture industry as a whole): to promote tourism and celebrate heritage. The contemporary Crop Over Festival has the backing of the Barbadian government, but as scholar Curwen Best notes, "the commercialization of Crop Over has gone on. By the late 1990s it seems as though planners of the festival have not managed to marry the cultural, historical significance of the festival with its economic potential."[138] By 1997 the government had challenged the NCF to raise its own funds for the Crop Over Festival.[139] As a result, in the late twentieth and early twenty-first centuries, the marriage between culture and economics has happened through the NCF's and private alcohol and telecommunications companies' co-sponsorship of "national" events. Touted as the "birthplace of rum,"[140] alcohol has a prominent place within Barbadian culture and consequently within the lyrical content of West Indian music. Sponsorship from alcohol companies provides much-needed capital to the festival and the libations to encourage the spirit of "letting go" that is a central part of the festival atmosphere. In this way, the sponsorship has married economic and cultural goals, but the image of drunken crowds of people may not be the image a young nation with a reputation of labor activism, pride, and respectability would like to promote on the tourist market. Such images can bring up older, classed arguments of respectability and coloniality that tuk and other indigenous forms were subject to.

The cultural and economic needs of the island are still at odds with the ideological entanglements of Barbados's main cultural influences. The heavy colonial influence of Protestant England and the retention and reclamation of African heritage are constantly contending for primacy within official representations of Barbadian culture that seek to focus on something that is distinctly Caribbean and uniquely Barbadian. In his book *Roots to Popular Culture*, Best explains how the cultural revolution (marked by an embrace and support of Barbadian culture, the founding of the NCF, and the success of Barbadian artists at home and abroad) that happened in Barbados in the 1980s and 1990s, continues to reflect the conflict between these two cultural influences, and how the embrace of cultural nationalism has required the nation to rethink which model (if either) will have primacy within the ideal of an independent Barbadian culture.[141] African-influenced practices are promoted during the Crop Over Festival, but not without critique. The festival walks a fine line between these two cultural influences, promoting an African aesthetic while taking care to at least monitor indications of "excess," lest it get out of control.[142] The Spiritual Baptists, who made waves in Barbadian society in the late 1950s with their assertion of black divinity, have become a staple of the opening ceremonies of Crop Over.[143] This gives the festival a religious blessing entrenched in a reclaimed African heritage. The festival atmosphere of "letting go," in which participants are encouraged to freely move their bodies, is associated with an African heritage.[144] Crop Over is an arena in which the prim and proper take a back seat, but that Protestant influence does

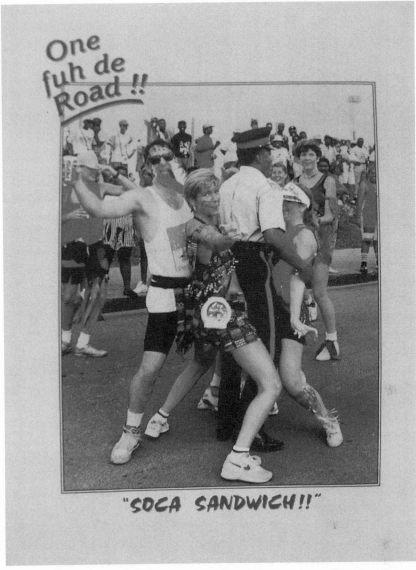

FIGURE 5. Kadooment revelers. The last page of *Crop Over 1993*. © David Brown and Bentley Williams.

not entirely disappear, and these two cultural influences of the island interact, often in bewildering ways, within this particular Caribbean expression.

Such an interaction is evident in figure 5, which is the final page to a souvenir magazine, *Crop Over 1993*. Magazines such as these are produced each year after the festival and feature photos and stories of each of the nationally sponsored

events. They are widely available for sale and can be purchased in most gas stations with the daily paper. In this photo, a few white revelers embrace the Crop Over tradition of "letting go" by encircling a member of Barbados's Royal Police Force as black Barbadians look on. The Crop Over Festival was revived, in part, to promote tourism, so this sight might appeal to white tourists and be interpreted as a successful effort. Wearing the remnants of Kadooment costumes and all smiles, these revelers seem to have fully embraced the Crop Over spirit. The photo does not show a mass of Barbadians expressing the celebratory Barbadian personality of Crop Over advertisements but rather a few people embracing, enacting, and/or imitating the spirit of the festival.

The presence of black Barbadians is important to the efficacy of the image. The Barbadian police officer, rigid and faceless with his hand holding one of the revelers close to him, represents the Protestant influence of Barbados's history, complete with the kind of stoicism that would rival that of a nineteenth-century English gentleman. His presence signifies authority, but he does not actively enact that authority in the captured moment. In the photo, his body is available for the pleasure of the revelers, and the authority of his position makes him even more attractive. Barbados becomes a safe place for fun, one in which even the police embrace a spirit of abandon while still vigilantly maintaining the posture of authority and order.[145] The black onlookers smile and dance on the sidelines. While throughout the rest of the pamphlet revelers of varying races and skin tones are prominently featured dancing and performing, the final photograph offered in the pamphlet features a "soca sandwich," which is encased in whiteness. That whiteness is embracing what is seen as an "African trait" of Barbadian culture, while the black Barbadians in this final image passively observe a figure of national authority enacting stoicism. Like tuk, this photograph represents the mélange of cultural influences that constitute performances of Barbadian culture.

Interactions such as this one represent the ongoing contradictions of the Crop Over Festival. The *Crop Over 1993* magazine features "over 100 full colour photographs" by skilled photographers David Brown and Bentley Williams. Their photography is the focus of the souvenir, allowing participants and spectators to carry tangible snapshots of the Kadooment experience with them after the day is done. The last of their featured photos presents the complexity of that experience, but the final images of the magazine are two advertisements, one for Cockspur Old Gold Rum and the other for Banks Beer. Each advertisement relies on a sunset theme, with the first featuring an old sugar mill and the second featuring a dark-skinned woman in a bikini. The specifically Barbadian experience captured in the Kadooment photographs ends with somewhat generic advertisements of Barbadian products that rely on images of the island's major industries, sugar, alcohol, and allusions to the stereotypical "sun, sex, and sea" of tourism. The economic objective of the contemporary form of the Crop Over Festival necessitates private investment and relies on the foreign income of tourists and returning

nationals. Without the financial backing of alcohol and communications companies, the festival would hardly be possible. Culturally, the tug-of-war between European and African influences is highlighted even within an expression indigenous to Caribbean culture. Yet the representations of the festival tie Barbadian culture to historical myths of the Caribbean as consumable, exotic, and leisurely— myths that, in promoting its tourist brand, the Barbadian government both exploits and tries to move beyond. The fact that such contradictions can be illustrated in a single photo followed by the requisite advertisements, and that that photo is used to promote the festival, speaks to the cultural ambiguity surrounding the ideal of the Barbadian personality.

The 1990s married cultural and economic concerns with new arenas. In 1991 the Barbadian state entered into an International Monetary Fund austerity program. The neoliberal practices of this program moved the state's cultural policies more firmly toward considering culture as an industry.[146] The 1990s also saw a cultural explosion that coincided with the rise of internet technology, forever changing what Caribbean culture could be.[147] The power of creative technologies allowed them to serve as an important site of representation. This is not to say that the historical traditions entirely disappeared. Those that had previously defined Barbadian culture became subsumed by their own hyperreal representations, which traveled easily across web pages, in chat rooms, and in blogs. In the twenty-first century, many of the gendered and classed discourses of the past reappear in these new spaces of cultural expression and representation. In the decades after independence, women's bodies became a symbol for the nation both on- and offline. In 2006 Susan Harewood noted that "up until quite recently visitors to the official [web]site of the Barbados Tourism Authority were invited to click on a picture of a woman's behind—and only her behind—dressed in her Crop Over costume to set it in wukking up motion."[148] Many of the "official" representations of Barbadian personality rely on a male voice, a female image, and a complicated web of class politics with varying definitions of respectability and pride. As men came to voice a Barbadian personality, women's bodies became a national resource as the nation continued to craft a tourist image for itself. The digital era has, to some degree, allowed for a democratization of national representation, allowing for both official and ordinary expressions of Barbadian culture to reach broad audiences. The constant barrage of representations geared toward foreigners and Barbadians alike become the standard for what is "really" Barbadian. In this way, images are "substituting the signs of the real for the real," creating what is essentially a new kind of myth.[149]

A "real" Barbados is constantly produced, policed, and redefined through the performance of national sincerity. All of the nation's cultural influences and sociopolitical contradictions are subsumed under, challenged by, and contained within an ambiguous ideal identity: the Barbadian personality. The cultural ambiguity evident in the contemporary Crop Over celebration is a part of the historical

heritage of Barbados. Pre- or postindependence, it is a fundamental element of Barbadian national identity. This ambiguity is illuminated most strikingly in the cultural arena, and in an independent Barbados, culture has become the leading arena in redefining Barbadian identity. The history of the island and the ideals of the present and future continue to contradict each other, and "at the beginning of the new millennium, the nation still strives to come to terms with its own contradictions. It is now faced with even more complexities related to its past, and to its present condition within a new global context."[150] Issues of migration, ownership, and national ideals are present in the production and policing of the island's popular culture forms, most notably its music. This history exists in the echoes of tuk, a recognizable piece of Barbadian heritage, and has continued within the music targeted at Barbadians, but also in the tourism industry, where the commodification of Barbadian culture raises questions of ownership and often erases histories of Caribbean innovation even within celebrations of heritage.

3 · CARIBBEAN QUEEN

Afro-Barbadian Femininity and Alison Hinds Performing the Erotic at Home and Abroad

On November 11, 2011, the popular U.S. morning show *Today* ended its "Where in the World Is Matt Lauer" week on the southern beaches of Barbados. Along with features on Barbadian cuisine and local sites of interests, as well as a bartending lesson, the show called on Soca Queen Alison Hinds to represent traditional Barbadian culture. Accompanied by stilt walkers and dancers in Kadooment costumes, Hinds explains the standards of good soca music—"good music, good hook lines, a very good party song, it makes people happy"—before giving a lesson about Barbados's Crop Over Festival.[1] The camera pans over a gauntlet of costumed Barbadians as Hinds details how shaggy bears represent the spirits of Barbadian ancestors and Mother Sally symbolizes fertility. The segment ends with Matt Lauer calling on Hinds to display what she is perhaps best known for, her movement. Hinds gives the *Today* show anchors a wukking-up lesson. As the "Soca Queen," Hinds has staked her career on such performances of Barbadian culture and her ability to translate it to those abroad. Many of her songs package this skill in a form that seeks to display, empower, celebrate, and create a distinct but malleable Barbadian femininity that speaks to women across the world.

This chapter examines the public performances and transgressions of Afro-Barbadian femininity across time, space, and genre. Beginning with a brief historical look at the ways in which Afro-Barbadian women have continually transgressed their prescribed roles in society, the chapter then analyzes key performances in Hinds's career, ending with an interrogation of how embodiments of Afro-Barbadian femininity are depicted in popular culture representations that circulate in expanding markets. Tracing public discourses of "appropriate" Barbadian femininity from the 1700s to the 2010s, the chapter shows how such discourses have been taken up by iconic figures, real and fictional, including hoteliers, protagonists of popular novels, and musical performers.

Throughout the island's history, Afro-Barbadian women have straddled the mores of a colonially defined respectability, various African retentions, regional cultural practices, and the material realities of living in an economically bounded colonial society. Even after independence, Afro-Barbadian women have still had to juggle these differing definitions of "appropriate" femininity. Public performances of femininity have always been strictly policed by Barbadian society, and women's public images have always been a contested arena in the Caribbean.[2] This chapter draws on Audre Lorde's definition of the erotic in order to explain the many ways in which Afro-Barbadian women have negotiated their own performances of femininity and navigated those performances within the patriarchal structures of colonialism and nationalism. Lorde defines "the erotic [as] a resource within each of us that lies in a deeply female and spiritual plane, firmly rooted in the power of our unexpressed or unrecognized feeling."[3] For Afro-Barbadian women, the erotic is both an individual and a diasporic resource. Jacqueline Nassy Brown uses the term *diasporic resource* to highlight the ways in which local populations strategically draw on specific aspects or practices of other populations within the African diaspora.[4] Afro-Barbadian women call on diasporic resources throughout the African diaspora, and in the late twentieth and early twenty-first centuries, their African heritage has interacted with a black nationalist and black womanist ethos in the form of an African queen ideal.

Ultimately, I argue that Afro-Barbadian women rely on the erotic in order to define themselves within Barbadian society and the wider world, that they employ diasporic resources such as the trope of the African queen in order to negotiate different definitions of femininity, and that Hinds's changing image exemplifies how this is evident within the arena of popular culture. Hinds's public performances demonstrate how articulations of Afro-Barbadian identity are both unique and simultaneously in conversation with and defined through broader definitions of femininity, black femininity, and Caribbean femininity. Her insistence on representing Barbadian and Caribbean femininity is an example of the performativity of these identities. She performs a national and regional sincerity through her own iconicity.

Hinds's performance as a queen expands the ideal of respectable Barbadian femininity beyond its previous iterations, which were based on the model of the "English lady."[5] Even in this expansion, however, Hinds's representations of Barbados, Afro-Barbadian women, and the Caribbean region are inevitably restrictive. She offers a persuasive model of female power that is still largely conservative and heteronormative and, by focusing on collective power through individual self-respect, does not overtly threaten systemic patriarchal structures. Nonetheless, Hinds's performance as a queen offers a marriage of female empowerment and national representation that acknowledges and bridges the commonalities and differences between gendered, national, and class identities and subtly opens the

possibilities of more radical representations and performances of Barbadian culture.

MARKET WOMEN AND THE MARKETS OF WOMEN

Barbadian colonial society based its definition of femininity on the ideal of the English lady. This ideal was modeled on upper-class whiteness, and it therefore excluded the majority of Barbadian women. Even within the white minority on the island, the poorer classes, having to labor for a living, were excluded from the dainty, dependent, prim ideal. As Erna Brodber notes in her 1982 study of the perceptions and stereotypes of Caribbean women, a lack of access to the ideal did not prevent its internalization. In examining sources from the nineteenth and early twentieth centuries, she finds that in Barbados and Jamaica, "the models ... were internalized as 'right' if not just as 'possible.' Today they are part of woman's psychic landscape and are influencing women's behavior."[6] Within the colonial setting, Barbadian women were inculcated with a gendered ideal that most did not have the ability to enact, but they internalized it nonetheless. Although the prescribed ideal was rigid and regulated, Barbadian women have always defied regulation and performed their own femininity. This section will briefly explore the "nonideal" models of Afro-Barbadian femininity that enslaved and free women performed historically: on the plantations, in the market, and within the business sector.

During the period of enslavement (1625–1838), women had limited roles within Barbadian society. The majority of Afro-Barbadian women were enslaved on sugar plantations or in urban households.[7] They performed varying roles within the plantation system, including those of cooks, servants, market women, and field hands. Female field hands were responsible not only for their own work but also for socializing the children on the plantation into the system of slavery. Historian Hilary Beckles writes that their lives were "characterized by excessive labouring, brutalization, malnutrition, vulnerability to nutritional related diseases, high mortality, and fear of abandonment when superannuated. They were the backbone of the agricultural enterprise, and therefore suffered the worst abuses."[8] They also suffered severe psychological abuse. Their role in socializing the children into the system of slavery was in tension with the consistent and varied efforts of their enslaved community to secure freedom. This is most evident in the apprenticeship period (1833–1838), when slavery was gradually abolished and children under six were no longer enslaved, but their parents and older siblings, cousins, aunts, and uncles were. Though the framework for apprenticeship allowed mothers to apprentice young children, most Barbadian mothers flatly refused and only one child was apprenticed on the island during the five-year period.[9] Many young children were largely left to their own devices, as their "apprenticing" families did

not want them to work on the plantations and plantation owners would not care for anyone who was not laboring for them.[10]

Although Afro-Barbadian women have "suffered the worst abuses," or perhaps because of this, they managed to exercise agency. A number of women carved out their own economic and social spaces or, at the very least, redefined the boundaries of their spaces within Barbadian society. The reports of runaways, the hucksters (street vendors) who openly and constantly defied the law, and the hoteliers who gained prominence within the colonial system of slavery all defied the expectations of "appropriate" behavior throughout the seventeenth, eighteenth, and nineteenth centuries. In a society built to uphold an elite (largely but not entirely male) landholding class, the power that they assumed and exerted posed a serious threat to colonial order, which depended on their adherence to rigidly defined social roles.

Some enslaved women became habitual runaways who repeatedly faced the consequences of recapture, including imprisonment, flogging, branding with hot irons, and other forms of torture. One habitual runaway was Quashebah from Codrington estate, who ran away five times in nine years.[11] The story of another young woman, Amelia, shows the strong family connections that serve as an impetus for such marronage. At sixteen years old, she was bought, then went "home" for one day before "absenting herself for three weeks."[12] She went to see her parents, and continued to do so, to the consternation of her owner. Women such as Quashebah and Amelia were adamant in determining their own freedom of movement, and in a slave society they were seen as a threat to slave owners who hoped their unabashed antislavery sentiments would not spread throughout the entire slave community.[13] Outside the plantations, Afro-Barbadian women defined their own markets in Barbados's limited urban settings.

Afro-Barbadian women have always had a very public presence in society, despite the colonial ideal of private femininity. Marisa Fuentes notes that while "white women were protected by law and domestic enclosure, . . . enslaved women were required to perform a particular type of public availability resulting in danger."[14] Such a presence and the danger it courted were, more often than not, tied to commodity and sexuality, two themes that would haunt public images of Afro-Barbadian women for centuries to come. As early as the seventeenth century, Afro-Barbadian women could be seen earning money as beggars, hucksters, and hoteliers in the streets of Bridgetown. Superannuated women would often be turned away from plantations and left to fend for themselves. Many of these women found their way to Bridgetown and survived by begging from the city's population.[15]

The tradition of hucksters is a rich one. Throughout the period of enslavement, some enslaved women were entrusted to sell their owners' goods in the Bridgetown market.[16] Other women sold their own wares. The economic and social freedom of vending in town often posed a threat to the colonial order, as evidenced in the

enactment of various forms of legislature directed against these women. Their persistence is demonstrated by the fact that so many laws, acts, and bills were enacted. The legislative efforts did not work. Huckster women often ignored these acts and continued to expand their market presence throughout the late 1600s and into the 1700s.[17] They also ignored legislation aimed at the routes of runaways. Beckles describes a runaway named Sarah who was "well known about the town as she has been for some time in the habit of selling dry goods."[18] Sarah, like others, disregarded the laws and went about defining the spaces of her world. The fact that she was well known and easily recognizable did not deter her from redefining her mobility, which speaks to the sense of community that Barbadians displayed in harboring each other in public and in private, regardless of the laws meant to prevent such conspiracy.

The visibility of huckster women greatly contributed to the conflict that their presence brought to the public market. Their physical bodies were on display in a space designed for the exchange of commodities. Since many hucksters were enslaved, the slave society had already defined them as commodities to be sold and purchased, but the agency they exerted by selling their own wares in the public marketplace separated them from the commodities that they sold. At the same time, their public presence allowed them to be visually consumed as spectacles. In a society that marked "appropriate" femininity as private, such a public presence wreaked havoc on the ideological order. It placed huckster women outside "appropriate" femininity. Colonial society could not view them as "real" women, but they were real enough to be sexual, to be a threat. Colonial discourses marked dark-skinned Afro-Caribbean women as asexual,[19] while colonial practices defined them as always available.[20] The marketplace became a place of tension between women and city constables, often leading to violent confrontations. By the turn of the nineteenth century, Barbadian officials had built stocks adjacent to the marketplace, which transformed the area into a site of public flogging and confinement.[21]

Definitions of Barbadian femininity are built on public images of Barbadian women and how these images interact with notions of the public and the private. The state, the church, and the educational system built colonial ideologies on the kind of liberalism that defined the public sphere as male and the private sphere as female, but these colonial gender ideals rarely fit the material and social realities of Barbados.[22] As far back as the seventeenth century, women worked both within the home and out in public. They played an important role in the Barbadian market, making a living for themselves and often contributing to the family budget.[23] Aside from the hucksters and beggars mentioned earlier, some of the most public women in Barbadian slave society were hoteliers.

The figure of the female hotelier is where notions of the public and private, as well as themes of commodity and sexuality, collide most violently. Historical records show that women were tavern and inn owners in Barbados as early as the

mid-1700s. Jill Hamilton notes that "historians tend to refer to these women as infamous rather than famous but they were recognized as being resourceful, independent of spirit and having the necessary managerial expertise to enable them to be successful business women."[24] As public businesses that provide private spaces, hotels, taverns, and inns bridged the worlds of men and women within early colonial ideology. What women hoteliers were in fact doing was selling privacy; most of their establishments were rumored to be brothels, and these hoteliers were thus much more likely to be women of color than white women.[25] Popular memory and the customs of the time heavily suggest that these were sites prostitutes may have used, if not actual institutions of prostitution. In the 1700s "prostitution was a means of social security for the women involved and many liaisons led to the ownership of property which in turn generated independence and the means to enter other lines of business if so desired."[26] Suspicions of prostitution, then, served as both accusations of impropriety and markers of the possibility of power, where the sexual and the economic paths would meet. The sale of a private space like a room in an inn signified the sale of the private domain, colonialism's female domain, thus placing such businesswomen under a cloud of commodity and sexuality in the public eye.

The most famous of these women is Rachael Pringle Polgreen, who is arguably the most well-known woman in the popular history of Barbados. Her legacy is built around both archival records and popular speculation. In memory, she has become both historical figure and comical caricature. One of the most salient tales of her and her Royal Navy Hotel narrates how England's Prince William Henry and some sailors drunkenly rampaged the hotel and the women within, destroying much of the property and throwing Polgreen herself out into the street on her backside. As the story is told, Polgreen, a comparatively dark-skinned, mixed-race Barbadian woman, calmly deferred to the royalty of this white English prince without comment or trouble. But the next day, she served the prince a bill for all of the property he and his party had destroyed, showing that she indeed meant business.[27]

Popular memory of Polgreen paints her as a woman well versed in various public and private performances: "proper" colonial femininity (deference to power), Afro-Barbadian femininity (resourcefulness and unabashed agency when necessary), business owner, mistress, ex-slave, slave owner, sexual object, sexual agent, and overall savvy woman. Tales of her reveal a woman who easily performed a demure femininity and who also readily participated in the physical brutality of being a slave owner. Her personal narrative has long since been overshadowed by her image in public memory, an image buttressed by a single surviving visual representation that has been reproduced on postcards and tourist souvenirs. Currently housed in the Barbados Museum and Historical Society, this 1796 lithograph originally printed in England depicts an older Polgreen outside her hotel (figure 6).

In the background is said to be a younger version of herself, her leering and inces-tuous father, and the sailor Captain Pringle, who would "rescue" her from her domestic situation by marrying her. The depiction centers her half-exposed breasts, and above Polgreen is a sign advertising her hotel. It reads, "Pawpaw Sweetmeats & Pickles of all Sorts," using double entendre to present a sexually explicit scene through covert references to consumable treats.[28]

The reproduction of this representation, an etching, polices the boundaries of her legacy while serving as a site of speculation. Her story is told through this one visual remnant and buttressed by a few pages in a sentimental novel published in 1842. The archival fragments of her will, a 1791 account by a British military officer named Captain Cook,[29] and her advertisements for goods are often overshadowed by the more popular sources that create a celebratory narrative of her life. Her story has also been told through song by popular calypsonians the Merrymen.[30] Her tale is mythic, creating a beautiful, mixed-race heroine who suffered under an inces-tuous slave system and triumphed as a business owner. The myth often erases the violence she endured and inflicted. The Merrymen sing of her beauty rather than a system in which marriage was the only means of escape and freedom was precarious. Her business savvy overshadows the limits of her participation in the eighteenth-century Barbadian economy as a woman of color. The wide circula-tion of the singular visual representation on cultural objects in the tourist market and the voices of others telling her story has posthumously provided Polgreen with a large audience while at the same time silencing her own voice, as she has become more caricature than person in the popular telling of her tale.

Polgreen's body, her legacy, and her person have been exaggerated by history to the extent that the material circumstances of her reality, the personal drives, aspirations, and hardships, are arguably all erased by the narrative of a few archi-val slivers and fictional accounts. She existed—that much we know. But the details of her existence get lost in popular fantasy and scant records. Fuentes writes, "From the only existing visual representation, Polgreen's race, gender and sexuality have become so concretely fixed as to make an alternative image of her body and lived experiences nearly impossible."[31] Popular memory of her, however, is still quite complex. It points both to the power of commodity that she held as a business-woman and slave owner and to her enactment of autoerotic power, one in which she used her status as mistress, wife, and possible prostitute to empower herself within a social and economic order that had little room for powerful black women. Polgreen's image is an extreme manifestation of a public woman in Barbadian soci-ety, one whose publicity forever placed her within stereotypes of sexuality and commodity, and whose memory clouds the many exercises and understandings of her power as an Afro-Barbadian woman. Her memory, and the ways in which it was caricatured, serve as a reminder of the relationship between public image and private reality. The former often overshadows the latter.

FIGURE 6. Thomas Rowlandson's 1796 lithograph of Rachael Pringle Polgreen. From the collection of the Barbados Museum and Historical Society.

MOTHERS, DAUGHTERS, AND WOMAN POWER

Fola saw her mother shiver and wilt, yet watched her as *this woman*. And Fola was grateful for the night and Camillon's discovery. She didn't believe a word of what Camillon had said about her mother and his friend; but the truth held no importance for her now. It made no difference to the fearful certainty which Camillon had established in her mind. This was the way

they had seen her mother. She existed for them in a certain way; and this way of *seeing* was now the only truth that mattered.
—George Lamming, *Season of Adventure*

In this passage of his 1960 novel *Season of Adventure*, George Lamming shows the ways in which daughters grow into mothers and the exchange of power in such a realization. His depiction suggests how important public image is to how Barbadian society defines women. At this social gathering, daughter and mother are almost indistinguishable. Their bodies are the same. Fola has grown into the one her mother, Agnes, never grew out of. When Camillon mistakes them for sisters, Fola, the daughter, is horrified that her mother would be seen as a sexual object. Her horror stems from the similarity between them and the fact that Camillon's view of her mother is no different than her own.

Her mother's actions and Fola's own ideas take a back seat to the image of her mother held by the young men who approach her. For a moment, the image overtakes the erotic power silent within both mother and daughter. Her mother becomes "*this woman*"—this sexual woman who can manipulate men with the sound of her laugh, the movement of her body, and the exuberance of her every move.[32] And because of the physical similarities between Fola and her mother, because they literally look the same, Fola understands that this view can very easily be applied to her. She rejects her mother, not because of anything that her mother has done but rather because the men have seen her mother as "*this woman*" and Fola wants to be more. Her rejection of her mother is the rejection of the perception, of the image. Fola, like many actual women, grows to understand how her society perceives women. She enacts a very specific inner strength, Lorde's erotic power, in order to find her own ways to navigate such perceptions and build her own public image.

Using the works of popular Barbadian literary figures, memoirs, and scholarly studies, this section argues that women are both revered as mothers and caretakers and reviled as "naturally" and sexually manipulative beings in representations of Barbadian society, that motherhood validates female sexuality within the public eye, and that Barbadian girls and women are taught to negotiate their own public images as they grow into womanhood. Such negotiations often center on the visibility of one's sexual agency and its reading through several definitions of respectability. In rejecting a prescribed public image while trying to carve out her own identity as a young woman, Fola employs the kinds of negotiations and definitions of Afro-Barbadian femininity that would later appear in discourses of "queens."

The ideal of the nuclear family (or, at the very least, the role that motherhood plays in dominant discourses and social practices of femininity) has tempered stereotypes of the hypersexual Barbadian woman. While the region has a historical

and contemporary reputation for being hypersexual in tourist discourses, local perceptions are quite different and more nuanced.[33] The label of hypersexuality exists as a threat to a woman's respectability. Gender studies scholars V. Eudine Barriteau and M. Jacqui Alexander both detail the ways in which Caribbean nation-states reduce women's bodies to the role of reproduction,[34] and Patricia Saunders notes how "women's articulations of their historical experiences were marginalized because they did not reflect the agendas of nationalist politics."[35] These same dominant notions prescribe the ways in which sexuality and family are to be exercised, as Rosamond King notes when she writes, "There is a dominant fiction within the region that Caribbean families should be heterosexual and patriarchal, and that the women at least should be serially monogamous. Such sentiments persist despite a large, established literature defining Caribbean matrifocality."[36] If society defines a woman by her body, by the sexual potential of her body, then she is also defined by the reproductive abilities of her sexuality. Historically, barren women found themselves ridiculed as "mules" in Barbados.[37] Because they lacked the ability to reproduce, some sectors of society questioned their femininity, and their humanity, framing them as worthless to the rest of the Barbadian nation; they could produce neither loyal colonial subjects nor new nation builders. Without the possibility of reproduction, the sexuality of these women became suspect. If they were not sexual for the sake of maternity, they must be sexual for the sake of pleasure, or capitalist gain,[38] or, even worse, as a form of manipulation. Motherhood, then, served as a public declaration of the fulfillment of a private role, one that marked female bodies as sexual in a socially acceptable way. But even motherhood was not enough to escape the image of hypersexuality, as Lamming shows in *Season of Adventure*.

After an encounter at the vice president's ball, Fola confronts the main divide between her mother and her. Because she has never known her biological father, Fola sees her mother as a whore. Fola is plagued by this lack of personal history, and she shapes her image of Agnes, her mother, around the silence surrounding her own birth.[39] The way the men at the ball speak of Agnes confirms Fola's image of her mother as a whore. Fola has never used the term *mother, mom*, or *mum*, preferring to call Agnes by her name or some variant, and as she looks at Agnes now as *this woman*, she sees it is because she struggles to reconcile the image of whore with that of mother. In Fola's mind, Agnes gets stuck within a madonna-whore dichotomy, and there is no room for reconciliation between the two poles.

The sexual divisions of colonial Barbadian society placed family within the woman's domain and sexual enjoyment within that of the man. For a man to father several children was expected and bolstered a sense of masculinity built on virility.[40] Fidelity was ideal, but not entirely expected in colonial discourse. But for a woman to do the same, to enjoy, express, and explore her sexuality, to be an erotic woman, contradicted the colonial ideal of femininity. Women who (somewhat) openly enjoyed sex, and the power and pleasure surrounding it, transgressed such

colonial ideals. Those who abided by the structures of respectability could still be deemed inappropriate, showing the complexity of the ways in which sexuality, pleasure, and commodity interact. Lamming's character of Agnes demonstrates this complexity. Her motherhood does not automatically grant her respectability, because her child is born out of wedlock and the father is unknown. She marries into respectability by partnering with a policeman, but because of her youthful appearance, other men still mistake her for a possible sexual conquest.

In Barbados, the colonial and nationalist ideals of woman as mother, ideally within a nuclear family, are dependent on a heteronormative discourse. Same-sex desire between women is rarely represented overtly. There are a number of reasons for this: female same-sex desire does not threaten the heteropatriarchal structures of society as much as male same-sex desire does, because of the historic and hegemonic view that a man's domain is in the public and a woman's domain is fairly private. However many times this boundary is transgressed, its weight in the public imagination means that when it comes to same-sex desiring communities, those who are male are more visible.[41] The public view of female sexuality and public performances of sexuality within Barbados may have little to do with actual sexual practice.[42] Motherhood in particular is the most public performance of what is "ideally" a private femininity, and while it usually betrays a heterosexual act, it says very little about sexual preference.

The relationship between the image of the mother and images of women in general is a complex and troubled one. Psychologist Ezra E. H. Griffith writes in his memoir, "It did not take me long to recognize that the word 'woman' generally meant mother, even if it did not mean wife."[43] As a Barbadian child in the 1950s, he understood *woman* as caretaker, as responsible social arbiter. Women are the private workers who keep both the family and the social order intact, and that is how Griffith defines the role of mother. Still, while respect for one's mother is mandated by society, it does not necessarily extend to respect for all women. Griffith's childhood conflation of the two terms does not translate into treating mothers and other women equally.

Children were taught to respect their mothers, with the understanding that it was motherhood that guided a mother's actions. The young male characters in Lamming's 1953 *In the Castle of My Skin* echo such a perception and are firm in their view of the discipline their mothers mete out:

"She says she'll beat the life out of you when she catch you," I said.

"It ain't the first time she say that," he said.

"But she will do it this time," I said. "Look the blow she give you in the ear."

"I ain't got feelings any more," he said. "I get sort of hardened to it." He looked up and smiled. His face was wet and heavy and remote.

"But I won't ever hit back," he said, "whatever she do me I won't ever hit back."

"You ain't to do that," I said. "They say you'll be cursed if you hit a mother."[44]

In the context of their time, the 1930s, the boys understand that the physical vio-
lence their mothers inflict is based on the religious tenet of "Spare the rod, spoil
the child," expressed in Proverbs 13:24. The boys, in turn, become hardened to the
physical abuse that they understand as an expression of a mother's love. Such love
toughens them in a way seen as appropriate for boys in early twentieth-century
Barbadian society.[45] This hardening is a consequence of the kind of socialization
that Barbadian politician Billie A. Miller describes in the foreword to Jill Hamil-
ton's *Women of Barbados*. Miller writes, "This is the Caribbean woman who raises
her sons to observe the commandment—disrespect all other women excepting
me."[46] Within popular imaginaries, such harshness, whether it be the physical dis-
cipline of a child or the use of sex or wit to provide for said child, becomes
expected and excused as a "natural" consequence of motherhood and, by exten-
sion, "complete" womanhood. One is to honor one's mother, knowing that she
wants the best for her children, but one must also repel her overarching reach in
order to define oneself as an adult, and excuse her offenses as "natural" expres-
sions of womanhood. In this sense mothers are both honored and repelled,
respected and questioned. Within this discourse women are imagined as poten-
tially dangerous, but the danger of a mother is acceptable and excusable as a form
of love. The danger of other women, however, is something to be negotiated, pre-
empted, and avoided.

While motherhood validates female sexuality as a productive force within Bar-
badian society, it also provides a wide brush with which to paint the image of
women caretakers as possibly manipulative, and it publicly marks the sexuality
of a woman. Such perceived manipulation can be interpreted as another form of
productivity.[47] If a woman has given birth, she must be a sexual being, and to
acknowledge a woman as a sexual being is to point to the danger of her using sex
as a manipulative tool. Not only can "real" women (mothers) produce children,
but they also know how to produce results. In both his fiction and his autobio-
graphical essays, Lamming contrasts these women with the prostitutes he encoun-
ters. He writes, "One of the basic fears planted in me as a little boy was that those
'women on the street' carried sickness."[48] There is a distinction between mothers
and "those women"; each of them carries a specific danger rooted in heterosex-
ual intimacy. Lamming's *Season of Adventure* character Agnes transgresses this
binary as a married mother who is still perceived as sexual conquest and whore.
This is what horrifies her daughter Fola in the epigraph to this section. Fola sees
the way in which the men of society are looking at her mother and fears that their
gaze will turn to her.

On her eighteenth birthday, Fola finds strength on the edge of madness as this
encounter with her mother reaches its height. Lamming writes, "Her rage had
given her an impossible strength; freed from any loyalty. She wanted to be a trai-
tor in the name of some original truth."[49] This moment is more than typical teen-
age rebellion. Fola is opening a chasm between herself and her mother that is

meant to free her from the horrific secret of her conception, and from the constraints of the patriarchal gaze that overdetermines her mother from without.[50] In this moment Fola finds her erotic power. Lorde defines the erotic as a hidden resource manifested through action; it is deeply female and a source of personal power.[51] This is the "original truth" Fola wants to return to, even if it means betraying her mother and the standards for women of the time.

This erotic power has been a source of strength for centuries of Afro-Barbadian women, so much so that it has become a definitive performance of Afro-Barbadian femininity. It is adaptable and deeply personal, and lives at the intersections of the private and public; it is regionally, transnationally, and diasporically informed but enacted and shaped within the specific circumstances of Barbados's history, the structures of the Barbadian nation-state, and the expectations of Barbadian society. The characters in Paule Marshall's *Brown Girl, Brownstones* explain, "'I tell yuh, Silla,' Florrie Trotman said once shaking her head, 'you's a real-real Bajan woman. You can bear up under I don' know what.'"[52] Written in 1959, *Brown Girl, Brownstones* is a coming-of-age story for a Barbadian community abroad. The strength displayed by this "real-real Bajan woman" is a front, a mask she wears for her Barbadian friends, who gather in her basement kitchen on weekends to knead, stir, and partake of the tastes of home. The sentiment of perceived strength is echoed later in the text in another character, whom her son describes as "the small hard dry type of West Indian who lives endlessly and endures all."[53] It is the daughter protagonist, Selina, who sees past the mask of endurance these women wear. She knows of her mother's restless nights filled with tears and worry, and, like Lamming's Fola, she charts a different path for herself, one wherein her power and strength feel like more than a public performance and are rooted in a sense of "original truth."

Fola's and Selina's fictional experiences are mirrored in the narratives of West Indian women and girls across the Caribbean and Caribbean diasporas. Gloria Wekker cites a number of studies to conclude that "women perceive that as wives they are expendable, but not as mothers and sisters (Sacks 1982); in other words conjugal bonds are weaker than consanguinal ones. This is one of the persistently noted Africanisms in black diasporic family life (Sudarkasa 1996)."[54] Oneka LaBennett's ethnography of West Indian girls in New York reports similar attitudes. The transnational upbringings of the teenage girls she worked with were rooted in performances of West Indian femininity. LaBennett notes that "Amanda's emotional work, how she managed the conflict with her mother, and her use of the words 'staying strong' to describe both her mother's way of surviving childhood trauma and her own manner of accepting her mother's prohibitions have been ascribed to West Indian culturally defined ways of managing depression (Schreiber et. al. 2004)."[55] The family structures mirrored those on the islands from which their families had migrated, including child fostering and extended kin networks.[56] And migration itself shaped these girls' notions of West Indian

femininity as a form of strength because "the self-reliance they learned in their parents' absence continues to shape their lives."[57] Even (and perhaps especially) abroad, young West Indian girls were taught that their femininity was tied to the notion of staying home. And even as their mothers wished for careers and success for them, such wishes were undercut by the idea that a woman should stay (at least close to) home.[58]

Whether fictional or nonfictional, migration allowed for a space to defy these performances and expand performances of femininity. Published three decades after Lamming's *Season of Adventure* and Marshall's *Brown Girl, Brownstones*, Marshall's aptly titled *Daughters* further explores the role of daughters within Afro-Barbadian literature and society with renewed attention to transnational experiences and how political power dynamics can circumscribe performances of femininity. Set within a transnational network that includes the fictional island of Triunion and the North American metropolis of New York, the novel details how the protagonist, Ursa, views her body, its reproductive capabilities, her relations with men, the rumors about her relations with women, and her role in the development of a nation-state and the transnational communities she is a part of. In this novel Marshall details the role of a daughter growing into a woman, paying special attention to the physicality of each character's body. Ursa is childlike. She has nubs for breast and does not fit the ideal that she knows her community expects. She rejects motherhood, choosing to have an abortion and only feeling guilty that her own mother had tried so hard to bring a child into the world and had such hard luck in doing so. The novel traces various relationships between women (mother-daughter, wife-mistress, friend); it delineates the "acceptable" roles and behaviors for men and women on the island and abroad and the consequences of transgressing them; and it identifies these relationships as the foundation for nation building. It is a coming-of-age story wherein the protagonist, Ursa, defines her identity as an adult woman and as a transnational, diasporic, and national citizen. Her identity formation is founded on her role as a daughter.

Ursa is born and largely raised in the New England region of the United States, but she is unequivocally identified as being from a small Caribbean island. In many ways, Ursa becomes what Fola hopes to be. She is her own woman. She has used the privilege of growing up in a stable, middle-class, "respectable" family to chart new paths of respectability and femininity for herself. Unlike Fola's, Ursa's body is rarely sexualized, and Marshall takes great care to contrast her almost prepubescent body with those of the taller, curvier, more "traditionally desirable" women in her life. Still, her femininity, her attachment to the small island where she was conceived, and her transnationality are ever present. Whenever someone doesn't understand Ursa in the United States, they blame it on Triunion, on her "foreignness," though she was born and has lived most of her life in or near Hartford, Connecticut. Whenever anyone in Triunion doesn't understand Ursa, they blame it on the United States or on the "foreignness" of her mother, Estelle, who continu-

ously transgresses the expected roles of a politician's wife on the island. Even those closest to Ursa read her personality through her "island ways." Her best friend tells her, "It's still go it alone, keep your business to yourself, maintain a stiff upper lip no matter what, and all the other nonsense they taught you in that place you're from. Massa really did a job on you folks down there."[59] The stereotype of Caribbean women's strength is thus interpreted through a New World history of slavery and imagined as a result of the isolation of small islands.

Both Lamming and Marshall use fictional islands (San Cristobal and Triunion, respectively) to specify general experiences of gendered nation building. Though these narratives are set in fictional lands, they have become a part of the Barbadian literary canon, and thus a part of the Barbadian cultural imaginary. Each novel places the social and formal politics of islands in conversation with globalized and transnational worlds. And each focuses these movements on the relationship between a daughter and her mother. While Fola's narrative unfolds alongside, but largely unrelated to, the political changes of her community, Ursa is directly, though covertly, involved in the politics of Triunion. She returns home at the clandestine request of her mother and surreptitiously helps a younger politician with a vision of uplifting the poorest of the poor defeat her father after decades of his being the central political icon for his district. Mother and daughter secretly manipulate the electoral process for the greater good. Though it breaks their hearts to go against a man they love dearly, their strength comes from both their family connection and their greater vision for a self-determined community. The stereotype of woman as manipulative is offered as a productive transgression of prescribed female roles that ultimately aids the larger community and the nation-state.

The ethos that shapes the figure of the mother is based on a stereotype of strength that is predicated on the social conditions of Barbadian society and the Caribbean region as a whole.[60] At historical points of societal change, Barbadian women become the martyrs of society. In the period of enslavement, the abuse of women made it necessary for them to demonstrate the most resistance. The socialization of young girls encourages them to take on the role of social pillar. In a study of girls in the Caribbean, researchers found that, from an early age, they are taught self-reliance, flexibility, a willingness to adapt to any situation, and the ability to seek solutions for themselves, all trademarks of the "strength" of Caribbean women.[61] The image of the strong Caribbean woman is built on women's self-reliance and self-actualization, both manifestations of an inner erotic power. Caribbean nation-states use this image to both the benefit and the detriment of Caribbean women.[62]

The power of women within Barbadian society has long been a source of concern to various power structures and a site of misunderstanding within society in general. Throughout Barbadian history, the economic construction of society has necessitated that women work, making a degree of independence, autonomy, and

assertiveness an integral part of Barbadian femininity.[63] Within postindependence Barbadian society especially, the growing gap between men and women in terms of education and job opportunities became the subject of many speeches, studies, and editorials. The stereotype that constructs Barbadian women (and Caribbean women, black women, and women of color in general) as hypersexual and sexually manipulative is still very much alive, and such postindependence concerns have given rise to various other stereotypes of Barbadian women as hard, conniving, manipulative, and morally bereft. On the other hand, nationalist and feminist movements, of the 1960s and 1970s, respectively, have provided at least the possibility that different views might become more prevalent in public discourse, views wherein women are respected as citizens and as people worthy of respect.

The popular ideology that places domestic issues firmly and almost exclusively within the domain of women creates complicated relationships between the state, women, and men, and such relationships manifest themselves in society's image of women. Child-rearing is seen as a female practice, and although the role of breadwinner is assigned to the man (within the heterosexual nuclear family ideal), it is the woman who is responsible for ensuring that the money the man brings into the household is properly distributed to cover the basic needs of the family.[64] Popular ideology places the burden of preparing children for success, maintaining their health, and providing basic needs largely on the shoulders of women within Barbadian society. This burden becomes especially heavy in times of economic hardship, when finding the money for school clothes, medicines, and basic foodstuffs becomes difficult. This difficulty is exacerbated in a society that historically condones the practice of men having several families, promotes the idea that women should be economically dependent on these men, and rarely provides the kinds of income-generating opportunities that would allow such men to financially support numerous families.

In order to make ends meet in such situations, "strong" women become "miracle workers." Barriteau describes the ramifications of such a stereotype: "This myth of the miracle worker obscures how gender relations are constructed to exploit the capacity of women to cope. These ideas posit that Caribbean women have some inherent, natural capacity for survival. By doing so, they conceal how the state counts on women to fill the gaps when changes in macroeconomic policy, whether introduced by structural adjustment programs or the effects of globalization, produce a severely reduced public sector and the further rationing of economic resources (Elson 1991)."[65] In such situations, Barbadian women often rely on alternative market structures and develop multiple income-generating skills. It is not uncommon for women to bake or take in sewing to augment their incomes. They may also rely on their own attractiveness to entice men who are willing to provide financial assistance to them and their families, a practice that

both feeds and justifies ideas of women as productively manipulative while simultaneously obscuring the possibilities and negotiations of erotic pleasure within sexual discourse.[66]

Such resourcefulness has colored the stereotype of the "strong" Afro-Barbadian woman. This stereotype springs from a common misreading of female power. The image of Afro-Barbadian women as hard, sexually conniving, and too independent is tied to what Lorde presents as the misrepresentation of the erotic. She explains that the erotic is often misunderstood or misrepresented as pornographic and that women are taught to distrust their own erotic power.[67] What is sensual and empowering about Afro-Barbadian womanhood is often misunderstood as sexually irresponsible and controlling, just as the ability to cope with and adjust to changing circumstances is misunderstood as a form of superhuman strength.

Afro-Barbadian women, in negotiating disparate definitions of womanhood, have had to call on the erotic, on a sense of inner power, as a means of survival. Their definitions of self have existed outside as much as within the dominant or official social structures throughout the centuries of Barbadian history. This negotiation becomes circular, as Barriteau notes in the quote just discussed: Afro-Barbadian women construct a specific femininity based on surviving in their circumstances, and thus the state sees no need for change because it is assumed that Afro-Barbadian women will always find a way to survive. The nationalist movement, in redefining a national identity that was tied to but different from a colonial identity, inspired new identity constructions. This work was furthered by the international women's movements, especially the efforts of women of color. Postindependence definitions of Afro-Barbadian femininity rely on a more outward performance of the erotic while still maintaining a base in the struggle between earlier disparate definitions of womanhood. In her study *Perceptions of Caribbean Women*, Erna Brodber notes, "It would seem from post-Independence newspaper reports that Barbadian women began to articulate their view of right behavior for women only with the onslaught of the women's liberation movement on the northern continent. This peaked with the UN declaration of a year for women" in 1975.[68] The feminist movement that followed on the heels of many national struggles and began a focus on women of color internationally gave Afro-Barbadian women the tools with which to differently articulate the erotic power that they had been exerting for centuries.

If the nationalist movement allowed Barbados to redefine itself as a nation-state, the subsequent international feminist movement provided Barbadian women a wide support base through which they could more publicly redefine their positions within Barbados. The structure of the Barbadian nation-state began to shift as well, and only a year after the United Nation's International Women's Year, the Barbadian government formed the Women's Bureau in 1976, becoming one of the first Caribbean governments to address women's issues at a national

level.[69] Women were actively working toward change in Barbados and "have been instrumental in getting the laws pertaining to the issue of domicile for spouses, common-law unions and family violence, changed or introduced. Barbadian women have also mobilized successfully around the issues of health and reproductive freedom. Women have also politicized the issues of gender in the wider society, either in terms of academic research or in terms of popular discourse."[70] Women took advantage of the social policies of the independent government— namely, free health care and free education. Education, in particular, became a contested site as the number of women reaching and finishing university began to surpass that of men.[71] Such a phenomenon was predicated both on the social policy of free education and on the social ideology of gender. While education was seen as an important avenue of uplift for all,[72] Barbadian girls were socialized to sit still inside (an environment conducive to studying), while boys were socialized to be outside and active. This is only one example of the ways in which preliminary efforts to address women's issues, coupled with older social expectations, served to create new stereotypes.

While Barbadian women have been actively redefining their own public images for centuries and those efforts have been welcomed to a degree, since 1975 such efforts have also been widely criticized. As women began taking advantage of new social policies, the idea that they, and any government efforts that supported them, were taking resources and attention away from men became a popular sentiment.[73] The rise in women's civic organizations paralleled the subsequent rise of men's organizations. Barriteau notes that "Barbados, of all Anglophone Caribbean countries has an organized men's network with a strident anti-feminist, anti-women agenda."[74] While she supports the idea of critically engaging gender and studying and supporting femininity and masculinity, she is wary of what she terms the "anti-woman focus" of many of the men's groups of the last few decades. Such groups act on the presumption that "the Barbadian state has conceded too much to women."[75]

The gendered discourses that were key to much of the literature of the independence moment moved into different arenas postindependence. With the rise of radio and later television, as well as the state's revival of Crop Over in 1974, music became more and more central to popular culture. While the voices of the 1970s and 1980s were largely male, a few female performers began to chart a path in calypso, spouge, and later soca. In the twenty-first century, even with backlash against the state's perceived favoritism of women, these women's voices have become central to defining a regionally and internationally informed "woman power" specifically within Barbadian society.

The twentieth and twenty-first centuries have produced multiple arenas of representation within the mass media market. As Brodber notes, "Today's image-makers have at their disposal more powerful instruments of persuasion than did those of the pre-independence era. A crippling mystique of femininity today per-

vades our society through the agency of the mass media, affecting the self-image and the aspirations of hundreds of thousands of Caribbean women."[76] In the twenty-first century, Barbadian femininity has a rich history of identity constructions and, in the hyperreal technological moment, even more influences to incorporate and negotiate.

Even in 2000, anthropologist Carla Freeman found that "women in Barbados are simultaneously revered, as mothers and providers, and ridiculed, as mercenary, manipulative sexual partners."[77] The difference in treatment hinges on notions of respect. In my own experience with Barbadians, including family, friends, strangers, and interviewees, I have found that to be respected is to be treated as (and at times explicitly referred to as) a queen. The trope of the queen allows women a public image that is educated, sexual, fun, powerful, and nonthreatening in a way that Ula Taylor defines as community feminist.[78] It is not unlike Marshall's depiction of Ursa and her mother, Estelle, in *Daughters*, but much more public in its contributions to community. This queen is a woman who navigates a space that marries feminism and nationalism by uplifting entire communities and empowering women even within the "traditional" female roles of mother and provider.

The queen discourse is most visible in the image of musical artists. Celebrations of International Women's Day and Mother's Day feature various performers, officials, and supporters who believe, as Barbadian female singer Terencia "TC" Coward put it in her performance at an International Women's Day event in 2010, that women present hope for the future, serve as a moral compass, and socialize the next generation of children.[79] It is worth noting that although here, as in many of her songs, TC places herself among those who are the hope and future of the nation in tending to children and generally performing "traditional" roles of support, she herself has no children and thus in many ways falls outside heteronormative assumptions of womanhood. Her command of the stage as the "Queen of Social Commentary" is an example of Taylor's community feminism, wherein the health of the nation is supported by women in nontraditional roles even while they use the discourses of traditional roles.

In the twenty-first century, Afro-Barbadian women find themselves the targets of old structures of power relations and new critiques of favoritism while negotiating between the images of who they are, who they should be, and who they know themselves to be. They continue to "mother" the nation with their strength and ability to cope, marking them as "real-real Bajan" women, dodging notions of themselves as "*this woman*," and still searching for ways to express and celebrate a feminine sensuality in a way that ensures their erotic power is not too threatening or dangerous to patriarchal structures. One telling example of this construction of an identifiable yet liberating Barbadian femininity is the career of popular performer Alison Hinds.

QUEEN ALISON: CROWNING MOMENTS AND DIFFERENT THRONES

> Alison Hinds, a true *Caribbean Queen*, came to the throne thru SOCA (popular dance music of the Southern Caribbean) that is rapidly gaining popularity among music lovers around the globe. It is a sexy music known for its infectious rhythms and spirited spicy lyrics that inspires jubilant audience participation albeit with waving hands and flags to swaying hips, all in a ritualistic celebration that exemplifies life today in the Caribbean and is synonymous with Caribbean Carnival celebrations worldwide.

This statement once began Hinds's biography on her fan web page.[80] Using familiar imagery of the "exotic" Caribbean, the African diaspora, and women performers, the writer is careful to invoke the trope of royalty and to rely on depictions of the Caribbean and its culture as sexy, infectious, and ritualistic before delving into exactly who Hinds is. Hinds came into the local public eye when she joined the popular band Square One at the tender age of sixteen. Born in England, an eleven-year-old Hinds moved to Barbados with her mother when her parents split up. A shy young girl, Hinds was encouraged to perform in order to assert herself, and she competed in the Richard Stoute Teen Talent Competition. Within Square One, Anderson Armstrong (a.k.a. Young Blood, a.k.a. Blood) had an immense impact on her early career, as did Terry "the Mexican Pan Man" Arthur. Square One's popularity rose in the early to mid-1990s, and Hinds moved from being a voice in the back to being one of the leads in the band. They toured the hotel circuit and performed various genres, such as R&B, soca, and reggae.[81] Touring with Square One took Hinds around the world, including to Sweden and Suriname,[82] but the name of Alison Hinds would take on new meaning when she partnered with John King. Their collaboration, entitled "Hold You in a Song," won the Barbados Song Contest and the Caribbean Song Contest in 1992.[83] The song's message of love, and the fact that its performance lacked the party aesthetics of many of Square One's more popular songs, appealed to both young and old audiences, who could focus on Hinds's and King's voices and skillful delivery. Its slow melodies and sentimental message endeared Hinds to a larger Caribbean crowd and foreshadowed many other collaborations with Caribbean male artists.

Hinds has traversed the different standards of Afro-Barbadian femininity that have emerged throughout Barbados's history, those based on colonial ideologies of the "English lady," a diasporically informed black femininity, and those based in the specificity of transnational Barbadian spaces. Throughout the years, her fans and the media have wholeheartedly supported her, dubbing her the Queen of Soca music. Hinds reluctantly accepted the title of queen, understanding that her fans were asking her to represent them and knowing the duties and pressures that such representation would entail. This section will explore the various uses of the queen

trope, how Hinds earned her reputation as "a true *Caribbean Queen*," and the ways in which she uses it to declare her position as a representative of Barbadian and Caribbean culture.

Unlike the record of Rachael Pringle Polgreen, the archive of Hinds's public image includes a plethora of visual materials. Throughout the years, Hinds has constructed a public image that both she and her fans are comfortable with. She is unapologetically middle class, but promotes and forwards Barbadian and Caribbean folk traditions (usually associated with the lower classes) over and above European and North American standards of culture.[84] After beginning her performance career with Square One, Hinds became the first woman to win the performance titles of Road Monarch and Party Monarch in the 1990s, and her appeal quickly grew throughout the Caribbean region.[85] In the early 2000s she took time off from performing to focus on her family, eventually returning to the stage and embarking on a solo career. Her public image has become more complex with time, growing to include the various roles that Afro-Barbadian women play, such as mother, wife, economic and emotional pillar, and entertainer and cultural icon. In 2000 she declared that her sexiness was not in excess and that she was an entertainer, not a babysitter for everyone's children.[86] By 2009 she opened her Alison's Wonderland show with a video montage that ended with a heartfelt message stating that she wanted her daughter to watch her shows and be proud. Hinds's current public image is centered on responsibility—to her immediate family, to the nation she calls home, to the Caribbean region, and most especially to the women within it.[87]

The trope of queen can be found throughout black popular music and the African diaspora as a whole. Sonjah Stanley Niaah explains how "the idea of the queen reveals the consistently elevated place of women as key counterparts of kings, formal or informal, named or unnamed. The pervasive elevation of a central female persona is consistent with African popular and sacred traditions."[88] Within black popular culture, the queen trope has been used as a means of gaining and demanding respect while asserting oneself as worthy of it. Within the black U.S. context specifically, one can easily point to such titles as the Queen of Soul, held by Aretha Franklin (who demanded R-E-S-P-E-C-T by taking an Otis Redding song and turning it into a women's anthem); the Queen of R&B, held by Mary J. Blige; and other iterations of the trope, such as Queen Latifah, Queen Pen, and Lil' Kim, who is also known as Queen Bee/Bitch.

As a songstress and emcee emerging fairly early in hip-hop history, Queen Latifah commanded respect by assuming the posture of royalty (the trope of the queen), and she demanded respect lyrically for herself and all women. Kamari Clarke explains how Queen Latifah entered the limelight "with a message of African nobility and urban American pride. Queen Latifah incorporated the themes of black pride from the earlier decade; however, her music was a response to American racism and the female derogation that was marketed by the largest

recording industries in the United States."[89] Some of her most popular songs and videos, such as "U.N.I.T.Y." and "Just Another Day," display this balance between black pride in an urban setting and resistance to female derogation, on the one hand, and the personal performance of "soft" femininity and "hardness," on the other. Notably, in the third verse of her 1993 "Just Another Day," she respectfully admits that without her community, she would not hold the title of queen. Within this song, she posits herself as a representation of the community that has shaped her. She is worthy of her title because of her lyrical skill, her knowledge and understanding of her community, and the support of that community.

Queen Latifah's acknowledgment of her community demonstrates the ways in which the title of queen is earned. It derives from both an inner erotic power, the result of knowing that one is worthy of royal status and capable of carrying out royal responsibilities, and the acknowledgment and respect of such power bestowed by a collective community. Diasporically, this title serves to represent local and specific identities to larger audiences. Hinds draws on this representative, community-oriented performance of the queen trope, as well as more specifically Caribbean iterations of queenliness, in order to translate her personal visibility as an artist into more critical attention for the Barbadian nation, the Caribbean region, and the women within it.

Some of the most well-known Caribbean performances of the queen trope happen within Jamaican dancehalls. The performance, competitions, and 1997 film *Dancehall Queen* have solidified the trope within the Jamaican context. Jamaican dancehall queens are both celebrated and vilified, but their status remains distinctly tied to the visibility of their bodies. They are recognizable through their dress and movement. Within the dancehalls, the highly suggestive movement of these women's scantily clad bodies is a celebratory resistance to Jamaican middle-class structures of morality, modesty, decency, and respectability. For women who do not have the resources to be a part of the "respectable" middle class (or who perhaps are uninterested in such a status), the trope of dancehall queen is one means of forcefully establishing one's existence, of defiantly enacting an alternative form of validation. While dancehall queens first gained celebrity status in their communities in the 1970s, throughout the 1990s reigning dancehall queens Carlene and Stacey "contributed the most to the rise of the image, style and appeal of such queens of dancehall, who are expected to demonstrate certain attributes of attitude and style as well as dancing skill."[90] The resistance to middle-class values is both proved and troubled by queens such as Carlene, a lighter-skinned woman of middle-class background who reigned throughout the 1990s. The idea that a woman of her status would willingly "debase" herself was troublesome to many, but her status opened new doors for the dancehall throne as she was featured in tourism advertisements and other arenas that were previously seen as too respectable for dancehall culture.[91] Such attention was bolstered by one of Jamaica's most popular feature films, *Dancehall Queen*.

As demonstrated in the film, distinguishing oneself visually is crucial to attaining the throne within dancehall culture. In the film, the protagonist, a working-class single mother named Marcia, finds power in redefining herself as the mystery lady of the dancehall. Marcia's adoption of this persona is spurred by economic need and inspired by her oldest daughter's self-confidence. Marcia can only embark on her journey to become dancehall queen with the help of a skilled dressmaker who creates her sexy outfits, complete with wigs, fake nails, and plenty of jewelry. Along the path to the throne of dancehall queen, the mystery lady is also aided by the dancehall photographer, whose attention is essential in acquiring the title. As Carolyn Cooper notes, "The camera's eye redefines Marcia as a subject worthy of attention, bedecked in all her borrowed glory."[92] As the mystery lady, Marcia reveals herself physically through her attire while concealing her identity in an act of dissemblance.[93] She discovers her sexual and sensual appeal as a site of power and uses it to demobilize threats to her family, to seek revenge against her daughter's rapist, and ultimately to discover her own erotic power. Such a performance of queenliness skirts the line between the erotic and the pornographic in its visual representation. Visually, Marcia (and other dancehall queens) can easily be interpreted as performing a pornographic role, one in which she is consumed by a voyeuristic audience focusing on her scantily clad body and her mastery of movement. Such an interpretation, however, disregards the erotic power of dancehall queens who find inner strength, monetary rewards, self-confidence, and respect through performing the role. These qualities are intrinsic to Afro-Caribbean women's performances of queenliness and femininity.

While Hinds represents Barbados, she does so within a specific paradigm, using the tools that she has, the most striking of which is the embodiment of a regionally and internationally informed Afro-Barbadian femininity. Hinds uses specific Barbadian forms, coupled with the adaptability forged through the sociopolitical circumstances of Barbadian experiences. Susan Harewood notes the ways in which "man of speech" discourses have silenced many women's voices in the Caribbean, and she urges scholars to look at less traditional archives to find women's narratives. While politicians such as Ermie Bourne and writers such as Paule Marshall have challenged the male dominance of "the Word," Harewood cautions that even in looking toward popular music as an alternative archive, scholars must be careful of the ways in which the practices and analyses of popular music forms become gendered.[94] A focus on queen performances allows women's voices to stand center stage in scholarly analysis. Hinds draws more on the local quotidian performances of the queen trope in Barbados than she does on the historical use of the queen trope in various traditions of black music and the traditional monarchical notion of the queen. Hinds is able to do so because of a host of female performers who paved the way for her.

Wendy Alleyne is one of the most notable forerunners of Barbadian female singers. Named by her fans as Barbados's "Queen of Song,"[95] she sang backup

vocals for the Draytons Two in the midst of spouge's popularity and became famous as Wendy Alleyne and the Sweet Sensations.[96] Performing in the 1970s, her sound resounded in a chorus of nationhood, feminine power, and her own individuality. In the midst of local and worldwide feminist movements, though her voice was celebrated at the time, her popularity also inevitably butted up against still-prevalent notions that a woman's place was not in the public sphere. In explaining how male artists would only accept so much female success, Alleyne says, "I didn't care about them saying that, 'cause I knew what I wanted from [the time I was] a child. . . . I wasn't gonna let anybody stop me, . . . that's not me. I'm a fighter."[97] Alleyne's success led her to tour throughout the Caribbean, spreading the name of Barbados, and an image of Afro-Barbadian women, far beyond the island's borders. But it wasn't until 2009 that she received official acknowledgment for her contributions to the nation when she performed on November 30 at Frank Collymore Hall as part of a celebration of Barbados's forty-third Independence Day. Online comments about the show sang her praises, but some lamented the fact that her legacy has not been as well kept as many who remember her would like. One commenter had this to say: "How come Wendy has not been given her due? We speak of Rhianna [sic] but I am sure there are those who would agree that were it not for Wendy some people would not have [known] a thing about Barbados . . . Wendy I love ya!!!!"[98]

Alleyne's success in the 1970s, on and off the island, paved the way for a number of female performers after her, one of the more notable ones being Lady Ann, who was the first woman to enter the Pic-o-de-Crop finals in 1984. In the 1990s Lady Ann migrated to Boston, "looking for greener pastures." There she worked as a nursing assistant before starting her own entertainment business.[99] She still performs, often in small venues where she can introduce her audiences to Caribbean music. Lady Ann is glad to see more women performing in Barbados, but "she believes they still have some ways to go in gaining the respect they deserve."[100] Both Alleyne and Lady Ann found that their most lasting success would be found, and ultimately their legacies would be best preserved, by going overseas. Their stories display the ways in which both Barbadian cultural forms and cultural representations are reliant on the migrations of Barbadian people, how the restrictions on success in the entertainment field are gendered, and how women performers can achieve the respect due to a queen by representing the nation abroad. Hinds's international performance schedule and the broad reach of her music demonstrate her queenliness in similar ways.

In 2005 the song "Roll It Gal" catapulted Hinds into international success. Within two years it had entered into the regular rotation of deejays playing Caribbean music worldwide and had been picked up by most major cell phone carriers as a ringtone. The song features the kind of "woman power" lyrics that Hinds had already used in earlier hits such as "Confidence" and "Ladies Rule." The lyrics speak of women's independence, strength, confidence, and, above all else, con-

trol. The chorus, "Roll it gal, control it gal," encourages women to roll their hips, while the verses implore women to take pride in their nonphysical assets and to protect and be proud of their bodies. Lines such as, "Go to school gal, and get yuh degree / Nurture and take care of yuh pickney / Gal yuh work hard to make yuh money," assert that such control and pride are founded on education, motherhood, and economic survival, but overall, "Roll It Gal" sends the same message that Hinds has given directly to her fans throughout the years: "Ladies, let's support and love one another!"[101] Hinds is a singular figure, but her queenliness is rooted in communal femininity.

Hinds is known for her performances, her body, and her movement. She has perfected what is known as the Caribbean wine, a dance in which one circles or rolls the hips and backside to the rhythm. "Roll It Gal" solidified the connection between Hinds's role as a Caribbean queen and the movements that she has built her career around. "Rooollllllll, roll it gal, roll it gal. Rooollllllll, control it gal, roll it gal." The words meld into the rhythm, forcing hips to wind around themselves, calling on a powerful Afro-Caribbean tradition. By rolling, wining, or otherwise wukking her hips, any "gal" is able to display an isolated control of her movement and direct any attention her body has attracted, and by circling this particular section of anatomy—where the body's center of gravity resides—she commands and manipulates the attraction of everything and everyone within her gravitational pull; she begins to master her very relation to the physical world. The call to "roll it gal, control it gal" is a specifically woman-centered invitation to display such power. It is a call that both exhibits Afro-Caribbean culture and invites any woman or girl who hears it to find power within the movement.

This movement is central to Hinds's performance of her Afro-Caribbean identity. The speed and control she is able to execute within her wine mark her as specifically Barbadian, wining as part of the national dance of wukking up.[102] Hinds's audience has come to know her as a woman in control, and the centrality of wining to her performance is but one manifestation of her authority over her body, her image, and her performance sphere. Manipulating her center of gravity, she attracts attention while the subtle nuances of her movements direct it. Feet firmly planted, often in stilettos, she stands her ground, challenging her audience to view her through the lens she chooses. Hinds is a wining, wukking-up woman whose movement and lyrics tell the history of Afro-Caribbean women's power in relation to the world around them. In doing so, "she challenges the objectification of the female body and demands a celebration of female sexuality," and she voices her celebration of this movement as a celebration of blackness.[103] The song "Roll It Gal" encourages women in the dance while promoting "woman power," both in the celebration of the female body and in the lyrics that promote education, health, and self-respect. The two attitudes of ancestral blackness and celebration of the body ultimately shape the ways in which Hinds has constructed her solo career as a queen—a powerful

woman in a cultural domain who maintains, represents, and expands a gendered, national, and regional identity.

The erotic power that Hinds exudes is tied to her own ideas of race, African ancestry, and Barbados as a predominantly black nation. In response to a critique of her sensual performances, Hinds had this to say in a 2000 interview:

> It's the same in Barbados. It's almost as if people are ashamed to do what for us comes so naturally. The grinding and the gyrating is within us, it's in our genes. We were not taught it. We don't have to be taught how to do it. When the music starts, we do what comes naturally. I feel sorry for those people who are not comfortable with being who they are, with being black, with what coming from Africa is all about. What are we expected to do? Stifle this thing that's within us until we finally choke on it? The wining must never stop! Carnival means time to let go, to let it all hang out. Time for breaking out of all those chains, placed on us by people who really don't know themselves. Our cultural safety valve![104]

Hinds's response is very much in line with Lorde's sense of the erotic. Lorde notes how "we have been taught to suspect this resource, vilified, abused, and devalued within western society. On the one hand, the superficially erotic has been encouraged as a sign of female inferiority; on the other hand, women have been made to suffer and to feel both contemptible and suspect by virtue of its existence."[105] Hinds decries the ways in which the power of the physical body and inner female strength are denigrated in society. But she also racializes this critique by tying the physical-psychic power to an ancestral blackness. Her own performances (and her defense of them) marry sensuality with an ambiguous and essentialist "Africanness" and celebrate movement and an awareness of it as part of a healthy sense of one's physicality and one's identity as a Barbadian.

The interview just quoted took place when Hinds was still quite young and in that stage of youth that is, more often than not, sexualized in its public representations, yet she was old enough and experienced enough for reflection and a discerning response to criticism. As a *young* woman, her body and its movement were assets to her publicity, but as an *adult* woman, she was able to articulate her own views of their reception. This is a quality that has come to shape Hinds's image over the past few decades. Her music has retained a very youthful vibe while she refines it to reach larger audiences; and with larger audiences and greater attention, she has had more opportunities to voice her opinions about what her music means to her and present her visions of what it can do for others. Negotiating her public image as she became a woman, she moved from being the daughter of Square One to taking the throne of Soca Queen.

As she began to reach out to broader audiences throughout the Caribbean and the world, Hinds thought it would be appropriate to use her status as queen in promoting her first solo CD in 2007. Explaining the title of the album, *Soca Queen,*

she says that she wanted to appeal to a mainstream market and for everyone to know that soca music is "a force to be reckoned with."[106] Those first encountering the genre through her music would be meeting the queen. Such an attitude is reflected in the album's packaging. Buyers are met with a close-up of Hinds's caramel-skinned face, carefully made up and lighted to create a slight glow on the front cover. She has a slight knowing smile, both inviting and secretive. Her jewelry is golden, simple, and largely on the margins of the image. Framing her face are a barely visible gold-link necklace and a similar round gold pattern lies on her forehead just barely in the camera's frame. Her eyes look out over a small nose ring. The album cover is entirely in soft earth tones, with a hint of yellow in the title. The title of the album is quite small and almost overshadowed by the artist's name just to the left of her face. Although she invokes her role as queen in the title of the album, Hinds's royal status is most evident in the visual image she presents on its cover.

The back cover continues the trend, with slight differences. This image of the queen is in profile, her gaze looking forward and no longer at the audience, while the shape of her head outlines the song list. With her red-tinted dreadlocks wrapped into a Nefertiti-style crown, Hinds has lost the headpiece featured on the front cover. The profile also includes the added feature of long, dangling, circular earrings, which fall just inches over her bare shoulders. The evocation of popular depictions of Nefertiti connects Hinds to a mythic African past, rooting her royal status in the image of an established and recognizable black monarch. The juxtaposition of these images, front and profile, is also strangely reminiscent of nineteenth-century ethnographic profiles and twentieth-century responses to these profiles.[107]

Hinds's second solo album, *Caribbean Queen*, invokes similar aesthetics. She loses the earth tones in favor of a royal-purple background. Again, her name far outshines the title of the album, whose content is consciously pan-Caribbean in musical stylings and subject matter. Her face still conveys a mysterious invitation, mostly in the direct gaze of her eyes and the slight turn of her head. The tribal-patterned tattoo on her right arm is just as prominent as the jewelry, which is much heavier than that of the previous album cover.[108] Her hair is upswept, invoking the same crown-like effect, while a few curled locks are allowed to fall, framing her face and resting on her, once again, bare shoulders.

These album covers portray a woman aware of her audience and in control of her space. The visual aesthetics echo Hinds's assertions in her interviews. She calls on hegemonic stereotypes of Africanness and womanhood but celebrates them from a place of agency rather than from a position of oppression. She negotiates hegemonic expectations by resignifying them in her public work. Hinds is looking at the viewer as she is being looked at. Her gaze suggests a power over consumers just as she is being consumed by them. The covers suggest such a power through hints of sensuality (her bare shoulders, the faint smile, an inviting glance)

that are held in check by the posturing of an African queen. These album covers sit squarely within the framing techniques of African diasporic women musicians, specifically those in the popular global market.[109]

Hinds's performance as a queen celebrates her African heritage, but it is not (or at least not only) an Afrocentric celebration employed in the service of black nationalist and/or black feminist empowerment. Hinds uses the trope of the black queen as a strategic tool of diasporic identification, crossing class, nationality, and differing politics of respectability. It is a statement of power, admittedly limited, yet potent in its achievability.

REFINING RESPECTABILITY: JAMMETTE AS QUEEN

Hinds's solo career is based on the trope of queen, enacted with an African-inspired aesthetic but also rooted in the history of public representations of Afro-descended women in Barbados and throughout the Caribbean. Belinda Edmondson notes that while, historically, "respectable" classes in the Caribbean looked down on (black) women performing in public, such a view "has been turned on its head in the late twentieth and twenty-first centuries as modernity and cultural progress have been linked to respectable women moving into the public sphere."[110] Hinds and many of her female contemporaries have redefined the parameters of respectability to include the kind of sensuality that is often credited to an African heritage and/or fought for in the feminist movements of the 1970s and 1980s. Hinds's reputation is largely built on this redefinition. These new parameters then incorporate historical elements and transform them within postindependence identity constructions. Through Hinds's performances, the movements, attitudes, sensuality, and cultural performances that once marked a woman as low class and of ill repute have become the signs of a culturally competent, respectable Caribbean queen. Such a transformation is apparent in the different historical readings of the term *jammette*.

Nineteenth-century Caribbean populations used the term *jammette* to denote a particular type of woman present in the public eye. Maude Dikobe explains, "Originally, the term 'jammette' referred to a prostitute, but in current usage it has become somewhat more generalized to refer to a woman who engages in unapologetic sexual activity. It derives from the French term *diameter*, specifically 'below the level (diametre) of respectability.'"[111] Dikobe goes on to trace the ways in which the jammette can be interpreted as a postcolonial expression: "Today the jammette image is 'honored' and perceived in a new and powerful light by some men and women who see it as a way to celebrate both African culture, and the rebellious role of Carnival as a form of resisting cultural and political oppression."[112] After independence, many of the practices that colonialism deemed inappropriate, lewd, and otherwise not respectable began to be viewed through the lens of (a usually nonspecific) African heritage celebrated in distinctly Caribbean

ways. The use of the hips and midsection, in particular, became central to an unapologetic performance of Afro-Caribbeanness. I use the trope of the jammette here as a tool to show the varied performances of the erotic in the specific history of the Caribbean.

The postindependence reclamation of the jammette celebrates what colonialism denigrated. It allows women to publicly celebrate their bodies, to display their own erotic power, and to exert control over the spaces in which they perform their femininity, ultimately redefining public standards of respectability. Even within such reclamations, not all jammettes are viewed in the same light. Especially since the reclamation of the term, various interpretations of the jammette trope have come to light in the performances of female artists throughout the Caribbean.[113] An analysis of three performers in the English-speaking eastern Caribbean— Destra Garcia, of Trinidad; Denise "Saucy" Belfon, also from Trinidad; and Hinds, from Barbados—demonstrates the variety of interpretations. Each performer is publicly sensual in ways that, by nineteenth-century standards, would earn her the title of jammette, yet each celebrates her body in her own unique way, providing three varied though related performances of the jammette trope. An analysis of the 2009 Soca Monarch collaborative performance of the song "Obsessive Winers" in Trinidad further illustrates this point.[114] It demonstrates the individuality of each performer, as well as the collective "woman power" that is central to performances of Afro-Caribbean femininity.

"Obsessive Winers" demonstrates different performances of Afro-Caribbean tropes of femininity, the autoerotic power of Afro-Caribbean women within popular culture, and the collective realization of that power. The performers—Destra, Saucy, and Hinds—all enact different performances of the jammette trope while engaging in a discourse of "woman power" as they entertain their audience. The lyrics to the chorus demonstrate the exceptionality of these women (as performers or as Afro-Caribbean women, it is not made clear), and the male vocals behind their voices underscore the point with a low-toned, "You're obsessed with this. You can't mess with this." Even though the women work collectively, it is Hinds whom both the audience and the performers are most obsessed with.

Hinds earned her titles of Soca Queen and Caribbean Queen through a repertoire filled with songs about wining and the language of movement in the Caribbean. Songs such as "Confidence," "Wukkin Crazy," and "Brace and Wine" all engage wining and wukking as a means to signify Caribbean culture, embody female power, and relate these things to wider audiences. Her titles engage both the Caribbean form of wining and the more specifically Barbadian form of wukking up, and her live performances mirror this negotiated space of a regionally and diasporically informed Afro-Barbadian femininity. In the 2009 Soca Monarch performance of "Obsessive Winers," each performer has her own style, but they all use a movement that has specific significance to the Caribbean, the wine, in order to demonstrate the power of the erotic within the Caribbean context. This particular

performance of the song occurs in front of a Caribbean audience that is both versed in and participating in one of the most salient expressions of Caribbean culture, carnival.

First to display her "obsessive wine" on the stage is Destra. Clad in a blue, tight, and very short dress, she turns her back to the audience in order to better display the movement of her hips and backside. She wears silver boots, colored highlights in her hair, a wide belt displaying a Coke bottle figure, silver bracelets, and noticeably long nails. Destra's carefully manicured appearance is one example of the ways in which "looks, costume, and a slim body are becoming part of a marketing strategy for soca that one cannot ignore."[115] As she moves, her dress slowly rises, and when her verse is through, the other performers come in with the chorus as Destra declares, "Is de dress, is de dress." Destra's performance here is one of a contemporary, respectable jammette. While her sexy and revealing costuming is an essential part of her marketing as a performer in that she "inhabits a conventional niche as a sex symbol—one associated with comfortable European pop icons of beauty," it also limits her movement (however slightly).[116] In declaring, "Is de dress, is de dress," she gives a slight apology for the fact that she is not willing to go to the level where she is completely exposed, and because of this, she is not able to execute the movement as fully as she would like within the moment. She is firmly within the public eye, but still somewhat apologetic.

The next performer to display her skill is "big bottom Alison Hinds."[117] Dressed in a sleeveless black-and-purple top with a high, sheer collar that shows just a hint of midriff, tight black pants, and what look to be four-inch purple stilettos, Hinds takes center stage. After a brief interaction with the audience, Hinds identifies herself as "Trinbajan," identifying with both her Trinidadian audience and the island she calls home, before stating that she has come to "represent" and asking the audience if they are ready. Hinds takes on the role of icon by consciously representing Barbados on a Trinidadian stage. Using the portmanteau *Trinbajan*, she marks herself as different and related to the women she performs with, embodying a national femininity that is regionally informed. As she turns around, she and her fellow performers turn their attention to the big screen behind them as both Saucy and Destra continue to comment on how big Hinds's "bumsy" is. As she begins to move slowly, there is roar of astonishment from the crowd that grows as the pace of her movement quickens. In the climax of her performance, when her hips wine the fastest and the audience gets the loudest, smoke blazes up on either side of her dancing body. Within seconds, Hinds has demonstrated that "yuh cyan wine like we."

Hinds's attire is tame compared with her collaborators'. Her movement, accompanied by other visual effects and eliciting the most crowd response, is celebrated. Here, in the context of the Trinidad Carnival in 2009, Hinds's movement—which in other contexts, in other times, could be interpreted as obscene and out of step with the mores of a respectable lady—is a source of pride. In this way, Hinds

becomes one of the most respectable and refined jammettes of her time. While clearly celebrating the movements, sense of abandon, and African origins of her culture, she is also careful to explain herself, stating, "I never go overboard. You'll never see me go down on the ground or lift my leg up. That's not even part of me. You can be sensuous and sexy without being slutty."[118] While celebrating folk culture as central to a Barbadian and a wider Caribbean identity, she still maintains a middle-class attitude. She has managed this balance between working-class culture and middle-class identity so well as to earn her the title of queen. In her performance of that title, however, she becomes a queen *of* the people rather than *over* them. Hinds carefully walks the line between the sociopolitical expectations of women in public that are based on a colonially imposed, English lady model and the cultural expectations associated with representing Barbadian people who define themselves in a complex manner that centers on the expression of a carefully controlled sense of abandon. In doing so, she negotiates national, regional, and diasporic identities while redefining class boundaries.

Last to take her turn is Saucy, also referred to during the performance as "Miss Teacher." Saucy is often critiqued as a more traditional jammette whose performances feature and rely on an unapologetic, raw sexuality.[119] She takes her solo only at the insistence of Hinds and Destra, and after shyly stating that she has nothing to offer and giggling at the back of the stage. Once "alla force [her]," she directly addresses the ladies in the audience, providing a lesson in what they should do with their men once they get home. The lesson begins with Saucy instructing the female audience members to tell their lovers (coded here as male), "Saucy send me to deal with you." In a single moment she transforms from a shy, demure, and girlish figure into a woman who is powerful, purposeful, and in control. Then, as Destra makes reference to the animal-print, midriff-bearing, skin-tight bodysuit that Saucy wears by asking, "Why yuh look like a porn star so?" Saucy interrupts her lesson to tell her, "I am a porn star." Even when being interrupted, she displays a keen awareness of her performance. As Saucy continues the lesson, demonstrating how the women should enter the bedroom, a young man from the audience finds his way on stage. In a most appropriate show of the autoerotic, Saucy sends him away, saying, "I don't want no man. I teaching the ladies what to do right now. So go back down. And I'm going to ask you in a little while what it is you like. Go on." Hinds and Destra recognize her actions as an act of "woman power." Saucy continues the lesson, demonstrating her wine, which ends with her trembling her backside and right leg.

Saucy is both unapologetic and in control. As a fairly short woman with curves and a bit of a belly, her body does not fit traditional Western hegemonic standards of beauty, yet she displays it willingly, celebrating her own beauty and leaving little to the imagination. She owns her movement and her role as a performer. The space of the stage is in her control, and while both her persona and her performance assume heteronormativity, she does not need a man to demonstrate her feminine power.

Rather, the idea of man becomes more important than the physical embodiment as she enacts her autoerotic power in a very public way. The support she receives from her fellow performers demonstrates the collective acknowledgment of her own definitions of beauty and a celebration of her individual power.

The three come together again for the chorus and continue to demonstrate that they are obsessive winers by getting "three bumpers going at the same time." Lining up according to the size of their backsides—"big, bigger, humungous"— Destra, Saucy, and Hinds begin to move together.[120] They must first adjust their timing to match each other in order to enact the collective performance of power that their execution of the dance relays. They begin moving in unison, but their movements become more individualized as the rhythm climaxes, displaying the agreement between their individual performance styles and their collective performance of female power. The performance ends with the three women singing the chorus of the song, followed by a collective hug, kisses on the cheek, and a shimmy of their breasts.

Their "woman power," their public performance of the erotic, is both individual and collective. Set within a carnival performance, the atmosphere of "letting go" is an expectation. The movements they use to display their erotic power are part of a familiar set of cultural practices most celebrated at carnival time. These performers (like many Caribbean women and men) use the movement of their hips, the wine, in order to perform Afro-Caribbeanness. Enacted by three women with special attention to the female body, this is a collective performance of Afro-Caribbean femininity, one in which each performer distinguishes herself as an individual and as part of the collective. By embracing these practices and the ethos of "letting go" in a very public arena, these performers call on the historical trope of the jammette. But the ways in which they define their performance space, the control that they promote within their public performance, and the clear articulation of that control as "woman power" make this a more contemporary enactment of the jammette.

Together the women represent a distinctly woman-centered power rooted in their presentation of the movement of their bodies, their ownership of their bodies, and their ownership of the space in which they perform. The male musicians, though present and important to the execution of the song, are largely absent in this part of the performance. The camera does not focus on the male bodies but presents the women as larger than life-size on a screen at the back of the stage. The musical accompaniment is scarce as the three women speak to each other and their audience, and the rhythms serve to accent the movement of the female performers' bodies.

Within this collective performance of Afro-Caribbean femininity, and of the erotic, Hinds stands out. The other performers, the audience, and the stage effects mark her body and movement as exceptional. The ways in which Hinds interacts with her audience display a deep understanding of performance, representation,

and artistry that both is endearing to fans and fellow performers and earns Hinds the right to the throne of Soca Queen. Her movement and her audience interaction are firmly rooted in the tradition of Afro-Caribbean performance that the other performers also enact, but as she performs on a Trinidadian stage and identifies with both the Trinidadians and Barbadians in the audience, her declaration that she has come to "represent" firmly places her as a representation of Barbados that has clear affinities with the neighboring nation of Trinidad and Tobago. While the regional affinities are clear, the specific histories of each island have subtly shaped the performances of gender. Hinds's identification as "Trinbajan" highlights the fact that her audience has extended beyond the shores of Barbados and has firmly taken root throughout the Caribbean as she continues to reach toward a global audience base. Her mastery of performance skills demonstrates why her audience has steadily grown over the duration of her career. The exceptionality demonstrated by the speed of movement, her artistic skills, and the response of both her fellow performers and their audience attests to her right to reign as Soca Queen. As a queen, she represents the nation and the region in her movement, displaying a cultural competence that makes her body a productive asset to the people she represents. As Harewood notes, Hinds's iconicity is important to her audiences. It shapes how they view their own possibilities. Hinds's fans "state that their participation in her performances is important to their own definitions of nation-home, and they link much of their positive engagement with Alison's performances to their perception that Alison is strong and in control. Alison and her fans' performance practices seek to re-position women[,] moving them from the margins, where they might only be visible as symbols, to the center."[121] In transgressing performances of class, embracing a broad African diasporic culture, and successfully negotiating disparate definitions of "respectable" femininity, Hinds uses her queenliness to reposition "woman power."

"I'M SO PROUD TO BE YOUR QUEEN"

And always, I've always wanted to have songs out there that represent women. Because there are so many places where women are seen as second class, or you know they're not permitted to go to school, or they're just supposed to stay home and have kids and that's it. And I felt like that was something that was missing. I didn't want to do it in a way that I had to beat down the guys in order to make the women feel good. I just want to make the women feel good, and just let the guys know, you know, we love you. We still want you, you know. We do. But I just wanted to make it known, and have songs out there that women can feel comfortable singing, and feel good about, and know that this is about us, and this is a way for us to empower ourselves.

—Alison Hinds, interview with *ABC News*

In representing Barbadian women, Hinds is careful to avoid the more recent ste-
reotypes that posit women as hard, conniving, and dangerous to men.[122] She has
a track record of producing songs that represent women's empowerment within
a symbiotic relationship with men.[123] This form of dialogue between woman and
man is most evident in a number of Hinds's collaborations with male perform-
ers.[124] Her womanist relationship with male performers is shown in the 2009 video
for "King and Queen," a duet with popular Jamaican reggae artist Richie Spice fea-
tured on the albums *Caribbean Queen* and *Motherland Africa*. The video to the
song visually demonstrates a collaborative partnership with man, places both
Hinds and Spice within a history of black royalty, and makes Hinds's performance
as queen accessible to an audience who may or may not be versed in the Barba-
dian movement vocabulary of wukking up.[125]

The video features a nuclear family and shows the parents (Hinds and Spice)
giving the two children (a boy and a girl) history lessons on famous black couples,
such as King Solomon and the Queen of Sheba, Emperor Haile Selassie I and
Empress Mona, Winnie and Nelson Mandela, and Barack and Michelle Obama,
who are portrayed by actors throughout the video. The two singers sing to each
other, but the camera rarely focuses on them together, and they only actually face
each other three times in ninety-seven camera shots. They are man and woman,
individual figures working together, complementing each other in a collaborative
relationship while drawing on hegemonic ideals of masculinity and femininity by
presenting a nuclear family.

The video begins with a shot of the family reading on the couch. The young
boy is holding a paperback copy of *Africa: Arts and Cultures*, edited by John Mack.
The girl brings a leatherback book entitled *Kings and Queens* over for them to read.
This family scene is the central storyline of the video. Hinds and Spice, working
within a nuclear family structure, are imparting a history lesson to the next gen-
eration. By referencing various African couples throughout different time peri-
ods and ending with Barack and Michelle Obama, the two place themselves within
a diasporic history of power and resistance. The scenes of King Solomon focus
on his wisdom and his love of the Queen of Sheba as the camera goes back and
forth between a depiction of the story of two mothers and shots of the two mon-
archs seated on their thrones with the king being openly affectionate toward the
queen.[126] The reenactment of Nelson and Winnie Mandela's relationship shows
him pensive behind bars and her just as reflective, seated in front of a Free Man-
dela sign. This depiction ends as she visits him and the two embrace through the
bars that imprison him. The final reenactment features Barack and Michelle
Obama. A preoccupied Barack sits alone, head in hand at the center of an office
scene busy with books and campaign materials. Michelle enters to give him sup-
port. Leaning her head on his shoulder, she reinforces the traditional view that
he is the source of strength while, whispering in his ear and giving a fist pound,
she clearly becomes an encouraging force. Each couple features an extremely

powerful man symbolizing wisdom, resistance, and possibility, but each man's power stems from the support, encouragement, and presence of the woman he loves.

In presenting these stories, Hinds and Spice historicize the kind of cooperative relationship that they embody in the video and that their lyrics support. They do this within a diasporic framework. Including the cover of *Africa: Arts and Cultures* in the opening shot conveys the investment in Africa that both Hinds and Spice have made a central part of their careers. As artists within distinctly Caribbean genres, this investment allows the two of them to represent the Caribbean region as a part of the African diaspora. Beginning with King Solomon and the Queen of Sheba, the tropes of king and queen become a diasporic resource as they elevate activists and political leaders from across continents to the status of royalty. The portrayal of each "royal" couple focuses on interdependence that encourages a (still unequal) sharing of power.

The presentation of Hinds's and Spice's bodies is central to the efficacy of the video. The fashion sense that they exude through their attire, the camera's framing of their bodies, and their subtle but constant movement places the video within their contemporary aesthetic moment while building on a historical base.[127] Interspersed between scenes of the family and reenactments of the stories of historical kings and queens are mainly solo shots of Hinds and Spice. The settings vary from a plain white background to a room with red walls and modern furniture to what appears to be an alleyway with wooden doors set in the stone walls of an archway. The fashion is just as varied and includes elegant black attire, bright flowing dresses, Malian bogolan mud cloth, and what could be called rock couture, complete with a dreadlocked mohawk. Each scene strengthens the image of these performers as adaptable Caribbean artists who belong to and are inspired by various musical and stylistic influences. The image of Spice wearing mud cloth and carrying a spear is familiar to his fans. He has fashioned himself as a proud African man born and raised in a Caribbean context. Yet the elegant black suit, the chocolate-brown jacket over pressed khaki pants, and even the orange-and-black coat he wears are not unfamiliar looks for him. Hinds shows her visual versatility as well with the kind of heavy bone and stone jewelry often seen on her album covers. Her dresses range from bright yellows and reds to all white, evoking both colonial ideas of purity and African diasporic sentiments of spirituality. Her long dreadlocks take on different forms, from the aforementioned mohawk to a coiffure that accommodates the length of her hair while providing her with a natural crown complete with a tiara of purple flowers (figure 7). As varied as her different ensembles are, each—along with the way she carries herself—presents a sense of dignity, maturity, and softness, creating an overall image of a woman quietly commanding respect.

Hinds's image in the "King and Queen" video is in many ways the result of a slow transformation over the years. From timid beginnings, through a stage during

FIGURE 7. Alison Hinds and Richie Spice in a video still from "King and Queen."

which she was criticized as overly sexual, and growing into the roles of mother and wife in the public eye, today Hinds stands as a woman who encompasses all of these images in one. In her interviews she comes across as a calm, open, and at the same time reserved woman; her stage performances and videos show a woman in control, outspoken, sexy, and dignified; and many of her endorsements, activist endeavors, and public service announcements rely on her role as a mother. Her role as the "queen" within the "King and Queen" video encompasses all of these qualities as well. She is a complement to Spice as "king" and in conversation with the other queens featured in the video. Hinds carries herself with the same stature as the Queen of Sheba, the lyrics show the same kind of support that Winnie Mandela shows, and the few interactions that she has with Spice are characterized by a playful encouragement similar to that present in the depiction of Michelle Obama. All of these women display an inner strength that they share as an expression of love for a man. Such an expression is still built on heteronormative gender roles. These women are powerful but not threatening. This is another example of Ula Taylor's "community feminism," a space that marries feminism and nationalism by uplifting entire communities and empowering women even within "helpmate" roles.[128]

While the video portrays Hinds in the powerful roles of queen, mother, and wife, noticeably absent is the celebration of her body through the physical movements that have made her career. The dancing in this video is tame, fluid, and not a focal point. The camera does not show the bottom portion of either artist's body, except when they are seated or in the four long camera shots. There is no view of the big "bumsy" that is central to the performance of "Obsessive Winers" or any of the movements that serve as the lyrical base of many, if not most, of Hinds's

most popular songs. Such an absence suggests that while her body is central to her image, Hinds has other assets to carry her successfully to wider audiences. The movements and celebration of movement central to her reign as Soca Queen take a back seat to a "safer" performance of queen that relies on a performative and conservative respectability. In this way, she still walks a fine line between the vulgar and the respectable Afro-Caribbean woman in public.[129] Although her public persona has pushed the limits of this dichotomy in the Caribbean setting,[130] her performance varies depending on the public she seeks to appeal to.

As a video, "King and Queen" reaches a much larger audience than live performances such as the one described earlier. This audience is further broadened by the presence of Spice, who has his own impressive Caribbean and international following. Hinds does not explicitly promote Barbados in this video, either orally or visually, but she does enact the Afro-Barbadian femininity that she has been so consistent in performing, one that is adaptable, transgressive, and informed by African diasporic and Afro-Caribbean cultural forms. In both her live and video performances, she enacts a performative Afro-Barbadian femininity through repeated performances of national sincerity. As the video for this song reaches a worldwide audience, it is important for Hinds to be relatable to as many people as possible. She and Spice achieve this by invoking a diasporic and historic Africanness, the same iterations of ancestral African heritage and African diasporic performance that have shaped her image over the last few decades.

As Soca Queen, Hinds is clearly rooted in Caribbean culture. Through the "King and Queen" video, she places herself within a larger African diasporic discourse of royalty. That discourse varies from an Afrocentric celebration that urges all African-descended peoples to imagine themselves as royalty in an effort at (perhaps an overly) corrective history to a strong critique of such royal utopianism that acknowledges that not everyone was or is royal and that such imaginings can overlook the serious issues of the "commonfolk," as well as lead to disillusionment.[131] Hinds's performance of the queen trope draws from both extremes of the African diasporic royalty discourse. Her celebration of blackness is built on both a mythic African past and the present materialities of diasporic relations. She encourages pride in the same way that previous Afrocentric arguments have, yet her "queenliness" is a matter of service rather than subjugation. Her lyrics, "I am so proud to be *your* queen,"[132] are both a romantic declaration and a statement of service to her audience. Her performance as Soca and Caribbean Queen serves as a way for her to walk the line between representing a nation and crossing national boundaries, between upholding standards of respectability and pushing those standards to be more inclusive, but walking a middle road also defines the boundaries more clearly.[133]

Hinds presents an image that works to demonstrate black female power through her performance of the role of queen, but she also tries not to offend. Ostensibly, this video does the work that Hinds hopes it will—namely, representing a strong

FIGURE 8. A video still of one of the family scenes in "King and Queen."

but respectable, educated nuclear family that celebrates a diasporic history while performing the prescribed roles of African "king and queen." But the ways in which Hinds represents as "queen" silences other possibilities. Her representation is conservative, heteronormative, and beautifully torn between Barbados's many cultural influences and the tastes and expectations of a wider audience.

While the video draws on a diasporic history, it leaves out "undesirable" parts of the story, such as the realities of premarital sex, queer sexualities, and the Mandelas' divorce. The nuclear family ideal that is proffered in the video is hardly representative of the reality of Barbados or the broader Caribbean, where most people are raised in single-parent households or extended kin networks.[134] It is, however, representative of the ideal that colonialism imposed for centuries and that nationalism has taken up in colonialism's stead. This nuclear family ideal not only ignores the historical constructions of Barbadian families, it also builds on the heteronormativity of the region.

Although the depiction of various queens in the video demonstrates a specific female power, the role of the daughter in the video holds little promise of this power. In the camera shots that show the family, she is often cropped out of the captured moment, and even when she is included, she is in profile while the rest of the family smiles head-on at the camera or focuses on the young boy between Hinds and Spice (figure 8). While the girl is the one who brings the book to the family (and thus brings the knowledge of an African diasporic past), her experience borders on exclusion.

Hinds's performance as a queen is one way in which she fights her own exclusion. When her fans gave her the title of Queen of Soca, they gave her representative status. This title will always link her to the communities, the nation, and the region she represents. But no matter how well she represents them, there will

always be identities that are left out of the iconic image that she offers. In order to appease the majority, she offers a powerful black femininity, one whose power is not too threatening to the social structures of old. The way in which she is expanding her fan base—slowly, through diasporic connections—allows her to remain rooted in diverse Caribbean communities while opening up the boundaries of that identity by showing the affinities and complexities of relations among diasporic populations.

MY SPACE: PERFORMING QUEEN BEYOND THE NATION

As Hinds builds on and remixes existing tropes of African royalty, she has also utilized changing technology to reach out to her audiences throughout her decades-long career. Her early work with Square One was firmly entrenched within regionalism and an African diasporic consciousness while offering a soundtrack for peace based on common humanity. Songs such as "Faluma," "Togetherness," and "Fireworks" seek to build community across national boundaries by using language indigenous to other Caribbean neighbors in "Faluma," declarations of unity in "Togetherness," and global critiques of war and conflict at home and abroad in "Fireworks." Hinds has come to use the internet, specifically her website (alisonhinds.com), Twitter, and Facebook, to connect with her audiences. In tweeting her daily activities, promoting her upcoming appearances, and posting "flashbacks" like these songs and old photos, she builds not only ambient intimacy[135] but also a community based on commonality.

On her first solo album, *Soca Queen*, Hinds melds the specific experience of being an "island girl"[136] with names and sounds familiar to a broader market. With "The Show," Hinds replaces big names in the industry, such as Beyoncé and Jennifer Lopez, by introducing the song with the following lines:

> Beyoncé can't make it tonight
> She musta hear about Alison Hinds
> Beyoncé couldn't make it tonight
> Tonight is Caribbean wine
> J.Lo couldn't make it tonight
> Tonight you have Alison Hinds
> None of them could make it tonight
> So here we go, here we go.[137]

Set to a Caribbean rhythm laid under the melody that opens "Are You My Woman" (by American soul group the Chi-Lites and sampled by Beyoncé in her 2003 song "Crazy in Love"), Hinds's self-placement is not only a way for her to declare her place on the world stage after a brief hiatus; she is also articulating that she has (or should have) the same status as the pop icons she mentions. She makes these

claims based on her ability to perform the Caribbean wine. Her comparison to these specific artists is important because they are also known for their movement, their bodies, and their mastery of each within specific realms of performance.[138] Hinds inserts herself into a global popular culture tradition of female performers known for their asses, their heterosexual performances, and, in using both, their ability to "challenge male authority over symbol-making."[139]

Musically, the rest of the song draws on a Caribbean rhythm interspersed with Diana Ross's 1980 hit "I'm Coming Out," which both interrupts the song and harks back to Hinds's performance roots on the Barbadian hotel circuit where she performed pop, R&B, and reggae covers. The hotel space is one where performances of Barbadian identity and culture are codified as a tourist product, and it is a space where performances of gender and sexuality are troubled and remade. Whereas in the eighteenth century the hotel space was one where women were both mired in disrepute and able to accrue wealth and business acumen, postindependence, the hotel space is one where culture is both performed and defined. Hinds notes that "playing in the hotels definitely gave [her] that opportunity to be able to learn how to adapt to different audiences."[140] She is hardly the only queen to be groomed in this space. Biological males who live as queens have been a part of Bajan culture for some time, often with high visibility as business owners and performers. In the late twentieth and early twenty-first centuries, many of these queens perform on the hotel circuit.[141] The choice to sample "I'm Coming Out" in "The Show" is both a declaration of Hinds's solo career on her first solo album and an acknowledgment of the nonheterosexual and nonconforming gender communities that often do not have as much visibility in Barbados or national representations of the island and its culture. The original version of "I'm Coming Out" "was partly created in response to New York drag queens who performed as [Diana] Ross," and it marked one way in which "Ross's cultivation of her iconic status includes intimate and strategic responses to her fans."[142] In sampling Ross, another iconic heterosexual female entertainer, and specifically a song that responds to her same-sex-desiring audiences, Hinds subtly acknowledges the fluidity of gender and sexual performances in her fan base and within the communities that she represents. As Rosamond King notes, Hinds has positioned herself as a heterosexual woman, performer, mother, and wife in the public eye, but in one of her more popular songs, "Faluma," she also (quietly) references same-sex desire in an affirmative manner.[143] Her confident insistence on her own iconicity is one way in which she "appropriates the male privilege of speaking and being heard, and, doing so in such a sensual and hyperfeminized body, allows her to transgress the boundaries of male roles and female roles."[144] With "The Show," Hinds claims her space among pop royalty, and, not unlike Diana Ross before her, she is able to perform as an iconic figure, as Soca and Caribbean Queen, while defining femininity in a space and in a manner that are accessible to a host of other women, performers, and queens.

On the same album, Hinds debuts "My Space," which uses the then popular social networking site as a platform for party promotion. Here, globalization is a site for fun.[145] The theme of music bringing people together across the world is made explicit and specific in the reference to Myspace. The title tells of a new vision for Hinds's career and the culture that she represents. An alternate reading of the title as "*My* Space" shows how every place the music touches is a site that belongs to the singer. The ubiquity of the music and the internet site that it references allows for new visions of travel and cultural influence. She sings, "All my crew who coming through / raise your hand, raise your hand / show your face if you're on Myspace / wine your waist in the place," establishing a community of music lovers and internet users. She ends the song by saying, "Myspace.com/ Alison Hinds, that's where you can find me, and in the party, and in the fete," using the song as both a practice of Caribbean culture and an advertisement for it. Claiming the internet, the performance sphere, and their intersections as "my space," Hinds's song supports Daniel Miller and Don Slater's assertion that the internet is one of many spaces within the social sphere and is not separated from "real" life and "real" space.[146] Hinds's use of space here is both an example of the hyperreal, where reality and representation compete, conflate, and work with one another, and a performance of her national sincerity. She represents her culture as she knows it, but her representation is still based on a mythic image of the Caribbean as fun, as leisure.

Hinds is an example of a Barbadian queen, a strong, powerful woman who complements man without quite needing him, who knows, builds, and spreads the power of her femininity without degrading masculinity. She is sensual and respectable. And most importantly, she knows it. When asked what it means for her to be a queen, Hinds spoke to the fact that she is always in the public eye. It is a persona that she has chosen to actively cultivate in both her stage performances and the quotidian performances of everyday life. She says, "I try my best to try and conduct myself a certain way, . . . understanding that I'm in the public eye and how my fans see me. Regardless of whether I'm on stage or not, my fans see me as the Soca Queen. . . . And then people you know they come up to you and say hi, and they give you compliments, and they talk to my daughter, ask me about my daughter too and all of that kind of stuff. You know all of that kind of comes into the whole persona and I take that very seriously and I try my best to be able to live up to those expectations."[147] By approaching the performance of queen in the way that she does, Hinds receives the respect accorded to that role both on and off the stage.

In physique, attitude, and performance, Hinds is the ideal queen, both inspiring and representing the people in her domain. Although specific performances (such as the Alison's Wonderland show in 2009) have been harshly critiqued, Hinds's reign as Soca and Caribbean Queen has been undisputed. The question remains how wide her rule will extend as she seeks to increase her audience, and

how her specific performance of Afro-Barbadian femininity will translate to these wider audiences. She represents both the nation of Barbados and the Caribbean region as a whole, but she also represents a particular form of black femininity that draws on both definitions of respectability imbued by colonialism and various African, Caribbean, and diasporic practices of femininity.

Hinds consciously uses the embodiment of Afro-Barbadian femininity to expose the world to Barbadian culture. Many artists who are working to make the genre of soca music more prominent within global popular culture find themselves mired in arguments about cultural and musical standards, as well as issues of resources, copyright, and cultural translation. Hinds agrees to some extent that much of soca music falls into the "jump and wave" category, which focuses merely on a party atmosphere specific to the Caribbean, and that this is one thing preventing the genre from reaching beyond the markets of the Caribbean and the Caribbean diasporas. She attributes the success of one of her most widely popular singles, "Roll It Gal," to its subject matter of "woman power," which many different cultures and peoples can identify with. The song has a strong message while maintaining a fun vibe and party sound.[148] It is her performance as a queen within this song, one who is both self-possessed and able to empower others, that has ultimately led to its popularity both within and outside Caribbean shores.

Hinds's distinct performance as a Caribbean queen is a tool that she uses to fulfill the responsibilities she feels toward the nation of Barbados, the Caribbean region, and the women within these spaces. Such a representation requires balance. When asked what she would like a foreign audience to take away from her performances, Hinds responded, "That Barbados is a vibrant little—it's a small island but it's very vibrant. We have a very rich culture . . . we know how to party and let go and just be, and we welcome everyone to be a part of what we have. And to take with them that special feeling, and that good energy, and a couple of Bajan slang words, and learning how to wine the waist, and you know, just know how to really release and forget your worries for a little while. We all have that pressure, but I think we're very good at that, we're very good at just 'yeah, we comin' out to party so forget about the bills for now, we're just gonna let go.'"[149] This attitude is one that is central to the genre of soca music that Hinds promotes, but she also believes that soca and Caribbean music in general must be about more than the party. Like many other artists, tourism ads, and ordinary citizens, Hinds's music represents Barbados as a place of relaxation and release, bordering on enforcing historical myths and stereotypes of the Caribbean region as a tropical paradise. Her music, however, does not dismiss the pressures and social issues that people need release from. Hinds doesn't "cry down" party music but rather believes that it must be balanced by social messages in order for it to break into wider markets.[150]

As a solo artist, Hinds understands that her individual efforts will not be enough to represent Barbados on a wider scale.[151] In a 2007 interview she explains,

"I understand that it's not just gonna take me alone. I can't carry the world of soca on my back . . . but I can try to make inroads, to at least try to get a foot in de door and crack open the door for other artists to come through."[152] This door leads to the global market, one that Barbados and the Caribbean region have always had a central role in. Postindependence, Barbadians wish to achieve more influence and assert a cultural identity with global performances. While some Barbadian artists are looking to Los Angeles and New York in order to break into the North American market, Hinds is looking farther than that. Her American audience is important, but it is only one part of the global audience she hopes to appeal to. She continues to collaborate with other artists, to reach for wider audiences, and to fly the flag of Barbados across the world, explaining, "My albums are not about America and Americans buying but made for the world to enjoy from the heart of the Caribbean. I represent Caribbean peoples, especially the Caribbean woman, independent, sexy, strong, loving, mother, wife, sister, friend, total. That's the way I roll. I am your Caribbean Queen."[153] In examining the ways that artists such as Hinds represent themselves and the nations they come from, one can see how national identities interact with gendered identities, the ways in which national interests and individual careers meet in commodity markets, and how individual artists imagine themselves as representatives.

Whether it be runaway enslaved women, propertied hoteliers, fictional pro-tagonists, or musical performers, Afro-Barbadian women have consistently used whatever agency they had to define and redefine their roles in society, all while negotiating the varied expectations and circumstances they faced. Sometimes these negotiations appear to go along with hegemonic understandings and expec-tations of Afro-Barbadian women, but more often than not they are more nuanced, both supporting dominant hegemonic representations of themselves and subverting them. Through an erotic performance of femininity that relies on the trope of queen as a diasporic resource, Hinds is able to negotiate a career as an artist and a national representative. Through community feminism, she is able to push the limits of "respectable" femininity and subtly create space for more sub-versive representations of Afro-Caribbean femininity by using her own feminin-ity in service of representing Barbados and the wider Caribbean region.

4 · "LOVE YOU ALL"

Rupee, Afro-Barbadian Masculinity, Activism, and the Temptations of a Global Pop Market

"Good morning, king. Happy New Year. Is this de way to . . ." An early-morning drive to see the sunrise on New Year's Day 2010 brings a sense of peace to the island. The display of respect between the two men before me now is refreshing after the interaction my friend and I witnessed just an hour before. Two men broke into an argument in the middle of an Old Year's Night celebration in the streets of Holetown.[1] The Holetown party is one of the more popular in Barbados on Old Year's Night, but as the liquor flowed and the crowds began to thin, some altercation was expected to arise. As soon as the men's voices began to get loud and attract attention, their friends pulled them away from each other before it turned physical. One walked away. The other continued to yell after him, chest puffed out, face askew with anger: "If I catch he on de street . . ." Onlookers seemed unimpressed. A well-traveled couple to my left spoke of how Barbadians are all talk. The woman noted that if it were Jamaica, the United States, or anywhere else, somebody would have been dead by that point.[2] Her friends agreed, careful not to wish such violence on Barbados but also noting the imitation of "the killer persona" in the bravado of the man still yelling down the street. Standing on the beach an hour later, surrounded by people drenched in a peaceful calm with the sun rising on a new decade, it seemed that there were mainly two models for young men in Barbados: peaceful kings and violent killers.

"Good morning king" and "How's it going, killer" are both common greetings among the younger generations of Barbadian men in the twenty-first century. Each identification asserts an unmistakable power: one based in the royalty of empire, the other in the ability to hold one's life in limbo. A desire for such power dates back to a colonial past when few men could perform the sociopolitical power that colonial structures defined as the masculine ideal. In the long period between Emancipation and independence, for most, masculinity was practiced *against*

something else: against femininity, against coloniality, against a perceived "effeminacy" (often referring to a particularly Barbadian form of homophobia)—indeed, against any sense of powerlessness. In postindependence Barbados, even with what may seem like a strict binary between peaceful king and violent killer, men perform masculinity in many more ways than was historically allowed. This chapter focuses on popular soca performer Rupert "Rupee" Clarke, a prominent postindependence Barbadian man who serves as an internationally circulating representation of Afro-Barbadian masculinity. As an artist who grew through the Barbadian performance scene before being signed to a major U.S. recording label, his masculine performances differ from those of colonial generations, and from those of other Afro-Caribbean male artists within the global mass market. Rupee's public-facing masculinity exemplifies a transitional Afro-Barbadian masculinity, one whose direction is still undetermined.

Rupee consciously represents Barbados, but perhaps less consciously represents Afro-Barbadian masculinity, which has undergone major historical shifts. The first shift occurred with Emancipation, which changed societal ideals, if not actual roles. The (largely Anglican) church and colonial powers encouraged Afro-Barbadian men to uphold a system of patriarchy, continuing and expanding the patriarchy of the plantation system. Christine Barrow asks, "How could this new patriarchal model be realized in the contest of powerlessness and racist oppression; unemployment, minimal wages, alienation from the land and poverty; and black female personal and economic autonomy and resistance to the wife/mother stereotype?"[3] The contradiction between the ideal and the societal realities remained throughout most of the nineteenth and twentieth centuries and is one way in which the different cultural standards that make up a national identity manifest themselves in specific gendered identities as well.

Colonial narratives of Afro-Barbadian masculinity depended in large part on sexual conquest, virility shown through fathering children, and a public image that sometimes (but not always) included violence. Frequently, Barbadian men searched for power through their relations with women. In rum shops, in galleries, and under streetlights, men articulated masculinity as "natural facts" rather than social constructions. In short, "man is man." In his 1987 study of Barbadian masculinity, Graham Dann notes that many of these discourses, even postindependence, arise through the gendered nature of early socialization. He demonstrates how school training genders the labor market as boys and girls are steered toward different occupations. Home structures also function as a site that defines the ways in which children perceive masculinity and femininity. Dann concludes that "socialization is sex typed, and that the subsequent image that Barbadian men have of their womenfolk will, to a certain extent, be based on the separation of life into two spheres."[4] Like all gender constructions, then, Afro-Barbadian masculinity is a product of socialization into a performative role.[5]

Further, even homophobia as a practice of "ideal" masculinity is built on a model of strict gender roles in society, creating "a panorama of views on homosexuality which range from total rejection to half-hearted acceptance. Nevertheless, underpinning most, to a greater or lesser extent, is the all too familiar sex typed dualistic world of male and female in which woman is subservient to man."[6] This notion of female subservience is one of the contradictory linchpins of colonial liberalism encouraged in post-Emancipation Barbados,[7] and one of the defining factors of Afro-Barbadian masculinity operating in a society in which the colonial ideal of the powerful man has always been challenged by Afro-Caribbean practices of femininity and sociopolitical structures that leave few areas for men to exert such assumed power.

Another shift occurred in the late 1970s when the world experienced an international feminist movement. A decade after independence, in 1976, the new nation-state was one of the first in the region to institutionalize a women's bureau. Rhoda Rheddock notes how investigations into "women's" issues during this time period began with the assumption that something was wrong with femininity, but they increasingly began to examine masculinity as well. This is reflected in Barbados, as the government changed the name of the Women's Bureau to the Bureau of Gender Affairs in 1999.[8] In the postindependence generation of Barbadian men, there were significant reactions to feminism. Reddock writes, "Whereas some men have sought simply to fight back against the women's movement, others have seized the opportunity to reflect upon their experiences of masculinity and manhood, in the same way as women for the past four decades have done for femininity and womanhood."[9] Many of these reflections have steered Barbadian masculinity in a slightly different direction from that taken in previous generations.

Barrow notes that younger men were "more inclined to conjugal equality."[10] This is still within the structure of heterosexual domestic unions in which the man is assumed to exert his "natural" authority.[11] In his study, Dann found that, "generally speaking, interviewees were far more tolerant of Women's Liberation than homosexuality" and that "there appears to be a slight linkage between having a positive attitude towards women and being prepared to respect their bodily rights in the context of a sexual relationship."[12] Bodily rights, however, are not quite the same as social roles, which are still entrenched in a heteropatriarchal system. Dann goes on to state "that any role reversal, in which a woman assumes the superordinate position in a relationship, will also be regarded with suspicion by men,"[13] suggesting that while gender definitions have changed, it has been a slow process that has yet to approach gender equity.

In the Barbadian public, male figures have been both lionized and vilified in the media and in public memory as stately kings and servants of the nation and as power-hungry protectors of their own reputations, their political parties, and their own public interests. The peaceful king and aggressive killer models are two of the most visible ways to represent a search for male power in postindependence

Barbados, but as this chapter shows, they are hardly the only ones. While Barbadian masculinity is still very much defined in relation to femininity and is still entrenched within a heteropatriarchal system, in the twenty-first century it is also defined by a responsibility to the nation centered on familial duty and on a balance between service and economic upward mobility.

Through his "love you all" aesthetic, Rupee performs Afro-Barbadian masculinity through a sense of duty and responsibility to God, to the Barbadian nation, to family, and to women. Rupee represents this contemporary masculinity through his critiques of male-female relations, his celebration of women, and his encouragement of responsible sexuality through both his HIV/AIDS activism and his critiques of and advice for younger artists. He draws on his experiences as a multiracial Afro-Barbadian man who was born abroad in order to employ transnational, regional, and diasporic influences in his work. As a "homegrown" artist who signed a deal with Atlantic Records, a major international label, Rupee takes his role as a performer, as a representative of Barbados, and as a man in the public eye very seriously. His performance of masculinity is still founded on a heteronormative patriarchy, as he promises to always "love, protect, and respect de women," but he uses this form of masculinity to market himself and to "fly the flag of Barbados and put it on the map."[14]

Rupee's persona as a heterosexual Afro-Barbadian man and his performance as a representative of Barbadian culture are based on love. His varied performances (as man, singer, and representative) are in conversation with many theorists and writers who "understand 'love' as a hermeneutic, as a set of practices and procedures that can transit all citizen-subjects, regardless of social class, toward a differential mode of consciousness and its accompanying technologies of method and social movement."[15] The inclusive nature of his performance (he "loves you all") constitutes what Chela Sandoval terms a "neorhetoric of love in the postmodern world,"[16] because it seeks to unite subordinated populations and to change both the boundaries of power and the sites where it is contested.

Rupee's performance both creates and mirrors the space for identities that cross national and regional borders to come together and physically be moved by his music while intangibly being moved toward an ethos of "'love,' understood as a technology for social transformation."[17] Such a performance is still rooted in national pride and a very specific Afro-Barbadian male experience, but it becomes an avenue through which Rupee shows that regardless of nationality, he does indeed "love you all." Such love transcends a surface reading of heterosexual attraction (a love for women) and extends to love for national culture, love for the power of performance (performative representation), and a greater love for humanity. As national and gendered identities continue to shift in a postmodern global world, Rupee's international performance of Afro-Barbadian masculinity rooted in love divorces his image from violent representations of the developing world and empowers his image with a discourse of love that crosses ideological

and rhetorical boundaries. The silences in his performance of masculinity, however, trouble the inclusiveness of his "love you all" declarations, thus limiting the power that a discourse of love has on representations of identity. Namely, in working within AIDS discourses while remaining relatively silent on homophobia and its effects on Caribbean masculinity, Rupee curtails the transformative potential of his performances of masculinity.

This chapter begins with a brief look at Afro-Caribbean male artists and Rupee's early performing career in order to contextualize the ways that Rupee takes Afro-Barbadian masculinity and Barbadian culture to a wider market using a creative blend of distinctly Barbadian forms and those more popular with foreign audiences. Rupee draws on previous performance tropes and discourses but situates them in his contemporary moment, bringing his personal history and his personal vision into the performance arena. He was born in Europe and raised in Barbados, and he uses African diasporic resources to intentionally represent his island home around the world. Rupee enacts an Afro-Barbadian masculinity that is not easily codifiable into familiar tropes of violence, danger, hypersexuality, or a generic "laid-back" island spirituality. His performances mark him as a national icon whose image insists on nuanced readings of gender, nation, and sexuality. Using Rupee's public persona as an example of Afro-Caribbean masculinity, this chapter will interrogate different tropes of Afro-Caribbean men, their relationships and attitudes toward Caribbean women, and how Rupee's performance of masculinity has contributed to his success as a performer and as a representative of Barbados. Through an analysis of "temptation," I argue that Rupee's reputation of being popular with and respectful toward women, and his negotiation of this reputation, underscores larger negotiations between local and global markets and the issues of representation that such negotiations present. Both the heterosexual temptations of female fans and the larger temptations of fame take a back seat to Rupee's more important pursuit of expressing love and representing his home. By analyzing his attention to women within his activism, I highlight his relative silence on same-sex-desiring peoples and explore the possible reasons for such silence within his representations of the nation. Much like the performances of other icons this book examines, his public performances have clear representational limits that make some form of silencing inevitable. Similar to Barbara Browning's ethnographic work,[18] this chapter will look at such silences as meaningful in exploring how they represent Afro-Barbadian men and Afro-Barbadian masculinity through what they (don't) say.

THIS IS RUPEE

In 1975 a white German woman gave birth to a son, Rupert Clarke. Rupert's father was an Afro-Barbadian man serving in the British military ranks. The family lived on a base in Germany. Rupert remembers being a fun-loving child who loved to

eat and who was close to his parents, especially his mother, who affectionately called him Rupee. Growing up in Europe, Rupert "Rupee" Clarke was not immune to the influence of the images and music coming out of the Caribbean. Rupee explains, "My household was West Indian and [my father] was always playing like Bob Marley and Red Plastic Bag and Sparrow. Me mom now was playing the Rolling Stones and Bob Dillon [sic]. So I've got quite a diverse musical taste instilled in me."[19]

While Rupee heard a diverse musical soundtrack in his home in Germany, the cultural and sociopolitical landscapes of the Caribbean were undergoing significant changes. In Jamaica, the decade after independence in 1962 had produced economic instability and society had continued to be rigidly stratified socioeconomically and culturally. People once seen as outliers and vagabonds were becoming more visible as "rude boys" and Rastafarians, two subcultures of the island nation. The music became grittier and more sociopolitically oriented and began to make incursions into larger markets. In Barbados, a similar phenomenon was occurring in the music scene. Only decades before, the island was tied to "high culture" through the Brahms and Beethoven played on the one radio station on the island.[20] By the mid-1970s, Trinidadian calypso was making inroads and the traditional forms of tuk and calypso that had gone underground in the World War II period began to slowly gain more respect among Barbadian audiences.[21] The relationship between these homegrown cultural forms and foreign money started to become institutionalized with the rebirth of the Crop Over Festival in 1974 as a tourist attraction. Performing a national culture was one way to stay economically afloat, and the upsurge in tourism brought the Caribbean region more firmly into the international eye, even if it was mainly as a paradise fantasy.

By the time Rupee was born in 1975, the world's image of the Caribbean region had changed drastically due to the visibility of the first Third World international icon, Bob Marley. Marley's "world-wide popularity put Jamaica on the map like never before, superseding the association which Harry Belafonte had had with the island when he recorded his first songs about Jamaica a decade earlier."[22] Marley's image, however, was not necessarily one that the entire Jamaican nation or Caribbean region was ready to enthusiastically endorse. He had long since outgrown the clean-cut doo-wop aesthetic of his early music career and had settled into the image of a "sufferah." This image melded those of the earlier Jamaican rude boy and the increasingly visible Rastafarian culture by focusing on those in society who felt the brunt of the economic and political crises of the 1970s. The album art to the Wailers' 1973 break-out album Catch a Fire put these images—rude boy, Rasta, and sufferah—together in the form of a candid head shot of Bob Marley smoking a big spliff.[23] This was not an image of British empire or an independent Jamaican civility. Marley's unruly hair, his assumed shirtlessness, his unshaven chin, and his direct gaze at the viewer over an illegal substance did not fit the bourgeois standards of any society.

This was an image that circulated far beyond the borders of Jamaica, beyond the waters of the Caribbean Sea, and beyond even the Caribbean communities abroad. The juxtaposition of the title and the image did not help matters. The title, *Catch a Fire*, carries connotations of contagion. There were serious implications in the threat of what was signified in this image spreading. The album appeared internationally only years after (sometimes violent) urban rebellions in the United States and decolonization efforts across the world. Both the title and the image evoke memories of rebellions where the enslaved would set fire to cane fields and watch both the flames and the spirit of rebellion spread throughout and across plantations. As this cover traveled, such a connotation was subversive in suggesting that a sense of rebellion could be contagious, and perhaps just as infectious as the popularity of Marley's music.[24]

As his was one of the most widely circulating images of a Caribbean man, Marley was extremely influential to young male artists born in the 1960s and 1970s in the Caribbean. His public image moved from one of a quick-to-fight "Tuff Gong" to that of a pensive and wise "natural mystic," and for a time after his death the subversive elements of his image and his legacy were explicitly removed by music retailers and the Jamaican nation-state, who preferred to focus on his message of "one love" in the 1980s and early 1990s multicultural moment.[25] In the last ten years of his life, he was reified as both young Jamaican killer and peaceful Rastafarian king, and his influence continued posthumously.

In Barbados, young artists were also looking to the likes of the Mighty Gabby, Red Plastic Bag, Grynner, and the Mighty Dragon as examples. These artists did not carry the same subversive visual aesthetics of Marley, but they did seek to speak for "sufferahs." Their art form, calypso, had been denigrated in many ways within a colonial society that looked to Europe as a cultural standard. Their predecessors traveled as strolling minstrels, surviving off of the generosity of individuals and practicing the art by literally singing for their supper.[26] The tradition of calypso (and the social commentary that characterizes it) has a long-standing history on the island, dating back (at least) to early plantation songs. As longtime calypsonian Red Plastic Bag defines it, the role of the calypsonian is "to be the voice of the people," to be the people's newspaper.[27] Bag, Gabby, Grynner, and Dragon worked to be included officially in the revival of Crop Over in the 1970s and bring repute back to their work and the voices it represents. By 1985 Barbadian calypsonians had established themselves as some of the most respected in the region.

At the same time, the Clarke family, including ten-year-old Rupee, relocated to Barbados. Rupee eventually entered the annual Richard Stoute Teen Talent competition and launched his own musical career. Winning the contest as a teenager in 1993, he went on to join the previous year's winner, Adrian Clarke, and another contestant, Terencia "TC" Coward, to form the popular group Coalishun.[28] They had regional success with songs such as "Tundah," which details the

competitive atmosphere of the dance floor, where a young man's reputation is threatened by the presence, boasting, and movement of a woman. Ultimately, the song is about who can outdance whom, who can control whom on the dance floor, and the social implications of such a contest. In songs such as this one, a man's quest for control over a woman (and thus his reputation) still defines masculine rhetoric. The song gives credit and respect to the woman, however, by boasting of her skill.

It was the 1996 hit "Ice Cream" that solidified the image that Rupee would become known for. The tone of the song is playful and slightly sensual, and although it follows in the tradition of objectifying and consuming the female body,[29] it is most often received as complimentary and respectful. Rupee's public persona became tied to these themes. Coalishun disbanded after five years and each member continued the musical craft, becoming staples within the musical tradition of Barbadian Crop Over competitions. Rupee's solo efforts continued to "uplift" and "respect" women with songs such as "She's a Winner," "Hold Me Tight," and "Enjoy Yourself." He went on to capture Barbadian, regional, and Caribbean diasporic attention as a solo artist in 2000 with the single "Jump." The song won the Party Monarch competition that summer.

Throughout the early 1990s, Rupee sported braids that, coupled with his light skin, reminded many in his audience of the Jamaican performer Red Rat.[30] At times he was even mistaken for his contemporary, whom he would collaborate with in 2003. At the same time that Rupee was establishing his musical career in Barbados using soca infused with dancehall stylings, dancehall was gaining a foothold in his birthplace of Germany. Martin Pfleiderer writes that in Germany, "although the reggae scene is only a minor cultural group it is, nevertheless, a vibrant part of the 'mainstream of minorities' within contemporary German popular culture, and it shares several attitudes and cultural orientations with other youth scenes."[31] Notions of "authenticity," appropriation, and cultural influence abounded in youth scenes on both sides of the Atlantic. As Rupee came into his own as a solo artist, he began to change his image visually by moving away from his earlier Red Rat look and relying on a fashion aesthetic more informed by U.S. hip-hop, which would dominate the covers of his next three solo albums (*Blame It on the Music* [2001], *Leave a Message* [2002], and *Thisisrupee.com* [2003]). He used both his mixed-race transnational background and African diasporic resources to build a public image for his musical career.

Musically, Rupee was neither peaceful king nor violent killer early in his career, falling more into the Caribbean tradition of saga boys or sweet-talkers. Songs like "Tundah" and "Hold Me Tight" exemplify this lyrically and vocally. His visual image, however, does not reflect this. The album cover to his first solo attempt is much less controversial than that of *Catch a Fire*, but it includes some elements of rebellion. A practicing graphic designer at the time, Rupee composed the packaging of this album, displaying an authorship over his image that is not common

for many musical artists. He relies on a 1990s hip-hop aesthetic, including a ban-
danna, gold chain, leather jacket, and direct gaze at the camera. Weed is not pre-
sent as it is on the *Catch a Fire* album cover, nor is Rupee's body sexualized by
shirtlessness. Unlike Marley's face on the *Catch a Fire* cover, which is character-
ized by deep contrasts of shadow and light, on the cover for *Blame It on the Music*
(and in many of his promotional images), Rupee's face is well lit. The images often
play with his light skin tone. Here, as a "red man," his skin is juxtaposed to the
warm yellows and the cool purples of the background. His reliance on a U.S. hip-
hop visual aesthetic rather than an identifiably Caribbean one can be read as an
attempt at rebellion or "hardness"; it could be reflective of migratory practices and
cultural influences, but such an attempt is undercut by the background image of
a smiling, dancing Rupee. While the forefront image is direct, the background
image sends a message of fun. The juxtaposition leaves one with the same king/
killer models, but the aggressive killer image is undercut by that of the peaceful,
smiling king, while musically, the album within doesn't fit into either category of
the false binary.

Rupee's next album cover features a direct, close-up head shot positioned next
to his trademark. Not only is the smile gone, but so is any eye contact with the
viewer, as Rupee wears dark sunglasses. The composition of the cover extends the
theme of the album, *Leave a Message*. By framing the head shot in such a way that
half of his face is out of the shot, slightly tilted away from the text, the composi-
tion gives the illusion that Rupee already has one foot out the door. The compo-
sition also positions Rupee as a larger-than-life image. His public face is too big
for the frame and serves to frame his logo. The use of a logo suggests that Rupee
has created a brand for his public image, which signifies his presence even as he
is leaving the frame. Such allusions to movement and absence are not to be inter-
preted as an attempt to leave Barbados behind. The content of the album roots
Rupee in Barbadian tradition by repeatedly imploring listeners to "leave a mes-
sage" because Rupee is off at festival celebrations. He communicates this message
of Barbadian nationalism visually in the color scheme of this album cover, using
his light skin tone, sunglasses, and a blue background to create the blue, gold, and
black of the national flag.

With his third album, *Thisisrupee.com*, Rupee not only uses his logo but also
introduces his own signature clothing line. He is unsmiling and framed within a
fairly sterile color scheme. The foreground image of him still plays on the theme
of being too big for the frame, but this time he confronts the viewer with a direct
gaze. There is a contrast between the seriousness of the foreground image, in
which Rupee wears a collared shirt and gazes directly at the camera, and the back-
ground image, where Rupee is dressed more casually in baggy jeans, sneakers,
and a cap, looking off to the side. This album cover does not feature any explicitly
nationalistic messages, but it does display two not entirely different snapshots of
masculinity.

When twentysomething Rupee released these albums, he had a serious decision to make. Although he had been crafting his career as a musician, he was also an accredited, practicing graphic designer. His audience as a performer, however, was steadily growing, and maintaining both careers had become too taxing to sustain. Meanwhile, Jamaican dancehall music was breaking outside the Caribbean market, and there were indications that soca music could do the same.

With few exceptions, such as Patra and Lady Saw, dancehall's entrance onto the world stage was largely in the form of male deejays. Radio host and scholar Donna P. Hope details the different subcategories of dancehall deejays: girls dem, slackness, bad-man, Rastafari, and all-rounder.[32] These categorizations crossed over into the U.S. and U.K. markets in the mid- to late 1990s and early 2000s with artists such as Shabba Ranks, Shaggy, and Beenieman. Popular music video shows such as BET's *Caribbean Rhythms* sought to reach out to Caribbean American populations and served as a way for a wider audience to consume Caribbean music.

As dancehall made its way to international audiences, Jamaican dancehall artists also appropriated U.S. hip-hop aesthetics. Wayne Marshall draws on Deborah Thomas's work on radical consumerism to conclude that "hip-hop's embrace by young Jamaicans is thus consistent with a broader cultural pattern across the Caribbean, whereby American popular culture—disseminated both by mass media and diasporic connections—has come to dominate the imaginations of young people yearning for the freedom and wealth denied to them in post- and neo-colonial circumstances and symbolized by the sensual sounds and images of African-Americans flaunting their power to consume."[33] While some may paint such practices as "inauthentically" Jamaican or as an example of U.S. cultural imperialism, Hasse Huss notes that "they are also an example of an ongoing musical dialogue, albeit between highly unequal partners."[34] The borrowing, influence, and appropriation of musical, visual, and performance stylings among African diasporic populations across the United States, Jamaica, and Barbados highlights the use of diasporic resources and also the complexity of identity formation. Even as these artists work in what is arguably national forms, the shared Caribbeanness of Jamaican and Barbadian artists and the shared diasporic experience of African-descended populations across all three sites connects them even as the specifics of national identities separate them.

Jamaica had largely cornered the market of Afro-Caribbean men producing internationally popular music in the early twenty-first century, thus continuing Bob Marley's legacy of framing global understandings of Afro-Caribbean men through music and its images. But the eastern Caribbean made a tiny inroad when Kevin Lyttle's "Turn Me On" reached the United States in September 2004. Lyttle had recorded the song three years earlier in a small studio in Saint Vincent.[35] "Turn Me On" reached regional success throughout the Caribbean and in Caribbean communities abroad, which eventually led the song to become "an international smash. It went No. 1 in the States and became a Top 10 single in much of

the rest of the world."[36] Lyttle signed with Atlantic Records in 2003, joining Jamaican artists Sean Paul, Elephant Man, and Wayne Wonder. The video for "Turn Me On" features the bright colors and scantily clad bodies of carnival. The choice to include carnival costumes can be read as a direct attempt to represent the eastern Caribbean, where carnival celebrations are more present than in Jamaica.[37] The song's slow yet up-tempo sweetness prepared the audience for another soca star who was soon to join the ranks of Caribbean men on the Atlantic Records label—Rupee.

Rupee's visual and musical style draws on the work of artists who entered the international market before him but remains distinct. One distinction between Jamaican artists and Barbadian artists is in representations of sex and gender. Jamaican dancehall is sexually explicit, while Barbadian calypso (and soca) relies more on innuendo and double entendre and often depicts men and women as partners in sex, in contrast to the suggestion of bullying, ramming, or agony that can be heard in Jamaican dancehall.[38] Rupee engages the various artistic influences he was exposed to but remains centered in the calypso and soca aesthetic. Within this aesthetic, he attempts to change the meanings and associations of the music. He explains, "What I do with my music is that I create soca music, I create calypso, I fuse elements of dancehall. You know I try to encourage people to have fun, to love one another, to have a good time, and still yet inject little elements of spirituality."[39] Such attempts are overt in songs such as "Thanks" and "Last Mas" on his earlier albums. Rupee attempts to bring a sense of responsibility and spirituality to party atmospheres by using performance standards that ask the audience to show their hands and enjoy themselves while at the same time asking them to "give thanks and praise on festival day." In live performances, he enacts this aesthetic in his interactions with the audience, often asking them to look at themselves and explicitly stating that Caribbean music and Caribbean culture are about peacefully enjoying oneself.[40] Moving global images of the Caribbean away from one of crime, "hardness," and poverty, he relies more heavily on images of the Caribbean as paradise and Caribbean cultures as loving and peaceful. Such practices are central to Rupee's "love you all" performance aesthetic and can be read as part of his discourse of love. Using his music, he seeks to promote Barbadian culture to a worldwide audience while at the same time highlighting human mortality by using practices common in many different musical forms.

Rupee's only album on the Atlantic label, 1 on 1 (2004), does not include such overt expressions of spirituality but lyrically still differs (rather drastically at times) from the work of his contemporaries. Most of the songs are based in a party aesthetic, but songs such as "What Happens in de Party" bring the specifics of Barbadian party etiquette to a larger audience, and "Woman, I'll Always Be There" has a much more serious tone. Overall, Rupee's intention with his first album on the Atlantic label is clear: "1 on 1, which is the title of the album, is going to allow

a totally new audience to get one on one with me[,] . . . this music and where it's from, this culture, and what it's about. That's what it's going to be, one on one, me and you."[41] He intends to give himself to a much larger audience, including the culture, rhythms, traditions, and attitudes that have shaped who he is.

Such an attempt is made visually in the packaging of the album. On the front cover of 1 on 1, Rupee is pensive. His eyes are cast down and to the left of the camera frame. His arm rests on something that is just out of focus. With his arm positioned so that his watch is turned to his ear, the image offers the suggestion that he is listening to time pass, alluding to earlier myths of the Caribbean as a timeless paradise. The background of the upper left-hand side of the image features a sunset over a wharf. The water blends with the wharf in shadow, while the colors of the sky feel warm against the blinding white of Rupee's shirt and hat. The background and much of the right side of the image are washed out in white light, which takes the objects out of focus. Centered is Rupee, with slightly golden skin and an earring that dissolves into the white of his hat, shirt, and lighting. His mustache and beard are carefully groomed, and his hair is cut short and just barely visible under a white hat with red trim. The lighting and his posture suggest an awareness of the calmness behind him (a waterfront sunset). His face is lit so that the half that is facing the waterfront is in a slight shadow. His features are clear. The composition of the image offers a calmness that seems contrary to the brightness, but the two are reconciled in the figure of Rupee himself. The color scheme may be a subtle reference to Rupee's main cause as an activist—HIV/AIDS awareness—as many benefit shows ask attendees to dress in red and white for the cause. The composition of this cover, rife with contrasts between light and dark, sharp and unclear, represents how Rupee is able to project a bright, lively, and "positive" image while being aware of the more pensive, darker realities.

Rupee's international debut song, "Tempted to Touch," distinguishes his image from the aggressive sexual image of his Afro-Caribbean labelmates. Lyrically, it draws on the same theme of heterosexual attraction, but without the elements of conquest employed by some of his Jamaican peers or even the sweetly sung forcefulness of Lyttle's "Turn Me On." "Tempted to Touch" is built on attraction and Rupee's "need" for the woman he sings to. In this sense, his enactment of Caribbean manhood is very much in line with some of the newer practices of Afro-Barbadian masculinity that rely on a sense of partnership between man and woman and express desire without conquest. Rupee is "tempted." He says what he wants and needs in the song, not what he is going to take.

The song's debut and subsequent reception were very much influenced by other Caribbean artists in the market. Marshall writes that "Sean Paul became a national darling of sorts thanks to his US chart successes, as well as the inroads he made into the lucrative, globally popular hip-hop scene."[42] Rupee and others sought to follow his example, but Rupee also consciously tried to distinguish him-

self as a soca artist, and to symbolize the nation of Barbados with such a representation. He says,

> Up until this day some people in mainstream America classify soca as reggae music. So you hear "New music, new reggae music from Sean Paul, new reggae music from Rupee," but at the end of the day Sean Paul has opened a lot of doors for other artists in the Caribbean. And it's up to us to pass through these doors and use them to the best of our ability, and we have one foot in it. We have to get the other one in it and use those channels to educate people and let them know soca music isn't dancehall. It isn't reggae. Every music out of the Caribbean doesn't come from Jamaica. There are islands like Barbados, St. Vincent, St. Lucia, Trinidad.[43]

For Rupee, as one of the few artists from the eastern Caribbean who have been able to break into a large, mainstream market in the twenty-first century, representing both the similarities and the particularities of Barbadian music is very important. Rupee's international debut hints at the temptations of large, mainstream markets and their possible effects on definitions of masculinity, and on national identities.

INTERNATIONAL ANGELS AND THE "REAL" RUPEE

Rupee's reputation, and thus his career, benefited greatly from his online interactions with his fans, where he strives to create a sense of intimacy between him and his audience, blurring the line between fan and friend. With his third self-released album, he released his own website, thisisrupee.com. When asked why it was important for him to have that avenue of interaction with fans, he says, "Essentially, we are in the internet age, and naturally it was very important for me to have a web presence. So we set up thisisrupee.com quite a few years ago. And it was very, very efficient in bringing people together from all over the world. It was definitely like a small community and it spawned the Rupee's angels, a real dedicated group of fans who support me wherever I go. And it was a good means of interacting with fans and letting people know who I am and what I'm about, what the music is about, what the mission is about."[44] In this way, Rupee used his internet presence to create a sense of intimacy between him and his audience. His openness created a group of fans, Rupee's angels, who then supported him offline at his shows and knew him well enough to answer questions other fans may have online. This intimacy has created a sense of community, one that is not based (necessarily) on geography but makes Rupee's music central to the interactions of a diverse audience of individuals around the world.

In August 2005 Rupee started a "NEW and IMPROVED ALL QUESTIONS ANSWERED HERE" thread on his site, allowing fans to get close to him by asking all the questions they wished. In the nineteen months that it was active, ninety users posted 212 questions and comments and Rupee responded fifty-five times. The

majority of users identified themselves as from North America (55 percent), while the Caribbean region was strongly represented as well (24 percent). Fans posted on the thread from various continents, with at least 9 percent representing multiple nations by listing their locations as "Hawaii/South Africa," "Maryland, GUYANA BORN," or "Denmark/Somalia." This is the small community from around the world that Rupee refers to in the foregoing quote. Users identified themselves as fans and as Rupee's angels, welcoming new users to the message board and answering questions that had been asked multiple times. Questions ranged from "Will you marry me?" to "Do you have any advice for someone getting into the industry?" Most users' posts asked about where Rupee would be performing (23 percent) or fell into the realm of the personal (23.6 percent): What car do you drive? What's your favorite food? Do you speak multiple languages? What character would you be from the Fantastic 4? and Do you want to have children?

Another repeated theme (1.9 percent) from new users was, "Are you really Rupee or just working 4 him?" Rupee's angels had several means of determining that they were indeed speaking to the "real" Rupee. One user, Diamond, says, "Its him. . . . He talks about his ANGELS on stage and things, little things like that so we KNOW its him!" Access to the "real" Rupee, the man as well as the star, was the main attraction of the blog space. The majority of users wanted to know the "real" Rupee, the mundane things that they could relate to. This became a window for up-and-coming writers, dancers, and musicians to ask about the industry (6.6 percent), and a means for Rupee and his fans to represent Barbados through a digital space that crosses geographical borders. Of the user posts, 4.2 percent specifically address Rupee's representation of the island nation, both thanking him for representing Barbados around the world and lamenting that that means he is often off the island. Presenting the "real" Rupee is also a representation of the "real" Barbados. If the myth of celebrity could be a reality, perhaps the myths of the Caribbean could be equally real.

Rupee has carefully managed his internet presence over the years, closing his stand-alone website when the popularity of that form declined. He then moved to Facebook and Twitter to interact with fans and friends. He maintained a Rupee fan page on Facebook and his own personal page under the name Rupert Clarke,[45] enacting his reputation as "the real Rupee" by posting simultaneously to various social media sites.

Keeping up with the new technology is not easy and at times affects one's public image, as Rupee found out. Just days after announcing his Twitter account in 2011, and after making a few corny jokes, he made this apology to fan and female emcee zoifemcee: "Clearly the novelty of this thing is obscuring my swag . . . forgive me ☺." In learning how to use new communication technology, Rupee had inadvertently altered the persona he wished to present to the rest of the world. His invocation of swag has specific implications for readings of his masculinity. Here he has embraced not only the technology but perhaps also the

awkwardness that can arise from its use. In exposing himself in these ways, he further blurs the line between person and persona, real and hyperreal, as his online and public persona is constantly communicating in ways an audience expects a person—not just a star or representation—would. Part of his performance includes giving his audience a backstage view (even if the backstage is also a construction).[46] This kind of openness invites a vulnerability that diverges from some of the earlier understandings of Afro-Caribbean masculinity.

The digital age has also allowed Rupee to interact with his contemporaries and up-and-coming artists as they support, share, and critique one another's work. Rupee's comments on his contemporaries tend to focus on different levels of craft and demonstrate the seriousness with which he takes on the role of representative of the nation. One of his biggest critiques has to do with the way in which new technology has changed the production of music.[47] While Barbadians boast of how modern and technologically current the nation is, Rupee notes the downside of some of these claims: "We all talk about technology and moving forward, but it seems as though with the forward movement of technology many elements of society have taken steps back, especially cultural ones, music being one of the ones at the forefront. Because when we examine today, any person with a laptop is basically a producer nowadays. . . . At one time Barbados was the musical powerhouse of the Caribbean. We were inspiring islands all throughout the Caribbean, even across the world with our infectious music. Very well produced, very melodic, good musicianship."[48] In Rupee's opinion, the advent of producing programs has allowed for a democratization of the production of music without subsequent quality control.[49] While many in the Barbadian music business continue to produce music that has been crafted, studied, and refined, there are just as many seeking to enter the musical arena with no intention of putting in the studied effort required for "good musicianship." Such a situation creates a problem at the level of radio. In 2000 Barbados instituted a regional content quota for local music on the radios.[50] More local music makes it to airwaves, but often it is produced by the same person who is deejaying, creating a monotonous sound and stunting the growth of the Barbadian music scene.[51] Unfortunately, as a result of efforts of cultural protection such as the regional quota, "there's no one telling these guys [inexperienced musicians] listen bruh, this is a good attempt but you need to work on your diction, you know work on your timing, inject a little more melody into it, watch your lyrical content because what you're singing about is pretty lewd."[52] With laptop technology, more people can make attempts at musical artistry, but not all of these newer artists approach the music with the sense of representation that was once inherent in the calypso and soca genres.

The concern over the standards of such cultural performances is rooted in the ideals of the independent nation-state. In building new national ideals, Barbadians produced an expectation and reputation for greatness. The motto Pride and Industry assumed that Barbados, its people, its culture, and all that would repre-

sent it would be something to be proud of. For the generations born around and after 1966, such pride, such a sense of standards, was assumed to be intrinsic to performing a national identity. In Barbadian journalist Cecil Foster's words, "Independence was supposed to be a gift to the young."[53] He says, "We were to be the prototype of the new Caribbean men and women."[54] Rupee takes such sentiments seriously in his role of performer, applying them to both national representation and a larger sense of duty: "At the end of the day I think musicians, artists, songwriters, poets, you are given musical talent for a reason. I think you are somewhat of a messenger. You have the ability, through your music or through whatever musical talent you have, to change people's lives, to influence them. It's God-given. And I think you have to use it wisely."[55] There are other Caribbean artists who express similar sentiments of responsibility. Jamaican American author and activist Thomas Glave says, "If anything, I think that creative people have a responsibility—and I say this very carefully—toward those who made it possible for us to do the things we do."[56] And Jamaican-born author Nalo Hopkinson notes, "What is equally as important is for writers to create stories of realities that do not yet exist. We must not only write what we see and what we know, but we must also be willing to imagine and to envision what does not yet exist."[57] Rupee would agree with her. In thinking about where he wants soca music to go and how to push the boundaries of the genre, he says, "There's a difference between people who have sight and people who have vision."[58] While these artists have clear ideas of the responsibility that is inherent in their talent (across geography and across form), the ideals of an independent Barbadian identity require representation. And as such, those ideals require a strict policing of public performance. Representations must not only be something to be proud of; they must be "real." The ideal of independence requires that performers also be performative. Such a sense of duty is tied to Rupee's understanding of himself as a performer, and it is also tied to how he performs masculinity.

Rupee's masculinity is built around a sense of strength that is founded in the vulnerability of openness and bolstered by his respect for and support of women. On Rupee's blog, many of the users identified themselves as women and girls performing a female role of support. The name Rupee's angels, though not inherently gender specific, does point toward this female support base in how Rupee himself has used the term *angel*. Rupee often refers to his late mother as an angel. In her memory, he's recorded the song "God Needed an Angel," which reasons that she was so supportive of people on earth that God called her to complete a higher mission. Such a reading is further exemplified by Rupee's tattoo, which he features in the liner notes of his 2001 album *Blame It on the Music*. The tattoo features a female angel praying and wrapped in text that reads, "MY LIFE, STRENGTH, MY MOTHER." Emblazoned on his upper arm, the artwork serves as a form of embodiment as he incorporates his mother's angelic strength into his own body. Rather than being demonstrated

through the conquest of female bodies, Rupee's strength, then, comes from the recognition and appreciation of an angelic female support, one that transcends geographical, digital, and cosmic borders.

Rupee uses his role as a performer to enact the kind of masculinity that he wishes were more prevalent in the world: one in which men treat the women of the world respectfully, and one in which sexual relations are undertaken with a sense of responsibility. He enacts his understanding of his role through his performances on and off stage, through his interactions online and offline, in interviews, and through his activism with HIV/AIDS organizations. His international hit "Tempted to Touch," its video, and the conversations he offers around each demonstrate this performance of masculinity in service of the nation.

TEMPTATION AND REPRESENTATION

> Silla had learned its expression early from her mother and the other women as they paused in the canefields and lifted their sun-blackened, enigmatic faces to the sea, as they walked down the white marl roads with the heavy baskets poised lightly on their heads and their bodies flowing forward in grace and restraint. They seemed to use this beauty not to attract but to stave off all that might lessen their strength. When a man looked at them he did not immediately feel the stir in his groin, but uneasiness first and then the challenge to prove himself between those thighs, to rise from them when he was spent and see respect and not contempt in their faces. For somehow their respect would mean his mastery of all of life; their contempt his failure.
>
> —Paule Marshall, *Brown Girl, Brownstones*

In colonial Barbados, Afro-Barbadian masculinity was predicated on and policed by attempts to assert heteronormative control over the female body in response to a lack of real socioeconomic and political control over the nation.[59] Historically, gender relations in Barbados relied on an exchange of strength and respect through actual and possible physicality. Relationships relied on love and fear. Although men and women interacted within a highly patriarchal structure, ultimately women held the defining (even when subservient) role because "as long as masculinity means control over women, women have the power to disrupt male identities."[60] Paule Marshall displays this in the foregoing excerpt from her 1959 novel *Brown Girl, Brownstones*. Writing of a preindependence generation, Marshall shows how an Afro-Barbadian woman's beauty became a spectacle to men, and how the possibility of physical or sexual contact, conflated with the desire for a woman's respect, became the defining factor of masculinity. Such desire colored gender relations on the island, and within the patriarchal structures of colonialism and, later, nationalism, a man's "mastery of all of life" was intrinsically linked

to his relations with the women surrounding him: his sexual relations, his (sometimes physical) control of their movement, his respect, and/or his abuse. Barbadian masculinity was an unwritten challenge to "prove [one]self."

Such an analysis is not meant to erase the existence of same-sex-desiring men in Barbadian society, but (especially preindependence) Barbadians had nuanced and complex approaches to same-sex desire and the performance of overtly non-traditional gender roles. On the one hand, homosexual practices were incongruent with dominant definitions of masculinity, and thus same-sex-desiring men were often derisively referred to as "she-shes." At the same time, some same-sex-desiring men lived openly as queens in their communities, overtly defying gender expectations. David A. B. Murray notes that by openly displaying "respectability" in running businesses, caring for their communities, and being discreet about romances, as well as standing up for themselves when challenged, these queens actively participated in their (mainly working-class) communities by displaying a shared set of values.[61] They experienced the liminality of being a part of their communities but outside the masculine ideal. Such a space is ensconced within a passive-aggressive homophobia, often misread as tolerance because of the relative lack of physical violence but rarely misunderstood as acceptance. After the emergence of AIDS (along with the rise of Pentecostal churches and the increasing popularity of violent dancehall music), same-sex-desiring men became less and less visible in Barbadian society.[62]

There have been significant changes in Afro-Barbadian masculinity since independence. In Christine Barrow's study in the early 1990s, she found that "men of the younger generation, especially those who are more educated and of the middle class, tended to define their role as husbands more as one of protector and supporter. . . . Speaking of their relationships, especially marriage, they referred to trust, love and mutual affection and less to overt authority."[63] This is the generation of Barbadian men that Rupee was born into, and one reason his performance of masculinity became a constitutive part of his popularity as an artist.

More than a few interviewers and fans have asked Rupee about his relationship to his female supporters. Often, he skirts the question. When answering directly, he avoids mention of any personal or sexual attraction, favoring a more neutral response such as, "I respect the support from the women."[64] Such an answer is rooted in a masculine public performance of silence about private affairs (outside of the bragging of the all-male arenas), while it carefully distances Rupee from practices of conquest or a sense of entitlement by declaring his respect. Rupee's male fans sometimes question his focus on women and feel neglected in his work. His response of "respect bredren . . . you know how it is..with so many beautiful ladies showing love it's hard to stay focused man . . . blessings,"[65] takes the conversation back to his female fan base while producing a kinship with other heterosexual men and invoking a sense of spirituality by ending with "blessings." As his performance career and popularity grew in the early 2000s, it was not only

the temptation of female fans but more general temptations of success that Rupee had to contend with. This dual temptation works together in Rupee's performances. He has built his career on lyrics that express love and respect toward women, and used that career to express his love for the nation of Barbados. The nation stands in for the woman he proves himself to, as it is his Barbadian audience he hopes to return to "and see respect and not contempt in their faces."[66]

In 2005 *SHE Caribbean* magazine debuted its seventh-anniversary edition with two up-and-coming Barbadian faces: Rupee and Tennille Stoute.[67] At the time of this issue, Rupee had achieved success throughout the Caribbean, had been signed to Atlantic Records, and accordingly was engrossed in an international touring schedule. All photos were taken at the Barbados Hilton Hotel by photographer Rick Wayne, giving the entire shoot a "local" flavor and a sense of luxury, while the interview for the article took place thousands of miles away in London. The distance crossed to produce the article is indicative of both the centrality of migration to Barbadian life and the necessity of travel for those who seek to represent the nation on a global scale. While Rupee's growing fame benefitted from the international popularity of dancehall at the time, this is one instance in which his presentation of Afro-Caribbean masculinity engaged with women much differently from how many of his male counterparts did.

The cover shot shows a man in control and seems slightly at odds with the "Reluctant Romeo" in the title of the article (figure 9). The contradiction is enhanced as Rupee bites his lower lip, gazing at the camera. He wears his signature line of clothing, both presenting himself uniquely and displaying business acumen. In his embrace of Stoute, he does not detract from her powerful stance, suggesting that his performance of masculinity is in partnership rather than competition with her femininity. Subsequent photos accompanying the article show Rupee playing piano alone and with three models lying atop it looking adoringly at him, as well as solo shots in which he is both playful and serious. The models vary in skin tone, hair length, and style, presenting slightly different forms of beauty.[68] Rupee's upward smile directed at the small bevy of diverse beauties enacts his "love you all" aesthetic.

The article explains Rupee's pronounced reluctance to accept the "Romeo" title. He details the experience of losing both of his parents to HIV/AIDS. In explaining that his father had extramarital sexual relations while on tour in the military and contracted the disease before passing it on to Rupee's mother, Rupee reveals why he both welcomes and is wary of too much attention from his female fans: "With his family's history, 'safe' is always the first thought for this young man with the hypnotic Bajan lilt.[69] 'I've been very fortunate in that I have a lot of female attention. I can find myself in very jeopardizing situations and actually temptation is around every corner. My parents' situation always comes back to me. It keeps my focus straight, humbles me and reminds me of the consequences of doing something like that.'"[70] Answers such as this one show how Rupee main-

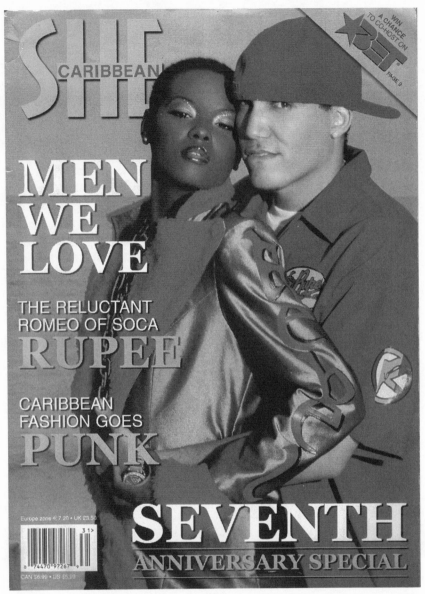

FIGURE 9. Rupee featured as "Reluctant Romeo" on *SHE Caribbean* magazine's seventh-anniversary edition cover, 2005. *SHE Caribbean* magazine, published by STAR Publishing Company, Saint Lucia.

tains control of his career by carefully controlling his physical contact with his female fans. This differs from hegemonic understandings of Afro-Caribbean masculinity as intrinsically tied to the sexual conquest of women, and offers a more nuanced understanding of masculine control that is still based on heterosexuality. Rupee's position as a public performer and a representative of Barbados makes him want "to sit and chat with anyone who shows an interest in his art form,"[71] but his personal experiences remind him of the gravity of giving in to the temptations that such availability can offer.

This sense of control differs in some ways from that of previous generations of Afro-Barbadian men. Afro-Barbadian masculinity has been naturalized by "man is man" discourses that are often weakly supported by biological justifications based on sex and virility. As Christine Barrow points out, these notions contradict a monogamous nuclear family ideal, resulting in an emphasis on virility that often works in tandem with infidelity, creating the common phenomenon of "outside" children. Such practices, "virility and the corollary, infidelity[, have] been identified as intrinsic to Caribbean masculinity."[72] It isn't only the fathering of children that matters; sex in general was extremely important to Afro-Barbadian men's sense of masculinity in Barrow's study: "A male, after all, was not a man unless—and to the extent to which—he could boast among peers of his sexual conquests."[73] Virility and the need for sex are naturalized in the men's responses in the study as an "uncontrollable urge rooted in biological and genetic make up—'it's natural, men can't help it.'"[74] The men in the study responded that they continue these practices "to keep you knowing you is man."[75] This becomes a circular logic wherein these men embark on sexual conquests because they are men and that is "naturally" what men do, and they know that they are men because of their ability to sexually conquer women. In Rupee's practice of control, a woman's body is not the site to prove one's "mastery of all of life," although women's respect is still very much important.

The temptations that Rupee faces come from his various performances as a soca performer, a heterosexual man, and, not unrelatedly, as a representative of contemporary Barbadian culture, which has been promoted vigorously through musical performance sites.[76] In 2009 Rupee explained that his popularity with his female fans is partly due to the nature of his music and the sites of its performance:

Yeah, it's uh, it's not easy, because of the vibe and the energy and the erotic element that comes with the music period. It's very sensual, very sexy. It involves a lot of revelry, a lot of mas, and uh, it's pretty hard. Especially considering the slot that I fit into. It was just a natural evolution that came about, me doing songs that generally uplift and honor women in many respects. Temptations are out there all the time, and especially considering the kind of songs I write and the environments that I'm always in, lots of women, lots of drinks flowing, good vibes. But I use my

life's experiences to keep me grounded and allow me to be focused, because I really must admit, it's not easy man. It's not easy at all.[77]

While Rupee does admit that "he has been less than a saint,"[78] because "man is man, you know,"[79] his public persona is one that is sexually responsible. In representing Barbados, he relies on the symbols of women, drinks, and vibes that have been promoted as desirable parts of Barbadian culture and are built on historical representations of the Caribbean as an exotic and erotic paradise, but in doing so, he is careful to publicly disassociate himself from the kind of "excessive" sexuality that can become dangerous in an age in which diseases such as HIV/AIDS are prevalent. Additionally, since the birth of his first child in 2006, the responsibilities of fatherhood have also become a part of his public image.

Rupee distances himself from older narratives of Barbadian masculinity that focus on virility, but even by doing this, he reaffirms the older discourses of "natural" sexuality by positing his control as "not easy." He stays grounded within older performances of Barbadian masculinity while reshaping them. Working within the soca genre is one way to stay grounded in Barbadian forms while representing a younger generation. Audiences often see soca as party music, especially when contrasted with the social commentary prevalent in its musical predecessor, calypso. While such a strict dichotomy has been troubled by scholars such as Curwen Best and Susan Harewood, and artists such as Terencia "TC" Coward, Red Plastic Bag, and Edwin Yearwood, to name a few, the association between soca and a party atmosphere remains strong. Rupee's music, his interviews, and his public persona seek to unite the different audiences of party music and serious social commentary. His masculine performance, however, differs from that of some of his Barbadian contemporaries who do similar work. Lil' Rick is perhaps one of the most popular male soca performers on the island, and like the artists and scholars just noted, he consistently troubles any notion of a strict party–social commentary dichotomy. Harewood argues "that Lil' Rick performs a style of Black, youth-oriented, lower-income emphatic Barbadian masculinity as a response to the ostensible menace specifically from Trinidadian political and economic elites, Indo-Guyanese, women, gay men, Black middle class Bajan men and White Bajan men."[80] She goes on to note that "Lil' Rick, through his wuk up style, presents hard masculinity as a way of asserting domination, particularly over women and gay men. His wukking up also works through the equation of wukking up as Bajan."[81] While both Lil' Rick's and Rupee's popularity are based on their representation of the nation of Barbados and their relationship to women, their respective performances of Afro-Barbadian masculinity differ greatly. And while Lil' Rick may be more popular on the island, Rupee has been more explicit in performing his Barbadian nationhood to larger audiences. He underscores his attempt to reach a wide audience with his signature expression, "love you all."

Rupee enacts his performative "love you all" aesthetic with a consciousness of the weight that such an utterance can hold, whether it be directed toward a specific crowd of women or in speaking to a global audience. When speaking of his first single on the Atlantic label, "Tempted to Touch," Rupee explains that the song is meant to apply to more than a physical attraction: "I took the rhythm, took it home, absorbed it, vibesed it and when I was writing it I mentally put myself inside of a dancehall. Not even necessarily a dancehall, actually, any situation where a woman puts herself before you and you're just tempted to touch her. It might not be physically, it might be mentally, or spiritually. It's real, everybody can relate to it."[82] In writing the song, Rupee made a conscious attempt to make it relatable to as many people as possible (or at least everyone who feels tempted by or desires women). The song first appeared on his 2002 album, *Leave a Message*, and reappeared on his subsequent album, *Thisisrupee.com*, before becoming the lead single for his first album on the Atlantic label, *1 on 1*. "Tempted to Touch" was then featured as the lead single for the soundtrack of the 2004 action film *After the Sunset*. While the song directly addresses a man being tempted by a woman, Rupee explains how the theme is more universal than heterosexual relations: "Temptation is something we all face on a daily basis. . . . You know, if you're on a diet and you pass a piece of cake that you're not supposed to eat, you're tempted to eat it even though you shouldn't."[83] Considering the wide circulation of the song, I argue that the accompanying video and its circulation extend the theme of temptation beyond romantic relations to the temptations of a global market.[84]

Rupee was already a star within Caribbean markets before signing to Atlantic Records in 2004, but his multialbum deal with the label gave him greater resources and a larger audience. By 2005 he had been seen in venues ranging from "MTV to BET, from Japan to Madrid, from Germany to Barbados," and the album had "already gone gold in Japan [before it was] scheduled to drop in August, 2005 in the U.S."[85] With all of the worldwide attention it would have been quite easy for Rupee to forget the small island that he calls home, but with his debut video he made it clear to his Barbadian audience that he would not be tempted away by the limelight. He says,

We didn't want the video to be shot in a studio with girls in Carnival costumes or, you know, a somewhat fabricated scene with maybe a beach somewhere in the States. We wanted to catch that true authentic element. And even though it put somewhat of a strain on the budget, we fought really hard to have it shot in Barbados. And, because of my manager's links at the time, we were able to get Hype Williams on the set who hadn't really done a major video in a long time. He was more focused on advertising, and it was somewhat, it was kind of his reentry into the music video game. He came down to Barbados and all of the Atlantic staff came through and he basically conceptualized the video. . . . He put it together, and nat-

urally we made shots of Barbados an integral part of the video, and it was received very, very well man. Very well.[86]

The video draws on familiar tropes of the Caribbean that easily appeal to larger audiences by focusing on scantily clad women and a sense of leisure, but it also strives to overtly represent Barbados. Williams's expertise in black popular music in the United States and in advertising allowed him to construct a visual aesthetic that both appeals to a U.S. crowd and sells the images of Rupee and Barbados.

Such a balance of advertising and representing the nation of Barbados places this video squarely between authenticity and sincerity. Rupee's desire to capture a "true authentic element" is also a performance of his sincere dedication to representing the nation of Barbados. By including various national symbols, the video further promotes Barbados to a larger audience while appealing to Barbadian audiences, who can feel proud to see such national representations in venues as popular as MTV, BET, and Yahoo! Music. Williams's expertise also increased the audience for the video, placing Rupee's music within an internationally popular hip-hop aesthetic that also relied on popular notions of Caribbean leisure.

Krista Thompson notes that "cultural critics often credit the influential cinematographer-turned-director Hype Williams with creating a particular look to hip-hop music videos, precisely by using aesthetics of money, flash, and shine."[87] Williams was already somewhat familiar with the Caribbean and South America, having shot hip-hop mogul Jay-Z's video for "Big Pimpin'" in Port of Spain, Trinidad, and Ja-Rule's "Holla Holla" video in Rio de Janeiro, Brazil.[88] These videos both begin with a large number of women in bikinis, on a yacht and on a beach, respectively. Both videos feature luxury vehicles in tandem with conspicuous alcohol consumption. Shirtless men pour champagne on the bodies of dancing women, increasing the shine on their skin. Coupled with shots of wads of cash and money raining down, these earlier videos use tropical backdrops to display wealth, leisure, and abandon. Williams uses a low-angle shot to imply the power of the musical artists. The audience must look up to them in all of their wealth and shine, with palm trees, water, and beautiful women as props.

Williams's direction of the "Tempted to Touch" video relies heavily on his earlier hip-hop bling aesthetic but also merges it with the already overlapping signs of tourism and visual signifiers of the "true authentic element" of Barbados. The "Tempted to Touch" video follows the same visual storyline as "Holla Holla," moving from the beach to the streets to the club, but in "Tempted to Touch" there is a noticeable absence of alcohol, luxury, shirtless men, and control over women.

The very first shot of the video focuses on a woman's behind as she walks down the street in a fashionable miniskirt.[89] The shot is quick and easy to miss. The first verse continues with a pastiche of shots of Rupee in front of a green screen (implying a technological blank slate), women dancing in and out of silhouette on the

beach and in a rum shop, and Rupee and other men playing dominoes. These last shots depict a commonplace scene in the West Indies that is often associated with Caribbean men (though women also play dominoes). Domino games allow for a display of skill, the right to brag, and (as dominoes are often slammed on the table for effect) a performative element of Caribbean culture. The game's association with men is rooted in the fact that it is often played in what are considered male spaces: bars, shops, under streetlights with makeshift tables. Such an association illustrates the same colonial ideology that holds that public spaces are male and private spaces are female.[90] In these scenes, Rupee wears a Baltimore Orioles baseball cap with a bandanna of the Barbadian flag tucked beneath, just barely visible. The presence of dominoes within the "Tempted to Touch" video provides a look at a "safe" practice of Caribbean masculinity and, coupled with Rupee's fashion stylings, signifies the cultural hybridity that is both representative of Barbadian identity and the broader Caribbean region and a constructed technique to reach various audiences.

Though shots of a young woman wining her waist between the barstools interrupt those of the men playing dominoes, there is no interaction between genders in the first verse of the video. It is not until the hook that audiences first see scenes of Rupee dancing with a woman. She is dark skinned and, as in much of Williams's work, her skin glistens. This amplifies the contrast between her skin tone and Rupee's. The dancers—in the rum shop, on the beach, and in the nondescript setting of the hook—are all being watched by the camera or the men present, but they rarely acknowledge their audience. These women, like those in Marshall's novel, "use [their] beauty to stave all that might lessen their strength." Rupee watches and dances with them, but he does not seem to rely on them in his "mastery of all of life."[91] As the central figure of the video, he is already master of the scene, both at home and in control. The beach scenes allude to a sense of leisure that is promoted both in many popular North American music videos and in tourist advertisements for the island and region. But unlike in the Jay-Z and Ja Rule videos, the low-angle camera shots in this video focus on the dancing women, placing them in a position of power, while sometimes also using a high-angle shot to look down on them.

There's a quick transition to Swan Street as the second verse begins (figure 10). Located in the capital of the island nation, Swan Street is a well-known shopping thoroughfare that is open to pedestrian traffic only. The city's old stone walls and the sight of vendors and shoppers lingering on the sidewalks are easily recognizable for most Barbadians. Rupee is featured outside, standing on the street and sitting at a bus stand with dancing women nearby. The visual pastiche of this verse links to the woman from the very first shot of the video, who now dances in front of Rupee on Swan Street. The camera moves to a minibus (figure 11). In Barbados, there are three major forms of public transportation: the federally funded, full-size transit buses; the small, privately owned, locally operated ZR vans; and

FIGURE 10. A video still of Swan Street from "Tempted to Touch."

FIGURE 11. A video still of a Barbadian minibus featured in "Tempted to Touch."

the medium-size, privately owned, federally regulated, flag-colored minibuses. This last type is the bus in Rupee's video. The pace of the different camera shots moves quickly. There's a consistently interrupted visual narrative to the video that fits with the rhythm of the song.

Throughout these first two verses, there is a distinct difference in the presentation of male and female bodies. The women are all scantily clad, while the men are all fully dressed. The women dancing on the beach and in front of the green screen wear bikinis, while those in the rum shop and street settings wear midriff-exposing outfits. The women's movements are highlighted by camera angles, the

colors and cuts of their clothing, and the attention given them by the men present. The men's bodies are rather sedentary. Those in the rum shop sit or lean against the bar or wall. The dancers dance on Rupee, more than with him. One woman sucks on a lollipop while dancing, alluding to the same kind of historical representations of consumption associated with a (sweet) female body.[92] There is little about the presentation of bodies in the video that is distinctly Barbadian, but when juxtaposed to national symbols and snapshots of the island, which are presented both in the style of music video and in that of Caribbean advertisement, the differences take on more meaning. The women's bodies become another Barbadian asset, another Barbadian sight for foreign viewing audiences, cast in roles and using tropes that are already familiar to them, while Rupee performs a postindependence Afro-Barbadian masculinity that is both attracted to and respectful of the women around him.

The final verse focuses on nighttime scenes in club and dancehall spaces. Rupee is dressed in all white, dancing with a woman as a strobe light punctuates the space. As the music plays him singing the lines, "I wanna love you," the camera cuts to a shot of him behind the turntables, wearing a jersey and a cap made of the national flag. He uses "authentic" Bajan scenes to perform a national sincerity. The pastiche with the club scenes also refers back to the earlier domino game scenes. There is a day-to-night narrative of the video that visually circles back on itself; a progression that also stays the same. This is not unlike the ideal tourist narrative of Barbados that features a nation-state that is modern and progressive and yet perpetually tropical, with all of the connotations that entails. The video visually represents Rupee's love of his nation as the lyrics profess a heteromasculine romantic love. Although this last verse still includes male-female interactions, by placing these interactions in the midst of a crowded club with dark lighting, the video shifts the focus of the viewer to the solo shots of Rupee. The final scene is of him smiling (figure 12). The audience cannot see his eyes, but they can see the colors of the flag he wears. In his debut video for an international label, his role as a national representative transcends his role as popular performer. He performs a national sincerity by literally wearing his national pride, all within the framework of a lyrically romantic and visually national love.

In the "Tempted to Touch" video, Williams still "depict[s] sexualized parts of black women's bodies in ways that heightened their shine,"[93] and the lighting is similar to that of his earlier work, as it features bright sunlight and punctuates the club scenes with strobe lights. But although the earlier scenes of men playing dominoes are set in a rum shop and the video ends on a dance floor, there are no shots of people consuming, pouring, or even holding alcohol. There is a conspicuous lack of wads of cash and luxury vehicles. Instead, the video presents a rum shop, public transportation, and pedestrian spaces, focusing on areas that cross class boundaries. And most notably, women are not touched by anyone other than themselves in the video. Whereas Williams's other works prominently feature men

Rupee
Tempted To Touch

FIGURE 12. The final shot of the "Tempted to Touch" video.

fondling women, in this one, men are "tempted" to touch, but even in close prox-
imity they are never shown actually laying hands on a woman. The women, how-
ever, relish touching themselves as they dance in an autoerotic display of power,
slightly disrupting the common use of women as props in music videos. Williams's
hyperreal aesthetics meet a "true authentic element" of Barbados in the visual
representation of local spaces and the subtle representations of gender relations.
As a cultural product, this video represents a myth-reality of Barbados.[94]

"Tempted to Touch" was Rupee's first big international video. He makes it a
point to foreground Barbados in this video, but he also reaches out to the norma-
tive global pop culture market. The visual images send different messages to var-
ied audiences. The video feeds the needs of a young MTV audience, but it also
reminds Bajans at home and abroad that Rupee has not forgotten who made him
a star. In an interview, he pays homage to his home by stating, "At the end of the
day, no matter how much I have succeeded, I can't overlook my carnival. . . . Crop
Over is what made me. I exist because of Crop Over."[95] At this point in his career,
he has made it to a large global stage, but he is not tempted to leave his home nation
behind. He has not forgotten the local festival where he began his musical career,
nor the Bajan audience that set him on his path to success.

Rupee has based his career on love, exercised as a duty to God, to the nation
of Barbados, and to women everywhere. This is the basis for his understanding
of himself as a Barbadian man. He asserts that he is not tempted by material suc-
cesses when he states, "I don't want to cling to the Mercedes-Benz, I'm just thank-
ful for the opportunity. I've been happy for the fact that, in the past few years,
I've made an impact on people's lives, whether it be ten or fifteen people; or ten
to fifteen thousand. The Almighty gave me the opportunity and I used it. I'm
happy, I'm living my dream."[96] He articulates such a dream in the interludes of

his first three self-released albums, in interviews, at concerts, and in blogs. Rupee tells one interviewer, "I strive for humility. It's always a part of what I do."[97] He says that he is proud to see thousands of people moving to his music, to have the opportunity to represent Barbados, and to promote Caribbean culture as peaceful and fun. This is the kind of Afro-Barbadian masculinity, and Barbadian culture, that is promoted in the "Tempted to Touch" video.

The Afro-Barbadian masculinity that Rupee presents in the video is still rooted in heteropatriarchy, even as it moves away from the overt search for control over women that characterized earlier generations' understandings of manhood. Some of Rupee's contemporaries in Barbados have been accused of the kind of misogyny and homophobia that is associated with preindependence practices. (Lil' Rick's promotion of hard juks and the controversy surrounding Peter Ram's "Pat and Crank" are just a few that come to mind.)[98] Still, as an artist who actively seeks to represent Barbados abroad, Rupee displays a more tender sense of masculinity that is focused on veneration, respect, and partnership, and this image of Afro-Barbadian men travels the world through concerts, blogs, magazines, videos, and activism.

"WOMAN, I'LL ALWAYS BE THERE FOR YOU"

First released on his 2001 album, *Blame It on the Music*, "Woman (I'll Always Be There)" is a tribute to Rupee's mother. Using an analysis of a 2005 performance of this song in Guyana at the Don't Dis Me concert, a concert dedicated to lifting the stigma of HIV/AIDS throughout the Caribbean,[99] I argue that Rupee's personal connection to this song and his public performance of it display the ways in which various relationships have changed on the island of Barbados in the last fifty years: mother-son relations, man-woman relations, and the relation between what used to be a private disease and public awareness of it. Such performances represent, in some ways, a break with both the historical performance traditions of the island and the expectations placed on Afro-Caribbean male performers in the wider popular culture market.

By 2005, Rupee had begun to take up a leading position in HIV/AIDS activism. He says, "I was one of the first real figures in Caribbean music to come out and share a story about HIV and losing somebody close to it, namely my mother and father." He was a teenager when his parents passed away from the disease, and it took some time before he and his family were ready to speak about it publicly.[100] His song "Woman" is one of his artistic efforts at activism, and its effectiveness in reaching an audience was evident at the 2005 Don't Dis Me concert.

In the twenty-first century, the Caribbean region has found it necessary to create a structured response to the crisis of HIV/AIDS through governmental, international, and nongovernmental organizations' efforts that address awareness, prevention, and care. Those in the cultural arena have been called on to help spread

awareness. The region is one of most affected by HIV/AIDS. Caroline Allen, Roger McClean, and Keith Nurse note that "since the first case of AIDS was diagnosed in Jamaica in 1982, the number of cases in the Caribbean region has risen consistently every year. By 2000, the annual number of new cases per 100,000 population was three times higher than in North America and six times higher than Latin America. . . . This rate is the highest in the Western hemisphere and second highest in the world after Sub-Saharan Africa."[101] In their essay that deals with the security issues that HIV/AIDS pose, they note that the disease often strikes "the most economically productive people in society."[102] The first cases were reported at a time when the region was still seeking economic and political stability, only decades after many island territories achieved independence. By the 1990s, discourse around HIV/AIDS had become a fraught public conversation. Owen Arthur, who became prime minister of Barbados in 1994, was one of the vocal governmental advocates on HIV/AIDS nationally and regionally. His government's efforts included reallocating money for prevention and control, showing the significance of the issue.[103] While this would fall in line with understandings of male leadership, the stigmas associated with HIV/AIDS would require any advocates to approach public masculinity slightly differently. Issues of same-sex desire, drug use, and sexual responsibility challenged earlier "man is man" discourses. Murray notes that "official and public HIV/AIDS talk in Barbados, while opening up new avenues of dialogue about sexual diversity in Barbadian society, has thus far reinscribed normative gender/sex roles, privileging heteronormativity as the default foundation of 'good citizenship.'"[104]

Rupee begins the "Woman" section of his performance by detailing the seriousness of the HIV/AIDs crisis and the disease's associated stigma.[105] By telling a stadium full of people, "Guyana if I have ever wanted you to listen to me before, I wan' yuh listen to me now more than ever," Rupee brings the atmosphere of revelry at a big stadium show into conversation with the event's purpose, erasing the stigma of HIV/AIDS. Rupee normalizes AIDS by comparing it to cancer and diabetes, clearly stating that it is not a homosexual or drug-related disease before telling the story behind the song he is about to perform. Introducing the song in this way distances AIDS from same-sex-desiring bodies in the context of homophobia and posits support for HIV/AIDS-infected people as good regional citizenship. Rupee is an AIDS-affected though not AIDS-infected person who identifies with those who have the disease but rejects the stigmatized connotations of homosexuality and drug use. This is the crux of his activism, and it is possible because of his particular performance of masculinity. Rupee's public persona is based on his love and respect for women. In many ways, he has become a poster child for heteromasculine strength that is not overbearing in a region where many still invent a connection between weakness and homosexuality.

Early AIDS activists in the Caribbean broke the silences surrounding the disease, and many also broke through the walls of the open secret of same-sex desire.

In the Barbadian context, Elroy Phillips was the first to publicly declare he had AIDS. Phillips "not only [gave] HIV/AIDS a face, he gave the infected a voice."[106] While he had always been open with his family about his desire for men, he was extremely hesitant to disclose his sickness when he was first infected. He eventually did go public in order to educate society about the disease. His memory was honored with the Elroy Phillips Centre, which until March 2011 was the only live-in facility for people with HIV/AIDS in Barbados. While the government closed the center "in keeping with its move from residential care to community care of those living with the disease,"[107] many in Phillips's family disagreed with the move. His sister "thinks Barbados still has a long way to go in terms of the acceptance of persons living with HIV/AIDS."[108] Only months later, another same-sex-desiring Barbadian man publicly complained that an officer of a government-sponsored social agency was discriminating against him because of his status as a gay man with AIDS.[109] Individual, government, and nonprofit ventures to fight the stigma of AIDS in the Caribbean are still waging an uphill battle, and some believe that "artistes, deejays, song-writers and producers are among the people . . . [Barbados] should draw more heavily on to effectively spread the HIV message."[110] Efforts such as the Don't Dis Me concert in Guyana are in keeping with this idea.

The perceived relationship between same-sex desire and AIDS in Barbados disrupts the complicated position that gender and sexuality, specifically cross-dressing and same-sex desire, hold within Barbadian performance. At the annual Party Monarch competition in 2009, a host of seasoned performers took the stage before the contemporary competitors. One calypsonian, Director, performed a standard in his repertoire, cross-dressing in an ill-fitting red dress and brown wig. Performances such as his are not uncommon in Barbadian history, wherein cross-dressing and gay male performance characters (such as MADD's Archibull Cox) are more often than not presented as comical.[111] Only an hour or so after Director left the stage, a slightly tipsy, shirtless photographer began to loudly berate a group of young men dancing nearby with taunts of "Kill a buller . . . these shirt-raising-up bullers," before warning a young boy, "Be careful there are bullers about." The photographer was offended by what he perceived as the young men's effeminacy and read it as homosexuality by showing his homophobia and calling the young men "bullers," a term used to denote those who engage in anal sex and usually used to reference gay men. The fact that the photographer himself was shirtless and dancing in much the same way had no bearing on his assessment of the young men. Similarly, the island's drag scene, male prostitutes, and history of gender-bending performance are often ignored by many Barbadians, and same-sex-desire falls outside the ideals of Barbadian society. H. Nigel Thomas notes that "in the 1980s a gay club existed in Barbados, [but] Barbadians demanded its closure after AIDS made its appearance."[112] The disease brought a stigmatized visibility to same-sex-desiring populations. In attempting to disaggregate the stigmas

of same-sex desire and illness, many AIDS awareness efforts seek to covertly distance the disease from homophobic stigma through the use of silence.

These pregnant silences are part of the stigma of the disease. Thomas Glave describes these silences in the Caribbean as "a kind of autocratic silence—a silence whose intention is erasure."[113] Rupee notes that his parents were diagnosed with HIV/AIDS

> at a time when the public wasn't very educated about it. There was an immediate assumption that everyone who has AIDS was homosexual. Unfortunately, in the Caribbean, as you know, homophobia is a very very big part of the culture. So when my father died of AIDS, I couldn't say it was AIDS at the time. We just had to tell everyone it was cancer. Because we weren't ready emotionally, first, in dealing with it and getting over it, and then dealing with how the public will perceive it, because it was a very sensitive topic and people always immediately assumed you were gay. I came to a point in my life where I had cried enough, I had to support my family around me to go public with it.[114]

The fear of homophobia placed a silence over his family's grief. The onset of the HIV/AIDS crisis and its associated stigmas in the Caribbean called into question the definitions that had structured societies. If "man" was based on heterosexual patriarchal control over women, men who desired men troubled that established norm. Glave notes that same-sex-desiring populations negotiate a different kind of "closet" in the Caribbean. He says, "It's a system of being that calls into play the very West Indian-ness of the person, an understanding, a deep understanding of the performative nature of life."[115] If "man" is a performative category, if same-sex desire disrupts that, and if AIDS is supposedly a "homosexual" disease, then what is a family to do with a heterosexual man who contracted AIDS because of how well he performed the "man is man" heterosexual discourse? Diana Fuss theorizes that "the fear of the homo, which continually *rubs up against* the hetero (tribadic-style), concentrates and codifies the very real possibility and ever-present threat to a collapse of boundaries, an effacing of limits, and a radical confusion of identities."[116] The story of Rupee's family disrupted both hegemonic definitions of manhood in Barbados and homophobic discourses of HIV/AIDS in a way that threatened the assumed fixedness of how individuals know themselves. Such a threat is also an opportunity for growth.

As the song "Woman" does not mention AIDS lyrically, it is important that Rupee share his story of how the disease took the lives of both of his parents. This establishes him as a man deeply affected by a heterosexual experience with the disease. At the Don't Dis Me concert, he implores the audience to show love and compassion for those with AIDS, accenting his message with an African diasporic performance standard of call and response by asking his audience, "If you believe

in that let me hear you say Yeah Yeah." Jocelyne Guilbault terms this call and response the "aesthetics of participation" within soca performance. She says, "For soca artists as well for their audiences, the focus of live performance is interaction—sensual, emotional, and physical. It is about sharing the experience of a moment, a pulse, a movement."[117] This is a public intimacy built on a shared understanding in order to elicit empathy in the service of change. Speaking of Trinidad, Guilbault notes, "Soca artists reinforce heteronormative relations, and so far have excluded homosexual expression."[118] In coming together, not every intimacy is treated equally.

Dedicating the song to his mother, Rupee keeps the atmosphere of the concert light by asking the crowd to say, "Hi Mummy," as he waves in the direction of the audience and sky. He explains, "My father as much as I loved him, he was a good man, but he gave my mother AIDS. And it was a reminder to me that the men of this earth aren't taking care of our women the way we're supposed to and we need to do something about it fast." After the crowd roars with applause, he continues, "If you love, protect, and respect de woman say Yeah Yeah." In performance moments such as these, Rupee walks a fine line between critiquing masculine practices of conquest and appealing to women through an offer of protection, but both sides of that line are founded in heteropatriarchy.

Rupee roots his critique of his father in love and celebration. In a 2018 interview he says, "My father was in the military. You know those guys when they go out and tour, the pressures they face. Unfortunately, he infected mum. I'm not saying that I, necessarily, forgive him for it. Even at my age now, after passing, for quite some time I still have internal struggles with it, but unfortunately the situation was that he did infect her."[119] Though critical of his father's actions, Rupee is careful not to distance himself from the man. He has a relationship with his father that is important to his understanding of his family's situation, his understanding of his father's generation, and his understanding of his own masculinity. Rupee's father was of a generation of Barbadian men who lived when the importance of virility to Barbadian masculinity was played out in boasting and in very different forms of fatherhood. In his memoir, Barbadian journalist Cecil Foster notes that "many of [his] friends were afraid of their fathers, whose main contact with them was to administer sound floggings."[120] Growing up in a fatherless home, his idea of fatherhood was the administration of discipline, protection, and child support, known as a "cock tax."[121] In the absence of his biological father, who had started another family abroad, Foster looked to his aunt's boyfriend as a father figure because "he sounded just like what in [his] mind [he] figured a father would, the right mixture of concern and firm authoritative approach."[122] His aunt's boyfriend "showed [him] that men could be good, kind and selfless. He taught [him] that men can get angry without beating anyone, especially their loved ones."[123] On the other hand, Ezra E. H. Griffith explains what it was like to grow up in a Barbadian household with a father. He says, "I was a little boy with a father, and I am

struck now by the full import of that observation. . . . Having a father conferred distinct advantages in Barbadian society."[124]

In dealing with AIDS as a family, Rupee's relationship with his father became complicated. In a 2005 interview he elaborates, "My emotions were mixed because I had a very close relationship to my father too. I was in a funny position in that this was a man we loved; this was my father, but he had infected my mother. He was in the army so he would go to places like Brunei and Hong Kong and I would imagine being in those situations, away from home, you have sexual needs and with prostitutes in the area . . ."[125] Rupee was forced to see his father as a *man*, subject to expressions of sexuality and all of the many things that defined his understanding of masculinity. Griffith explains that in the Barbadian context, especially when one's father is or has been present in the household, for a son, "one's father could never be just a man."[126] A father who lived in the household served as a supreme example of masculinity. His biological ties, coupled with his presence, offered an often unspoken but clearly understood love that separated one's father from "regular" men.

The lens that Rupee saw his father through was also complicated by generational differences in the performance of masculinity. Foster reflects on his own parents in his memoir: "My mother becomes genuinely emotional when she talks about missing her role as a nurturer. My father, true to his military training but more so still a victim of the Caribbean male tradition, suggests emotion is a luxury we cannot afford."[127] Foster's father came from a generation of Caribbean men who, more often than not, displayed strength through an absence of outward emotion. Griffith describes his father (of this same generation) as caring, loving, jovial, and respected, but not emotional. His connections to his father came through his father's presence, his insistence on respect, and his supportive and formative actions that, although they were performed out of affection, did not rely on an outward show of emotion. Rupee's father's voice is largely absent from his performances. His relationship with his father is part of the foundation of the performance, but the performance is from the perspective of a mother-son relationship. Rupee's struggle to process his love for his parents, the severity of their infection, and the circumstances under which they were infected manifests in his performance style.

The tradition of Caribbean men's emotional silence in public is not what Rupee enacts in Georgetown, Guyana, at the Don't Dis Me concert. While singing "Woman (I'll Always Be There)," Rupee is seated on a large stage with the crowd in front of him and a full band behind him, making him appear smaller. There is nothing but a microphone and an acoustic guitar between Rupee and the thousands of fans before him. His seated posture displays vulnerability before such a large crowd, and his choice to begin this song alone with a few chords on an acoustic guitar creates a sense of public intimacy before the band comes in. The story of the song, with lyrics such as, "What they saw it was a human disguise . . . couldn't

hear our inner cries," furthers the intimate relationship with his audience. His eyes are closed throughout the entire first verse, and he is visibly emotional throughout the performance. His emotion and artistry blend as he ad-libs, bringing his message to the audience home with comments such as, "You gotta love people with HIV. I love them too. That's how we'll make it through, for real." Such a performance invites a very different intimacy from that of the heterosexual temptation described in songs like "Tempted to Touch." Here, Rupee invites his audience into his personal story in order to bring public awareness to what used to be a private disease.

Although this song still relies on a patriarchal model of man (even a young man or boy) as protector, it does not assert or aspire to control the central woman figure but instead demonstrates the connectedness of man/woman and mother/son. Instead of performing a hypermasculinity based on domination, competition, and/or homophobia, in "Woman," Rupee performs a masculinity that is based on inner strength and an outward expression of love and protection of his mother. Such a performance shifts slightly from those of a previous generation of men. The testimonies of postindependence men "suggest a generational change in imaging and defining fatherhood into their lives. The social fathering of a few emerges at least as importantly as the biological fathering of many. Responsibilities to the family of origin persist, especially as sons to mothers, and not as an unfair burden."[128] Rupee's protection of his mother is part of a masculine duty wherein protection of family and anyone else who may need it is a constitutive part of a performance of masculinity. This is, in fact, one of the ways in which Rupee defines masculinity, as "being a father who looks out for his child, and supports his child, and supports the mother of that child. Or a man who looks out for his family, a man who works honestly to put food on the table."[129]

With lyrics such as, "Many nights we would sit down and cry / Tears from mine would be tears from your eye," or, "It's not about the experience of revealing one's innocence / It's about the air you breathe inside of me / To all mankind, and to all them baby," Rupee posits an emotional connection to his mother that is so strong it becomes physical. This is an intimate physicality that is emotional rather than sexual, confirming rather than controlling. Rupee contrasts this physicality with that between his mother and his father. He subtly critiques the practices of masculinity of his father's generation by including the lyrics, "How he used to love you / How he used to treat you / Said he'd never leave you / How he used to beat you,"[130] but he quickly returns to the theme of loving and supporting the woman of the story, his mother. In the song, Rupee and his mother cry each other's tears and breathe each other's air, allowing Rupee's strength as a young man to be read as the inner strength of his mother, but it does not rely on the kind of violent physical display that his father (and many in his father's generation) used.

The song's lyrics bring together different forms of physicality, emotion, and support within a family's relationships, all of which are ultimately plagued by HIV/

AIDS, a disease that goes unnamed. Many efforts at HIV/AIDS activism silence same-sex desire, but in Rupee's focus on his family's heterosexual experience, the disease itself is ironically silenced by a publicly intimate disclosure. Rupee's performative offering to the fight against the disease is a musical translation of his dis-ease with the situation of watching his parents die. Such dis-ease is complicated by his positionality as a son, as a public performer, as a soon-to-be father, and as a young Barbadian man in a time when the meanings and performances of masculinity were noticeably shifting. As Keith Nurse notes, masculinities have a power differential, and nonhegemonic masculinities are often represented as effeminate or infantile and have been historically racialized and sexualized.[131] With songs such as "Woman," and especially within Rupee's live performances of such songs, Rupee presents a masculinity that is still rooted in hegemonic patriarchy but relies on emotion and vulnerability in such a way that it displays strength rather than effeminacy. Rupee portrays himself as a young man unable to protect his family against AIDS but able and willing to use their story as one means of protecting a larger population. By showing his fans how he has been affected, he engages in an effort to protect others. He performs an alternative masculinity that is different from misogynist, homophobic practices, but also different from the loss of control and "effeminacy" feared in those other practices.

Rupee is not the first Barbadian artist to address HIV/AIDS. In 1988 calypsonian the Mighty Gabby released "The List," a satirical critique of the prevailing conversations surrounding AIDS at the time.[132] By the late 1980s the disease had become a health crisis and the Caribbean region was hit hard. Reactions in Barbados were often voiced through what is arguably one of Barbados's most common, prevalent, and long-lasting social traditions: gossip. As one of the first calypsonians to comment, Gabby critiqued such gossip in a satirical song in which the topic of gossip is a mythic list of those on the island who have contracted HIV/AIDS. Gabby ridicules the rumors in true calypso fashion, placing prominent individuals, including other calypsonians and himself, on the list.[133] By pointing to the bacchanal that the rumors surrounding the disease had caused in a comical way, Gabby exposes the stigma that the rumors are creating while poking fun at the female gossips.

Gabby's chorus, "Well what is this, what is this / that cutting like razor blades / this is the list of the fellas that got the AIDS," addresses homophobia as an undertone within its satire. By focusing on "the fellas" in a time period when the disease was heavily associated with same-sex-desiring communities, in a country that focuses much more on gay men than on same-sex-desiring women, Gabby challenges a masculinity that had (overtly or covertly) been predicated on homophobia. He says, "This song did not go down well with many in the society, as there was so much fear associated with the disease and hostility against gays who were starting to demand their rights."[134] In his satire, homophobia becomes the fear of effeminacy, the fear that the husbands, sons, and lovers of women are actually the

often-derided "she-shes." Such a fear is coupled with that of a health risk, further stigmatizing homosexual acts by painting them as a threat to national health.[135] Gabby's satire, however, suggests that it is the secretive nature of same-sex desire in Barbados that is the real threat, while at the same time poking fun at those who feel threatened. By satirizing the gossip, he implies that the gossipers are not quite sure about their husbands' or lovers' heterosexuality, but by placing himself on the list, Gabby is able to comically assert that he is secure enough in his own het-erosexual masculinity to mock it. Gabby did similar work over a decade later in his performance of the song "The Wedding" in the Pic-o-de-Crop competition.[136] After living abroad and seeing the growing support for gay activists, Gabby notes that such activism is bound to happen in Barbados and uses his music to poke fun at audiences that might resist it. Nearly thirty years after "The List" and only a couple of years after "The Wedding," Rupee's Don't Dis Me performance of "Woman" is emotional, personal, urgent, and anything but comical. It still addresses the issues of stigma and, in some ways, critiques previous generations' performances of masculinity, but it does so with very limited attention to same-sex-desiring communities or practices.

Such a silence in Rupee's performance is not necessarily indicative of public conversations about same-sex desire or HIV/AIDS happening in Barbados. While there had always been communities of same-sex-desiring people on the island, in 2001 United Gays and Lesbians Against AIDS in Barbados formed, and that year also saw the first public gay marriage on the island.[137] In 2003 there was a government proposal to decriminalize prostitution and "buggery."[138] The pro-posal ultimately did not pass, but the conversation became very important, including allusions to the supposed sanctity of Barbadian culture, national "morality," and the economic effects of the criminalization of specific sexual acts in a tourist economy.[139] In this period, the suggestion was also made to pass out condoms in the island's penitentiary to stop the spread of HIV/AIDS in the inmate population.[140] The suggestion was vehemently opposed with similar rhe-toric of protecting the "morality" of the nation and the masculinity (still read as heterosexual) of the inmates, a concern that seemed to outweigh the health risk that the spread of HIV/AIDS posed. As Barbara Browning notes, "A society's notion of its own health always involves violences against what it considers uncontrollable or excessive."[141] In this way the contagion of HIV/AIDS is both tied to and in competition with the "contagious" practices of homosexuality, read as moral decay. The threat to national health presented by the spread of a dangerous disease is in competition with the supposed threat of moral, social, and cultural "decay" presented by some of the efforts to fight it.[142] In the 1990s there was a regional response to HIV/AIDS in dancehall. Buju Banton's 1993 "Willy" and Lady Saw's 1996 "Condom" both promote the use of condoms, reg-ular sexual checkups, and conversations about past partners as ways to steer clear of the disease. Neither of these efforts addresses the homophobic stigma sur-

rounding the disease, but the artists do frame their work in such a way that it is not critical of heteronormative promiscuity.

Rupee's performance addresses the issues of morality and health by using "woman," in the form of his mother, as the central figure, rather than focusing on a competitive and/or homophobic masculinity. In this way, he is able to evade public conversations of same-sex desire by focusing on a responsibility to women. Even while showing his vulnerability, Rupee enacts his heterosexuality, relying on parts of a patriarchal ideology while using the discourses of love and responsibility to offer a different (if only slightly) presentation of Afro-Barbadian masculinity. Rhoda Reddock writes that "the HIV/AIDS pandemic has provided the space to examine one of the most controversial and pivotal subjects related to masculinity construction—homophobia,"[143] and Nurse offers, "It is suggested that homophobic responses to gay men are one of the means by which hegemonic masculinity polices the boundaries of a traditional male sex role and reinforces a strict heterosexual practice. . . . Homophobia is one of the building blocks in the construction of masculinity."[144] If these statements are true, then what do we make of an artist who seeks to destigmatize HIV/AIDS, but does so without either promoting or condemning homophobia? And how do his own infectious rhythms affect such discourses?[145]

By relying on a "love you all" aesthetic, Rupee is able to quell concerns of detrimental cultural contagion in ways not unlike the Jamaican state's and Island Records' uses of Bob Marley's "one love" image. The posthumous use of Marley's image and "one love" theme in promoting the Jamaican nation-state, its tourist industry, and Island Records silenced the elements of rebellion within his image that bourgeois classes feared would spread with the circulation of his music.[146] Rupee's use of a personal heterosexual story, rooted in familial love that is extended to "all," silences the moral panic of openly engaging in discourses of same-sex desire. In the case of Marley, it is the rebellious, discontent communities within Jamaica (and the world) that are distanced from his image by the Jamaican state's use of it. In the case of Rupee, it is the same-sex-desiring communities of Barbados (and the world) that are neatly silenced in most of his HIV/AIDS activism. Such silence can be read in multiple ways, as drawing on conservative fears of moral panic, as participating in Caribbean discourses of same-sex desire that treat it as an open secret that need not be spoken aloud, or as simple avoidance. Rupee himself disidentifies with hegemonic pop star masculinity.[147] Such disidentification allows him to perform a masculinity that is not explicitly homophobic, that is sexually responsible in an age of sexually transmitted diseases, and that promotes a national ideal of heterosexuality. He uses love not only as a transformative hermeneutic in the fight against HIV/AIDS and in his representation of the nation but also as a way to play it "safe." Rupee's relative silence on homophobia—even with the many different readings of it—limits the transformative power of his discourses of love.

In May 2010, at a ceremony hosted by the AIDS Foundation of Barbados, Rupee announced that he would be launching the Soca for Life AIDS Foundation.[148] In his announcement, he declared that too many musicians were promoting a dangerous promiscuity, and, not excluding himself from his own critique, he said, "Music is my life. I honestly don't think I am doing enough. But this is really my first step to [making] this happen."[149] Rupee proposed a post–Crop Over performance where a number of performers would coalesce to support responsible sexuality and HIV/AIDS awareness. He was firm in his vision of such an event: "Entertainers in Barbados will come with all the HIV/AIDS paraphernalia. The entertainment and the quality and value of the entertainment will be absolutely positive. There will be no rude behaviour."[150] Although he was clear in his vision, one could still ask, What exactly is "positive," and what is "rude"? Would same-sex desire be addressed or tolerated in such venues, or is that a "negative" quality of Barbadian culture? Would homophobia be condoned, or is that characterized as "rude" behavior?" What does "responsibility" look like?

Such activism coming from one of the nation's more popular performers is a performative enactment of Barbadian culture. Rupee is, in Stuart Hall's definition of the word, *representing* Barbados and the larger Caribbean—both presenting what he knows and enacting the kind of culture he wishes to see in the future. He, like Nalo Hopkinson, uses his creativity to enact a vision. Such a vision is based on expressions of love and responsible sensuality. Rupee's relative silence around same-sex desire and homophobia can be read as serving to make invisible whole communities that may not fit an "ideal" vision of the Barbadian nation, or as part of a tradition in which sexual identities need not be announced. But how does a performer represent national "truths" while also presenting national "ideals"?

Rupee answers questions like these through a neorhetoric of love. In dealing with his complicated relationship with his father, his attitudes toward same-sex desire, his view of the "morality" of the nation, and his role in representing a generation of Caribbean men whose gift is independence, Rupee still struggles to live up to the "positive" image he has constructed. In a 2012 interview with the *Antigua Observer*, he has this to say,

Before my mother and father died I was very homophobic. . . . When my father died and he was in the hospital I went to his ward [and] while I was there, there was one guy in particular who was a homosexual and he was infected with the disease. He was a big fan and it turned me around. It made me mature, basically overnight. When my father died he was up when everyone else was sleeping and he heard my father cry out for me and told me what my father's last words were; I absolutely have no hatred or scorn for homosexuals. I'm a strong believer in God so naturally from a religious perspective I don't support homosexuality, but whoever chooses to love that lifestyle it's their choice.[151]

Expressing his earlier homophobia as immaturity, Rupee examines his compli-
cated relationships by relating an interaction between him, a fan, and his father.
In this exchange, Rupee offers a "mature" sense of sexuality and his tolerance of
same-sex desire even as he condemns it religiously. Coupled with his comment
that "sex is a beautiful thing which should not be scorned or considered taboo, it
should be practised 'carefully and respectfully,'" such maturity is founded on
respect for life and other human beings.[152] Rupee elaborates on his earlier
homophobia in a 2018 interview where he ties it not only to Barbadian and wider
Caribbean cultural norms but also to his early career as a musical artist and what
his growth as a person and a public figure has looked like. He explains in further
detail how the death of his father and his experiences in the hospital influenced
his career and his thinking:

> What's interesting is that when I started my job with Coalishun, I used to do dance-
> hall. I used to do all of the latest covers at the time, specifically dancehall and
> TOK in particular man, and you know they had "Chi Chi Man" *fyah go bun dem*. I
> was so heavy into dancehall. Shout out TOK, that's family. I actually lived and
> embraced that energy. I was quite homophobic myself. And the experience of los-
> ing my mum and dad to the disease and going public with it completely changed
> my attitude and my life and my energy towards that because in the hospital, Ward
> C-10 is the AIDS ward, dreaded AIDS ward as they claim it back then. There were
> people from all walks of life, all sexuali—sexual preferences, and it was actually a
> gay man that was next to my father that I developed a back and forth with. He
> would be there. No one would come to see him. We'd talk. I'd try to make him laugh
> and feel as comfortable as possible. He shared stories with me about his life. It
> changed me as a person in terms of my love for people and my appreciation for
> humans in general. It made me do a complete 180. And that brother was actually
> the person who told me that my dad cried out for me in his last breaths, which is
> pretty emotional. But through sharing my experience with people, I've worked
> with the UN in terms of their AIDS awareness program throughout the world. I
> go to schools, I talk to kids, I do seminars. I work with a lot of organizations in
> Barbados. I do community outreach, speak in the schools, and just sharing my
> experiences and just trying to inject it whenever I can because naturally in a dance-
> hall environment or a club environment, those are the people who need to hear
> the message most. Because we're the most risky, we're the most promiscuous. But
> I can't go on stage and preach, so I just try to inject the messages every now and
> then. Songs like "You Never Know" . . . "Giving Thanks" those types of tunes. I try
> to creatively inject my message into what I do. And that's how I do it: working with
> the various organizations in the Caribbean and the world, and through my music.[153]

Rupee disseminates this message throughout Barbados, the Caribbean, and the
world. While his Soca for Life effort has yet to come to fruition, he has been an

active voice in the Live Up campaign, UN efforts to promote HIV/AIDS aware-
ness, and other regional and global HIV/AIDS activist initiatives.[154] Rupee's
understandings of masculinity as a responsibility to his family, to the nation, and
to his fans often find voice in his activism. Using his Facebook page, Rupee took
time out on World AIDS Day in 2014 to post a message:

> Been in the air all day, just landed at MIA had to acknowledge #WorldAidsDay
> Awareness about #AIDS and #HIV is a big part of who I am having lost both of
> my parents to the disease. During my many testimonies I'm often asked how I made
> it through the experience. #Love was the answer and ultimate healer. . . . from
> friends, family, strangers..reflecting that love right onto those affected by the dis-
> ease was the most important part of the equation. Inevitably you will know some-
> body affected by AIDS..love them more than you ever have before..it's more power-
> ful than any medicine prescribed! #RIP mum and dad..miss you, love you.
> #LoveIsTheAnswer #LiveUp.[155]

Rupee's experience with HIV/AIDS forced him to mature. His period of mourn-
ing coincided with a changing conversation surrounding the disease, and his expe-
riences in the hospital forced him to see and practice humanity in a new light.
His public performance of masculinity moved from a violent form of dancehall
to a rhetoric of love on and off the stage, which became a central part of his under-
standings of himself and his representations of Barbadian culture. In using his
musical craft to deliver social messages, Rupee also seeks to establish himself as
a producer, loving, protecting, and respecting the music that is his life by guiding
younger artists in "good musicianship."[156]

SOCA NATIONS, PERFORMING HOME

In June 2011 Rupee released "I Am a Bajan," a midtempo celebration of all things
Barbadian. In less than two months, the song had touched people across the island
and across the world, winning Rupee the title of People's Monarch in the 2011 Crop
Over competition, and winning the hearts of Barbadians.[157] Online praise showed
that neighboring Trinidadians and people as far away as Iran were impressed with
the song's sincere expression of pride in nationhood. The song traveled across the
airwaves and throughout cyberspace, where grateful comments abounded. Rupee
responded in kind, thanking his audience and the deejays who played his work,
and revealing his attitude that representing "de Rock" (Barbados) is a duty and a
pleasure: "Lol . . . give thanks king . . . I appreciate the support bro . . . dun kno is
a must tuh rep de rock!! For real boy!!"[158] This responsibility to represent the
nation is not new,[159] but it is very explicit in Rupee's music. His performances of
Bajan nationality and Afro-Barbadian masculinity place this representation firmly
within his technological, materialistic moment. Beginning with animated inter-

net lingo ("lol"—laugh out loud), Rupee makes the connection between God, man, and duty, specifically a Bajan man's duty to represent the island. Addressing the fan as "king" shows respect while encouraging the man to connect with God by giving thanks. This is the framework for the two main points of the post: a thank-you for supporting the work, and the assertion that representing "is a must." In the short format of a Facebook comment, Rupee uses technology to represent a different form of "mastery of all of life." He both relinquishes control to God by giving thanks and masters a site of interaction that allows him to expand his world outside the geographical borders of the nation and the physicality of his own travel. Furthermore, Rupee's 2011 hit "I Am a Bajan" is more than a lyrical declaration of national pride. He donated a portion of the proceeds of sales to the National Trust, which maintains historical sites on the island along with providing other services focused on preserving the island and its culture.[160] Selling the single through iTunes and Amazon, Rupee was able to appeal to an international digital audience. Those buying the song need not understand its message in order for Rupee to accomplish his goal of promoting and supporting the nation. Endeavors such as this show that Rupee views the role of a public performer as a privileged position that carries national responsibilities.

The need to represent is heightened by the level of travel that has always been a part of Barbadian life. Those abroad (even those who claim other citizenships) often feel that representing Barbados is a part of asserting who they are in the wider world. Speaking of the 1950s, Ezra Griffith relates his own experiences with the Barbadian men he grew up with, as well as his observations of the way in which travel affected their assertions of identity. When speaking of his father, Griffith asserts that even with his father's "self-imposed exile from an island he loved so much,"[161] Griffith still understood how "that look in his eye translated total confidence in his assertion about Barbadians. Over the years, I never had the slightest doubt that he knew what it meant to be Barbadian."[162] Adjusting to life in New York, Griffith saw the same thing in other Barbadian immigrant men, most notably the doctor: "He was serious about the business of representation, much like my father. These Barbadian men of that generation, particularly once they moved away from the island of their birth, seemed to feel pressure to play a special role and represent values and symbolic styles that they thought were important."[163] This generational imperative to represent changed after independence. Postindependence generations still assert the need to represent abroad, as it is central to Barbadian identity, but technological advances allow this representation to take place in different forms, and the ideologies of respectability and masculinity take on different performative imperatives. Although an important part of Barbadian identity and Barbadian history, the ability to travel is still a privilege. With such a privilege comes a responsibility to represent the nation. This sentiment is etched into the very idea of the independent nation, as the Pledge of Allegiance ends with the words, "to do credit to my nation, wherever I go."

Though he was born abroad and spends much of his time elsewhere traveling and performing, Rupee firmly asserts, "Barbados will always be home."[164] Rupee's travel (and that of other artists such as Gabby, Edwin Yearwood, and Hal Linton) is similar to that of earlier generations in that it provides broader opportunities for employment than otherwise found on the island, but it differs in that Rupee's specific line of work—entertainment—allows him to serve as a very public face for the nation in a moment when "travel" itself is redefined by various communications media. Such artists' employment depends on their publicity. Whereas the men Griffith writes of represented Barbados personally in their daily lives, performers such as Rupee have made this representation their profession. Rupee's success as a performer is inextricably linked to his role as a representative of Barbados and the wider Caribbean region. By presenting himself as a gentle, attractive, respectful Afro-Barbadian/Caribbean man, he distinguishes his masculinity from the "hard" masculinities of many of his contemporaries. Although often placed within the same cadre, Rupee is not Beenieman, Sean Paul, Lil' Rick, or Peter Ram. As interviewer Amina Taylor asks, "Who could ask for the Caribbean to be represented with more talent and grace on the world stage? In Rupee the world will wake and see the different side to the Caribbean male."[165]

The song "I Am a Bajan" is one example of the ways in which Rupee celebrates and represents Barbados. While mentioning the local festivals such as Crop Over, the Jazz Festival, and Reggae on the Hill, he also recognizes Bajan femininity as a national asset by asserting that Barbados is "where de women look heaven sent." In his nationalism he performs masculinity in relation with femininity. In speaking of his motivation for the song, he tells fans, "So tired of all this 'cock back' and 'skinout' music . . . disrespecting and degrading our women . . . has our music now come to calling women sheep and getting forwards?..time to bring pride back to Barbados and bajan music #iamabajan,"[166] and, "I made this song because I felt that amidst all the negative vibes out there, we needed to put Barbados back into the positive light that has shone upon it for so long . . . so we can see the true reflections of this gem!"[167] Rupee also reminds Bajans that "tourists come in from near and far to be where we are" and employs a sense of cultural performativity by singing, "One peaceful loving society / we're one family." This is a performative musical attempt at restoring the Pride and Industry of Barbadian music. The pride that undergirds this song is based in a sincere love for Barbados, a sense of duty as a musical artist, and an attempt to re-create or at the very least uphold an ideal cultural legacy for Barbados.

Rupee continues to represent Barbados on local and global stages both as performer and as a person. His public image maintains its focus on sexual responsibility, family, and national pride. He expresses these themes through his music, his activism, and his digital presence, consistently presenting an Afro-Barbadian masculinity based on the heteropatriarchal structures of old with an eye toward a respectful, humble future. Rupee's national and regional representation includes

his writing of the anthem for the 2007 Cricket World Cup, "The Game of Love and Unity," which he performed with Trinidadian Faye Ann Lyons and Jamaican Brit Shaggy. As in his later "I Am a Bajan," in this song, he posits Caribbean culture as one of "love and unity," in this case in the context of an international tournament that demonstrates the popularity of the sport across the world. He and many of the Caribbean artists who were signed to the Atlantic label in the early 2000s no longer appear on its roster of entertainers, but Rupee has recently been signed with Ultra Music, continuing his blend of Caribbean, European, and U.S. sounds on an electronic music label.[168] While the U.S.-based global music market has cycled through a dancehall phase before moving on to reggaetón and a more recent and less distinct Caribbean-inspired pop, Rupee continues to perform locally, regionally, and internationally. That globally implicated locality sustains his career as he continues to collaborate with regional artists and producers and make plans to compete in the local Crop Over Festival, where he first made a name for himself.

5 · RIHANNA

Where Celebrity and Tourism Meet at a Dangerous Crossroads of Representation

> The Caribbean figured as a dangerous crossroads, is the place where East and West, North and South, Third World and First World, capitalism and communism, global high tech and local poverty, tourists and drug runners, all collide. In this "trafficking" it becomes increasingly less clear what is inside and what is outside, what is pure and what is impure, what is North and what is South, what is local and what is global.
>
> —Mimi Sheller, *Consuming the Caribbean*

"Rihanna! Rihanna! Rihanna! Rihanna!" a concert crowd chants, awaiting and demanding a star's presence. Cut to Rihanna in stilettos, walking casually backstage. Members of the crowd jump up and down, hands waving as the colored lights from the stage wash over the area. The camera flashes an image of Rihanna in a makeup mirror. She puts on her face as someone else works on her red hair. The sounds and images of the concert crowd give way to fireworks in the night sky, laughter, and the sound of a vehicle driving along a road. Each sound, each image, cuts into the next until the sun sets on a beach scene and the music begins.[1] National representation within Robyn Rihanna Fenty's "Cheers" video is part of the 2011 deal between Rihanna and the Barbados Tourism Authority (BTA).[2] The video presents a back-and-forth between the glitz and madness of stardom and the peacefulness of an ideal Barbadian experience. It links these two entities—a pop star and the nation she represents—in a constructed, salable image of excess and release. And it represents a dangerous crossroads of representation.

In his seminal text *Dangerous Crossroads*, George Lipsitz argues for the social, economic, political, and cultural importance of popular culture commodities.[3] In examining the popular culture of so-called marginalized communities, he offers the term *dangerous crossroads* to describe how histories of colonialism and power imbalances meet contemporary globalized markets and how the cultural practices

of immigrants challenge discourses of assimilation, and he argues for the performative power of popular culture. Lipsitz's invocation of *crossroads* implies a meeting point—a site of connection and separation, a point of circulation that is simultaneously a point of possible redirection. In African diasporic discourse, crossroads play an important role and often signify the circulation of power that cannot be characterized by simple binary terms such as *good* or *bad* but that instead derives its strength from its multiplicity.[4] The "Cheers" video is but one manifestation of such a dangerous crossroads. In the first thirty seconds of the video, the viewer is privy to both the backstage makings of an international star and leisure shots of the place she lived before her stardom. Rihanna's voice emerges from the sound of the sea's waves and rises over the sound of her chanting fans. Both the constructions of pop stardom and the constructions of a Caribbean ideal of leisure and pleasure meet within this video, representing Rihanna's relationship to the island she calls home and the dangers of representation within that relationship.

The image of Rihanna is where myths of the Caribbean meet global pop culture expectations of being young and sexy. When Rihanna first signed a record deal in 2005, most people, producers included, didn't believe that she was the best singer, but what they did see in her was determination. Jay-Z explains, "When she came into the office I was like, 'Whoa.' She had this look in her eyes, this determination, that could just freeze a room."[5] Between that first audition and album number five, Rihanna had put in the work to reign as "Princess of Pop" or simply "Princess Ri Ri," at least according to her fans and media headlines. In earning the right to "reign," Rihanna has incurred the responsibility of representing the nation that birthed her—first through the coincidental combination of her celebrity and the fact that she was raised on an island whose national identity demands representation, and second through her 2008 acceptance of a cultural ambassadorship. To be Barbadian is to represent Barbados. To say the Pledge of Allegiance is to declare that one will represent or "do credit to the nation, wherever [one] go[es]." And to accept a position as the island's cultural ambassador to youth is to acknowledge and embrace that representational responsibility.

In the national symbols of Barbados, one can discern a concerted effort to map the resources of an independent nation. The national crest features representations of both the fishing and sugarcane industries. The flag's colors represent the blue and gold of sky, sand, and sea. These latter resources are hard to export. Successive independent Barbadian governments have invested in one of the nation's most well-traveled and self-reproducing resources: its people. To be a Barbadian citizen is to be a representation of the nation, especially when abroad. Those who travel have the added burden of melding the nation's ideals of paradise and modernity in contexts that make it difficult to relay the complexities of that Relation. And for Barbadian international pop star Rihanna, this burden of representation is entangled with her own individual celebrity.

This chapter argues that Rihanna embodies the ambiguity—with all of the possibilities and dangers—of performing a Barbadian national identity through a young, female, celebrity body for a global audience of millions. As a pop star, Rihanna's gleam sheds light on the nation of Barbados, but it also illuminates discourses of sexuality, drug use, cultural standards, and violence that many would wish to leave in the shadows. This is not to say that her audience automatically sees her homeland in her image, but rather that because of her celebrity, many looking at Barbados for the first time do so through the lens of her stardom. The global circulation of Rihanna's image is both an asset and a liability to a nation that depends on a reputation of respectable release within a global tourist market. Rihanna's sexuality, her spontaneity, and her youth are attractive to the BTA and to many of the citizens it serves, but Barbadian critiques of her reveal that she also represents segments of the nation's youth who may not care very much to enact the ideal Barbados promoted in advertisements. And perhaps even worse, they may enact the historical myths of the Caribbean, complete with sexual overtones and promises of leisure, far too well. Her success within the global pop market, coupled with the at times cavalier way she handles this success, offers an image of Barbadian pride and industry that her Barbadian supporters are proud of, but one that causes her Barbadian critics to bristle. Rihanna represents Barbados—not necessarily the national ideal, but all of the complicated discourses that surround it.

The relationship between Rihanna's stardom and the nation's reputation rests on the pride associated with being a Barbadian and the national expectation that those raised on the island will do their part to preserve and promote the nation.[6] Rihanna's public statements about her relation to her homeland have varied over the course of her career, but when speaking of her Barbadian critics, she has often painted their criticism as constitutive of Barbadian culture. In 2006 *SHE Caribbean* magazine featured Rihanna in a cover article entitled "The Bajan Beyoncé." When asked about "the backlash that invariably follows the acclaim," Rihanna explained how she reorganized her social circle and excused her Barbadian critics with the following statement: "In Barbados we have this pride thing, people hate to give up compliments. It physically hurts them to say congratulations so they find it easier to be mean."[7] In her representation of the island, the national motto, Pride and Industry, takes on a somewhat catty meaning. Barbadian pride becomes coldness, perhaps even tinged with jealousy. Rihanna is not the only one to hold such a view. Referring to calypsonian the Mighty Gabby, Barbadian journalist Timothy Slinger says, "Popularity in Barbados always comes with a price. Jealousy makes people want to pull you down and you become a victim, a target. As a human being you must develop a mindset to keep your dignity."[8] Each artist negotiates between their success and their audience, a negotiation that is even more fraught and complex within representations of the nation that span large and varied audiences.

Rihanna's representation of Barbadian pride in this instance slightly contradicts the way she describes Barbados and Barbadian people. The article goes on to say,

> She might be carrying a big responsibility on her young shoulders but Rihanna takes her role as the region's unofficial female ambassador seriously.... She can never say enough about her love for her island and the music that still drives the beat of her heart, despite her international success. "The people are so warm, you'll find a few rude ones but I guess those sneak through wherever you go. The major-ity of Bajans are warm and friendly. We love to welcome people from other coun-tries, generally we cater to them well. We love to hang out, we love to party. Music is our love. We embrace music like reggae, hip hop, RnB. Soca and calypso are our cultural music but we Bajans love the full flavors of the Caribbean.... It is such an honor to carry the torch for Barbados and the rest of the Caribbean. When I performed at the MTV Music Awards so many people had the Barbados flag and people back home saw that and were just so touched. The people at the Barbados Tourist Board saw that and were just so moved. They had never seen a Bajan artist represent on the international stage like that before which is amazing. Sometimes, when you have that kind of support you feel like you could take on the world."[9]

Here Rihanna distinguishes Barbados as her homeland but also places it within a pan-Caribbean culture open for consumption. In her depiction, Barbados loves and is part of "the full flavors of the Caribbean"; these flavors are attractive and available to visitors but can be bitter when they come in contact with each other. She says that Barbadians are "friendly" to tourists but sometimes "mean" to each other. The "pride thing" noted just a few paragraphs before disappears. "Mean" people are just "a few rude ones," but the bulk of Barbadians are painted as warm, friendly, and supportive of Rihanna's success. Through Rihanna's then-eighteen-year-old eyes, Barbados is first a fun place to party, a place where tourists are wel-comed and catered to, rather than a site of industry or international trade, a part of world history, or a politically and economically stable postcolonial nation. And she is proud to represent this place. Not only does she take it seriously, but Bar-badian support becomes the foundation of her success, making her "feel like [she] could take on the world."[10]

Her statements in this article betray her definitions of Barbadian culture and Barbadian pride, but they also betray how she defines her role as a representative. In her description of her performance at the MTV Video Music Awards, Barba-dians are not necessarily touched by Rihanna's performance as much as they are by their own reactions to it. It is the Barbadian flags seen in the audience that move those back at home. Rihanna's stage performance allows the space for the trans-national representation of Barbadian identity. Her performance enables those Bar-badians in the United States to represent their nation through their support of her. It sheds light on the migration and settlement of Barbadians across the world.

And it creates the space for them to speak to their sistren and brethren in Barbados and to represent their nation to foreign audiences via the media coverage of Rihanna.

Five years and five albums later, Rihanna took a slightly different stance on her relationship to the nation of Barbados. When asked, she asserted her love for her nation. In the 2011 *Esquire* magazine article "Rihanna Is the Sexiest Woman Alive," she explains her earlier position:

> Early in your career, you used the word *hate* a lot when describing the way the people of Barbados responded to your success.
>
> *I grew to realize that that hate was just pride. I realized that it's a part of our culture. I'm always representing Barbados. All over the world, no matter what I was doing, no matter what I achieved, no matter what award it was, I always shouted them out. So, I started making them feel like, "This is our girl. If people in the UK could get this excited about her, what's wrong with us?"*
>
> You're the most famous person in the history of your country.
>
> *And I never turned my back, too.*[11]

Here Rihanna still expresses her pride in Barbados. She still equates criticism or "hate" with Barbadian pride and understands it as a part of the national culture. But her language places her both within and outside that culture. It is "our" culture, but she shouts "them" out. Her comments here paint her as an alienated representative. She asserts that she is still connected to her home nation, but in her search to understand and explain the criticism that comes from that part of her audience, she portrays "them" as somewhat inadequate and self-reflective of that inadequacy by putting the words "What's wrong with us?" in the mouths of her Barbadian critics. Her success as a pop star has made her the most recognizable Barbadian in the nation's history, but in interviews such as this one, the complexity of such a position is subsumed under assertions of confidence in the form of "understanding" her critics.

The conflicts between pop stardom and national representation are dismissed by subtly invoking a historical trope: the United Kingdom is great and Barbados should be like it. If Barbadian tastes differ from U.K. tastes, then something is inherently wrong with Barbadians. Librarian and biographer Barbara Chase notes that "when it comes to Bajans appreciating the talent from among them, it is those within the diaspora who lead the charge."[12] Novelist George Lamming also relates the complexity of this in his aptly titled collection of essays *The Pleasures of Exile*. Rihanna's invocations of Barbadian pride and industry, then, expose the many facets and meanings of those concepts and their centrality to Barbadian national identity. There is national pride in the quality of a given work; pride is performed as a specific attitude; pride is a form of scrutiny, policing, and sometimes respectability politics. Industry is both the attitudes and actions of those who work hard

and the various ways in which labor, products, people, and culture can be consumed within economic and ideological markets. Positioned as a businesswoman, sex symbol, uncomfortable role model, superstar, and ordinary young woman, Rihanna stands as an icon for the ambiguity of these terms.

Both the 2011 "Cheers" video and Rihanna's representations of Barbados more generally play on a back-and-forth between the individual and a nation, between what each has to offer the other, and between varying and often competing ideals proffered to the global market. While Barbados has a reputation for social conservatism, it is not odd that of all the songs on her 2011 *Loud* album, the one most explicitly about alcohol is chosen to represent the nation. Part of the historical myth of Barbadian exceptionalism questionably touts the island as the "birthplace of rum,"[13] and alcohol consumption has long been a staple of Barbadian culture. The chorus of the song, "Cheers to the freaking weekend / I'll drink to that, yeah yeah / let the Jameson sink in / I'll drink to that, yeah yeah," refers to Irish whiskey rather than Barbadian rum and celebrates the ability to party rather than Barbadian industriousness.[14] These elements of imported alcohol and release from stress rather than working through hard times are elements of Barbadian life, but they are much more evident in the image of Rihanna as a national icon, and the image of the tourist market, than in any of the "official" national symbols geared toward a global market. Rihanna's representations of Barbados collide head-on with her representations of pop culture, young women, conspicuous consumption, and youth, as the presence of icon of youth angst Avril Lavigne alludes to in the video.[15]

The first verse of the "Cheers" video presents the dangerous crossroads between the stage and the "ordinary" island. It begins by mapping a flight plan over the Caribbean region, but in featuring a jet, a boat, and luxury spaces on the south side of the island, it presents an extravagant experience, one that is both exclusive and aspirational. Rihanna is an ordinary woman with family and friends like anyone else, but she is not as ordinary as the bulk of her audience. Her experience exists on that line between ordinary and extraordinary, and she doesn't have to care what anyone thinks about it. The lines, "People gon' talk whether you doin' bad or good / Got a drink on my mind and my mind on my money," are a not-so-subtle dismissal of her critics, many of them Barbadian, that also promotes her personal wealth. The second verse begins with an image familiar to visual discourses of the Caribbean: a coconut vendor. While the lyrics talk about a party at night at the bar, the visuals promote life on the island washed in the sunlight of the day before returning to a nighttime stage. The juxtaposition of shots of island life, using familiar tropes and "authentic" images, and images of rock star work and play is the central theme of the video and of Rihanna's representations of Barbados. As Rihanna sings, "It's only up from here, no downward spiral," she could be speaking of her own career, or she could be in conversation with the national anthem's claims that "upward and onward we shall go, inspiring, exalting, free, and

greater will our nation grow in strength and unity." Images of racks of suitcases, the sky as seen from a plane, Kadooment costumes, flags, karaoke, and the ever-present water, whether the beach at sunset or a boat cutting through the stillness, cut in on one another in a pastiche style that presents Rihanna's unique positioning as celebrity and national representative. This first identity is much more overt than the latter in the video.

Part of what makes these representations dangerous, or at least risky, is their ambiguity. As an icon, Rihanna could be representing any number of things (Barbados, pop stardom, young black women, Caribbean culture, transnational music, the globalization of culture). She may not be representing any or all of these, and the viewer will never really know. But through subtle references to familiar tropes, viewers are made to feel as if they might know. As the final chorus begins with a multitude of voices, it is Rihanna's song that they sing. The video provides an inside look at Rihanna's "regular life" (swimming, with family, with friends, laughing), as well as glimpses of the place from which her star rose. A global audience may be familiar with images of popular artists such as CeeLo Green, Kanye West, Avril Lavigne, and Jay-Z, but most would not recognize the children, friends, and publicity team members who also appear in the video. The video furthers notions of authenticity by giving backstage glances and shooting in a documentary style. Viewers are presented with the "real" Rihanna and the "real" Barbados all at once. Barbados is both hypervisible and subsumed in the video. It ends with Rihanna having the last words as she screams "Rihanna Navy" into the camera as the night winds blow.

The subtlety and ambiguity of Rihanna's representations of Barbados and the Caribbean began early in her career. Even while auditioning for the record label that would launch her career, she was "dressed to evoke the spirit of the Caribbean's azure waters in a blue boob tube, white trousers and white boots."[16] Through her attire, Rihanna signified the island's most abundant natural resources (sky and sea) as she enacted her own role as a resource by stepping into the public eye. Her 2005 commercials for the BTA rely on the same idyllic tropes by presenting the island as an "exotic" place where foreigners can live out their luxurious fantasies. Using her body to signify, Rihanna continues a Barbadian discourse in which women are viewed as both national resource and local spectacle.[17] Rihanna's public image became the site of these dangerous crossroads as her success moved her into the realm of the iconic.

As Vicki Goldberg notes in her study of American photography, icons have symbolic significance: "They concentrate the hopes and fears of millions and provide an instant and effortless connection to some deeply meaningful moment in history."[18] Rihanna's image stands in for a Barbadian ideal, the image of modern tropicalism that the Barbadian nation-state has been crafting for decades. Her stardom has the power to spread the name (and perhaps influence) of Barbados further than previously imagined. She "is iconic in the commonly held sense of the

term: a representative image of profound significance to a nation or larger group."[19] But what specifically does her iconicity do to and for the nation of Barbados, especially when it is packaged in the kinds of sexuality and consumerism that Barbadian ideals both applaud and abhor? What is the danger of being a national icon when you are simultaneously a global pop icon?

Throughout her career, Rihanna has (with the help of her Def Jam mentors, family, friends, and professional team) built an artistic vision, creating and molding the salable product "Rihanna" (often distinct from the person Robyn Fenty). "Rihanna" as a celebrity brand promises an experience and encompasses much more than any one album or commercial item. As Sarah Banet-Weiser writes, "More than just the object itself, a brand is the perception—the series of images, themes, morals, values, feelings, and sense of authenticity conjured by the product itself. The brand is the essence of what will be experienced; the brand is a promise as much as practicality."[20] Rihanna's image is both reality and fantasy, and it has been one of the most malleable in the contemporary pop culture market, rivaling those of reinvention masters such as Madonna. In a 2011 interview, *British Vogue* writer Christa D'Souza writes that Rihanna is "not so much a 'black Madonna' (what she wanted to be as a girl growing up in Barbados) as a real-life avatar for the twenty-first century."[21] Madonna's manipulation of her image throughout her career has had real effects on the construction of femininity within the pop market, as "her continual change of image across these early music and video outputs promoted the idea that female identity was a construct that could be orchestrated and manipulated at will."[22] Rihanna's career trajectory has successfully taken up the idea of feminine image as product as she has built her name as a brand, expanded beyond the music industry, and displayed a chameleonlike ability to refashion her public self. In her representations of the nation, what, then, does her malleable femininity say about Barbadian women? Similar to yet still distinct from Alison Hinds, Rihanna also uses her pop stardom as a place to enact a Barbadian femininity that is adaptable: it can be sexual and commanding, it can be "respectable" and exemplary, and, through a woman's body, it enacts the negotiations of cultural code-switching that Bajans perform in different geographical and ideological settings.

This chapter focuses on the period between Rihanna's first tourism commercial with the BTA and into her three-year deal with the BTA signed in 2011, a period spanning her first five albums. It begins by detailing Rihanna's whirlwind rise to stardom, her public negotiation of her own celebrity, and the ways in which she has become an icon. Such an analysis is important in detailing what is at stake in having a young female pop superstar as the most visible face of a nation within a global market. Despite numerous tourism campaigns across North America, South America, and Europe and attempts to reach into expanding markets in Asia and Africa, there are few images of Barbados that come close to rivaling Rihanna's image in terms of circulation,[23] giving little in the way of an alternative perspective.

The following sections look at Rihanna's superstardom in conversation with Barbados's tourist economy, as well as how each relies on myths of tropical paradise, urbanity, and modernity, before exploring the ways in which the brand of Rihanna interfaces with Barbados's tourism brand.

REPRESENTING A NATION, BECOMING A STAR

One day, a sixteen-year-old Robyn Fenty was an aspiring singer in a virtually unknown girl group on the small island of Barbados, and then, in the presence of megaproducer Evan Rogers, she sang a demo, batted her emerald eyes, and was caught up in a hurricane of stardom, landing at a table in New York City signing a record deal.[24] Her vocals were still shaky and she was young and inexperienced, but as if she were a West Indian Dorothy clicking her heels, all the Wizzes of Def Jam Records affirmed that she had all she needed to become a star.

From *Vogue* to *Esquire*, magazine after magazine tells the origin story of Rihanna's career—the teenage schoolgirl who had the good luck to be seen by a big American record producer and was flown to New York in 2005 to audition for Def Jam executives Jay-Z and Jay Brown—a fairy-tale beginning. What Def Jam producers saw in her was that "certain quality, easy to perceive but hard to define, possessed by abnormally interesting people. Call it 'it.'"[25] As a team, they would produce a superstar, both mysterious and ordinary, whose itness would only grow. What Rihanna brought to the table was a work ethic and "that countenance, the effortless look of public intimacy well known in actresses and models, but also common among high-visibility professionals of other kinds, [that] is but one part, albeit an important one, of the multifaceted genius of It."[26] With the backing of the Def Jam label and producers with some of the best résumés in the business, a superstar was born. This star was built on recognizable tropes of young-girl pop stardom and exotic Caribbeanness backed by determination. Her first album drew attention to her background with a cover of one of the most recognizable crossover dancehall songs (Dawn Penn's "No No No") and displayed her accent on her first pop single, "Pon de Replay." She fit the mold of many young, black, female singers in the United States at the time, but with the combination of her Barbadian accent, her skin tone, her light eyes, and her foreignness packaged in ways that were familiar to U.S. audiences, she could stand out. She would be able to cross national boundaries, displaying both a diasporic malleability and the globalization of hegemonic popular culture in the twenty-first century. Rihanna's fairy-tale path to becoming a superstar mirrors the kind of story the Barbadian nation-state has sought to write for itself in its attempts to secure its place on the global stage while working with limited resources, big dreams, and industriousness.

When Rihanna first appeared on the music scene in the United States in 2005, she had never competed in Barbados's Crop Over Festival and many people in

Barbados had never heard of her. That soon began to change. During her first year of stardom, Rihanna shouted Barbados loud and clear in interviews, on awards shows, and in commercials. While her target audience at that time was largely U.S. teenage girls, most of whom had never heard of Barbados before, when her accolades reached the ears of fellow Barbadians, she solidified her place as a (then still unofficial) cultural ambassador. By April 2006, BTA officer Rob McChlery was telling a press conference that "Rihanna is currently the face of Barbados and the face of the tourism authority out there and what is so interesting is that it is a young, clean, obviously very beautiful face. She has spoken well on television; she has done all of these interviews and she has talked about how good her country is. *Rihanna is Barbados.*"[27] McChlery went on to say, "What Rihanna has done is given freely of her time to us. Starting last December, all of our television commercials or 30 second pieces that ran all across America, all of our television commercials have had Rihanna in it."[28] With tourism forming a substantial part of the Barbadian economy, commercials such as these play an important role in the economic survival of the nation. In McChlery's comments, the "official" myths of a Barbadian ideal meet the constructed image of pop stardom, each creating a hyperreal loop that authenticates the other through a constant and continued performance.

The commercials that McChlery speaks of, while seeking to serve the Barbadian nation-state's economy, are geared toward a U.S. audience. They are full of visual imagery that satisfies North American desires for leisurely escape.[29] Within such paradise discourses, "places such as the Caribbean should presumably be preserved in limbo, sites frozen in a paradisiacal timelessness in which nothing is done and there is nothing to do."[30] This leisure is attractive because of its supposed fixity in a time before the stresses of an industrialized and/or urban modernity. Advertisements that promote this discourse focus on domesticated "nature" and service work that is not "real work" because it is in service of leisure. One such commercial begins by showing the island's white-sand beaches and features scenes from Rihanna's music video for the song "If It's Lovin' That You Want."[31] The viewer is hurried through quick shots of white families running on the beach and being served by black waitstaff on the terrace of a hotel. There are shots of Barbados's famous golf courses, windsurfing, and secluded swimming coves. The latter part of the commercial focuses more on local-foreign interactions, showing a party in the street, Barbadian children smiling into the camera, and a fisherman bringing in his catch near tourists diving from a boat. The camera shots move between bright sunlight, comfortable shade, and nighttime scenes. These images are interspersed with shots of Rihanna walking along a beach, wantonly waving brightly colored fabric. The thirty-second commercial is both strikingly family oriented and plays on familiar tropes of sexual availability. The camera focuses on young Rihanna wearing a bikini and sarong, enticing the camera while singing lyrics such

as, "If it's loving that you need, baby come and share my world," and, "If it's lovin' that you want . . . I got it right here baby," a message whose double entendre serves as both a tourist invitation and a sexual invitation, two purposes that are hardly mutually exclusive.[32]

The song, Rihanna, and the carefully crafted images all work in service of a state ideal that shows Barbados as desirable. The commercial builds on nostalgic tropes of the exotic and erotic Caribbean while also highlighting the modern amenities of Barbados's tourism product. Rihanna's body and her music are dually inviting. As a young woman she is sexually desirable, but the lyrics, "If it's lovin' that you want . . . I got it right here baby," both build on that sexuality and negate it by engaging the trope of the young West Indian au pair that already exists within a North American audience's imagination. She becomes both exotic jezebel and safe mammy ready to love, protect, and guide a family through leisure. The video ends with a call to "experience the authentic Caribbean," representing the "real" Caribbean through images that agree with the "imagined Caribbean" many visitors already know.[33] Using Rihanna's image in this way, the BTA offers Barbados as alluring, exotic, comfortable, and safe while firmly asserting Rihanna's Barbadian "authenticity" for a U.S. audience.

Rihanna's role in the commercial is effective precisely because of her status as a pop star. In 2006, when the commercial aired, her image centered on youthful sensuality. Barbados was still a very young nation-state, and it was calling on a young artist to represent it, using both her body and the physical landscape of the island as visual cues. Representations of the Caribbean within the tourist market (both historically and presently) also rely on an exotic sensuality, one in which women's bodies are central and Caribbean landscapes are both feminized and sexualized.[34] Rihanna is one of the few Barbadians in the commercial not overtly servicing tourists. This is typical in a tourist commercial. The goal is to show tourists enjoying themselves. Rihanna's status as a pop star allows her to step into service of the nation by representing it in a commercial, but her pop stardom places her outside the world of those other Barbadians in the service industry.

Within the first two years of her career, Robyn Rihanna Fenty had reached beyond the music market, entering into fashion, film, and entrepreneurship (revealing her own fragrance). As her star began to rise higher and higher in the pop culture sky, many in her audience began to pay more attention to her relationship to the island of Barbados. Critiques rolled in: Was she doing enough for the island? Did she exploit her roots in Barbados to further her own image? Supporters argued that she may not have written any nationalistic songs about Barbados, but Rihanna had found her own way of performing a sincere nationality. Aside from the tourism videos, she was able to bring in other Barbadian artists to sing on her second album.[35] And for her supporters at least, Rihanna's relation-

ship to the island was indicative of recent trends within Barbadian music. Speaking in 2009, Rupee explains,

> If you examine the type of music Rihanna does, you know, it isn't Caribbean. I mean, naturally because of her background, she is Barbadian, and you can hear mild references to the Bajan accent, but predominantly it's pop music. . . . Now let me just reinforce that I don't have a problem with that. I love Rihanna like a little sister. But what scares me is that as I mentioned all the artists I just called [Shontelle, Jaicko, Hal Linton, Livvi Franc, Vita Chambers] they're not being signed for music that's indigenous to us.[36]

If most Barbadian musicians with prospects on the larger market were rarely performing music that was indigenous to Barbados, then how were they representing Barbadian culture? The representation often lies in the stories of these artists themselves, rather than in the genre of their music or even the visual aesthetics of their promotion. Their histories of migration, striving for and adapting to modern forms, and multiple cultural influences are a common part of Barbadian life. These histories, undergirded by an undeniable work ethic and a sense of personal (and national) pride, are the hallmarks of a mythic "Barbadian personality," a specific constructed ideal of Barbadian life that is recognizable to many Barbadian audiences if not to the larger world.

While Rihanna's career took off, some of the editorials featured in Barbadian papers argued that with her level of visibility, the mere mention of Barbados from her lips would bring immeasurable publicity to the nation. Rihanna released five albums in as many years, all successful; but as she began to make drastic changes to her public image, debates about her representation of the nation changed. It was no longer an issue of whether she represented Barbados; the question had become, Was she a "good" representative of the nation? Did she represent the ideals of the nation? And as a young artist in a growing pop culture melee, should she be expected to adhere to Barbadian ideals?

When an individual becomes a symbol of a nation, the formation of her image is constantly in conversation with representations of national identity. Trinidadian-born Caribbean historian and cultural theorist C.L.R. James reminds us that "artistic production is essentially individual and the artistic individual is above all, unpredictable."[37] Over the course of the first six years of her career, Rihanna's public image morphed multiple times. Her Barbadian citizenship and her relationship to the Barbadian government define her as a representation of the nation. Her publicity gives her iconic status, but she is both a Barbadian icon and a pop icon, and the stakes of representation differ widely between those two positions. Such relations are further complicated by the different aspects of Rihanna's identity: she is Barbadian, she is a young woman, and she is also of a generation growing

up in an increasingly global world. Some have noted that Rihanna's skin and eye color have a large part in her iconic status. They assert that her comparatively light skin tone and green eyes serve as an exceptional and thus more "exotic" representation of a nation whose average citizen has darker skin than Rihanna and brown eyes.[38] A look at the early years of her career and her first five album covers reveals how flexible her iconicity is, as well her evolution as a young female artist.

Rihanna's first album dropped in 2005 in a pop market that had a rather narrowly defined image for young, black, female artists. Her public persona was quite similar to those of Beyoncé, Christina Milian, Ashanti, and Ciara, all young, black (in a midrange of skin tones), with long and usually straight hair, performing in a pop/R&B style that featured catchy rhythms, nonpolitical lyrics, and hip-hop dance. Rihanna's accent on her first single, "Pon de Replay," sets her apart from them even as the visual aesthetics of the album are squarely tied to the black female pop/R&B space that these other artists inhabit. The cover of Rihanna's first album, *Music of the Sun*, presents her as young, fresh, and slightly alluring. The name of the album is dwarfed by both the direct head shot of Rihanna and her name in gold, shining bubble letters. Backed by warm (almost sunrise) colors, her gaze is direct. The framing of the shot, combined with her makeup and bright bubble-gum-colored lip gloss, presents Rihanna wrapped in teeny-bopper glamour.

Music of the Sun introduced an unknown Barbadian singer into a U.S. market. Rihanna's sartorial style reflects typical North American teen R&B fashion on that album. Although *A Girl like Me* was released only a year later, Rihanna already had a considerable amount of name recognition by that time. This album and its packaging reflect an attempt to infuse elements of the Caribbean into the U.S. market. Utilizing musical collaborations with Barbadian Dwane Husbands and Jamaican Sean Paul, *A Girl like Me* relies on fusions of R&B and Caribbean-based genres in its sound, without losing its pop appeal. Visually, the album packaging relies on prevalent notions of the Caribbean as inviting, alluring, pure, and fun by using tropical flora as a backdrop, the contrast between white and warm colors in the color scheme, and the inviting but distant head shot on the cover. Both of these albums use the head shot to increase Rihanna's "exotic" allure by focusing on her green eyes,[39] but the cover of *A Girl like Me* produces more allure by obscuring part of Rihanna's face with a lock of her hair and presenting her backlit with sunshine.

In 2006 Rihanna was only eighteen years old and her management team was still pushing a very youthful persona, but she was hoping to do more with her image. She explains in an interview with *Glamour* magazine, "In the beginning of my career, it was really strict for me. . . . We had a young fan base, and they were trying to keep me fresh. But I just really wanted to be myself."[40] It was the 2007 album *Good Girl Gone Bad* that marked the first drastic shift in Rihanna's image, only three years after being discovered by producers Evan Rogers and Carl Sturken. Nineteen years old at the time of the album's release, Rihanna had passed into legal adulthood and began to display this in her aesthetic. As the title suggests,

the *Good Girl Gone Bad* album is where Rihanna breaks her earlier mold of bubble-gum teen "good girl." Gone are the colors of her previous image. Gone are allusions to the Caribbean or to teen culture. This is a grown-up Rihanna, one who has moved away from the small Caribbean island and now lives in a U.S. metropolis, who has left behind the image of innocent exoticism for a more dangerous urbanity. Represented in the images of the liner notes, the backdrop of her world is now brick walls and satin bedsheets. And this is the image she most identifies with.[41]

On this album, Rihanna also begins to slowly move from the R&B genre into a more pop-oriented sound. The album features collaborations with crooners/producers Ne-Yo and Justin Timberlake, as well as mentor/rap star Jay-Z. Although her sound and her image no longer allude to the Caribbean, the album does not entirely leave Barbados behind, as three songs (including the title track, "Good Girl Gone Bad," and one of the more popular singles, "Shut Up and Drive") were recorded in part at Barbadian studios. Selling over six million copies, this album solidified Rihanna's stardom.[42]

Good Girl Gone Bad does not necessarily lose the good girl, pop glamour aesthetic, but rather adds a bit of edge to it. In building an enigmatic persona, she built on previous bad-girl bombshell tropes while still retaining a youthful aesthetic. One could ascribe Richard Dyer's description of film star Lana Turner to Rihanna during this period: "The girl-next-door was that never-never sex bombshell, plain-knit and voyeur's delight were one."[43] Such a coupling was already common in the U.S. pop music market. Britney Spears, Christina Aguilera, and Beyoncé had all done this before as they grew from girls to women in public. Their enactment of the bombshell good girl, however, lacked the kind of mystery that Rihanna created around her image in the first few years of her career. The sense of allure was aided by both Rihanna's Barbadian accent and her silence. Her silence invited mystery,[44] but when she opened her mouth, there was more than a good girl, more than a bombshell; there was a manner of speaking that was unfamiliar to many in her international audience. This sense of mystery would be both exposed and re-created with her fourth album.

The enigmatic charisma that surrounded her second and third albums disappeared with the 2009 release of *Rated R*. Rihanna explains, "It was important for me to grow. *Good Girl Gone Bad* was the first time I really took the reins in my career creatively. Then *Rated R* came right after that, and that's when I realized, OK, my fans love the music; now I need to get a little deep with them, get a little more vulnerable, open up."[45] Such vulnerability was influenced largely by the media coverage of Chris Brown's 2009 assault on Rihanna. After photos of her bruised face were leaked to the press, she could no longer be a cool enigma. Robyn Fenty's personal business had become front-page news in ways that Rihanna could not control. But in "opening up" to her audience, Rihanna could redefine her own personal freedom in light of the attack on her mystery. Beyond the trauma of assault, Robyn Rihanna Fenty had to manage the pain of publicity and maintain

a career at a time when she "didn't want people looking at [her]" and "felt really lonely."[46] After the assault, she went home to Barbados. She regrouped. She began writing. In November of the same year, she released the first single from the *Rated R* album, "Russian Roulette."

If Rihanna stepped outside the good-girl pop star mold with *Good Girl Gone Bad*, she smashed it to pieces with *Rated R*. The album is dark. The cover is done in a sharply contrasting black-and-white color scheme. Her face is heavily made up with dark lipstick and eye makeup and half obscured by her own hand, which is covered in hard metal jewelry. The simplicity of the nine rings and their small chains on the fingers that cover the right side of her face give one a sense of tiny shackles. Her body is covered in a bulky black leather top. Her hair is dark at the root and shaven on one side, but the length of it is platinum blond and mostly sweeps upward out of the frame, with one lone lock dangling down. The title of the album is almost hidden in the lower left corner, and this is the first album cover in her career to feature a parental advisory label. The viewer/listener is no longer in teeny-bopper land. The images throughout the liner notes and the back cover continue the theme of the front. They feature Rihanna exposed: there are peeks into her creative process with shots of her writing and sleeping; a look at "regular" life as she shops; and plenty of images of her smoking, smiling, just barely covering herself with leather, chains, barbed wire, and comments on censorship that allude to discourses of bondage and sadomasochism. This is Rihanna's way of "opening up." She presents the mundane details of her world, her creative process, and her mostly bare body, all packaged in aesthetics that call on exchanges of power and pleasure.

The styling of this album fits with the kind of rock aesthetic that allows young angst to express unadulterated pain as a practice of healing. The rock elements continue in a collaboration with Guns N' Roses guitarist Slash, and in many of the aesthetic choices of the music. The visual imagery of the album is directed by children's book author turned "painter, filmmaker, set designer and brand visionary" Simon Henwood.[47] Rihanna's team enlisted Henwood to be creative director of her global image, including the album, videos, television spots, and logo, which he created as a two-edged sword. Henwood writes that the logo began as a piece of origami and explains to music blogger arjanwrites, "One side symbolizes strength and the other vulnerability."[48] Such a contrast is evident in Rihanna's half-hidden direct gaze on the album cover.

Nicole R. Fleetwood reads the violent lyrics of this phase of Rihanna's career, her S&M aesthetics, and her collaborations with male singers as a form of incorporation. Rather than run from violence, Fleetwood argues, Rihanna employs violence in her image as a form of healing.[49] Around the same time that *Rated R* was released, Rihanna collaborated with rapper Eminem, a male superstar known for his violent lyrics and troubled relationships with women. In reading the video to their collaboration, "Love the Way You Lie," Fleetwood writes, "Eminem . . . raps

from a safe distance, the space of recovery. He is in a field of wide open expanse with beautiful setting sun. Rihanna stays close to the heat, singing in front of the burning house."[50] Fleetwood argues that rather than running away from a very public violent trauma, Rihanna chose to face it head on by incorporating violence into her creative work and exploring the relationship between pain and pleasure.

On November 7, 2009, only weeks before the release of Rated R, Rihanna's first interview since Chris Brown's assault aired in full on ABC's news show 20/20.[51] Rihanna appeared before Diane Sawyer channeling Sharon Stone's character in the 1992 film Basic Instinct. Her look for the interview was strikingly similar to Stone's in the famous interrogation scene: blond hair pulled back, white dress, neutral lipstick, and matching nail polish. The choice to sartorially mimic this character colors the reception of the interview. By dressing as a mysterious and dangerous, maybe sadomasochistic, perhaps misunderstood woman who can hold the attention of everyone in the room, Rihanna sartorially enters the interview from a space of unabashed power. Was Rihanna manipulating the media the way Stone's character manipulated her interviewers? Was this another way for her to assert power by calling on a powerful female character? Could this be read as a performance of Barbadian femininity adapting to the circumstance and reasserting a sense of strength? In breaking her silence on domestic abuse so close to the release of her album, many in the public eye questioned Rihanna's motives, or those of her management and corporate sponsorship. Was the interview a publicity stunt? Was it her idea or her record company's? Was it healthy for her? Was she ready? Throughout the interview and throughout the album, Rihanna made it clear that she had no intention of being anybody's victim.[52] When questioned about her initial decision to go back to her abusive boyfriend after the incident, Rihanna says at first, "I felt like I built this empire and the man that I love beat me and because I'm going back I'm gonna lose it? No."[53] She goes on to say that in all of the mail and online discussion circling around her, it was the letters from young fans who were also in abusive relationships that solidified her decision to leave: "When I realized that my selfish decision for love could result in some young girl getting killed, I could not be easy with that part. I couldn't be held responsible for telling them to go back. . . . I just didn't realize how much of an impact I had on these girls until that happened. It was a wake-up call a big wake up call for me."[54] Being forced to step away from her enigmatic image, and the violent way in which her private life was made public, showed Rihanna the stakes of her stardom in a way that she says she had not previously imagined. Alisa Bierria writes that "Rihanna not only expresses worry about other survivors, she also *identifies* with them. Establishing her combinations of strength and vulnerability—both global pop star exuding personal and sexual power *and* woman victimized by common gendered violence—facilitates solidarity between Rihanna and other survivors, while recognizing her amplified position can be leveraged as a model of a process of survival."[55] It was largely the internet interactions with her fans that

revealed to her the extent of her iconicity. In trying to make a personal decision, Rihanna was confronted with her status within a global market. Her decisions (however personal she may have wished them to be) influenced millions of others, and, especially as a young a woman whose image is tied to sexuality, power, pleasure, and pain, such decisions carry heavy weight.[56]

Since Robyn Rihanna Fenty signed to Def Jam in 2005, the name Rihanna has reached across the globe and transcended the music industry. "Rihanna" is the construction of her public face, successfully built into a brand name that sells commodities as diverse as umbrellas, cosmetics, and telephones. Somewhere beneath this image is Robyn. This is the name that those close to her use, those she trusts, those who were there before the mega-persona of Rihanna was invented. As someone who lives in the public eye, she can "'get kind of numb to hearing Rihanna, Rihanna, Rihanna,' she says. 'When I hear Robyn, I pay attention.'"[57] Rihanna and Robyn are hardly mutually exclusive, and it is in the intersections of these two appellations that the tensions of stardom and representation live.

As Rihanna's popularity skyrocketed between 2005 and 2010, as she took more control over her public image, she also invited more scrutiny. Bombarded by bloggers critiquing her image, her body, and her every move, Rihanna employed a practice that has roots in black American women's communities—the practice of dissemblance. Historian Darlene Clark Hine defines *dissemblance* as "the behavior and attitudes of black women that created the appearance of openness and disclosure, but actually shielded the truth of their inner lives and selves from their oppressors."[58] In Hine's analysis, black women migrating to the midwestern United States used dissemblance to take control over their sexual and economic safety while gaining a degree of personal autonomy. She states that "the dynamics of dissemblance involved creating the appearance of disclosure, or openness about themselves and their feelings, while actually remaining an enigma."[59] As a young, female, immigrant pop star in the United States, Robyn Rihanna Fenty's "oppressor" came in many forms: specific individuals, fame, media, and critics. Creating an enigmatic image early in her career was one way to protect Robyn Fenty from the visibility and scrutiny Rihanna had incurred. The distinction between public and private face, one in which even the public face can appear to be open, is also not uncommon in depictions of Caribbean women.[60] The success of Rihanna's career spread her image beyond national, genre-specific, and music industry borders. Even in constructing her image, she and her management could never control it. Especially after Chris Brown assaulted her in February 2009, her publicity became oppressive. No longer able to remain a mystery, the strategic practice of dissemblance has allowed her to hide within rather than from the limelight.

In 2009 Rihanna began to talk of giving her audience the "real" her. This sense of realness was manifested through her use of the same technologies that had enabled people to criticize her, and that had ultimately shown her the extent of her stardom. She took over her Twitter account, giving fans a sense of access to

her by posting mundane details of her day, thus providing an intimate connection. Posts on her Facebook and official fan pages went from being cast in an impersonal third-person voice to being written in the first person. She actively created "the appearance of openness" but walked an extremely fine line between declaring "the real Rihanna" online and in interviews and stating that much of what the public saw in her videos was "a character [she] play[ed]."[61] The distinction she has tried to make, however, still gets blurred when she is overtly representing the nation. Much of the anxiety surrounding her relationship with the Barbadian state centers on whether it is Robyn Fenty (who grew up in the parish of Saint Michael and attended Combermere secondary school), the "real" Rihanna of her Twitter feed (which features content that many Barbadians find objectionable),[62] or one of the many characters of her videos who is representing the nation in tourism commercials, in print advertisements, and as a cultural ambassador. As acclaimed producer L. A. Reid put it, "[Rihanna] became a star before she became an adult. Her nature is to protect herself."[63] In this way, "opening up" to her audience has allowed her to exert some degree of power over the relationship between her public image and her private self—between Rihanna and Robyn. In practicing dissemblance, she can be both vulnerable and protected.

The assault blurred the line between Rihanna as pop icon and Robyn as young woman in ways that neither identity was quite prepared for. One particular comment brought this to light. Rihanna noted, in reference to one blogger's criticism, "A lot of people get so brave behind the computer screen. . . . I get it—she's a blogger, whatever. But when she started jumping to conclusions about my personal decision, it really pissed me off."[64] It is this kind of public commentary, demonstrating both the distance and the ubiquitous presence of an internet audience, that Rihanna negotiates through dissemblance. The space of internet blogs blurs the lines between public and private (if they ever existed), but not the emotional connection to the idea of privacy. The anonymity of blogging creates a power differential that is uncomfortable for Rihanna as a star and, presumably, for Robyn as a person. By calling out this particular blogger, Rihanna is reasserting her right to define her "self," especially her "real" personal self that is supposed to exist outside the maelstrom of her public persona. Fleetwood asserts that "Rihanna's music and comments about her post-assault defensiveness speak to the ways in which intimacy is structured through public discourse and mediation. This is true more so for black women, whose private lives and intimate relations are severely regulated."[65] Rihanna could no longer be a mystery once her personal life came into the public eye, but she found ways to be "open" with her audience that have allowed her perhaps some sense of a private identity.

This may work for her as a pop icon, but as a national icon, it carries a different weight. The relationship between a complex individual person and an embodied representation of a national ideal is in a constant negotiation based on differing audiences. Tourist discourses from the nineteenth to the twenty-first century

represent the Caribbean region as consumable, and new forms of communication invite new forms of consumption. Potential tourist audiences have access to Barbadian news (through official newspaper websites and interpersonal communication) that may or may not support the ideal image the government wishes to convey to the world. Dissemblance may be an option for Rihanna, but it is not as readily available for national representations of Barbados. Both the individual and the nation, however, have used various communication technologies to produce a sense of availability to their target audiences.

Rated R not only marked a drastic change in Rihanna's visual (and musical) aesthetic, it was also the first time she was listed in the writing credits for the majority of songs on one album and, more importantly, as an executive producer. The image of the "real" Rihanna she proffered was one of a hurting, angry, twenty-year-old woman. In describing her hurt, she alluded to a tropical childhood scarred by an addiction-ridden father who was also abusive toward her mother.[66] After the public assault, she went home and emerged with her head half-shaven; her body exposed more than ever, barely hidden in leather and chains; a cigarette in hand; and a gun tattooed on her side, singing, "I lick the gun when I'm done," "I'm such a fucking lady."[67] In describing the entire *Rated R* campaign and the many photo shoots it involved, Henwood notes other paradoxes in his experience with Rihanna. He writes, "She works harder than anyone I know on so many levels— always with a relaxed Barbadian stride, and always with time for a passing fan encounter or two."[68] Might the idyllic image of the island she represented also have some hidden complexities? Rihanna's public presentation of her personal healing through often violent creativity still exuded the Barbadian trait of industry, colored by a "relaxed Barbadian stride."

Regardless of whether Rihanna's new image was the "best" representation of Barbados, it was certainly the most visible image of a Barbadian (even if not the most visibly Barbadian image). Most critics acknowledged the pain in the album, and perhaps because of the way she and her team described it as deeply personal, many stayed silent about the album itself, preferring to critique Rihanna's changing public image; but others were troubled by the way in which Rihanna's most public display of healing linked violence, sexuality, and "rude" behavior.[69] Rihanna was not the first (and probably won't be the last) young Barbadian artist to be critiqued for the sexual content of her music. Soca stalwarts Edwin Yearwood and Alison Hinds also contended with close scrutiny early in their careers and were "frequently accused of not setting the best example for their young fans to follow."[70] The concerns over the conspicuous sexuality and/or violence in the personas of Barbadian artists were part of a growing concern over the morality of Barbadian youth.

The 2010 *Loud* album, Rihanna's fifth, complicates the good-girl-gone-bad image of her previous two efforts. Here, she steps back from the punk rock, sado-masochistic imagery of *Rated R*, returning to the frills, lace, and bouncing curls of earlier images, but this time in the super bright shade of her loud red hair. The

cover features this bold coloring in a very tight head shot in which her face is framed by red curls and her barely open lips are centrally positioned in matching bright-red lipstick. While her face is positioned in the same direct pose as on earlier albums, this time the viewer is held at a distance by her closed eyes. The liner-note images combine many of the motifs of her previous albums, including an image of Rihanna swirling in a white dress with her red hair contrasting with the greens of an outdoor setting, and close-up nearly nude body shots. This album's theme, however, seems to center on the image of a sexy flower.[71] She lies in a bed of roses, kisses a rose stem, and holds one light-pink rose between her seemingly naked thighs in an image reminiscent of the kind of not-so-veiled sexual statements made by Lady Saw and Betty Davis.[72] The boldness of her red hair is both highlighted and washed out with bright lighting that blends with her white clothing. The imagery presents a very delicate rebellion flowering in the public eye and signified by the visibility of her "rebelle fleur" neck tattoo.

This fifth album shows Rihanna as both dangerous and fragile. While the flower motif has less shock value than *Rated R*'s imagery, the lyrics and accompanying videos for the singles "S&M" and "Man Down" fulfilled the controversy quota of pop stardom. If the bans on these videos were not enough, reports of Rihanna's onstage antics during the Loud Tour helped to fuel the flames. Journalist Ricky Jordan offers his analysis of Rihanna's image: "Many of Rihanna's videos post-2008 feature a delicate contest between power and abuse. I think Rihanna is pushing the envelope by dabbling in areas that are designed to raise eyebrows and spark controversy: areas like suicide, lesbianism, violence against women, and media bashing. And she packages them with a thuglike coating of guns and chains under an umbrella of sex that simultaneously excites men, encourages women and makes children curious, while disgusting a minority. It works for her and for Def Jam."[73] Rihanna's ever-changing image parallels the discourses about Barbadian youth, highlighting taboo subjects while polishing well-worn tropes. Jordan's analysis reminds Rihanna's audience that however her image represents the nation of Barbados, she is also an individual, and as a pop star, her image is a commodity.

In the late 1980s and 1990s the effects of Barbados's shift to a tourist economy started to become apparent within a new generation of youth. The constant presence of tourists on the island raised expectations and increased the desire for material goods, as Barbadians were constantly in the presence of supposed leisure.[74] The grandchildren of independence witnessed the signs of the unsustainability of the nation's free health care and free education when Barbados's economy experienced crises in the early 1980s and again in the early 1990s, resulting in International Monetary Fund consultations and programs. As Prime Minister Owen Arthur took office in 1994, he favored a neoliberal privatization approach to the economy.[75] More attention turned to the influx of popular culture that featured "glitzy" lifestyles, and by 2011 Steve Blackett, the minister of social care and community development, was quoted as saying, "The popular music culture and the

adoption of bling and glitzy lifestyles have largely been responsible for the increase in social decay in our communities."[76]

Such concern over the social "decay" of society and Barbadian youth, in particular, was voiced in part in response to the perception of rising crime rates in the early years of the twenty-first century.[77] Some of the most violent crimes those now living in Barbados had ever seen took place in the early 2000s, most notably the October 2010 robbery of Campus Trendz that ended in arson, killing six young women in the capital city of Bridgetown. The crime shocked the nation, mainly because the young robbers had already gotten away with the merchandise when they decided to set a store on fire, trapping the inhabitants inside. Reports of the crime showed a grave concern over the young assailants' lack of value for life.[78] On the other hand, the island has also produced a number of successful young entrepreneurs and university graduates.[79] This is the generation of Barbadians that Rihanna comes from. It is a generation in which many young people have made great strides professionally, but others have fallen victim to the lack of jobs, the rising cost of living, and a perceived disregard for the value of life, ultimately creating victims of their own. Both Rihanna's success and the sometimes undesirable elements (violence, overt sexuality, gaudy materialism) of her image are a reflection of the complexities her generation of Barbadians has faced.

THE URBAN EXOTIC AND MODERN MYTHS

The song "What's My Name" from the 2010 album *Loud*, its video, and Rihanna's 2010 American Music Awards performance of it display the kinds of intimacy, dissemblance, and ideals that are at the center of both Rihanna's negotiation of her own publicity and her relationship to the Barbadian nation's construction of an "authentic" Caribbean experience. Having already declared on the *Rated R* album that she is "such a fucking lady," Rihanna draws power from notions of respectability (being a lady) and rebellion in order to demand recognition in the title of one of her singles, "What's My Name."[80] She refuses the "repressive respectability of a conservative gender ideology" by disidentifying with dominant definitions of a "lady."[81] Her collaboration with Drake, a Canadian rap artist whose masculinity both detours from and reaffirms common practices within the rap genre, suggests an affinity with other artists who play with the boundaries of prescribed molds. The video relies on the powers of sexual temptation, public flirtations, and domesticated performances of desire. Her live performances of this song, however, covertly display the power of representation. They can be read in light of her rise to stardom in that the narratives of her performance mirror her career trajectory and that of the nation she represents. They represent the myth-reality of pop stardom and Caribbean fantasy.

The video opens with a head shot of Rihanna washed out in bright backlighting.[82] Her face is the landscape over which a sun is rising. The lighting produces

the effect of her glowing that is seen on some of her early album artwork. The camera pans over a city before finding Drake in a corner store buying lottery tickets. Rihanna passes and the story begins. The video chronicles an attraction between the two, showing them in the corner store and later in an apartment. Interspersed are shots of Rihanna singing to camera alone (often with the same lighting as in the first shot), shots of Rihanna walking through the city streets, and shots of a gathering crowd of onlookers and drummers that culminates in an outdoor celebration.

The camerawork of the video plays with the notion that this pop star is ready to give her audience the "real" her. The construction of intimacy is evident in the difference between indoor solo shots, indoor shots with Drake, and shots of Rihanna out in public. In the public scenes, she is a spectacle. Her persona is created by her audience. Her already loud, bright-red hair is adorned with an even brighter red netted ribbon tied in a big bow. Her simple black top is covered by a black-and-white-striped jacket that is short enough not to cover her black-and-white minishorts, which are finished in bright colors. Her jewelry is large, plentiful, and gaudy. In the store, she catches the eye of Drake and (briefly) the man behind the counter. When she walks through the streets, everyone she passes takes notice. We see Rihanna—made up, dressed, doing what pop stars do—in the midst of the common people of New York. While Drake is able to approach her in the controlled, constructed scene of the corner store, everyone else is held at a distance. Their faces blurred, they are the backdrop to the pop star's world, the night sky to her stardom.

The interior shots show the "real" Rihanna, seductive, sweet, and in control. There is a submissiveness in the way she is almost always looking up at Drake. She has no voice in these shots. Her attire is muted: a large blue-gray sweater with gray knitted knee-highs. While these scenes present her in a position of domesticity (she pours the wine and washes the glasses afterward), she is still the center of attention. In collaborating with Drake, Rihanna extends her power over the genre of rap music. Her power over Drake in the video serves as a metaphor for her power to cross boundaries within the music industry, a feat that is supported by the popularity of her earlier collaborations with popular rap stars.

These scenes serve as a metaphor for the modernization of Caribbean colonial myths of tropical paradise. Scholars note how the early tourist discourses of the nineteenth century presented Caribbean peoples and landscapes as available, feminized, virginal, and ready to be conquered. Quiet, submissive populations were inviting, and ordered, domesticated landscapes were posed as a sign of civilization.[83] In the postcolonial era, such myths have been reworked within tourism discourses.[84] The construction of domesticated, conquerable pleasure is a leading feature of advertisements of the Caribbean, and constructed images of controlled abandon (with all of their connotations of sex, excess, and liberatory absolution) feature in the advertisements of Barbados specifically. The marketing

campaigns for luxury tourism promote virginal white sands, carefully manicured lawns, gardens, golf courses, and calm seas. Festival promotions center on the bodies of Barbadians, abundant pleasure, and party aesthetics. These advertisements seek to serve the Barbadian economy without necessarily disrupting or challenging global flows of resources and ideologies. In the video, Rihanna's performance of domesticated, controlled femininity, one that hints at pleasurable excess and tempered power, embodies and individualizes a modernized version of much older discourses of colonial desire.[85]

The construction of Rihanna's image is most apparent in the interior solo shots. She wears a blue-and-white halter top and the camera focuses on her face. She acknowledges the camera's presence, singing directly into it and breaking the fourth wall. This is a powerful young woman who commands the attention of everyone around her and (thanks to careful lighting) seems to shine even when by herself, but her power is not threatening. It is not overtly political. There is no readily discernable radical statement. Not unlike in historical tropes of the Caribbean region, her power is presented as sweet, domestic, sexual, and unassuming. Such a performance is in line with other enactments of Barbadian femininity and Caribbean woman power. It can be direct (and at times purposely excessively so), but often it manages to negotiate and enact power without appearing overtly threatening to social, national, or global structures.

The final scenes of the video mix many elements of Rihanna's image. Here she is out in public, in but not necessarily with the crowd. The individuals who served as the backdrop to the urban streets of the rest of the video have come from different corners—with bucket and sticks, djembes, congas, and smiles—to collect at a nighttime park fete. They are racially and fashionably diverse. The lighting is hazy and glowing red. The camera dances between close-ups of faces, dancing bodies, and fragments of movement while splicing in still, serene scenes of Rihanna and Drake's domesticity. The various types of drums and dancing, the nighttime setting, and the firelight meld the urban setting with a performative exoticism seen earlier in Rihanna's career. Set in the urban global city of New York, the scene modernizes colonial desires to "go primitive" in its celebration of open-air rhythm, dancing with abandon, and human diversity.[86] Rihanna is both at home and foreign. She belongs although she is different. Much like the never-never bombshell meets girl-next-door persona that marked the first major shift of her career, here Rihanna is carefree, enacting a "playful badass" vibe.[87] In the final shot, the viewer is taken back to the apartment setting. Drake kisses Rihanna on the cheek. She smiles, not looking at him or the camera. Rihanna gives Drake the illusion that she's been conquered by his affection; but not unlike in colonial discourses of the Caribbean, she is open to being conquered again.[88]

Fleetwood notes how in this song in particular, "Rihanna crafts the scenario under which she will bring her suitor under her control. He must succumb to her through recognition of her power over him, and an articulation of his

desire for her."[89] This sense of desire is what Barbados's tourism seeks to capitalize on. The video exoticizes an urban (read modern) space in ways that Barbados's tourism industry has been striving toward. Rihanna's performance places her within an urban setting but still relies on notions of exoticism in the brightness of her clothing, in the "diversity" of the people featured in close-up shots, and ultimately in the drums and fire at the end of the video. The video is both excessively alive in these last scenes and calmly domesticated in the interior shots, with the background of a modern, urban space throughout. Barbados's tourism industry has sought to marry Barbados's reputation for modernity (including a highly literate population, political stability, and decades of relative economic stability) with imaginaries of the tropics that are often premised on ideas of "primitive" exoticism. It seeks to draw on the excess of carnival culture in promoting Crop Over, while also touting its serene beaches and peppering the national cultural and tourist calendars with "modern" jazz and reggae festivals, as well as folk culture celebrations. Ideally, Barbadian tourism would be able to capitalize on paradisiacal desires while building and maintaining a modern Caribbean imaginary geared toward its own citizens and a global audience.

At the 2010 American Music Awards, the audience is filled with Rihanna's pop contemporaries, idols, and mentors, and she begins her segment alone, sitting on a crystal structure that hangs high above the stage while singing her part of the Eminem duet "Love the Way You Lie."[90] Below her is what looks like a field of crystal grass. Surrounding her is a dark background with specks of light such that, again, she is positioned as a star in a night sky, but this time surrounded by dangerous beauty. The accompaniment is scarce. Once she has set the stage with the chorus, the lights suddenly dim and she falls from the sky.

The transition to "What's My Name" is quick as the fields of crystal grass move on and off the stage, smoke bellows out, and the big crystal structure Rihanna was sitting on lights up in neon colors. As the hook to the song comes in, the beautiful danger on stage has already given way to a mysterious fun. Rihanna emerges from the haze in a black-and-white halter top with a sweetheart neckline; a pair of high-waisted black minishorts covered by a tiny, brightly colored wrap skirt; high-heeled stiletto boots; huge gold hoop earrings; and a host of thick, multicolored bracelets on each arm. Her look manages to be both excessive and provocative. It draws on the visuality of popular culture and urban styles while giving a nod to signs of an imagined "primitive" Africa. Throughout the first two verses, she is alone and in control, dancing and strutting, commanding the audience's attention, not unlike in the scenes of her walking through the city streets in the "What's My Name" video. As the song crescendos, the rhythm changes and four dancers in similar costuming join Rihanna on stage. Their costuming effects the same urban/exotic aesthetic as the scenes at the end of the video, combining potato-sack tops, peacock feathers, and stilettos.

The rhythm shifts again as four djembe drummers appear at the back of the stage. Rihanna trembles her behind throughout their short solo before launching into "Only Girl in the World." More dancers come on and off the stage, but by the hook Rihanna is alone again. She belts the chorus, with lines about how she is understood, before she trails off, letting the back track take over and smiling toward the audience. This "understanding" is ambiguous in the performance. The lyrics point to a romantic understanding between two individuals, but her performance of these lines asserts a power in the knowledge that she withholds from the audience. The djembes reenter and Rihanna lets her hips lead her over to a drum, where she squats and bangs away as a drummer continues his part. Fire burns at the back of the stage as the dancers return, re-creating the final outdoor scenes of the "What's My Name" video. As the flames die down, Rihanna ends the song alone, leaning against the same lit structure she began the performance with. After the last note, the lights rise over the theater and Rihanna smiles coyly as the audience rises for a standing ovation, creating one of many moments when the twentysomething Robyn and the pop idol Rihanna seem to meld into one.

The framing of this performance is important to its efficacy. Rihanna begins with two popular duets but sings them alone before launching into "Only Girl in the World." She begins with danger and sets the stage by enjoying a lie. Then she declares her stardom with the song "What's My Name" and ends with a fantasy of justified control. She is a small-island girl on a really big stage. Though her home is not overtly referenced, her performance is similar to the the goals of an independent Barbados, a little island thrust onto the world stage in 1966. Prime Minister Errol Barrow's wish that Barbados be "a friend to all and a satellite of none" is reflected through a pop music lens in Rihanna's pleas for recognition and control. Rihanna's performance marries an "exotic" aesthetic with "modern" elements in ways that are central to the promotion of Barbadian tourism. In the twenty-first century, Barbados struggles to maintain economic stability. Within tourist and celebrity discourses, it is often subsumed under "primitive" imaginaries of the Caribbean region and the Third World. While the island still struggles to maintain and assert sovereignty and autonomy while relying heavily on tourism in a failing global economy, Rihanna is already living her fantasy.

The relationship between representation and audience, between ideology and commerce, is evident in NIVEA's 2011 advertising campaign.[91] With Rihanna as the face of the campaign (and NIVEA sponsoring her Loud Tour), NIVEA exhausted its advertising options using digital technology as much as possible. One of the methods they used was an augmented reality campaign where users could buy a special tin of NIVEA Crème or download a coded image from NIVEA's site (figure 13). When the tin or image is held up to a webcam, Rihanna holographically appears, singing her 2011 single "California King" from the 2010 *Loud* album (figure 14). Consumers can literally hold one of the world's most popular

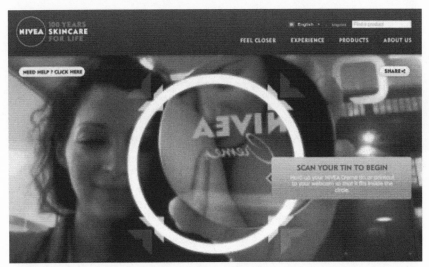

FIGURE 13. Still image from "NIVEA Augmented Reality Campaign."

FIGURE 14. Still image from "NIVEA Augmented Reality Campaign."

pop stars in their hands while performing a daily ritual of cosmetic hygiene. It "really" is Rihanna's voice that digitally sings. She is available, inviting the consumer to follow her through a web of white linens into a sky-blue background, but only as a holograph. In a song of failing romance, she both invites consumers and distances them.

Rihanna's Barbadian heritage is not referenced in the campaign, but she follows in a tradition of Caribbean consumption based on new technology. Like the

postcard of the late nineteenth century, this example of augmented reality creates a tangible, consumable product. Unlike the static photograph on a postcard, however, here Rihanna performs, coming to life—an alternate, digitally produced, hyperreal life—in one's hand. A tin for cosmetics becomes a twenty-first-century music box, including both a familiar song that holds the power of nostalgia and a visible, specific figure.

While Rihanna's representation of Barbadian tourism had been established by this point in her career, her representation of other consumer brands was not guaranteed. Her pop stardom made her an attractive target for celebrity endorsements, but some brands also saw her particular performance of fame as a liability. When a new CEO, Stefan Heidenreich, stepped into power at NIVEA in 2012, he axed the campaign, reportedly because he could not see how Rihanna's stardom aligned with the family values of the NIVEA brand.[92] This situation mirrors that in Barbadian poet Kamau Brathwaite's poem "Blanche." He writes of Blanche putting clean white linens out on the line for everyone to see. Their cleanliness is temporary and always contested, as Brathwaite hints at all the things that have happened on those sheets. They are on display and everyone knows how clean they are now, as well as how contingent their brightness is.[93] The myths of paradise at the root of tourism discourse can be similarly fragile. They have endured through the ages but are constantly threatened by more complex realities. Rihanna's position as a representative, whether a national representative or a commercial one, is attractive. As BTA officer Rob McChlery noted in 2006, hers is a "young, clean, and very beautiful face."[94] Yet the realities of her humanity, the fact that she is more than a face, always affect her representative status. And her proclivity for testing notions of respectability and displaying an unabashed sexuality sometimes creates concern among the brands and the nation that she represents.

BRANDED BEAUTIFUL: BRAND RIHANNA MEETS BRAND BARBADOS

> It's not the music industry anymore.... It's the entertainment industry. The goal is not just to be an artist, it's to be a brand.
>
> —Jay Brown, in conversation with Josh Eells, "Queen of Pain"

> The process of branding impacts the way we understand who we are, how we organize ourselves in the world, [and] what stories we tell ourselves about ourselves.
>
> —Sarah Banet-Weiser, *Authentic*™

The dilemma of cultural standards has reared its head many times in regard to Rihanna's music. In 2010 one of the many songs at the heart of this debate was "Rude Boy," a reggae song on Rihanna's *Rated R* album. "Rude" culture (often

associated with the youth of the Jamaican working class) features overt sexuality, conspicuous consumption, and sometimes violence. It generally flouts middle-class and elite standards of "acceptable" behavior and is a prime example of what Paul Gilroy calls a counterculture of modernity.[95] Barbadian magistrate Ian Weekes spoke out against Rihanna's "Rude Boy" song, saying that it was "purely sexual" and emblematic of music that promoted a "rude" subculture on the island. According to him, "certain standards need to be set."[96] This is not unrelated to the concerns over "bling lifestyle" noted earlier. Each presents a fear that, whether through consumption, behavior, or both, the moral standards of society are in peril, and each locates the roots of such fear in "foreign" influences. Over the past twenty years, there has been a fear in Barbados that a rude subculture could come to represent the nation in the same way that it came to represent Jamaica,[97] thus threatening Barbadian respectability and perhaps tarnishing brand Barbados. In debates over whether to ban the "Rude Boy" song on Barbadian airwaves (and others in Rihanna's oeuvre), supporters of a ban seem to argue that such "rude" or detrimental music is not a part of Barbadian culture (or at least not reflective of Barbadian ideals). Others suggest that the nation needs to support "its own," especially a Barbadian artist who is getting so much acclaim abroad. The argument over standards seems to become entangled in questions of what a Barbadian standard is, what a global pop standard is, and which should take precedence in a nation's expectations of a global pop artist who is Barbadian.

When Rihanna first signed with Def Jam records in 2005, the BTA claimed her as the "face of Barbados."[98] In subsequent years, she worked more toward developing her own star quality, but the association (or expectations of an association) between her and the island would only grow. It was in 2008 when then–prime minister David Thompson appointed her cultural ambassador for youth and culture that her public connection to the Barbadian nation-state was cemented (to the applause of some and the chagrin of others). And in 2011, when Rihanna signed a three-year deal with the BTA to promote Barbados exclusively, the nation reined its (arguably) biggest global asset into national service once again. This deal was signed during Rihanna's 2011 Loud Tour, which was quickly slated to make an appearance on the island. Brand Rihanna would meet brand Barbados.

Shortly after inking the three-year deal with the BTA, Rihanna shocked many with a surprise appearance at one of Barbados's most visible performances of national culture, Kadooment, only days before her scheduled performance on the island.[99] As thousands of people danced through the streets in costumed bands, participants, observers, and photographers spotted Robyn Rihanna Fenty smiling, drinking, dancing, and generally "gettin' on bad" like most everyone else. Photographs of the "Pop Princess" and "Soca Queen" Alison Hinds appeared on the internet, as did photos of Rihanna and Rupee, but the photos that received the most attention from the international celebrity media were those of Rihanna dancing with friends, on a truck, and throughout the streets wearing her Kadooment

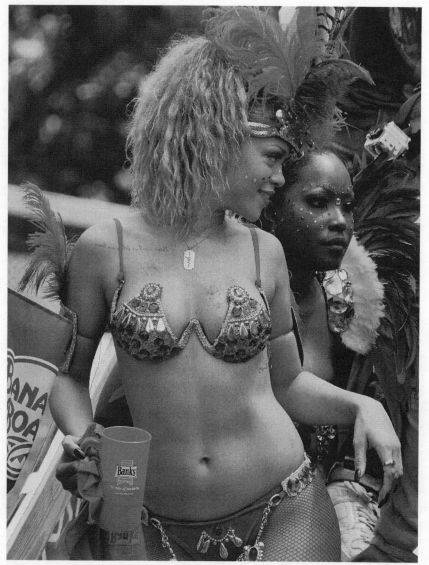

FIGURE 15. Rihanna in the 2011 Kadooment Day parade. © Splash.

band costume. Celebrity photographers captured photos and video, and the British and U.S. celebrity media sites that used them were widely consumed in Barbadian digital spaces. One online magazine reported, "Rihanna goes back to her rude girl ways getting raunchy as a scantily-clad carnival queen."[100] While Rihanna's presence was duly noted at the festival, she was one of thousands of participants, not necessarily the "carnival queen."[101] The same article goes on to

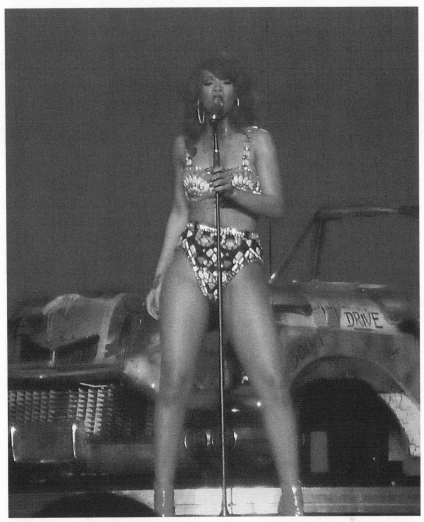

FIGURE 16. Rihanna performing during her Loud Tour. Photographed by the author.

note her "raunchy moves" as she danced "with a willing fan." The "raunchy moves" are a common part of the national dance, wukking up, and the "willing fan" happened to be one of her closest friends, Negus Sealy.[102]

Many online articles framed Rihanna's behavior as part of her growing wildness, comparing her Kadooment costume to those she wears on stage (figures 15 and 16) and labeling her dancing as shocking and disgusting. These reports, by and large, originated on celebrity news sites whose focus was strictly on Rihanna but whose reports extended her behavior (and their critiques of it) to a nation of people. While comments on Rihanna's "skimpy" attire floated in cyberspace, fans

(and nonfans) sought to correct misinformed media reports in an effort to protect both Rihanna and the festival where she was photographed. In this way, critiques of Rihanna, brought on by her status as a celebrity, caused the indignation of Barbadians who were furious that their culture could be grossly misread through uninformed readings of one young woman's body.

Before the sun had set on Kadooment Day in Barbados, E! Online posted a short article titled "Which Singer Is Rocking a Teeny Bikini and Feathers?"[103] Before revealing the identity of the singer, the article cautions readers that "it's not surprising to see her in such a getup, because one thing she's definitely famous for is her sense of edgy fashion."[104] Here is an instance of cultural mistranslation in which a costume common to the Crop Over Festival and similar carnival celebrations worldwide is attributed to the fashion sense of one individual among the many who wore the same thing but were often cropped out of photos. The article states that Rihanna had "returned to her native land of Barbados for the colorful street bash celebrating the annual Kadooement [sic] Day parade."[105] Besides misspelling the name of the event, the language of the statement has overtones of exoticism that continue in the remarks found most offensive to commenters:

So what the heck is Kadooement [sic] Day?
It's an ancient tradition and public holiday in Barbados, which involves people masquerading in costumes that consist of natural materials and takes place during the Crop Over Festival. The event rejoices the end of the sugar cane crop harvest and acknowledges the crop sacrifices made to the gods for good luck.
Ri-Ri was spotted shaking her booty (Get it, girl!) with friends and (we can assume) wowing those around her with a barely there costume.[106]

Arguably, the ancientness of the tradition can be read as another editorial invention, as Kadooment Day began as part of the contemporary Crop Over Festival in the 1970s.[107] Next to photos of Rihanna wearing a bikini made of synthetic materials and decorated with fake feathers and plastic beads, the idea that Kadooment costumes are supposed to consist of "natural materials" reads as an attempt to "primitivize" the festival by inventing a connection between the participants' bodies and "nature." Such mistranslations are not uncommon when it comes to Afro-Caribbean women and women of current and former colonies more broadly. As Gloria Wekker notes in her analysis of Afro-Surinamese women, "The cultural sedimentation of the colonial system in the metropolis is a deep-seated conglomerate of imagery constructing black women's sexuality as overactive, deviant, excessive, closer to nature, not in control, and animal-like."[108] In these celebrity media articles, Rihanna's image was always already excessive, already deviant and naturally so. Author Bruna Nessif's assumption that Rihanna's costume stands out in the crowd erases the rest of the Baje International band wearing the same cos-

tume and the thousands of other participants wearing similar attire. Many Barbadians reading the article wondered why they had never heard of the "crop sacrifices made to the gods for good luck," but most recognized they had never heard of such a tradition because it did not exist in the contemporary form of Crop Over.

About an hour after the article was posted online, the comments began to pour in, including statements on the beauty of Rihanna's body, expressions of disgust at the public display of her body, proclamations of support for carnival celebrations around the world, and, most notably, corrections to the article and others' comments on it. Throughout the 125 comments posted to the article within the week, certain attitudes became quite clear. One of the clearest sentiments was that self-identified Barbadians felt misrepresented, and thus they defended the modernity of their culture, defended Rihanna, and declared their pride. At least a third of the commenters identified themselves as Barbadian either in their comments or in pseudonyms such as IAMABARBADIAN, Barbadian and Proud, 246Bajan, or Offended Barbadian. At least thirty-three (26 percent) of the comments spoke against the article's mention of sacrifices to gods, and many asserted that Barbados is a Christian nation. One commenter, Lee-Ann, ended her comment with the words "Oh, and btw, WE ARE NOT PRIMITIVE." The declaration that Barbados is a Christian nation that serves one God, which was repeated throughout the comments, is one way to show the nation's affinity to modern, "First World" nations through monotheism, but it also erases a rich tradition of religious diversity.[109] One comment in particular tried to clear it up for everyone:

Enam Wed, Aug 3, 2011, 10:13 A.M.

Ok to all Bajans getting offended, the part about the festival being about a celebration of the end of the sugar harvest is true (that's why it's called crop over). The part about it being related to the gods is also true, not so much for good luck, but more a way of giving thanks to the gods (... go to the Barbados Museum and check the African Gallery). It was also a way to celebrate African culture which was suppressed year round. Originally the parade was held on various plantations, not one big festival as is the case today with Kadooment. This is of course the original crop over, the one today was brought back by the government in the 70's and still celebrates the end of harvest but emancipation as well. EOnline, get your facts straight, Bajans you too.[110]

Here "facts" are used to dispel both the misinterpretations of celebrity media and the idealistic representations offered by other Barbadians. Many of these comments were not only looking for journalistic accuracy but vehemently defended the modernity of Barbadian culture. Even in a politically independent Barbados that is proud of its "blackness" and African heritage, the idea of practicing "primitive" sacrifices to various gods was offensive to some commenters. Barbadian

blackness as performed during Crop Over is supposed to be a modern black-ness,[111] and commenters bristled at the idea that they would be subsumed under discourses of a "primitive" Africa or Third World.

Petra Rivera-Rideau notes how such tensions have played out in Puerto Rico. In her analysis of race and cultural politics, she identifies the difference between urban blackness and folkloric blackness within Puerto Rico's unique constructions of racial democracy (which itself is not without racism).[112] In the eyes of the state, folkloric blackness is "safe," encouraged though marginalized, and is the least influential in Puerto Rico's cultural mix. Urban blackness, however, "perpetuates common stereotypes of blackness, such as violence and hypersexuality, that are attributed to the residents of working class, predominantly nonwhite, public housing developments called *caseríos*."[113] In efforts to root out this latter "threat," the Puerto Rico government instituted Mano Dura (Iron Fist) policies in 1993. The rhetoric was that there would be three phases to rescue, restore, and reempower the *caseríos*, but "many people saw *Mano Dura* as merely a political 'spectacle' to assert state power and control."[114]

These competing representations of blackness have parallels throughout the Caribbean and are intrinsically tied to notions of modernity. In Deborah A. Thomas's examination of Jamaica and modernity, she notes how blackness and different class distinctions have been imagined within representations of the independent nation-state. She writes that in the 1970s, only a decade into independence, "the state no longer viewed Jamaica's African heritage merely in terms of preservation and presentation, but as having the potential to positively influence individual and national growth."[115] Thomas notes that while some feared that rural African-derived cultures would die out in Jamaica, the poorer populations were looking to carve out spaces for themselves within modern imaginaries, and they did this largely through transnationalism.[116] Culture, experience, and "Jamaican-ness" were greatly affected by class outlooks, and for poorer black Jamaicans, folk culture and urban culture were two of the most influential models. The most prevalent representations of urban Jamaican culture circulate within dancehall spaces, music, and videos that are both specific to Jamaican locales and travel internationally. Both Thomas and Belinda Edmondson note that such discourses of Jamaican representation are plagued by class issues, as calypso and soca (from the eastern Caribbean) are associated with the middle classes and receive more resources than dancehall music, which is associated with poor and working-class Jamaicans.[117] While Barbados has not instituted a policy as direct as Mano Dura, the racial class tensions exist as individuals, various audiences, and the state engage in different imaginaries of blackness, different imaginaries of the Caribbean, and different imaginaries of the Third World, and as they begin to parse out what they mean within representations of a larger Barbadian culture.

Such discourses about the modernity of Barbadian culture and cultural representations highlight the main dilemma within both national identity construction

and the construction of a national brand within Barbados: how to build an attractive global product that is based on a modern identity but whose attraction is also directly linked to historical myths of the "primitive" and "tropical," as well as contemporary countercultures of modernity.[118] The commenters on this E! Online article seem to want to offer the kind of "modern blackness" that increases their cultural capital and social capital.[119] Kadooment, a celebration that is particular to Barbados but has strong similarities with other cultural practices the world over, offers a specifically Barbadian reference within brand Barbados; but without control over representations of the Kadooment celebration, Barbadians are at the mercy of outside interpreters who may not understand the delicate balance between counterculture and modernity.

Underlying these concerns is the role that Rihanna's body, or more accurately the display of her body, plays in representing the nation. As a Barbadian, her attire during Kadooment is perfectly acceptable. As a pop star, the level of bared skin has different meanings—meanings that change across audiences and contexts. In this instance, Rihanna's body is read through the lens of celebrity media, and Barbadian commenters see such a reading as inaccurate because it does not take into account the context of Kadooment Day and Barbadian culture.

Barbadian Soca Queen Alison Hinds also had to defend herself from controversy and allegations of being overly sexual early in her career. As the front woman for the popular band Square One, Hinds attracted quite a bit of attention. As she continues her career as a solo artist, she has carefully fielded critiques, seeking to establish a standard for Caribbean women that marries respectability and sensuality. Although not shy in her performances and known for the movement of her backside, Hinds still commands the respect due to a "lady." In 2000 she explained, "A woman called . . . and in reference to my music asked if I considered my act vulgar. Of course I defended myself. Yes, some of my stuff is sensuous but it never gets to the point where it might be legitimately considered smutty. I reminded the caller of the big difference between sensuous and promiscuous."[120] Hinds's so-called vulgarity is a stage performance.[121] She has defined her own sensuality and is conscious of its limits. In so doing, she builds her own politics of respectability, working within public discourses while maintaining her sense of herself as a lady and a queen. Rarely does Hinds get into the details of her sexual life either on or off stage, and her performance of femininity is strongly rooted in Afro-Caribbean traditions wherein a woman asserts power and control over her own body. The accusations of hypersexuality or "rude" behavior that have been leveled at Rihanna begin in critiques of her lyrics and performances within a global pop aesthetic but extend beyond her music to her offstage antics and interviews. In a 2011 interview she says, "I like to take charge, but I love to be submissive. . . . Being submissive in the bedroom is really fun. You get to be a little lady, to have somebody be macho and in charge of your shit. That's sexy to me."[122] Rihanna's public understandings of being a lady are often framed within a sexual conversation

and under a cloak of patriarchy. Her "lady," then, transgresses middle-class notions of respectability by imbuing them with eroticism,[123] since, as Rosamond King notes, "public revelation or acknowledgement of erotic desire can be considered transgressive and can place women outside of middle-class norms" in Caribbean societies.[124] The fact that Rihanna openly shares her sexual likes and dislikes with numerous interviewers also changes the reception of her sexuality, giving her a sense of availability that is commonly and historically associated with the consumption of "exotic" locations such as the Caribbean and the women who live there.

Similar concerns have plagued other Caribbean women in the international spotlight. Former Miss Trinidad and Tobago Universe winner Anya Ayoung-Chee found herself in the midst of scandal when a sex video of her with her boyfriend and another woman was leaked to the media without Ayoung-Chee's knowledge or consent. Her accomplishments as a spokesperson for the Tallman Group (a charitable organization that seeks to empower underprivileged youth) and her role as a national representative as a beauty queen were tarnished by images of overt sexuality.[125] Even though Ayoung-Chee did not willingly expose her sex life, the exposure nonetheless placed her body (which had previously been read as a national asset) in the realm of the vulgar. She says that her entrance into the beauty queen world allowed her to develop her fashion skills, and she designed many of the pieces she wore during the pageants; however, she states, "When it comes to the beauty queen thing, I am still very uncomfortable about it and what it says about women. But it gave me a platform and it is one of the few platforms that young women have, particularly in the developing world. You take what you have and you run with it."[126] Ayoung-Chee redeemed herself in the public eye by winning season 9 of the popular reality show Project Runway in 2011. In creating her own clothing line, Ayoung-Chee still seeks to represent the Caribbean region. She says, "The Caribbean is something that everyone wants a piece of and we are blessed enough to own it. I want this to be an international Caribbean brand."[127] In buying her clothes, everyone can own a piece of the Caribbean. As one writer put it, her story as a "scandal-plagued exhibitionist beauty queen with a flawless complexion and exotic background" is the stuff that reality television is made of.[128] Yet Ayoung-Chee's activities on Project Runway highlighted her nonphysical talents, as she focused on adorning the body rather than revealing it. Ayoung-Chee, then, began as a respectable beauty queen, fell to the realm of rudeness via sex scandal, and redeemed her respectability by commodifying her own image of the Caribbean through fashion.[129]

The conversations surrounding Rihanna's presence at Kadooment expose some of the difficulties facing Barbadians who wish to promote Barbados as a modern nation-state in the shadow of Caribbean myths of exoticism and primitivism that, at times, serve the tourism product. Barbadian culture is both rigidly conservative and conspicuously laid back. Promotions of the island's culture rely on a care-

fully constructed image of controlled abandon, one that is easily misread in celebrity news outlets that focus on individuals rather than collective identities. All of these misreadings, their corrections, and the corrections of corrections stemmed from a few photos of one woman circulated out of context. Rihanna's commodified celebrity image threatened to overshadow that of brand Barbados. Her celebration of Kadooment, as some commenters noted, should not be an extraordinary event. But her participation, in light of her celebrity status, affected how the rest of the world views the nation and exposed some of the insecurities of the national identity in the conversations that ensued. While Rihanna's participation in the festival gave it more publicity than most advertisers could afford, many Barbadians wondered whether such publicity was worthwhile if it meant that the festival and the nation could (and would) be grossly misrepresented by celebrity-oriented media.

As the 2011 Loud Tour made its way across the United States, praise and criticism swirled around it. Regardless of one's standards of quality for live musical performance, most of the criticism surrounded the idea that Rihanna should be a better role model, and that the crotch-grabbing, expletive-laced ad-libs, drinking on stage, and "simulated sex" with audience members brought on stage for that purpose were perhaps not the most wholesome antics for a young woman in the public eye. These reports, which circulated globally, did not go unnoticed in Barbados. While international critiques focused on the intersection of pop star and role model status, Barbadians were reminded that Rihanna was also cultural ambassador to youth on the island. Her level of success was to be applauded, but her onstage behavior fed an ongoing fear that "rude" culture would subsume "respectable" Barbadian ideals on the island. The comments that circulated in the Barbadian press were no different from those in earlier discussions of her stardom—praising her, criticizing her, and, as a child of Barbadian soil, protectively doing both—but when it was announced that she would be bringing the show home to the island in August 2011, the conversations changed.

While a few in the business sector voiced concern over the timing of the concert, fearing that it might draw the limited funds of Barbadians away from the Crop Over festivities,[130] by and large, most Barbadians who had something to say about it (Rihanna included) thought it was long overdue.[131] Very few of the concerns voiced expressed any wariness about the content of the show itself. Perhaps most commenters agreed with C.L.R. James's 1960s assertion that "at this stage of our existence, our writers and our artists must be able to come home if they want to."[132] Local papers showed photos of the stage being built in Kensington Oval and the faces of onlookers who recognized that it would be the biggest show the island had ever seen.[133] Tickets sold out. Hair salons, barbershops, and retail stores saw a small boom in business as concertgoers prepared for the event. The BTA reported that the concert "attracted more than 10,000 regional tourists, who pumped $8.6 million into the Barbadian economy."[134]

While the BTA emphasized that the show would be the same as every other performance on the tour, attendees who had seen the show before noted that much of the sexuality prominent in Rihanna's ad-libbing and spontaneous performance acts had been noticeably toned down. On the one hand, it was an important statement of Barbadian modernity for a Bajan artist to bring such a technical show to the island. On the other hand, attitudes toward the sexual content of the cultural ambassador for youth's performance were ambiguous. Such ambiguity has become a signature aspect of Rihanna's brand, and it was evident within the Loud show itself.

One segment of the show began with a montage of images of Rihanna dressed in a men's suit in some shots and wearing a dress in others. Not quite androgynous, she flirted with herself on-screen before being revealed seated in a suit on stage. While she began to sing a cover of Prince's hit "Darling Nikki," she played with a cane while her female dancers used the poles to either side of her.[135] During this part of the performance, Rihanna often stopped singing in order to dance with or just touch the dancers' bodies, performing an ambiguous sexuality. During the song, she remained in control of them, but the tables turned as her dancers stripped her down to a black bodysuit and chained her for the performance of "S&M." The choice to cover Prince's "Darling Nikki" is telling, as it highlights the ways in which Rihanna used her sexuality during this stage in her career. One of Prince's largest assets as a star was his in-your-face yet ambiguous sexuality. The ambiguity of his performances extended to his image, as he sat squarely between "godliness and promiscuity, maschismo and effeminacy, spirituality and material ostentation, futurism and nostalgia, black rhythm and white rock."[136] Prince's endurance in the music industry relied on his musical talent, but also on the power he exerted through sexuality and the allure he produced through his ambiguity.

The performance of this Prince cover was not the first time Rihanna had displayed an ambiguous sexuality, one that falls squarely outside a brand Barbados ideal (not necessarily Barbadian reality) but squarely within Rihanna's brand of pop stardom. In 2010 she released "Te Amo," whose lyrics and accompanying video released in Europe more than hinted at same-sex desire and sexual curiosity,[137] and in response to questions about her relationship with Matt Kemp, she told one reporter, "I hate to burst your bubble . . . but no. I'm dating girls!"[138] Rihanna's public performances of bisexuality could be read as a transgressive exercise of power in the face of conservative politics of respectability; a youthful attempt to exert the kind of control performed through Barbadian and/or queer femininity; a ploy of stardom to remain ambiguous, ambivalent, and thus enigmatic à la Prince; merely a camp performance;[139] or (as she suggested in response to her controversial "S&M" video) a metaphor for her relationship with stardom.[140] What these performances do is create the possibility of "something more" in her public image. They tell her audience that no matter how much of her or how often they may see her, there's always the possibility of something else,

so that even in her most revealing of costumes, her allure is solidified, since "the most charismatic celebrities are the ones we can only imagine, even if we see them naked everywhere."[141] Rihanna's performances during the Loud Tour, her videos, and some of her collaborations (with Shakira and Britney Spears, for instance) suggest an ambiguous sexuality that sits precariously between personal preference and celebrity enigma. It raises the question, If ambiguity is a constitutive part of pop stardom, what happens when a pop star is given the task of representing a nation, one that, however ambiguous its national realities may be, has a fairly clear ideal image of national identity that it would like to proffer to the rest of the world?

The written reports that came out after Rihanna's Loud show in Barbados featured an overwhelming pride in a young woman who had worked the stage for her home. Much of this pride was rooted in the idea that bigger is better, and that Rihanna's theatric setup brought a different level of modernity to the island's performance scene.[142] The biggest international star of Barbados had brought the biggest show the island had seen to one of its most heralded venues. And to top it off, she sat on the edge of the stage and told the audience how good it felt to perform for them.[143]

The critiques surrounding the show focused on the BTA's role and hardly mentioned Rihanna at all. One commenter summed it up: "All take a bow. That said, while the Rihanna/RocNation delivery was flawlessly world class, the same cannot be said for the local hospitality and logistic elements of the show,"[144] suggesting that in the eyes of the audience at Kensington Oval, brand Barbados needed to catch up to brand Rihanna. One of the complaints was that unlike in other performances at Kensington Oval, the national anthem was not played at the outset of the show.[145] In this moment, brand Rihanna stood in for brand Barbados. Regardless of her genre, Rihanna's performing on Barbadian soil may have been symbolic enough that the customary expression of nationalism through the playing of the national anthem could be momentarily discarded, but not without the notice of her Barbadian audience. In her role as a widely successful pop star who grew up only blocks from the stage she was performing on, she signified both the modernity of Barbadian culture and its attractiveness to a global audience. Another interpretation is that the officials representing brand Barbados might have been star struck by Rihanna. Commenter tanyarespect notes, "The BTA officials were too busy trying to get close to Ri Ri to bother 'bout lack of national pride or to ensure proper protocol (i.e. national anthem etc.) was in order. They were also too busy hob-nobbing to come to centre stage to speak a few words. For them this was the chance of a life-time that could not be missed!"[146]

The praise of Rihanna was slightly stained only months later when an interview she gave to British Vogue magazine reached stands. Rihanna commented that she owns a small chain that says "cunt" and that the "word is so offensive to everyone in the world except for Bajans. You know African-Americans use the n-word to their brothers? Well, that's the way we use the c-word. When I first came here,

I was saying it like it was nothing, like, 'Hey, cunt,' until my make-up artist finally had to tell me stop. I just never knew."[147] These comments fueled a variety of criticism over the way that Rihanna was representing the nation, especially after having just signed the three-year deal with the BTA. Some questioned where exactly in Barbados Rihanna had grown up that she would hear the word used so casually, noting that it was language used by men after a few drinks, but Bajan *women* were not so vulgar.[148] Others admitted that the word was used often,[149] but with obvious offense intended.[150] Still others were baffled as to how a young woman who had gone to one of the top secondary schools on the island, who had been said to be so articulate, "never knew" how offensive the word was.[151] Even some of her supporters chimed in, writing articles with titles like "Rihanna, Shut Up and Sing."[152] Yet, not unlike in the discussion of Crop Over, others were keen to defend Rihanna's comments, stating that they had heard the word used as Rihanna described. One commenter goes on to state that "while it is appalling that she would proudly broadcast this, I think that we shouldn't jump on her and tell her to 'shut-up and sing' without first analysing ourselves. She didn't tell a lie, if you are honest with yourselves, you'd admit that too. Bajans use the 'c-word' as though it was an 'a' i.e. with NO reservation; why is it so controversial now? I tip my hat to her for being herself and proud of her (somewhat warped) heritage:| If this is so despicable for her to embrace the word, why isn't it so big an issue when everyday bajans throw it around in casual conversation, while 'the world' frequents the country?"[153] This comment in particular captures the various issues at stake in Rihanna's representation. The commenter finds it appalling that she would mention such "bad language" while representing the nation internationally yet recognizes that she isn't lying and is critical enough to wonder about the difference between Rihanna's audience in celebrity news and the tourists who hear the "real" Barbados when they come to the island's shores.

The accuracy of Rihanna's representation was further proved the next year when on November 20, 2012, Barbados Labour Party member of Parliament William Duguid used "cunt" on the Barbadian parliamentary floor.[154] In an impassioned debate about the morality of one of the Democratic Labour Party members "making money off of people who take off their clothes," Duguid was cut off by the presiding authority but continued to speak before taking his seat and uttering "your mutha's cunt" into a live microphone. Those defending Duguid noted that his comments were in response to being called a "big fat slob." Still, he issued a public apology two days later, and fellow politicians agreed that there was no room for such "vulgarity" in the "civilized" space of Parliament. Both Duguid and Rihanna brazenly perform Barbadian language as they know it, and both are critiqued by those who would prefer they perform Barbadian culture in its most ideal and "respectable" forms.

The initial celebration of Rihanna as unofficial and then official spokesperson had gone sour as some realized that her pretty face did not mean that she would

always have pretty things to say about her culture. The beauty proffered within brand Barbados was very different from and perhaps more delicate than the beauty of Rihanna's pop star image. In relying on Rihanna as a spokeswoman, Barbados has to negotiate between images of modernity and Rihanna's reliance on countercultural practices. Brand Barbados and brand Rihanna are both appealing to global audiences, but the stakes are very different. As a national brand, brand Barbados has hundreds of thousands of people who are invested in its success or failure, making it much more delicate than the team of people promoting and directly depending on a pop star like Rihanna.

Regardless of the continued critiques of Rihanna's behavior, in the eyes of the Barbadian government, the possibility of tapping into the global name recognition of brand Rihanna seems to outweigh the risks of publicly allying brand Barbados with its most well-known citizen. Reports of Rihanna's "bad" behavior include details on how she spends her leisure time—"The Bajan singer's been spotted at a strip club in London, a sex shop in Paris and a marijuana 'coffee shop' in Amsterdam"[155]—and opinions from "sources close to" her, such as, "Rihanna is running on empty but she's still been going out drinking and living it up," and "Rihanna's living a rough life these days."[156] While such headlines are not uncommon in celebrity news reports on young stars, in this case, they are also read through Rihanna's role as a national representative. Religious leaders on the island have expressed concern over her "bad habits" and called her "unfit" to be an ambassador, while laypersons seem divided, both supporting the critiques and dismissing them.[157] Still, the BTA (if not Barbadians more generally) stands by Rihanna, using her individual celebrity as a promotional tool for the nation.

The Barbados government's deals with Rihanna to make her a spokesperson for the nation and its youth are an attempt to capitalize on her embodied cultural capital as a young Barbadian woman who has successfully entered into the U.S. music industry and built a brand name in the global market. Their contracts, however, fall short of ownership over brand Rihanna, and as such Rihanna can ignore the critiques and continue to promote her brand. In a 2012 interview with *Elle* magazine, she explains that her love of party scenes is built on her discomfort with always being in the public eye, saying, "I love going to the club, because that's the one place that nobody's checking for *me*."[158] The interviewer goes on to explain that Rihanna "refuses to conform to anyone else's ideas about how she should behave."[159] However dependent brand Barbados may become on the image of one woman, neither the Barbadian government nor Barbadian citizens—whether fans or critics—own the means of production of brand Rihanna. They can only hope to reap the material and symbolic benefits of Rihanna's capital while attempting to make the ideal of brand Barbados a reality. Such hope continues in the BTA's 2013 print campaign, which relies heavily on Rihanna's image to sell the island to tourists.[160]

Rihanna sits at a crossroads of iconicity, representing the nation of Barbados, her own celebrity brand, and a particular form of pop stardom that relies on "foreignness," familiarity, sexuality, and various performances of femininity. These representations often overlap, not just in how audiences interpret Rihanna's image and presence (as in the reports of Kadooment in 2011) but also in the products themselves. The photo shoot for the 2013 campaign was a joint venture between the BTA and Rihanna and Roc Nation, and Roc Nation repurposed the images as part of the promotional campaign for Rihanna's River Island fashion line in collaboration with hotels on the island.[161] Doing so melds the consumption of her products and the consumption of Caribbean imaginaries for potential consumers of brand Barbados, brand Rihanna, and each product sold within them, exemplifying representation within a brand culture.

In building an image, Rihanna has relied on the Caribbean as a backdrop, but her presentation of the region and the island of Barbados is arguably based on foreign tropes of what the Caribbean should be. Her position as a pop star marks her image as a product, and her representations of the region are packaged much the same way she is. Still, using old tropes of the Caribbean and of women in general, Rihanna has been able to create a space for herself in an international market. A 2006 cover article in *SHE Caribbean* magazine notes, "From Jamaica's Bob Marley and Sean Paul to Trinidad's Mighty Sparrow, Kevin Lyttle from St. Vincent and fellow Bajan Rupee, prior to Rihanna's success it seemed the prerequisite for Caribbean musical achievement was male DNA. Women were generally only granted local stardom, destined to work the regional music circuit until hopefully fate intervened."[162] Though many came before her, no other Barbadian woman has reached the heights of international stardom that Rihanna has. Her use of familiar tropes provides a sense of nostalgia for an older audience, while she purports to speak for the current generation. She relies on foreign narratives of the Caribbean to represent her island home yet is unapologetic in promoting the Barbados she knows.

Through Rihanna's image, foreigners can still view the Caribbean as sexy, leisurely, familiar, and exotic. Her quickness in forging her career makes for an unclear picture of her success. Perhaps it is not that Rihanna has done anything new but rather that she has taken definitions of success to new places using a multitude of the same old paths. Hers is an individual story that is indicative of the specific circumstances she came from and has echoes in historical representations of the region and a host of other artists' biographies.

C.L.R. James explains how "we cannot force the growth of the artist. But we can force and accelerate the growth of the conditions in which [she] can make the best of the gifts that [she] has been fortunate enough to be born with."[163] When Rihanna began her career, critics of her work weren't sure what, if any, gifts she possessed, but her growing list of accolades suggests that perhaps she has the gift of mimicry. In Derek Walcott's sense of Caribbean mimicry, the kind that "is

an act of imagination,"[164] Rihanna has built a celebrity empire. Her superstardom, like much of Caribbean culture, originated in imitation and ends with invention.[165] Rihanna's stardom has produced a penchant for avatar-like reinvention that slowly shrinks the distance between the "real" Rihanna and Robyn Fenty, between Barbadian ideals and Barbadian realities, and between the commodities of popular culture and popular performances of culture. She does so with Barbados as her foundation, saying that with the support of her Barbadian fans, she "feels like [she] could take on the world."[166] In her use of various tropes, she has been able to construct an individual career and a space for national representation hitherto unseen. Yet her reliance on these tropes (specifically those of the Caribbean as tropical, exotic paradise and the image of a defiantly [hyper]sexual young black woman) runs the risk of enforcing them within the public eye. In the context that the superstar of Rihanna grew out of, constructed representations become just as important as the realities they purport to represent. The masks overtake the faces behind them. An entire generation of young consumers, artists, and nations constantly reinvent themselves using a plethora of images and models to fly free of each representation's limitations. The conversations between her overlapping audiences (Barbadians at home, Barbadians abroad, state structures, music industry peers, and a world of consumers) expose how national discourses are similarly entangled with economics, culture, home, away, ideal, and "real," constantly moving in and through each other. With all of the ambiguity in her performance as a global celebrity and her performance as a young black Barbadian woman, as a public persona, Rihanna exemplifies the possibilities and dangers of a young female pop superstar representing an independent national identity on a global stage.

CONCLUSION
Celebrating Barbadian Independence: The Golden Jubilee

It's November 30, 2016. After nearly a year of expensive celebrations, the culmination of the Golden Jubilee, commemorating fifty years of Barbados's independence, has finally arrived. Days of hard rain have forced some celebrations to be rescheduled, but the nation's Mega Concert will go on. It's scheduled to take place at Kensington Oval, a cricket venue and one of Barbados's most venerated physical spaces. The doors have already opened and the crowd is growing. It's hot and stuffy directly in front of the stage. There's a group of middle-aged Bajans from Brooklyn just in front of me to the right. I find myself near and then suddenly amid a group of exchange students attending the University of the West Indies at Cave Hill; some are drunk, some are quiet, some are annoying the others around them. The people are pressing in on each other in anticipation of the start of the concert. They want to see Rihanna. Her name floats through the crowd. The media outlets have been focused on her arrival and that of Prince Harry for the last few days. The radio advertisements and online news have been saying for weeks that Rihanna will open the show by singing the national anthem with the schoolchildren; the prime minister himself has announced it.[1] The folks from Brooklyn begin cussing a student over space: "You ent coming up here!" He keeps trying to get closer to the stage. He says his girlfriend is just beyond them, but they are unconvinced and unmovable. Standing there waiting, I hear half of his life story as he tries to convince them to let him through. He is an Iraqi-born Russian who was raised in Finland, he and his girlfriend may or may not be in the middle of an argument, and he is not getting by these Bajans.

The crowd consists of Barbadians and foreigners and is as global and as local as the nation itself. Some of the concertgoers live on the island, some live abroad. In celebrating the nation, old tensions around claims to physical, cultural, and ideological space are played out in the audience as individuals and groups stake their claims with their bodies and their voices. People wait patiently for something

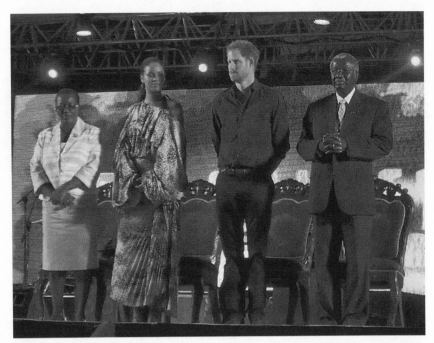

FIGURE 17. Dignitaries at Barbados's Golden Jubilee Mega Concert. Photographed by the author.

to happen and others shout loudly, demanding action. Half an hour past the advertised start time, four high-backed red velvet chairs are placed just left of center stage in Kensington Oval. The photographers move hurriedly to get in place and test equipment, knowing things will be moving along soon. Dozens of schoolchildren take the stage in uniform. The restless crowd begins to murmur with excitement. And the evening begins: the schoolchildren begin to sing, "In plenty and in time of need . . . ," while Barbados's minister of foreign affairs, the Honorable Senator Maxine McClean; Robyn Rihanna Fenty; Prince Harry, representing the British Crown; and Freundel Stuart, the prime minister of Barbados, stand before the red velvet chairs (figure 17). The young celebrities, Princess Riri and Prince Harry, are centered and receive the most attention from the audience.

To those in the audience who believe that Barbadian culture and the legacies that Barbadian music narrates and creates are valuable, the heat, the mud, the wait, and the tensions that play out in the space are worth it. And for those closest to the stage, those tensions are directed at and released by the presence of Rihanna, the Barbadian-born pop star who has become a global entity unto herself, and Prince Harry, an heir to a legacy that seems both indispensable and outdated in the twenty-first century. As they sit side by side, the crowd reads the relationship between the British Crown and the independent nation anew, applying the lens

of celebrity, gender, and sex to their bodies. Prince Harry casually represents the formality of the history, but Rihanna is the more popular of the two, and she belongs to the nation in this moment.

As the children sing, the crowd near the stage seems confused. Rihanna is not performing, just standing and sometimes singing along, without a microphone. The drunkest people are the loudest: "Does she know the anthem?!" Only yards away on stage, she can hear them, and she fights and sometimes fails to keep from turning toward the comments, from reacting in any way. "Oh God, she looks so uncomfortable! Oh God she look tortured! How is she so beautiful?! Rihanna I love you!" The anthem has finished by now. The children stand patiently on stage as the speeches begin and the four dignitaries sit in the big, high-backed chairs. Dressed in school uniforms, the children personify Barbados. With all of their assumed innocence, they enact a Barbadian remix of British discipline and tradition as they celebrate the nation by singing on demand and muster their self-restraint to patiently wait through the speeches.

The crowd in Kensington Oval is still crying out for Rihanna. She waves and smiles cautiously as they continue screaming for her, screaming at her. She alternates between smiling and not quite knowing where to look. Prince Harry seems flabbergasted by the crowd's reaction to her. It shows on his face as he looks back and forth between her and the audience, reacting each time her name is screamed. "You're the cuter brother!" He's not immune to the crowd's comments. "Give him a lap dance Rihanna!" Fifty years of independence and cultural performance continues to set the stage for understanding and celebrating Barbadian national identity; and to the masses of this crowd, celebrities continue to overshadow political dignitaries. At this celebration, Rihanna's and Harry's youth and their popularity as two of the twenty-first century's most visible celebrity icons rewrite a colonial relationship in an independence era, a relationship that stubbornly lingers even as the nation celebrates its passing.

After technicians fix a minor issue with the microphone at the podium, Prime Minister Stuart steps up to address the audience and the larger nation. His speech echoes his usual tone: formal, didactic, and just shy of condescending. He speaks of the ordinary Bajans who make the nation happen and have kept the nation-state running. He defends his decision to spend millions on the Golden Jubilee celebrations that started eleven months ago, smiling widely and proudly at the culmination of those efforts. The crowd boos him loudly at times. Many have publicly questioned his budget for the celebrations as the island's roads are eroded by heavy rains and the potholes have become dangerous, affordable housing continues to be an issue for the poor, and new taxes have been introduced. In addressing Barbados, he also acknowledges neighboring Guyana's fiftieth jubilee earlier that year with a nod toward the minister of foreign affairs, Senator McClean. When he welcomes Prince Henry of Wales, some of the loudest voices in front correct him several times, shouting, "It's Prince Harry!" Stuart insists on using

his formal name. Many in the audience never knew that the prince's name is Henry, and a few in the crowd are ironically and audibly embarrassed that the prime minister would seemingly get it wrong.

The audience has come to see a show. Their celebration of Barbados is tied firmly to the music that the nation has produced over the decades. The formality of the political introduction is delaying the main event. The audience's reaction to the prime minister and his seeming obliviousness to it paint him as a caricature of old and ongoing stereotypes of West Indian leadership, those stereotypical caricatures of a man who seeks the status and the trappings of officialdom without the skill or experience to run a nation-state. His message mirrors that of more successful Barbadian leaders fifty years earlier, one of self-determination, achievement, and hard but valuable struggles ahead. But his performance on the national stage leaves the audience wanting.

In this moment, the old tensions of nation, empire, and nation-state are apparent in both striking and subtle ways. The celebration sits squarely within "formal" politics in that it is sponsored by the state and introduced by politicians, and it is "cultural" in its form, a musical concert offered to and for the wider population. The tensions exist between the formality of the moment and the "letting go" ethos of the music that is to come. This formality is tied to people who are connected to the island but ultimately live abroad, while the music and histories that will grace the stage this night are distinctly Barbadian, with all the transnationality and diasporic entanglement that entails. The tensions collide as the representatives of an independent nation-state share space with a representative of their former colonizer, all before an actively participating local and global audience. Economics, politics, and culture; histories and futures; homes and aways meet in the voices and the silences of those who take the stage this night and those who come as active spectators.

Prince Harry is the next to speak. He is a royal who will never see the throne. He has publicly been uncomfortable and come to terms with his own royalty and what it may mean in a changing world. For these celebrations, Prince Harry left a European island for a Caribbean one, bringing Kensington Palace to Kensington Oval. And tonight, Prince Harry seems remarkably at home in front of the microphone. He lauds Barbados's vision at the time of independence fifty years ago and encourages the nation to develop the talents of its youth moving forward. His speech is premised on acknowledging Jamilla Sealey, a Barbadian environmentalist who is one of sixty young people honored by the Queen's Young Leaders program.[2] After welcoming her to the stage and listing her achievements, Prince Harry presents her with her honor and they both retreat, he to his high-backed chair and she off into the shadows again. Throughout these introductory speeches, the Honorable Senator McClean and Rihanna sit silently listening.

Prince Harry, Rihanna, and Prime Minister Stuart stand for a brief photo op before the chairs are taken away and the musical performances begin. Rihanna

moves to the center for these photos. Standing between the two men, her smiles and her silence throughout the opening are framed by the echoes of their voices. Senator McClean, still sitting in the background, has all but disappeared. She embodies the unfortunate role of women politicians in too much of Barbadian history, present and yet all but forgotten. Throughout this formal introduction to the show, Rihanna is the only honored guest who is not explicitly tied to "formal" politics. She is one of the most recognizable Barbadians in the world. It would be odd to hold a concert celebrating fifty years of the Barbadian popular music landscape without the nation's most acclaimed and world-recognized superstar, but other than in the photo op that ends the speeches, there scarcely seems to be space for her in the evening's program. Over the next five hours, the crowd still audibly anticipates a performance, sporadically calling her name between sets. I wonder whether she is still in the stadium.

That one of the culminating events of Barbados's Golden Jubilee independence celebrations would be a Mega Concert should come as no surprise. Neither should the concert's formal opening by politicians. The ways in which Barbadians and the Barbados nation-state have used culture as a political forum are central to the island's five decades of independence. The loudest voices of the concert crowd and later the international media show why popular culture is so efficient in pushing the politics of the people and the politics of the state. Popular culture provides a means of reaching large audiences with carefully crafted narratives. It is a means for state actors to proffer and enforce an ideal narrative, and it allows masses of people to support, resist, or rewrite those state ideals. The media and the concertgoers focus on the two young celebrities sitting center stage, Prince Harry and Rihanna, two faces that are much more recognizable internationally and much more popular locally than Prime Minister Stuart's or Senator McClean's. Unlike many of the artists who will perform on this stage for the event, Rihanna became a national icon by achieving fame abroad before being widely known in her own home. Prince Harry has provided the world with a rebellious reimagining of the monarchy's role after empire. But of the two, only the British prince has a voice on this particular independence stage.

The relationship between politics and culture plays out on this national stage under local and international eyes. The debates of national identity, with all of their gendered, classed, sexual, and diasporic nuances, unfold in this moment of introduction to the concert. Some of those debates are captured and represented by the cameras, while others play out just out of the frame. The framing of Kensington Oval is rich with significance here. It is a cultural space that hosts the national sport of cricket, but it also hosts concerts and other sporting and cultural events. It is a political space during this formal introduction. It is a central space of Barbadian public life, and its name echoes a historical relationship to the United Kingdom. The struggle to stake one's space (as a citizen, as a returning national, as a foreigner) plays out in the crowd, while in the photo the gendered place of politics and pop-

ularity is juxtaposed to the national emblem of the anthem, sung by those wearing the local symbols of education, school uniforms. In explaining her choice to write about islands, Barbadian American author Paule Marshall says, "Because the islands were small, they permitted me to deal with a manageable landscape. I could use that to say what I wanted to about the larger landscapes."[3] In the space of Kensington Oval on November 30, 2016, the larger landscapes squeeze into an island arena. The larger issues of nation, nation-state, cultural history, and empire meet each other on stage and in the audience.

These larger issues are tied to the economics of the event. Economic priorities are debated in the prime minister's speech and the crowd's boos. This is a space and time where debate meets celebration. The crowd prefers to celebrate and define a national identity through the cultural workers who will grace the stage, rather than the officialdom of a prime minister. This is what the Mighty Gabby had argued over thirty years before when then-prime minister Tom Adams sued him for libel. Since independence in 1966, culture has been indispensable to the Barbadian economy. The cultural industries have been promoted by the state, and culture is at the heart of the tourism that sustains Barbadian economics. In sexualizing the visible, iconic bodies of Rihanna and Prince Harry, the audience builds on old myths of Caribbean availability and new myths of celebrity promiscuity. Both of these myths are a part of Barbados's tourism image, which is centered on controlled abandon. The celebration brings tourism from foreigners, but it also brings Barbadians home. And the presence of those from home and those from away injects the local economy with a boost, not unlike that of Crop Over or the remittances from abroad that have sustained the local economy throughout the twentieth and twenty-first centuries.

The celebration itself is deeply national, but because the nation spills out beyond geographic borders and celebrates its national independence on a regional and global stage that includes international superstars, it must also be more than national. Home and away are performed through those who returned to the island from abroad. This includes Rihanna, a Barbadian girl born to a Guyanese immigrant mother, who has grown into an international woman. This is not a singular tale. Gabby also migrated to the United States, where he was politicized and where he honed his theatrical and artistic talents before returning to become one of the most heralded calypsonians in the Caribbean. Both Alison Hinds and Rupee were born in Europe and have gone on to represent Barbados on stages across the world. Only days before this Mega Concert, there was another celebration of Barbadian music. The Spouge Spectacular was held at Saint Ann's Garrison and produced by a Barbadian diasporic group. It featured the voices of those who had heralded what has been described as one of Barbados's few indigenous musics: spouge. All of the performers were Barbadians. Almost all of them flew in from their homes abroad to perform that night. Tonight, Rihanna has returned to the same stage where only five years ago she gave her first concert on the island. That LOUD Tour

show was one of the most technical that Kensington Oval had seen at the time. And with the focus on her, Rihanna had spoken of growing up only blocks away. But on this night, she doesn't speak on stage at all. Her superstardom is both essential to and out of place in this moment of national celebration.

Five hours and over thirty performances later, the crowd begins to thin. It's a quarter to three in the morning. The Merrymen, Gabby, Red Plastic Bag, Hinds, and Rupee are just a handful of those who have graced the stage. Tomorrow, the politicians will return to Kensington Oval in all of their most formal officialdom to begin the rescheduled Independence Military Parade. Nurses, cadets, the Barbados Defense Force, and U.S. Marines will march and perform before Prince Harry (more formally known as Prince Henry of Wales), who will be in full ceremonial dress with the besuited governor-general and prime minister beside him. After the Golden Jubilee, when all of the celebrations are over, when it is all said and done, the photos and videos remain, the representations of a moment. Each look, each shot, presents a different story, capturing a different emotion and presenting a highly mediated hyperreal narrative. And at the center of the attention are Princess Riri and Prince Harry, two young adults representing an old colonial relationship in new times on an independence stage. Their youth stands before fifty years of Barbadian independence and a nearly four-century-old relationship between a Caribbean island and a European island empire. Tomorrow, the march for independence will continue, starting with the performances of old empire reworked, remade, and resignified.

ACKNOWLEDGMENTS

I am deeply grateful for all of the opportunities to workshop, get feedback on, and improve this work. I have received a generous amount of advice along the way. Any mistakes made within are wholly mine.

Many thanks to the Rutgers University Press Critical Caribbean Studies series for supporting this project. Thank you to the reviewers, the series editors, Jasper Chang, and most especially Kimberly Guinta, who shepherded this project through many challenges and was a pleasure to work with.

I thank all of those who have played the roles of mentor, colleague, professor, and friend: Jasmine Johnson, Ryan Rideau, Kelley Deetz, Robeson Taj Frazier, Justin Gomer, Petra Rivera-Rideau, Michael McGee, Jasminder Kaur, Mario Nisbett, Paul Dunoguez, Catherine Newman, Gavin Cumberbatch, Ianna Hawkins Owen, Jessyka Finley, Ameer Kim El-Mallawany, Ayize Jama-Everett, Chris Letton, Darian Parker, Marcia Burrowes, Marisa Fuentes, Aaron Kamugisha, Lindsey Herbert, Hazel Carby, Leigh Raiford, Robert Stepto, Kamari Clarke, Robert Farris Thompson, Elizabeth Alexander, Brandi Catanese, Laura Pérez, Margaret Wilkerson, Robert L. Allen, Nadia Ellis, Jonathan Kidd, Quamé Patton, Cara Stanley, Nwamaka Agbo, Selam Minaye, Susu Attar, Samira Idroos, Muisi-kongo Malonga, Kemi Balogun, Kate Kokontis, Amy Lee, Sole Anatrone, Jason Hendrickson, Amanda Rogers, Tiffany King, Gladys Francis, Jonathan Gayles, Julia Gaffield, Shanya Cordis, Michael Simanga, Jamae Morris, Cora Presley, and my dear friend Jonathan Goode.

The institutional support I received while writing this book was immensely valuable. At Barbados's National Cultural Foundation, Wayne Simmons, Andre Hoyte, Wayne Hall, Ronald Davis, and Michelle Springer were incredibly helpful. Thank you for your time and attention. At the University of California, Berkeley, the Alice Baker Research Funds and the Center for Race and Gender writing group made this work possible. The Erskine Peters Fellowship at Notre Dame University allowed me much-needed time to write and welcomed me into a community of scholars. Thank you to Jason Ruiz, Timothy L. Lake, Jon Coleman, Kira Thurman, Funke Sangodeyi, Raé Lundy, Patrick Schoettmer, Dianne Pinder-hughes, Maria McKenna, Brenna Greer, Minkah Makalani, and Richard Pierce. Thank you to Makieva Graham and Gail McFarland for your assistance with the details. The Georgia Atlantic, Latin American, and Caribbean Studies Initiative (GALACSI) has seen this project through to the finish line. Thank you for the advice and feedback.

There are a number of people who graciously shared moments that helped to shape this work. Whether it was bits of advice, encouragement, or brief conference

comments, I thank Rosamond King, J. Dillon Brown, Riley Snorton, Sonia Stanley Niaah, Deborah Thomas, Lyndon Gill, Xavier Livermon, Patricia Saunders, Faith Smith, and Rinaldo Walcott.

At times what I needed most was space to write, space to think, and space to just be. For that I am grateful to the folks of Guerilla Cafe, Ébrik Coffee Room, and the librarians and security staff of the Speightstown, Holetown, and Bridgetown branches of the Barbados National Library Service.

This project began in family. Thank you to my mother, Anita Babb, for always keeping home alive even when we were away and for ushering us through Speightstown, through memories, and through legacies that have allowed us to create new futures. Thank you to my father, Emerson Bascomb, for teaching me the national anthem, and to my sisters, Joi and Patricia. Thank you to all of my cousins, uncles, aunts, families, and family friends who shared their stories, gave me rides to and from concerts, provided libations, and shared laughs, debates, and love along the way. To Samanta, Les, Keisha, Glenn, Dario, Kim, Natalie, Chris, Wayne, Roy, Maxine, Tabba, Sir Weekes, the Queen St. Babbs, the Thomases, the Pinders, the Richards, the Rowes, the Agards, and most of Speightstown, thank you.

To the spirits who guided me, as I mourn and celebrate you, I also thank you, Ruby Babb, Walter Jemmott, Ricardo Agard, VèVè A. Clark, Carmen Mitchell, Ellen Patton, Myrtle Mitchell, Wellington Selden Sr., Peggy Selden, Lorene Scantlebury, and Audre Babb.

I am very grateful to all of the artists who shared their time and opened their creative spirits to me. To Red Plastic Bag, Gabby, Alison Hinds, and especially Rupee, whose artistry served as an early inspiration, I hope this work does justice to your own.

PERMISSIONS

The lyrics of Barbados National Anthem are under copyright to the Crown and appear here with permission from the Barbados Cabinet Office.
"THE ARRIVANTS" by Kamau Brathwaite appears by permission of Oxford University Press.
The lyrics to "Jack," "Cadavers," and "The List" appear with the permission of Anthony Carter.

CHEERS (DRINK TO THAT)

Words and Music by Andrew Harr, Jermaine Jackson, Stacy Barthe, Avril Lavigne, Laura Pergolizzi, Robyn
Fenty, Scott Spock, Lauren Christy, Graham Edwards and Corey Gibson
Copyright (c) 2010 Universal Music Corp., Stacy Barthe, Almo Music Corp., Avril Lavigne Publishing LLC, Trac N Field Entertainment LLC, Notting Dale Songs, Inc., BMG Rights Management (UK) Ltd., Mr. Spock Music, Rainbow Fish Publishing, Ferry Hill Songs, Primary Wave Anthems, Quarter Inch Love Songs, BMG Gold Songs, WB Music Corp., Warner-Tamerlane Publishing Corp., EMI Blackwood Music Inc., Annarhi Music LLC and Sony/ATV Music Publishing LLC
All Rights for Stacy Barthe Controlled and Administered by Universal Music Corp.
All Rights for Avril Lavigne Publishing LLC Controlled and Administered by Almo Music Corp.
All Rights for Trac N Field Entertainment LLC, Notting Dale Songs, Inc., BMG Rights Management (UK) Ltd., Mr. Spock Music, Rainbow Fish Publishing, Ferry Hill Songs, Primary Wave Anthems, Quarter nch Love Songs and BMG Gold Songs Administered by BMG Rights Management (US) LLC
All Rights for Annarhi Music LLC, EMI Blackwood Music Inc. and Sony/ATV Music Publishing LLC Administered by Sony/ATV Music Publishing LLC, 424 Church Street, Suite 1200, Nashville, TN 37219
All Rights Reserved Used by Permission
Reprinted by Permission of Hal Leonard LLC

IF IT'S LOVIN' THAT YOU WANT

Words and Music by Makeba Riddick, Jean Claude Olivier, Samuel Barnes, Scott Larock, Alexander Mosely and Lawrence Parker
Copyright (c) 2005 Sony/ATV Music Publishing LLC, EMI Blackwood Music Inc., Janice Combs Publishing, Inc., Yoga Flames Music, Ekop Publishing, Enot Publishing, Zomba Enterprises, Inc., Spanador Music and BDP Music
All Rights for EMI Blackwood Music, Inc., Janice Combs Publishing, Inc., Yoga Flames Music, Ekop Publishing and Enot Publishing Administered by Sony/ATV Music Publishing, 424 Church Street, Suite 1200, Nashville, TN 37219
International Copyright Secured All Rights Reserved
Reprinted by Permission of Hal Leonard LLC

G4L

Words and Music by James Edward Fauntleroy II, William Frederick Kennard, Saul Gregory
Milton, Brian Kennedy Seals and Robyn R. Fenty
Copyright (c) 2009 ALMO MUSIC CORP., UNDERDOG WEST SONGS, FAUNTLE-
ROY MUSIC, UNIVERSAL MUSIC PUBLISHING LTD., UNIVERSAL POLY-
GRAM INT. PUBLISHING, INC., UNIVERSAL MUSIC CORP, B UNEEK SONGS
and UNKNOWN PUBLISHER
All Rights for UNDERDOG WEST SONGS and FAUNTLEROY MUSIC Administered
by ALMO MUSIC CORP.
All Rights for B UNEEK SONGS Administered by UNIVERSAL MUSIC CORP.
All Rights Reserved Used by Permission
Reprinted by Permission of Hal Leonard LLC

WAIT YOUR TURN

Words and Music by Mikkel Eriksen, Robyn Fenty, Takura Tendayi, Tor Hermansen, James
Fauntleroy, Saul Milton and William Kennard
Copyright (c) 2009 EMI Blackwood Music Inc., Sony/ATV Music Publishing (UK)
Limited, EMI Music Publishing LTD, Annarhi Music LLC and Unknown Publisher
All Rights obo EMI Blackwood Music Inc., Sony/ATV Music Publishing (UK) Limited,
EMI Music Publishing LTD, Annarhi Music LLC and Unknown Publisher
International Copyright Secured All Rights Reserved
Reprinted by Permission of Hal Leonard LLC

TEMPTED TO TOUCH

Words and Music by Rupert Clarke and Darron Grant
Copyright (c) 2004 EMI Music Publishing Ltd. and Darron Grant Publishing Designee
All Rights on behalf of EMI Music Publishing Ltd. Administered by Sony/ATV Music Pub-
lishing LLC., 424 Church Street, Suite 1200, Nashville TN
International Copyright Secured All Rights Reserved
Reprinted by Permission of Hal Leonard LLC

Every effort has been made to trace copyright holders and to obtain their permission for the
use of copyright material. The author apologizes for any errors or omissions in the above list
and would be grateful if notified of any corrections that should be incorporated in future
reprints or editions of this book.

NOTES

INTRODUCTION

1. See the discussion of the interaction between stage, ritual, and quotidian performances in Schechner, *Between Theater and Anthropology*.

2. See, for example, Barriteau, *Political Economy*; Beckles, *Afro-Caribbean Women*; Beckles, *Natural Rebels*; Meena Jordan, *Physical Violence*; Mohammed and Perkins, *Caribbean Women*; and Smith, *Sex and the Citizen*, as a small sample.

3. See, for example, Ellis, *Territories of the Soul*; Gill, *Erotic Islands*; and Rosamond King, *Island Bodies*.

4. See, for example, Cooper, *Noises in the Blood*; Hope, *Inna di Dancehall*; and Saunders, "Is Not Everything."

5. See Lipsitz, *Dangerous Crossroads*; and Scott, *Domination*.

6. See the careers of Vita Chambers, Cover Drive, Livvi Franc, Jaicko, Hal Linton, and Shontelle.

7. This book does not seek to give a comprehensive look at all things Bajan or even all Barbadian performers. There is a considerable amount of Barbadian culture that will not be addressed here. Some of that work has been done elsewhere, and some of it has yet to be done. Similarly, there are a number of cultural workers who have contributed immensely to the Barbadian cultural landscape but who make scant appearances, if any at all, in this text. The text narrowly focuses on popular music culture, and even in this it leaves out genres that it could be argued should be included in the category of "popular." Curwen Best, *Politics of Caribbean Cyberculture*, 51–52. My use of the term *remapping* refers much more to Arjun Appadurai's sense of scapes than to a more traditional geography discourse. The depth of the readings I attempt to offer here requires that they be selective, and they are inevitably shaped by my own scholarly training and cultural interests. They have been selected for what they can offer toward an understanding of Barbadian national identity and Barbadian performance, as well as toward an understanding of the possibilities of Barbadian futures.

8. Beckles, *History of Barbados*, 3; Chamberlain, *Narratives of Exile*, 19.

9. Davis, *Cavaliers and Roundheads*, 27–28; Puckrein, *Little England*, 7.

10. Beckles, *History of Barbados*, 3. Captain Powell, who led the first expedition of English settlers, is said to have brought a family of Arawak peoples from what is now Venezuela to help the settlers learn how to live in the area. Davis, *Cavaliers and Roundheads*, 29.

11. Puckrein, *Little England*, 22–26.

12. Davis, *Cavaliers and Roundheads*, 69–70; Puckrein, *Little England*, 56.

13. Chamberlain, *Empire and Nation-Building*, 100; Howard, *Economic Development*, 4–8.

14. Beckles, *History of Barbados*, 14; Errol Barrow, *Speeches*, 65.

15. Davis, *Cavaliers and Roundheads*, 99–102.

16. Ibid., 189.

17. Puckrein, *Little England*, 109.

18. Ibid., 118. In fact, in 1883 N. Darnell Davis writes, "It is not improbable that in the names subscribed to the Declaration as now given may be found those of the ancestors of some of the Founders of the North American Republic, for many persons subsequently left Barbados to settle in the older North American Colonies." Davis, *Cavaliers and Roundheads*, 217.

19. Davis, *Cavaliers and Roundheads*, v.

20. Chamberlain, *Empire and Nation-Building*, 102; Puckrein, *Little England*, 27.

21. Knight, *Caribbean*, 283. See also Duke, *Building a Nation*, 11.

22. Errol Barrow, *Speeches*, 67.

23. Chamberlain, *Empire and Nation-Building*, 100; Howard, *Economic Development*, 4–8.

24. Melanie Newton, *Children of Africa*, 11.

25. Chamberlain, *Empire and Nation-Building*, 109; Linden Lewis, "Contestation of Race," 156; Worrell, *Pan-Africanism in Barbados*, 11.

26. Burrowes, "Cloaking of a Heritage," 226.

27. Chamberlain, *Empire and Nation-Building*, 15.

28. Ibid., 158; Duke, *Building a Nation*, 222.

29. Chamberlain, *Empire and Nation-Building*, 184–185; Duke, *Building a Nation*, 96.

30. Duke, *Building a Nation*, 47.

31. This is most often in performing her song "Chocolate and Vanilla" (on Hinds, *Caribbean Queen*).

32. Govan, *Rihanna*, 10; McCammon, "Sexiest Woman Alive"; Russell, "Whose Rihanna?," 300.

33. De Certeau, *Practice of Everyday Life*, xv.

34. Butler, *Gender Trouble*, 25.

35. Ibid., 139.

36. Trilling, *Sincerity and Authenticity*, 100.

37. Goffman defines performance "as all the activity of a given participant on a given occasion which serves to influence in any way any of the other participants." Goffman, *Presentation of Self*, 15.

38. Trilling, *Sincerity and Authenticity*, 5–6. Goffman differs from Trilling in that Goffman believes a sincere performance implies intentionality but not necessarily falsity. He characterizes performances as sincere if the performers believe the impression they offer of themselves.

39. Ibid., 12.

40. Ibid., 11.

41. John L. Jackson, *Real Black*, 14, 17.

42. Ibid., 14–15.

43. Ibid., 15.

44. For a conversation of identity as performance and performative, see E. Patrick Johnson, "'Quare' Studies," 135–147.

45. Stuart Hall, "Cultural Identity and Diaspora," 234.

46. John L. Jackson, *Real Black*, 18.

47. Fanon, *Black Skins, White Masks*, 116.

48. John L. Jackson, *Real Black*, 228. Michel de Certeau defines a tactic as "a calculated action determined by the absence of a proper locus. No delimitation of an exteriority, then, provides it with the condition necessary for autonomy. The space of a tactic is the space of the other." This is opposed to a strategy, which is the deliberate calculation of an isolated subject with will and power. De Certeau, *Practice of Everyday Life*, 37, 35–36.

49. Trilling, *Sincerity and Authenticity*, 112.

50. Glissant, *Poetics of Relation*, 142.

51. Ibid., 11.

52. Ibid., 33.

53. Tölölyan, "Rethinking Diaspora(s)," 13.

54. Glissant, *Poetics of Relation*, 11.

55. Stuart Hall, "Cultural Identity and Diaspora," 244.

56. Such relations have been further expressed through Brent Hayes Edwards's insistence on translation and VèVè A. Clark's offering of diaspora literacy. Edwards defines *diaspora* as "a

term that marks the ways that internationalism is pursued by translation," and he notes "the use of the term *diaspora* . . . forces us to articulate discourses of cultural and political linkage only through and across difference in full view of the risks of that endeavor." Edwards, *Practice of Diaspora*, 11, 13. Clark defines *diaspora literacy* as the "ability to comprehend the literatures of Africa, Afro-America, and the Caribbean from an informed, indigenous perspective." She notes that this literacy is more than intellectual and requires both the narrator and author to possess a knowledge of different cultures' lived and textual experiences. Clark, "Developing Diaspora Literacy," 42.

57. Stuart Hall, "Cultural Identity and Diaspora," 246.

58. Stuart Hall, introduction to *Representation*, 2.

59. Trouillot, *Global Transformations*, 83.

60. Stuart Hall, "Cultural Identity and Diaspora," 234.

61. Stuart Hall, introduction to *Representation*, 11.

62. Appadurai, "Disjuncture and Difference," 37.

63. Glissant, *Poetics of Relation*, 13.

64. Glissant, *Caribbean Discourse*, 169.

65. Barthes, "Myth Today," 114.

66. Ibid., 109.

67. Ibid., 119.

68. Ibid., 129.

69. Strachan, *Paradise and Plantation*, 255.

70. De Certeau, *Practice of Everyday Life*, 181.

71. Sturken and Cartwright, *Practices of Looking*, 12. They draw on the work of Stuart Hall, who in turn is drawing largely on Ferdinand Saussure and Michel Foucault. Hall further distinguishes between constructivist views of representation by detailing Saussure's semiotic approach and Foucault's discursive approach. Hall, "Representation, Meaning and Language."

72. Sturken and Cartwright, *Practices of Looking*, 12–14.

73. Ibid., 14.

74. Ibid., 15.

75. Jorge Luis Borges's "Del Rigor en la Ciencia" ("On Exactitude of Science") (1946) is a one-paragraph story that is itself a simulacra, a fictional tale with a fictional citation and an ironic title.

76. Baudrillard, *Simulacra and Simulation*, 1.

77. Ibid., 2.

78. Ibid., 80–81.

79. In his explanation of why he chose Barbados as a research site, Sidney Greenfield relies on the myth of Barbados as "Little England." His attempt to enter the argument over the rupture or retention of African culture in the New World posits that New World black populations (Barbadians specifically) are not African culturally but instead are a not fully modern English in their social structure. Greenfield, *English Rustics*, preface. Krista Thompson writes of the American-owned Marine Hotel, whose landscape was built to resemble a jungle. The representations of the hotel sought to cater to imaginaries of the Caribbean rather than the local environment and included Cannibal Canal, where hotel staff were employed to act the part of cannibals in a controlled version of "the wild." Thompson, *Eye for the Tropics*, 154.

80. Baudrillard, *Simulacra and Simulation*, 6.

81. Belinda Edmondson uses the term *romance* "to describe the idealized representations of Caribbean society." She draws her use of the term from literary studies, where it is observed that the romance genre relies heavily on stock themes, and she says that "it is precisely this quality, this petrification of ideology into stock characters, ideas, and phrases that connects

the romance genres to the themes of classic Caribbean discourse." Edmondson, "Caribbean," 2, 4.

82. Sheller, *Consuming the Caribbean*; Krista Thompson, *Eye for the Tropics*.

83. Strachan, *Paradise and Plantation*, 4.

84. Ibid., 125.

85. Baudrillard, *Simulacra and Simulation*, 23.

86. Bhabha, *Location of Culture*, 126.

87. Walcott, "Caribbean," 8.

88. Sturken and Cartwright, *Practices of Looking*, 59.

89. Nixon, *Resisting Paradise*, 91.

90. Strachan, *Paradise and Plantation*, 112.

91. Gill, *Erotic Islands*, xxii–xxiii (italics in the original).

92. Strachan, *Paradise and Plantation*, 89.

93. Krista Thompson, *Eye for the Tropics*, 108.

94. Faith Smith, "Introduction," 10.

95. For a specific example in the collection that deals with Barbadian reactions to homosexuality in popular culture, see Gillespie, "'Nobody Ent.'"

96. Faith Smith, "Introduction," 14.

97. Austin, *How to Do Things*; Butler, *Gender Trouble*; E. Patrick Johnson, "'Quare' Studies."

98. Stuart Hall, "What Is This 'Black'?," 25.

99. Ibid., 32 (italics in the original).

100. Kempadoo, *Sexing the Caribbean*, 1.

101. Scholars such as Melanie Newton argue that using the term *indigenous* in this way in Anglophone Caribbean discourse erases the culture, memory, and contemporary presence of first-nation indigenous peoples in the archipelago. Newton, "Returns." While I in no way encourage such erasure, I believe that the term *indigenous* has a larger meaning than describing first-nation peoples. It also defines the practices that are created in any given space. And the usage in the Anglophone (and wider) Caribbean has named an important twentieth-century anticolonial rethinking of culture that declared that the peoples of the Caribbean, far from being mere mimics of their colonizers, have a culture that is their own, one that they have created. See Curwen Best, *Roots to Popular Culture*. There is also a debate about the racial implications of the term *indigenous* that Mark Anderson and Robin D. G. Kelley, among others, engage with. Anderson, "When Afro Becomes"; Kelley "Rest of Us." For more on how some items and practices stop being foreign and come to represent a regional identity, see Trouillot, *Global Transformations*, 33–34, and for more questions on Caribbean indigeneity, see Trouillot, "Caribbean Region," 24. I continue to use the term *indigenous* throughout this book, mainly in respect to the artists who describe their own work in this way, and I distinguish between "indigenous" cultural practices and "first-nation indigenous" peoples.

102. Freundel Stuart, "Prime Minister's Independence Message."

103. Ibid.

104. A year and a half later, in May 2018, Freundel Stuart and the entire Democratic Labour Party would be voted out of office in a historic sweep. Mia Mottley, who comes from a long line of Barbadian politicians and boasts an impressive list of experience and qualifications herself, would become Barbados's first female prime minister.

105. Barthes, *Image, Music, Text*, 73. Barthes is drawing on Bertolt Brecht's reading of epic theater and Sergei Mikhailovich Eisenstein's cinematic theory.

106. Brathwaite, *Arrivants*, 195.

CHAPTER 1 ENGLAND'S CHILD, THE PEOPLE'S NATION

1. Barbados was the second English colony in the Caribbean after Saint Kitts. Beckles, *History of Barbados*, 8; Trevor G. Marshall and Watson, "Barbados," 345.
2. Relaxing together in a group.
3. Bim is an affectionate nickname of the island. The National Cultural Foundation used to offer the following explanation for the origins of the term on their website: "The island has been called Bimshire or Bim because the word 'bim' was a word frequently used by slaves, Igbo people who originated in eastern Nigeria. The word is a contraction of *be mu*, which means my people." Other popular versions of the origin include a connection to an English parish named Bimshire, and a seventeenth-century English royalist by the name of Byam.
4. See Beckles, "Radicalism and Errol Barrow"; Curwen Best, *Roots to Popular Culture*; and Richard L. W. Clarke, "Roots."
5. Forbes, *From Nation to Diaspora*, 7.
6. Ibid.
7. Lamming, *In the Castle*, 11.
8. Paquet, *Caribbean Autobiography*, 112–113.
9. Lamming, *In the Castle*, 99.
10. Ibid., 175.
11. Lamming, *Pleasures of Exile*, 26 (italics in the original).
12. Ibid., 13.
13. Ibid., 27.
14. J. Dillon Brown, *Migrant Modernism*, 1.
15. Paquet, foreword to *The Pleasures of Exile*, ix.
16. Ibid., xxi.
17. Forbes, *From Nation to Diaspora*, 44.
18. Fanon, *Wretched of the Earth*, 254.
19. Errol Barrow, *Speeches*, 25.
20. Ibid., 29.
21. Haniff, preface to Barrow, *Speeches*, 11.
22. See Richard L. W. Clarke, "Roots"; and Curwen Best, "Popular/Folk/Creative Arts," 237.
23. *Barbados Economic and Social Report 2015*, 104.
24. Beckles, *History of Barbados*, 9.
25. Hoyos, *Barbados*, 25.
26. Historians, archaeologists, and cultural theorists have shown the contradictions of touting Barbados as Little England. See Curwen Best, *Roots to Popular Culture*; Finneran, "'This Islande'"; and Puckrein, *Little England*, as examples.
27. Davis, *Cavaliers and Roundheads*, v.
28. Greenfield, *English Rustics*, preface.
29. Ibid., 174.
30. As noted in Greenfield's acknowledgments.
31. Lamming, *Pleasures of Exile*, 217.
32. Puckrein, *Little England*, 27.
33. Knight, *Caribbean*, 283.
34. Errol Barrow, *Speeches*, 67.
35. Puckrein, *Little England*, 104.
36. Ligon, *True and Exact History*, 168.
37. Davis, *Cavaliers and Roundheads*, 128–129.
38. Ibid., 82.

39. Puckrein, *Little England*, 169.

40. Chamberlain, *Narratives of Exile*, 20–21; Melanie Newton, *Children of Africa*, 232.

41. Barriteau, "Liberal Ideology and Contradiction," 437, 441–443.

42. Christine Barrow, "Caribbean Masculinity and Family," 342–343.

43. Lamming, *Pleasures of Exile*, 215.

44. *Brown* here refers to the mixed-race or "colored" populations on the island. I use the term in the same vein as Stafford, "Growth and Development."

45. Melanie Newton, "Race for Power," 23.

46. Ibid., 21.

47. Beckles, *History of Barbados*, 140; Melanie Newton, "Race for Power," 35.

48. Melanie Newton, *Children of Africa*, 276.

49. Melanie Newton, "Race for Power," 38.

50. Winston James, *Holding Aloft*, 30.

51. For more on the Barbadian experience in Panama, see Conniff, *Black Labor*; and Velma Newton, Drayton, and Marshall, *Barbados-Panama Connection Revisited*.

52. Winston James, *Holding Aloft*, 44.

53. Ibid., 122.

54. Ibid., 136.

55. Worrell, *Pan-Africanism in Barbados*, 12.

56. Chamberlain, *Empire and Nation-Building*, 109.

57. Linden Lewis, "Contestation of Race," 156.

58. Winston James, *Holding Aloft*, 66.

59. Lamming, *In the Castle*, 39.

60. Winston James, *Holding Aloft*, 14.

61. Errol Barrow, *Speeches*, 47.

62. Winston James, *Holding Aloft*, 53. Interestingly, white West Indians were welcomed into the British ranks.

63. Ibid., 60.

64. Ibid., 64.

65. Chamberlain, *Empire and Nation-Building*, 15; Winston James, *Holding Aloft*, 52.

66. Downes, "Boys of the Empire," 131.

67. Chamberlain, *Empire and Nation-Building*, 15.

68. Knight, *Caribbean*, 289.

69. Chamberlain, *Empire and Nation-Building*, 41; Worrell, *Pan-Africanism in Barbados*, 22.

70. Chamberlain, *Empire and Nation-Building*, 42.

71. Worrell, *Pan-Africanism in Barbados*, 22.

72. Chamberlain, *Empire and Nation-Building*, 41.

73. Ibid.

74. Ibid., 45. The Great Depression of the 1930s reversed much of the earlier migration to the United States, and West Indian migrants returned home to islands that were already economically challenged and growing worse without the earlier remittances. The economic depression occurred at the same time that several new imperialisms staked their claim across the globe. Japan invaded Manchuria. Italy invaded Ethiopia. And this last invasion became very important to the growing black internationalism. Black West Indians petitioned Britain to fight in the Ethiopian force without denouncing their loyalty to the Crown, and "in Barbados, supporters of Ethiopia held prayer meetings and raised money for the Ethiopian Red Cross." Duke, *Building a Nation*, 96. Another radicalized World War I veteran, Arnold Ford, would go "on to write the lyrics of the immensely popular Universal Ethiopian Anthem of the UNIA. He was musical director of the UNIA at Liberty Hall. He later became a leader of the black Jews in Harlem,

migrated to Ethiopia in the early 1930s and died in Addis Ababa in 1935." Winston James, *Holding Aloft*, 69. Ethiopia was a symbol of an independent black world, and the importance given to its symbolism showed the collective organizing and intellectual fissures of the growing black nationalist movements. Some leaders, such as George Padmore, Amy Ashwood Garvey, and C.L.R. James, unwaveringly supported the defense of Ethiopia (Duke, *Building a Nation*, 97–99), while others, such as Marcus Garvey (who had initially supported Ethiopian efforts against Italy and who fell out of step with many contemporaries when he changed his position), felt there were more pressing priorities. Winston James, *Holding Aloft*, 259.

75. Chamberlain, *Empire and Nation-Building*, 4.
76. Winston James, *Holding Aloft*, 117–118.
77. It's unclear whether he knew he was born elsewhere.
78. Chamberlain, *Empire and Nation-Building*, 4.
79. Ibid.
80. Beckles, "Independence and the Social Crisis," 531.
81. Chamberlain, *Empire and Nation-Building*, 6–7.
82. Ibid., 5.
83. Ibid., 6.
84. Ibid., ix.
85. Lamming, *In the Castle*, 158.
86. Ibid., 26–27.
87. Duke, *Building a Nation*, 80–81.
88. Chamberlain, *Narratives of Exile*, 113.
89. Ibid., 28–29 (italics in the original).
90. Winston James, *Holding Aloft the Banner*, 77.
91. Lamming, *Pleasures of Exile*, 214.
92. Errol Barrow, *Speeches*, 45.
93. Duke, *Building a Nation*, 106.
94. Errol Barrow, *Speeches*, 45.
95. Lamming, *In the Castle*, 224.
96. Ibid., 127.
97. Ibid., 175.
98. Ibid., 295.
99. Ibid.
100. Ibid., 296.
101. Chamberlain, *Empire and Nation-Building*, 155.
102. Ibid., 158.
103. Unfortunately, as historian Penny Von Eschen notes, "the broad anticolonial alliances among African Americans and the fledgling politics they represented did not survive the early Cold War." Von Eschen, *Race against Empire*, 77.
104. Chamberlain, *Empire and Nation-Building*, 124 (italics in the original).
105. Lamming, *Pleasures of Exile*, 29.
106. English Caribbean novels existed before this era, but it was in this Windrush generation that a shift in understanding West Indian literature occurred. See J. Dillon Brown, *Migrant Modernism*; and Rosenberg, *Nationalism and the Formation*.
107. Forbes, *From Nation to Diaspora*, 157.
108. Lamming, *Pleasures of Exile*, 39.
109. Ibid., 28.
110. Chamberlain, *Empire and Nation-Building*, 132.
111. Ibid., 140–141.

112. Forbes, *From Nation to Diaspora*, 155.

113. Duke, *Building a Nation*, 30–32.

114. Chamberlain, *Empire and Nation-Building*, 184–185.

115. Ibid., 149; Duke, *Building a Nation*, 130–131.

116. Duke, *Building a Nation*, 158.

117. Ibid., 199.

118. Ibid., 47.

119. Ibid., 70.

120. Ibid., 169.

121. Ibid., 188.

122. Ibid., 194.

123. Ibid., 217.

124. Ibid., 222.

125. Chamberlain, *Empire and Nation-Building*, 162; Duke, *Building a Nation*, 244.

126. Duke, *Building a Nation*, 244.

127. Chamberlain, *Empire and Nation-Building*, 180. Many of Barrow's policies between 1961 and 1976 were adapted from the earlier Democratic League founded by his uncle Charles Duncan O'Neal. Hilbourne A. Watson, "Errol Barrow," 42.

128. Duke, *Building a Nation*, 244.

129. Negotiations among the ten and later the eight were complicated and depended on political strategy, political personality, one-on-one conversations, and a number of larger formal meetings. The ultimate failure of the Little Eight federation has been detailed in Arthur Lewis's "Agony of the Little Eight."

130. Errol Barrow, *Speeches*, 50.

131. Hilbourne A. Watson, "Errol Barrow," 66.

132. Ibid., 46.

133. Errol Barrow, *Speeches*, 75.

134. Ibid., 74.

135. Ibid., 77.

136. Ibid., 42.

137. Ezra E. H. Griffith, *I'm Your Father, Boy*, 81.

138. Lamming, *In the Castle*, 241.

139. Stephens, *Black Empire*, 60.

140. Ibid., 73.

141. Saunders, *Alien-Nation and Repatriation*, 8.

142. Lamming quoted in Andaiye, foreword to *Conversations*, 13.

143. Paquet, *Caribbean Autobiography*, 111.

144. Chamberlain, *Empire and Nation-Building*, 182. A referendum could also counter his efforts if it were to turn into a partisan issue as the referendum on federation in Jamaica had four years earlier.

145. Ibid., 183.

146. Errol Barrow, *Speeches*, 89.

147. Hilbourne A. Watson, "Errol Barrow," 47.

148. Lamming, *In the Castle*, 130.

149. Errol Barrow, *Speeches*, 71.

150. Ibid., 90.

151. Lamming, *Season of Adventure*, 330–331.

152. Lamming, "Nationalism and Nation," 114.

153. Chamberlain, *Empire and Nation-Building*, 119.

154. Lamming, *Pleasures of Exile*, 158.

155. Errol Barrow, *Speeches*, 94.

156. Ibid., 94.

157. Fanon, *Wretched of the Earth*, 254.

158. Errol Barrow, *Speeches*, 92.

159. Hilbourne A. Watson, "Errol Barrow," 44.

160. "National Emblems of Barbados."

161. Gmelch, *Double Passage*, 26.

162. Errol Barrow, *Speeches*, 190.

163. While the national symbols were chosen through competition, it can also be argued that the choice of Burgie's work represented older forms of elite control, since he was asked to write the lyrics by prominent members of the community and his work was entered into the competition on his behalf before being ultimately chosen. He did not know of the competition until he was told he had won it. Burgie, *Day-O*, 211; Gercine Carter, "Pride Sprung."

164. Barriteau, "Liberal Ideology and Contradictions," 441.

165. Collins, "'Sometimes You Have,'" 387.

166. Paquet, *Caribbean Autobiography*, 117.

167. Collins, "'Sometimes You Have,'" 386; Linden Lewis, "Contestation of Race," 185. Hilbourne A. Watson notes, "Many men and women asserted that politically active women wanted to get close to political parties to promote their sexual interest in male leaders, reinforcing the common patriarchal prejudice that politics was the preserve of men." Watson, "Errol Barrow," 60. Dame Edna "Ermie" Bourne was the first woman elected to Barbados's Parliament in 1951, the same year that began universal adult suffrage on the island. Barrow-Giles and Branford, "Edna," 29. It would be another few decades before another woman held that position. More women entered into high-ranking political positions in the Caribbean toward the end of the twentieth century.

168. Lamming, *Season of Adventure*, 17.

169. See Fanon, *Wretched of the Earth*, 47–54, for a more detailed account of class and decolonization.

170. Lamming, *In the Castle*, 288.

171. Kamugisha, "Survivors of the Crossing," 13.

172. Lamming, *Season of Adventure*, 18–19.

173. This self-determination is not always defined by discourses of "progress," as some characters choose the way things have always been. It is their ability to choose, however, that makes them feel free.

174. Gordon Lewis, "Challenge of Independence," 511.

175. Errol Barrow, *Speeches*, 73, 77.

176. Hilbourne A. Watson, "Errol Barrow," 38.

177. Errol Barrow, *Speeches*, 189; Hilbourne A. Watson, "Errol Barrow," 38.

178. Hilbourne A. Watson, "Errol Barrow," 69n17.

179. Beckles, "Radicalism and Errol Barrow," 229.

180. Lamming, *Coming, Coming Home*, 17.

181. Kamugisha, "Survivors of the Crossing," 20 (italics in the original).

182. Beckles, "Radicalism and Errol Barrow," 228; Hilbourne A. Watson, "Errol Barrow," 41.

183. Beckles, "Radicalism and Errol Barrow," 228. See also Chamberlain, *Empire and Nation-Building*, 189.

184. Beckles, "Radicalism and Errol Barrow," 228.

185. Chamberlain, *Empire and Nation-Building*, 190.

186. Gordon Lewis, "Challenge of Independence," 512.

187. One example is his support for the Public Order Act, which "prohibited individuals from engaging in any serious discourse on race for fear of being construed as inciting racial conflict and tension, or of being arrested for making inflammatory speeches." Linden Lewis, "Contestation of Race," 158. He allowed activists like Rosie Douglas from Dominica into Barbados. He even allowed Stokely Carmichael (a.k.a. Kwame Ture) and Patrick Emmanuel to enter Barbados after they were kicked out of Trinidad, but he wouldn't let these activists speak publicly. Hilbourne A. Watson, "Errol Barrow," 51.

188. While his political rhetoric often catered to the working class and his policies benefited all classes to an extent, he was criticized by the black nationalist, radically Marxist People's Progressive Movement, founded 1965. They chastised Barrow for what they saw as his anti-working class policies in their newspaper the *Black Star*. Linden Lewis, "Contestation of Race," 156.

189. Lamming, "Portrait," 179.

190. Hilbourne A. Watson, "Errol Barrow," 34.

191. Gordon Lewis, "Challenge of Independence," 512.

192. Ibid.

193. Indeed, such a stance would be nearly impossible, since even after independence the queen of England remained the symbolic head of state in Barbados. This is a point that has been raised by successive governments every few years.

194. See Fanon, *Wretched of the Earth*, 44–45.

195. Gordon Lewis, "Challenge of Independence," 513.

196. Ibid.

197. Lambert, "'Part of the Blood,'" 346.

198. Ibid., 350.

199. Comissiong, "Re-defacing of Nelson"; Mounsey, "Nelson Defaced."

200. "Independence Square."

201. David King, "Lord Nelson Statue."

202. For a more recent debate in the press, see Beckles, "Why Nelson Must Fall"; Evanson, "Nelson Part"; Clifford Hall, "Nelson a Fact"; and Trevor G. Marshall, "Facts about Nelson." Note that while the public discussion largely consists of male voices, some of the academics in this more recent iteration of the conversation are noted women scholars.

203. By 1969 tourism had become the biggest industry on the island, surpassing agriculture, which had long had a stranglehold on the island's economy. *Barbados Annual Report 1969*, 4.

204. Lynch, *Barbados Book*, 77.

205. Sheller, "Demobilizing and Remobilizing," 13.

206. Gordon Lewis, "Challenge of Independence," 513.

207. Hilbourne A. Watson, "Errol Barrow," 50.

208. Sheller, *Consuming the Caribbean*, 30.

209. Beckles, "Radicalism and Errol Barrow," 224.

210. "Speightstown." Speightstown earned its nickname Little Bristol because of the bustling trade between the two cities in the seventeenth century.

211. See Iton, *In Search*, 135.

212. Lamming, *Season of Adventure*, 246 (italics in the original).

213. Ibid., 367.

CHAPTER 2 PERFORMING NATIONAL IDENTITY

1. Founded by Guyanese businessman Peter Stanislaus D'Aguiar, Banks Barbados Brewery Limited opened its doors in 1961 and became one of the leading breweries in the English Carib-

bean. "History: Banks Beer Barbados." Because of its production and the number of shares, it was long seen as a Barbadian beer. In December 2015 Banks Beer became part of the Brazilian conglomerate AmBev. Edward, "Banks Holding Limited."

2. Pseudonym.

3. Glissant, *Poetics of Relation*, 141.

4. Ibid., 142.

5. Richard L. W. Clarke, "Roots," 304.

6. Curwen Best, *Barbadian Popular Music*, 18; Meredith, "Barbadian *Tuk* Music," 83.

7. National Cultural Foundation, *25 Years of Crop Over*, 9–16; Foster, *Island Wings*, 44.

8. The use of plantain leaves as a costume for a common carnival character also has diasporic iterations in the Garifuna people of the Caribbean and Central America and traditions of the old Kongo empire. Such costumes feature in creolized New World celebrations, such as Crop Over, Jonkunnu, and Wanáragua, that feature stock characters, cross-dressing, and social and spiritual elements. Greene and Castillo, *Play, Jankunú, Play*.

9. National Cultural Foundation, *25 Years of Crop Over*. The Mother Sally character was traditionally performed by men, but as the tradition continued, women increasingly played Mother Sally and still wore the exaggerated elements of the costume. (See Rosamond King, *Island Bodies*, for more on cross-dressing performance traditions in the Caribbean.) These early Crop Over celebrations also included acrobatics, a greased pig, a greased pole competition, stick-licking competitions, barrel dancers, and hand-walkers.

10. Curwen Best, *Barbadian Popular Music*, 10. Best identifies the rhythms and performance traditions as Igbo.

11. Meredith, "Barbadian *Tuk* Music," 81.

12. Trevor G. Marshall and Watson, "Barbados," 345.

13. Curwen Best, *Popular Music and Entertainment*, 4–5.

14. Susus are informal mutual aid societies formed in the eastern Caribbean that provide a sense of collective economics to the islands' poorer classes. See Curwen Best, *Barbadian Popular Music*; Curwen Best, *Roots to Popular Culture*; Trevor G. Marshall, *Notes on the History*; and Rudder, *Marching*.

15. Burrowes, "Cloaking of a Heritage," 230.

16. While Best's earlier work (Curwen Best, *Barbadian Popular Music*, 11) posits this as part of a tradition of African spiritualism in the Caribbean, his later work (Curwen Best, *Popular Music and Entertainment*, 6) is careful to note that such moments are not the same as the mounting or spirit possession of Vodoun, Santeria, Shango/Ṣango, etc. throughout the Caribbean.

17. Burrowes, "Cloaking of a Heritage," 215–216.

18. Ibid., 224, 232.

19. Burrowes notes that the Landship adopted the language of "stars" from the Universal Negro Improvement Association and were part of the official welcoming committee when Marcus Garvey made a one-day visit to Barbados in 1937. Burrowes, "Cloaking of a Heritage, 231, 226. Melanie Newton examines the complex relationship that free people of color in Barbados in the early nineteenth century held toward Africa. She characterizes this relationship as ambivalent. Their interest in African colonization schemes as a civilizing mission and their efforts to advance politically and socially on the island as British subjects demonstrate a productive tension between their imperial nationalism and diasporic consciousness. Newton, *Children of Africa*, 11, 196–209.

20. Trevor G. Marshall, McGeary, and Thompson, *Notes on the History*, 20. *Internal colonialist/colonialism* refers to the power structures of the island, including legislature, the Anglican Church, and the planter class.

21. This decline has been attributed to the scarcity of resources during these years (National Cultural Foundation, *25 Years of Crop Over*) and the move from small sugar estates to large, corporate plantations (Meredith, "Barbadian *Tuk* Music," 96).

22. Trevor G. Marshall, McGeary, and Thompson, *Folk Songs of Barbados*, xiv.

23. Meredith, "Barbadian *Tuk* Music," 89.

24. Ibid., 82–83.

25. Stafford, "Growth and Development."

26. Anthony "Gabby" Carter, interview by the author.

27. Trevor G. Marshall, *Notes on the History*, 25–29; Pinckney, "Jazz in Barbados," 61.

28. National Cultural Foundation, *25 Years of Crop Over*. Kensington Oval is a cricket arena also used for large performances.

29. Trevor G. Marshall, *Notes on the History*, 29–30.

30. Harewood, "Policy and Performance," 213.

31. Trevor G. Marshall and Watson, "Barbados," 350.

32. Elizabeth F. Watson, "Cultural Heritage."

33. Curwen Best, *Barbadian Popular Music*, 51–54; Millington, "Barbados," 820.

34. Meredith, "Barbadian *Tuk* Music," 83n3.

35. Curwen Best, *Popular Music and Entertainment*, 38.

36. Curwen Best, *Roots to Popular Culture*, 232.

37. For examples of tuk used in hotels and promotions, see ShontelleOnline, "vBlog."

38. Meredith, "Barbadian *Tuk* Music," 98–99.

39. Curwen Best, *Barbadian Popular Music*, 12.

40. Ibid.; Meredith, "Barbadian *Tuk* Music," 82.

41. Meredith, "Barbadian *Tuk* Music," 100–101.

42. Chamberlain, *Narratives of Exile*, 19.

43. Ibid.

44. Ibid., 18.

45. Bhabha, *Location of Culture*, 200.

46. Benedict Anderson, *Imagined Communities*, 6.

47. Chamberlain, *Narratives of Exile*, 24.

48. Ibid.

49. Ibid.

50. Gmelch, *Double Passage*, 55.

51. Chamberlain, *Narratives of Exile*, 84.

52. Velma Newton, Drayton, and Marshall, *Barbados-Panama Connection Revisited*, 44.

53. Chamberlain, *Narratives of Exile*, 26–27. For more on the Barbadian experience in Panama, see Conniff, *Black Labor*; and Velma Newton, Drayton, and Marshall, *Barbados-Panama Connection Revisited*.

54. Hoyos, *Barbados*.

55. Beckles, *History of Barbados*, 234. For more on the labor rebellions throughout the Caribbean in the 1930s, see Chamberlain, *Empire and Nation-Building*, 4.

56. A prime example would be the relationship between the Democratic League (the nation's first political party, founded by Charles Duncan O'Neal and Clennell Wickham in 1924) and the Workingmen's Association. Chamberlain, *Empire and Nation-Building*, 45; Worrell, *Pan-Africanism in Barbados*, 22–23, 27.

57. Waters, *Black Identities*, 22.

58. Kasinitz, *Caribbean New York*, 54.

59. Ibid., 55, 68–79.

60. Gmelch, *Double Passage*, 26.

61. Rudder, *Marching*, 8–9. See also Linden Lewis, "Contestation of Race," 145.

62. Kasinitz, *Caribbean New York*, 90.

63. Gmelch, *Double Passage*, 54.

64. Chamberlain, *Narratives of Exile*, 102.

65. Glissant, *Poetics of Relation*, 143.

66. Ibid., 141.

67. Trouillot, *Global Transformations*, 5.

68. Vickerman, *Crosscurrents*, 139.

69. Waters, *Black Identities*, 6.

70. Ezra E. H. Griffith, *I'm Your Father, Boy*, 9.

71. Waters, *Black Identities*, 24.

72. Benítez-Rojo, *Repeating Island*, 25.

73. Kasinitz, *Caribbean New York*, 19–20.

74. Gabby, *Gabby 'til Now*.

75. Anthony "Gabby" Carter, interview by the author; Chase, *Who Gabby Think?*, 23.

76. Gmelch, *Double Passage*, 184.

77. Merrymen, *The Merrymen Story Live!*; Trevor G. Marshall, *Notes on the History*, 31.

78. "Merrymen," 20.

79. Ibid.

80. Merrymen, *The Merrymen Story Live!*

81. Trevor G. Marshall, *Notes on the History*, 31.

82. Curwen Best, *Popular Music and Entertainment*, 23–25.

83. Trevor G. Marshall, *Notes on the History*, 32.

84. Stuart Hall, "Cultural Identity and Diaspora," 234.

85. Bhabha, *Location of Culture*, 209 (italics in the original).

86. Goffman, *Presentation of Self*, 17–18.

87. While labor unions existed in Barbados, they did not yet exist in the entertainment industry when Gabby migrated in the 1970s. The first registered trade union for entertainment workers was the Musicians and Entertainers Guild of Barbados, founded by Sach Moore in 1976. Rudder, *Marching*, 72–73.

88. Gmelch, *Double Passage*, 189.

89. Gabby, "Jack," on *Gabby 'til Now*.

90. Chamberlain, *Narratives of Exile*, 96.

91. Gmelch, *Double Passage*, 194.

92. Ibid., 195.

93. "Jack" asserts Barbadians' right to use the local beaches in the face of rising tourism and an effort to keep so-called beach boys from harassing tourists. "Hit It" uses the national sport, cricket, as a reference for an encounter between Gabby and a woman named Jill. It relies on the listener's cultural knowledge of cricket and double entendre within Caribbean music. "Boots" is a critique of using taxpayers' money on what Gabby sees as the unnecessary size of the Barbados Defense Force, as well its deployment to other parts of the Caribbean.

94. Gmelch, *Double Passage*, 195–196.

95. Anthony "Gabby" Carter, interview by the author.

96. Chase, *Who Gabby Think?*, 178.

97. Anthony "Gabby" Carter, interview by the author.

98. Ibid.

99. Gabby, *Gabby 'til Now*.

100. Anthony "Gabby" Carter, interview by the author.

101. Ibid. Gabby's audience and fellow musicians tout him as a folk singer, calypsonian, and "architect for socio-cultural change in Barbados." See Gabby, *Well Done.*

102. Gmelch, *Double Passage*, 199.

103. Trevor G. Marshall, *Notes on the History*, 32.

104. See Scott, *Domination*, xii.

105. Stafford, "Growth and Development."

106. In addition to the National Cultural Foundation–sponsored events, private producers also put on shows, some of which have become staples of Crop Over. Occasionally, cosponsored events between the government and private parties are canceled or scaled back because of funding concerns, as has been the case with Cohobblopot, which has not happened since 2014. In 2015 Cohobblopot was replaced by a Trinidadian-produced One Love concert that featured Trinidadian artists, to the dismay of many entertainers. "Not Much Love."

107. Along with junior competitions, newcomers to the stage are also welcomed and developed through a series of cavalcades that occur at the very beginning of Crop Over season in May. This brings a sense of democracy of access to the performance stage. Outside of Crop Over, Richard Stoute's Teen Talent show has ushered a number of Barbadian performers into their careers for decades.

108. Turino, *Nationalists, Cosmopolitans*, 190.

109. Curwen Best, *Roots to Popular Culture*, 54.

110. Regis, *Political Calypso*, ix.

111. Mike Alleyne, "Globalization and Commercialization," 247.

112. "About the NCF."

113. Errol Barrow, *Speeches*, 144.

114. Ibid., 145.

115. Ibid., 146.

116. Ibid., 146–147.

117. Ibid., 150.

118. Ibid.

119. Ibid., 153.

120. While I believe that Clarke's work here is important to understanding the processes of defining and articulating Barbadian identity, I find his perspective of racial essentialism a bit oversimplified.

121. Richard L. W. Clarke, "Roots," 336.

122. Baudrillard, *Simulacra and Simulation*, 2; Stuart Hall, "Cultural Identity and Diaspora," 234.

123. Manley, introduction to Errol Barrow, *Speeches*, 14.

124. Richard L. W. Clarke, "Roots," 302.

125. Baudrillard, *Simulacra and Simulation*, 6.

126. Ibid., 23 (italics in original).

127. Krista Thompson, *Eye for the Tropics*, 10.

128. Ibid., 13.

129. Baudrillard, *Simulacra and Simulation*, 23.

130. Jennifer V. Barrow and Roberts, "Market Positioning," 55. In 2014 the Barbados Tourism Authority split into Barbados Tourism Marketing and the Barbados Tourism Product Authority. This text uses the older name Barbados Tourism Authority, as that was the name of the entity during the time period covered.

131. Ibid.

132. *Barbados Annual Report 1969*, 4.

133. Beckles, "Westbury Writes Back," 31.

134. Nixon, *Resisting Paradise*, 22.

135. Jennifer V. Barrow and Roberts, "Market Positioning," 55.

136. "Crop Over Festival," in *Crop Over Festival Magazine*, 3.

137. This is not to imply that Barbadians do not participate in Crop Over. They support the festival as artists, as producers, as participants, and as spectators. The spectator role is performed in many different ways. Spectatorship in the festival can be active in that it involves dancing, making noise, singing along, and providing energy and support for the performers. But it is also true that this spectator role is one in which many Barbadians can passively participate, watching others enact the "expression of the Barbadian personality." Spectators can stand on the road and watch as other Barbadians, West Indians, and tourists dance and perform. They can watch the shows and performances on television, while others actively perform and support performers in the audience.

138. Curwen Best, *Roots to Popular Culture*, 152.

139. Ibid.

140. The origins of rum are debatable, but Barbados has, rightfully or wrongfully, earned this title as a result of the earliest written record of "rumbullion" coming from a traveler to the island. Different fermented drinks made from sugarcane predate the record in Barbados. As journalist and food historian Richard Foss notes, "Though it is doubtful that Barbados deserves the often-claimed title of 'birthplace of rum,' it was certainly the first place that rum was commercialized and turned into a more refined drink." Foss, *Rum*, 31.

141. Curwen Best, *Roots to Popular Culture*, 231.

142. See Harewood, "Transnational Soca Performances," 34–35; and Square Roots, "Mannequin," on *In Full Bloom*.

143. Curwen Best, *Roots to Popular Culture*, 178. See also Ezra E. H. Griffith, Mahy, and Young, "Barbados Spiritual Baptists."

144. While the NCF makes connections between Barbadian culture and the Igbo culture of West Africa, the Barbados Museum connects the shaggy-bear characters of Crop Over to the egungun of the Yorùbá, the centrality of wining and wukking up in Barbadian dance also indicates a Congolese influence, and many iterations of Barbados's African heritage rely on a nonspecific imaginary of Africa.

145. See Krista Thompson, *Eye for the Tropics*, for a historical account of images of black Barbadian policemen.

146. Harewood, "Policy and Performance," 216.

147. Curwen Best, *Politics of Caribbean Cyberculture*, 1.

148. Harewood, "Transnational Soca Performances," 36. Wukking up is the national dance of Barbados. While it involves many elements, most of the movement happens in the hips and pelvic region. It features wining (the rolling of the hips), which is also a feature of many Congolese dance traditions and others with Congo roots throughout the African diaspora.

149. Baudrillard, *Simulacra and Simulation*, 2.

150. Curwen Best, *Roots to Popular Culture*, 231.

CHAPTER 3 CARIBBEAN QUEEN

Portions of this chapter have been published in another form in *Meridians: Feminism, Race, and Transnationalism* 13, no. 1 (2015): 78–102.

1. "Where in the World."

2. Edmondson, "Public Spectacles," 1; Fuentes, *Dispossessed Lives*, 75–77. See also Bascomb, "Rude Girl, Big Woman."

3. Lorde, *Sister Outsider*, 53.

4. Jacqueline Nassy Brown, "Black Liverpool," 298.

5. Springer, "'Roll It Gal,'" 103–106.

6. Brodber, *Perceptions of Caribbean Women*, 55.

7. Fuentes, *Dispossessed Lives*, 73.

8. Beckles, *Afro-Caribbean Women*, 32–33.

9. Melanie Newton, *Children of Africa*, 144.

10. Beckles, *History of Barbados*, 132.

11. Beckles, *Afro-Caribbean Women*, 65.

12. Ibid., 62.

13. Ibid., 64. See also Fuentes, *Dispossessed Lives*, 17.

14. Fuentes, *Dispossessed Lives*, 97.

15. Beckles, *Afro-Caribbean Women*, 29–31; Fuentes, *Dispossessed Lives*, 35.

16. Beckles, *Afro-Caribbean Women*, 48. While the expectation was that they would take the profits back to their owners, many women took the money and ran. Those who were literate and who spoke "good" English had a greater chance of escaping slavery, as they were less likely to be questioned.

17. Ibid., 49–59. Acts against huckstering included a 1688 law, two 1694 bills that were never enacted into law, a 1708 law to eradicate huckstering by slaves, a 1773 law, a 1774 law, and another in 1779.

18. Ibid., 62.

19. Sheller, *Consuming the Caribbean*, 134.

20. Fuentes, *Dispossessed Lives*, 94.

21. Beckles, *Afro-Caribbean Women*, 58. See also Fuentes, *Dispossessed Lives*, 39–42, for a more detailed history of the many sites of punishment in Bridgetown.

22. Barriteau, "Liberal Ideology and Contradictions," 437.

23. Hamilton, *Women of Barbados*, 24.

24. Ibid., 28.

25. Fuentes, *Dispossessed Lives*, 50. While women of all races owned property in the city of Bridgetown, the business opportunities for women of color were limited, and thus the least "respectable" businesses were reserved for them.

26. Hamilton, *Women of Barbados*, 34–35.

27. Connell, "Prince William Henry's," 157–164; Fuentes, "Buried Landscapes," 41–42; Hamilton, *Women of Barbados*, 28–30; Orderson, *Creoleanna*, 79. Fuentes notes that though the story celebrates Polgreen as the victor, it is more complicated than that, as she put a notice in the paper for missing items (at the same time as the prince's visit), presumably demonstrating that the money she recouped was not enough to replace the sentimental value of the items themselves. Fuentes, *Dispossessed Lives*, 59–60.

28. The artist, Thomas Rowlandson, was known for erotic references in his work. Fuentes, "Power and Historical Figuring," 569–571.

29. Fuentes, *Dispossessed Lives*, 60–61.

30. Merrymen, "Rachael Pringle," on *The Merrymen Story Live!*

31. Fuentes, "Buried Landscapes," 33.

32. Lamming, *Season of Adventure*, 139.

33. Rosamond King, *Island Bodies*, 7.

34. Alexander, "Not Just (Any) *Body*," 6; Barriteau, *Political Economy of Gender*, 96.

35. Saunders, *Alien-Nation and Repatriation*, 8.

36. Rosamond King, *Island Bodies*, 7–8.

37. Gmelch and Gmelch, *Parish behind God's Back*, 106–107. This language continues in the twenty-first century, as seen in some of the commentary surrounding a 2017 debate between

members of Parliament. See comments by lswiltshire and Jennifer on Marie-Claire Williams, "Oh No, Mara!" Mara Thompson criticized two "childless" female members of the opposition party by implying that they should have been guided by the parents in the party. "Shame on You"; Marie-Claire Williams, "Oh No, Mara!" This episode shows the ways in which sexuality, motherhood, and respectability have been tied together as a political tool, and the backlash against the remarks demonstrates that many Barbadians do not view motherhood as a necessary mark of respectable womanhood.

38. Saunders, *Alien-Nation and Repatriation*, 34. Saunders is looking at Trinidadian literature here.

39. For an analysis of this text and possible metaphors of gendered nationhood in Fola's character, see Forbes, *From Nation to Diaspora*, 169–181.

40. Christine Barrow, "Caribbean Masculinities," 40.

41. Rosamond King, *Island Bodies*, 97–98.

42. This can hold true in the wider Afro-circum-Caribbean context. Gloria Wekker notes this of Suriname and attributes it to a shared West African heritage. She writes, "In an Afro-Surinamese working class universe it is sexual activity and sexual fulfillment per se that is significant; it is not the sex of one's sexual counterpart that carries the most meaningful information. I understand this principle as expressive of the West African cultural heritage." Wekker, *Politics of Passion*, 118.

43. Ezra E. H. Griffith, *I'm Your Father, Boy*, 77.

44. Lamming, *In the Castle*, 13.

45. Wilma Bailey et al., *Family and the Quality*, 18; Downes, "Boys of Empire."

46. Billie A. Miller, foreword to *Women of Barbados*, ii.

47. Saunders, *Alien-Nation and Repatriation*, 34. Here Saunders is speaking of Trinidadian yard-women specifically, but the sentiment translates loosely across the islands.

48. Lamming, *Pleasures of Exile*, 222.

49. Lamming, *Season of Adventure*, 154.

50. Fanon, *Black Skins, White Masks*, 116.

51. Lorde, *Sister Outsider*, 53.

52. Paule Marshall, *Brown Girl, Brownstones*, 200.

53. Ibid., 243.

54. Wekker, *Politics of Passion*, 144–145.

55. LaBennett, *She's Mad Real*, 187.

56. Ibid., 2.

57. Ibid.

58. Ibid., 63–64.

59. Paule Marshall, *Daughters*, 86.

60. See Barriteau, *Political Economy of Gender*, 122.

61. Wilma Bailey et al., *Family and the Quality*, 86.

62. Barriteau, *Political Economy of Gender*, 121–150.

63. Freeman, *High Tech and High Heels*, 109.

64. Ibid., 156.

65. Barriteau, *Political Economy of Gender*, 122.

66. Similar practices can be seen in Suriname (see Wekker, *Politics of Passion*, 113–117) and are represented in the literatures of Trinidad (see Saunders, *Alien-Nation and Repatriation*, 34). Such sexual productivity is included in definitions of sex work, although rarely understood as prostitution. See Kempadoo, *Sexing the Caribbean*, 64.

67. Lorde, *Sister Outsider*, 54.

68. Brodber, *Perceptions of Caribbean Women*, 15.

69. Barriteau, *Political Economy of Gender*, 10.

70. Linden Lewis, "Contestation of Race," 182.

71. According to the Barbados Economic and Social Report, between 2002 and 2015 the population of Barbadian students attending the University of the West Indies was on average 67 percent female, despite the general population being roughly 52 percent female in the same years.

72. Gmelch, *Double Passage*, 28.

73. Barriteau, *Political Economy of Gender*, 13.

74. Ibid., 12.

75. Ibid. The Men's Educational Support Association and the more recent Men Against Naughty Dead Beat Mums Barbados are two organizations that have such a reputation on the island.

76. Brodber, *Perceptions of Caribbean Women*, xiii.

77. Freeman, *High Tech and High Heels*, 59.

78. Ula Taylor, *Veiled Garvey*, 2.

79. Bynoe, "Women's Day Celebration."

80. "Biography—Alison Hinds" (italics in the original).

81. Hinds, interview by the author.

82. Spliffietv, "Alison Hinds Interview—Pt. 1."

83. Babb, "Musical Icons."

84. Curwen Best, *Roots to Popular Culture*, 90. For a more in-depth discussion of class, Caribbean culture, and Hinds, see Springer, "'Roll It Gal.'"

85. In 1996 Hinds became the first woman to win the title of Road Monarch in Barbados's Crop Over Festival with the song "Ragamuffin." Within the next year, she had also taken the title of Party Monarch with her song "In the Meantime." The title Road Monarch is given to the singer of the most played song on the road during the road march called Kadooment. The Party Monarch competition was for the best party song of the Crop Over season and has since been restructured as part of the Soca Royale competition. Coming after years of consistent musical success, these titles cemented her audience's appreciation and redirected the history of the Crop Over competitions. Hinds was the first woman to win both the Party Monarch title and the Road Monarch title. Spliffietv. "Alison Hinds Interview—Pt. 2." In 1986 Lady Ann was the first woman to make it to the Pic-o-de-Crop finals. Rita Forrester was the first to win a Pic-o-de-Crop title in 1988. These early pioneers opened the door for artists like TC (the Queen of Social Commentary), Natahlee (Ragga Soca Queen) and Hinds (Soca Queen of the region), who all began competing in the 1990s. Hinds's titles in 1996 and 1997 built on a history of female entertainers and cemented the role of women in Barbados's Crop Over competitions. Harris, "Divas."

86. Wayne, "Celebrity Focus," 24.

87. She is also an activist for AIDS awareness, women's rights, diabetes awareness, and physically challenged children.

88. Stanley Niaah, *Dancehall*, 138.

89. Kamari Clarke, *Mapping Yorùbá Networks*, 151.

90. Stanley Niaah, *Dancehall*, 138. For more on dance and African diasporic queens, see Jasmine Elizabeth Johnson, "Queens' Diaspora."

91. See Edmondson, "Public Spectacles," 7; Stanley Niaah, *Dancehall*, 138; and Stolzoff, *Wake the Town*, 243.

92. Cooper, *Sound Clash*, 128.

93. See Hine, "Rape and the Inner Lives."

94. Harewood, "Transnational Soca Performances," 29.

95. Saxeous, "Wendy Alleyne."

96. Ibid.

97. Ibid.

98. "Wendy Alleyne Show."

99. Rollock, "Lady Ann Born to Sing."

100. Ibid.

101. Alison Hinds, "Ladies, let's support and love one another!," Facebook, March 8, 2010, https://www.facebook.com/pages/Alison-Hinds/39601973164?fref=ts (site discontinued).

102. For a lyrical breakdown of different island cultures' dancing practices, see Mr. Dale, "W. I. Cultuh."

103. Springer, "'Roll It Gal,'" 103–104.

104. Wayne, "Celebrity Focus," 25. For further analysis of the relationship between movement and identity see Daniel, *Caribbean and Atlantic Diaspora*; Gottschild, *Digging the Africanist Presence*; Harewood and Hunte, "Dance in Barbados"; and Sloat, *Caribbean Dance*.

105. Lorde, *Sister Outsider*, 53.

106. Spliffietv, "Alison Hinds Interview—Pt. 2."

107. For a more in-depth discussion, see Shawn Michelle Smith, *Photography*, 9–10.

108. The tattoo is perhaps featured as a nod to various cultural forms of indigeneity.

109. For more on African diasporic aesthetics in musical packaging and album covers, see Gilroy, *Small Acts*, 237–257.

110. Edmondson, "Public Spectacles," 2.

111. Dikobe, "Doing She Own Thing," 11. See also Rosamond King, "New Citizens," 214.

112. Dikobe, "Doing She Own Thing," 151.

113. See Dikobe, "Bottom in de Road."

114. G. Bailey, "Destra Denise and Alison."

115. Dikobe, "Doing She Own Thing," 158.

116. Ibid., 160.

117. As Saucy refers to her as she moves center stage.

118. Marcia Henville, "The Lowdown on Alison Hinds Real Bumper!," *Trinidad Sunday Express*, January 24, 1999, 19, quoted in Dikobe, "Doing She Own Thing," 154.

119. Dikobe, "Doing She Own Thing," 150–154.

120. The women line up not by body type but rather according to the size of one body part, perhaps the most important body part in the Caribbean movement vocabulary.

121. Harewood, "Transnational Soca Performances," 36.

122. This section's title is from Alison Hinds featuring Richie Spice, "King and Queen," on *Caribbean Queen*.

123. "Ladies Rule," "The More You Get," "Thundah," and "Roll It Gal" are just a few examples, all featured on her 2007 album, *Soca Queen*.

124. Hinds has collaborated with such Caribbean performers as Blood, Jah Cure, Rupee, John King, Shaggy, and Moses, just to name a few.

125. Will, "King and Queen."

126. This refers to the biblical story of two mothers from 1 Kings 3:16–28. King Solomon hears the case of two mothers both claiming to be the mother of one child. He orders the child split in half to appease both of them. As the sword is raised, one mother cries out, preferring to see the other woman have the child than for the baby to be under a sword. Solomon deduces that only the true mother would show such care, thus deciding the case and proving his wisdom.

127. For more on the importance of sartorial presentation in African diasporic contexts, see Monica L. Miller, *Slaves to Fashion*.

128. Ula Taylor, *Veiled Garvey*, 2.

129. See Edmondson, "Public Spectacles," for more on the distinction between the vulgar and the respectable.

130. Springer, "'Roll It Gal,'" 106.

131. See Gilroy, *Black Atlantic*; and Hartman, *Lose Your Mother*.

132. Emphasis mine.

133. This is an example of the cultural studies concept of articulation. See Stuart Hall, "Race, Articulation," 33.

134. Wilma Bailey et al., *Family and the Quality*, 39.

135. Reichelt, "Ambient Intimacy."

136. Hinds, "Island Girl," on *Soca Queen* and *Caribbean Queen*.

137. Hinds, "The Show," on *Soca Queen*. Lady Saw does similar work in her 2004 "Move Your Body."

138. See Cooper, *Noises in the Blood*; Dikobe, "Bottom in de Road"; Harewood, "Transnational Soca Performances"; and Negrón-Muntaner, "Jennifer's Butt."

139. Harewood, "Transnational Soca Performances," 40. Harewood is referencing the familiar performance of self-reflection here.

140. Hinds, interview by the author.

141. Murray, *Flaming Souls*, 69–71.

142. Fleetwood, *On Racial Icons*, 64.

143. Rosamond King, *Island Bodies*, 158.

144. Harewood, "Transnational Soca Performances," 43.

145. Thank you to Selam Minaye for this point.

146. Daniel Miller and Slater, *Internet*, 5–7.

147. Hinds, interview by the author.

148. Spliffietv, "Alison Hinds—Pt. 3."

149. Hinds, interview by the author.

150. Spliffietv, "Alison Hinds—Pt. 3."

151. Even in terms of her own stage performances, Hinds is careful to give credit to the teams of people who make each show possible.

152. Spliffietv, "Alison Hinds Interview—Pt. 2."

153. Steven Jackson, "Alison Hinds Aim."

CHAPTER 4 "LOVE YOU ALL"

1. Old Year's Night is another name for New Year's Eve. Holetown is a city centrally located on the west coast of the island. It is one of the bigger sites of commerce outside of the capital Bridgetown.

2. Between 1995 and 2008 the intentional homicide rate per one hundred thousand people was nearly four times as high in Jamaica as in Barbados. The U.S. rates are roughly on par with the Barbados rates. Petrini, "Homicide Rates Dataset."

3. Christine Barrow, "Caribbean Masculinities," 38–39.

4. Dann, *Barbadian Male*, 8.

5. Butler, *Gender Trouble*, 24–25.

6. Dann, *Barbadian Male*, 64.

7. See Barriteau, "Liberal Ideology."

8. Barriteau, *Political Economy of Gender*, 92.

9. Reddock, introduction to *Interrogating Caribbean Masculinities*, xiii. Examples of men's organizations that fight back against the women's movement include the Men's Educational

Support Association and the more recent Men Against Naughty Dead Beat Mums Barbados. Barriteau, *Political Economy of Gender*, 12; Haynes, "Sylvia Wynter's Theory," 108.

10. Christine Barrow, "Caribbean Masculinities," 45.

11. Ibid., 44–47.

12. Dann, *Barbadian Male*, 60.

13. Ibid., 64.

14. Rupert "Rupee" Clarke, interview by the author.

15. Sandoval, *Methodology of the Oppressed*, 157.

16. Ibid., 130. Sandoval is reading this "neorhetoric of love" through the work of Barthes, *Image, Music, Text*, and Fanon, *Black Skins, White Masks*.

17. Sandoval, *Methodology of the Oppressed*, 2.

18. Browning, *Infectious Rhythm*, 11.

19. Rupert "Rupee" Clarke, interview by Maya Trotz, 2003. See also Musa, "Rupee Opens Up."

20. Anthony "Gabby" Carter, interview by the author; Chase, *Who Gabby Think?*, 36–37; Rudder, *Marching*, 28.

21. Trevor G. Marshall, *Notes on the History*, 24–25.

22. Whitney and Hussey, *Bob Marley*, 16.

23. A spliff is a cannabis-and-tobacco cigarette. The original release had a kitsch album cover of a lighter that opened to a flame. This was the second cover.

24. These connections between infectious music and power struggles at the local and global levels have been noted by other scholars and artists. See Browning, *Infectious Rhythm*; and Reed, *Mumbo Jumbo*.

25. Stephens, "Babylon's 'Natural Mystic,'" 156–158.

26. Shillingford "Shilling" Agard, Cammie Reid, Mighty Slammer, Mighty Jerry, Blackman, and Mighty Pointer practiced calypso in the 1930s, 1940s, 1950s, and 1960s. Trevor G. Marshall, *Notes on the History*, 24–25.

27. Stedson "Red Plastic Bag" Wiltshire speaking on Barbados radio station 98.1 The One, August 4, 2009.

28. The group's performance style was similar to that of their contemporaries, but it relied much more heavily on an older calypso performance aesthetic rather than what Susan Harewood terms "vibe performance." Harewood, "Calypso, Masquerade Performance," 128–130.

29. For a history of advertising female bodies as food in Barbados, see Marisa Fuentes's reading of a lithograph in "Power and Historical Figuring," 571.

30. Early in British Caribbean colonial history (the seventeenth century), poor white workers were derisively referred to as red legs. In the contemporary language, *red* is used to describe anyone with light skin, and the term has lost some of its earlier stigma. Red Rat's stage name is derived from this history and his light skin tone. See Sheppard, *"Redlegs" of Barbados*.

31. Pfleiderer, "Soul Rebels," 96.

32. Hope, *Inna di Dancehall*, 31. In the Jamaican context, the term *deejay* has a different meaning from in the U.S. context. Here it can be read as denoting a vocal performer.

33. Wayne Marshall, "'Bling-Bling,'" 65.

34. Huss, "Zinc-Fence Thing," 186.

35. Wartofsky, "Island in the Song."

36. Ibid.

37. See Edmondson, "Trinidad Romance," for a class analysis of the popularity of dancehall and carnival in Jamaica.

38. Carpenter and Walters, "So Di Ting Set," 355.

39. Rupert "Rupee" Clarke, interview by the author. See also Musa, "Rupee Opens Up."

40. Such statements have historical precedents within Barbadian music, notably calypsonian Red Plastic Bag's song "Caribbean Music."

41. Untitled video clip, Rupee's Myspace page, accessed September 14, 2009, http://www .myspace.com/rupeemusic/ (no longer available).

42. Wayne Marshall, "'Bling-Bling,'" 51. Marshall notes that despite Sean Paul's uptown background (that is, despite not being representative of the Jamaican majority), some Jamaicans still supported the inroads he was able to make for Jamaican music internationally.

43. Rupert "Rupee" Clarke, interview by the author.

44. Ibid.

45. Ibid.

46. Goffman, *Presentation of Self*, 111–135.

47. For a more detailed discussion of technology and the forms and structures of music and other cultural forms, see Best, *Politics of Caribbean Cyberculture*.

48. Rupert "Rupee" Clarke, interview by the author.

49. Celebrated calypsonian the Mighty Gabby has expressed similar views in his song "Fast Food Music."

50. Nurse, "Popular Culture," 337.

51. A satirical video hit the web in 2010 on this very subject. The video pokes fun at deejays who use their position to play music that they produced and then collect all of the royalties. Throughout the video, text questions the actions of the deejay and provides statistical information on who has profited most from the regional quota and copyright laws. Cropoverbarbados, "DJ Tricky Trick."

52. Rupert "Rupee" Clarke, interview by the author.

53. Foster, *Island Wings*, 158.

54. Ibid., 159.

55. Rupert "Rupee" Clarke, interview by the author.

56. Campbell, *Queer Caribbean Speaks*, 58.

57. Ibid., 105.

58. Rupert "Rupee" Clarke, interview by Andre C. Y. Choo Quan.

59. Christine Barrow, "Caribbean Masculinities," 38–39; Ezra E. H. Griffith, *I'm Your Father, Boy*, 44.

60. Christine Barrow, "Introduction and Overview," xxxvii.

61. Murray, *Flaming Souls*, 71–72.

62. Ibid., 72.

63. Christine Barrow, "Caribbean Masculinities," 46.

64. Rupert "Rupee" Clarke, interview by Andre C. Y. Choo Quan.

65. Rupert Clarke, "lol . . . respect bredren . . . you know how it is..with so many beautiful ladies showing love it's hard to stay focused man . . . blessings," Facebook Timeline, November 15, 2009, https://www.facebook.com/rupert.clarke.77.

66. Paule Marshall, *Brown Girl, Brownstones*, 135.

67. Stoute is a Barbadian model whose career at the time this cover appeared had just turned international with her signing to Karin Models in New York. *SHE Caribbean* promotes itself on its website (http://shecaribbean.com/) as "the only magazine dedicated to the Caribbean woman."

68. They all wear white, suggesting innocence or spirituality, and midheight stiletto heels and makeup, referencing the construction of beauty aesthetics.

69. In Barbados, *safe* also has a slightly different vernacular meaning of "okay," as in "everything safe man, everything good."

70. Amina Taylor, "Rupee," 36.

71. Ibid.

72. Christine Barrow, "Caribbean Masculinities," 40.

73. Ibid.

74. Ibid., 41.

75. Ibid., 40.

76. Harewood, "Policy and Performance."

77. Rupert "Rupee" Clarke, interview by the author.

78. Amina Taylor, "Rupee," 36.

79. Rupert "Rupee" Clarke, interview by the author.

80. Harewood, "Calypso, Masquerade Performance," 217.

81. Ibid., 239.

82. Rupert "Rupee" Clarke, interview by Maya Trotz, 2003.

83. Rashbaum, "Rupee Educating People."

84. My analysis will focus on the first version of the video. A second version was released featuring scenes from the *After the Sunset* film.

85. Rupert "Rupee" Clarke, interview by Maya Trotz, 2005.

86. Rupert "Rupee" Clarke, interview by the author.

87. Krista Thompson, *Shine*, 176.

88. Ibid., 195–196; Sharpley-Whiting, *Pimps Up, Ho's Down*, 43. Both videos were released in 2000.

89. Shyguy974, "Rupee."

90. Dominoes have, to a large extent, taken the place of warri (also called mancala in other traditions) within Caribbean traditions. Warri is a traditional game with ties to African and Asian cultures, and while warri is still played, World War II imported Italian dominoes, and the display of skill that used to be enacted through warri is now enacted within dominoes. National Cultural Foundation, *25 Years of Crop Over*.

91. Paule Marshall, *Brown Girl, Brownstones*, 135.

92. Fuentes, "Power and Historical Figuring," 571.

93. Krista Thompson, *Shine*, 224.

94. Strachan, *Paradise and Plantation*, 125.

95. Charles, "Soca's Blend."

96. Amina Taylor, "Rupee," 36.

97. Musa, "Rupee Opens Up."

98. Many of Lil Rick's performances include a call for and display of hard juks (strong pelvic thrusts), suggesting that his performance of masculinity centers on sexual virility, "hardness," and physical display. See Harewood, "Transnational Soca Performances." In 2010 another popular Barbadian performer, Peter Ram, produced "Pat and Crank," a song celebrating female masturbation. A fan uploaded a video for the song to YouTube using images of women interspersed with images of Peter Ram. The video caused a controversy, with critics accusing Peter Ram of blatant misogyny in the depiction of dancehall women even while the lyrics promote a distinct sense of dancehall respectability and not so subtly laud female masturbation and autoerotic autonomy. Theman35z, "Pat and Crank."

99. The Don't Dis Me campaign was started by the Guyanese government and USAID and supported by business. Similar campaigns to fight stigma and increase voluntary testing have been started throughout the Caribbean, one of the most visible being Jamaica's Live Up campaign, which both Rupee and Alison Hinds are a part of. Barbadian efforts at HIV/AIDS awareness have also increased with a host of artists participating in benefit concerts. In Barbados, the National HIV/AIDS Commission was established in 2001, and "Barbados' leading performance poet Winston 'I' Farrell launched the CD *Red Ribbons* in association with the AIDS

Foundation of Barbados and the Division of Youth Affairs during 2005. He collaborated with calypso producer Richard Bourne to release a sleek, catchy, near-haunting musical and lyrical warning about the threat of AIDS." Curwen Best, *Popular Music and Entertainment*, 147.

100. Musa, "Rupee Opens Up."

101. Allen, McClean, and Nurse, "Caribbean, HIV/AIDS, and Security," 224.

102. Ibid., 233.

103. Ibid., 239.

104. Murray, *Flaming Souls*, 31.

105. GuyanaLive, "Don't Dis Me Concert."

106. Rollock, "Face of HIV/AIDS."

107. Ibid.

108. Ibid.

109. Luigi Marshall, "Gay Man Cries Foul."

110. Rhonda Thompson, "Artistes Best." This has in fact been the case, as more and more artists perform at benefit concerts dealing specifically with AIDS awareness on the island.

111. Cross-dressing also has a long history throughout centuries of carnival in the Caribbean and elsewhere. See Rosamond King, *Island Bodies*.

112. Campbell, *Queer Caribbean Speaks*, 30.

113. Ibid., 47.

114. Musa, "Rupee Opens Up."

115. Campbell, *Queer Caribbean Speaks*, 71.

116. Fuss, "Inside/Out," 6.

117. Guilbault, "Music, Politics, and Pleasure," 21.

118. Ibid., 19.

119. Musa, "Rupee Opens Up."

120. Foster, *Island Wings*, 81.

121. Ibid., 83. In the autobiographical fictional work *In the Castle of My Skin*, George Lamming makes similar connections. Using the boy characters, he notes how discipline and child support are connected by explaining how, in the eyes of the young boys and their mothers, a man has no right to discipline a child he is not supporting.

122. Foster, *Island Wings*, 301.

123. Ibid., 116.

124. Ezra E. H. Griffith, *I'm Your Father, Boy*, 16.

125. Amina Taylor, "Rupee," 34.

126. Ezra E. H. Griffith, *I'm Your Father, Boy*, 13.

127. Foster, *Island Wings*, 266.

128. Christine Barrow, "Caribbean Masculinity and Family," 356.

129. Rupert "Rupee" Clarke, interview by the author.

130. In a study commissioned by the Bureau of Women's Affairs, Meena Jordan reported that in 1985, "81.2% of all non-sexual physical crime is committed against women by men." Jordan, *Physical Violence*, 10. She found that for the period of the study (1977–1985), the general attitudes of society were that "crime" happens between strangers rather than in domestic relationships (ibid., 22), and that conflicts between men and women were sexual rather than about power (ibid., 25). This general understanding of physical partner violence as a domestic affair led police and others to be hesitant to intervene or seek to curb it. She saw that the attitudes toward this were beginning to shift.

131. Nurse, "Masculinities in Transition," 8.

132. The song was released before any men had publicly declared a positive HIV/AIDS status on the island.

133. For a more detailed account of the Mighty Gabby's gendered performances, see Harewood, "Masquerade Performance."

134. Chase, *Who Gabby Think?*, 239.

135. Harewood, "Calypso, Masquerade Performance," 135.

136. Ibid., 138.

137. Ibid., 156, 133.

138. The Sexual Offenses Act in Barbados distinguishes between "buggery," or sodomy (which is widely understood as anal sex between two men, although the act also covers anal sex between a man and a woman), and "act[s] of serious indecency," defined as "an act, whether natural or unnatural, by a person involving the use of genital organs for the purpose of arousing or gratifying sexual desire" (which is what two women having sex could be charged with). Alana Griffith and Wickham, "Tolerance, Acceptance," 2–3.

139. Harewood, "Masquerade Performance," 203.

140. Bryant, "Barbados to Maintain Laws."

141. Browning, *Infectious Rhythm*, 27.

142. For a more in-depth analysis of same-sex desire in the Caribbean, activism, and its ties to the Global North, as well as a very nuanced analysis of homophobia, see Rosamond King, *Island Bodies*.

143. Reddock, introduction *Interrogating Caribbean Masculinities*, xx.

144. Nurse, "Masculinities in Transition," 8.

145. See Browning, *Infectious Rhythm*.

146. Stephens, "Babylon's 'Natural Mystic.'"

147. Muñoz, *Disidentifications*, 12.

148. He says that setting up a foundation like this was an idea "he had toyed with for years." In fact, on the message board quoted earlier, one of Rupee's angels had also made this suggestion in 2005.

149. "Rupee to Set Up."

150. Ibid.

151. Alicia Ward, "Rupee Speaks Out."

152. Ibid.

153. Musa, "Rupee Opens Up."

154. "Rupee for GDF"; "'Live Up' Media Campaign."

155. Rupee, "Been in the air all day, just landed at MIA had to acknowledge #WorldAidsDay Awareness about #AIDS and #HIV is a big part of who I am having lost both of my parents to the disease. During my many" Facebook Timeline, December 1, 2014, https://www.facebook.com/pg/TheRealRupee/posts/?ref=page_internal.

156. Alicia Ward, "Rupee Speaks Out."

157. "I Am a Bajan" won over "Wow" by Mr. Dale, an accomplished Bajan musician and two-time Party Monarch. "Wow" features a driving rhythm under a fast-paced delivery of lyrics celebrating the dancing female body. While "I Am a Bajan" focuses on nationalism and "Wow" focuses on the female body, both include lyrics that posit Barbadian women's beauty as a national asset.

158. Rupert Clarke, "Lol . . . give thanks king . . . I appreciate the support bro . . . dun kno is a must tuh rep de rock!! For real boy!!" Facebook Timeline, June 21, 2011, https://www.facebook.com/rupert.clarke.77 (no longer available).

159. This is something that is central to the soca and calypso genres. See Regis, *Political Calypso*.

160. Rupert Clarke, "RUPEE-I AM A BAJAN Buy Now On iTunes and Amazon! Support Barbados! Part proceeds go towards the Barbados National Trust," Facebook, July 27, 2011, https://www.facebook.com/photo.php?fbid=10150269548244253&set=a.452521414252&type

=3&theater; Rupee, "RUPEE-I AM A BAJAN Buy Now On iTunes and Amazon! Support Barbados! Part proceeds go towards the Barbados National Trust," Facebook, July 25, 2011, https://www.facebook.com/TheRealRupee/photos/a.426191597534/10150249066812535/?type=3&theater.

161. Ezra E. H. Griffith, *I'm Your Father, Boy*, 152.

162. Ibid., 154.

163. Ibid., 146.

164. On his blog www.thisisrupee.com (now defunct).

165. Amina Taylor, "Rupee," 36.

166. Rupert Clarke, "#iambajan So tired of all this "cock back" and "skinout" music . . . disrespecting and degrading our women . . . has our music now come to calling women sheep and getting forwards?..time to bring," Facebook Timeline, June 17, 2011, https://www.facebook.com/rupert.clarke.77.

167. Rupert Clarke, "@babywalapoppa I made this song because I felt that amidst all the negative vibes out there, we needed to put Barbados back into the positive light that has shone upon it for so long . . . so we can," Facebook Timeline, July 13, 2011, https://www.facebook.com/rupert.clarke.77.

168. EBUZZTT, "Archived: Even With."

CHAPTER 5 RIHANNA

Portions of this chapter have been published in another form in *Black Sexual Economies: Race and Sex in a Culture of Capital*, published by the University of Illinois Press, 2019.

1. RihannaVEVO, "Rihanna—Cheers."

2. Luigi Marshall, "Rihanna Video."

3. Lipsitz, *Dangerous Crossroads*, 27.

4. Such discourses are often tied to the figures of Legba, Elegua, Eshu-Elegbara, etc.

5. Van Meter, "Living Out Loud," 264.

6. At times citizens are explicitly asked to consider their role in tourism. See the discussion of the 1994 Tourism and You campaign in Krista Thompson, *Eye for the Tropics*, 302.

7. Amina Taylor, "Bajan Beyoncé," 65.

8. Chase, *Who Gabby Think?*, 114.

9. Amina Taylor, "Bajan Beyoncé," 65.

10. Ibid.

11. McCammon, "Rihanna is the Sexiest," 115 (italics in original).

12. Chase, *Who Gabby Think?*, 183.

13. For a history of rum, see Foss, *Rum*.

14. Perhaps this is in reference to Rihanna's Irish ancestry (see Govan, *Rihanna*, 1) and the larger history of Irish settlers on the island (see Sheppard, *"Redlegs"*).

15. "Cheers" samples Lavigne's "I'm with You."

16. Amina Taylor, "Bajan Beyoncé," 65.

17. See Harewood, "Transnational Soca Performances," 36.

18. Goldberg, *Power of Photography*, 135.

19. Ibid., 136.

20. Banet-Weiser, *Authentic™*, 4.

21. D'Souza, "Rihanna Rocks," 173.

22. Lisa Taylor, "'Baby I'm a Star,'" 159.

23. Luigi Marshall, "Show a Success."

24. Rogers has produced pop stars such as Christina Aguilera and Kelly Clarkson. He was vacationing with his Barbadian wife when he was introduced to Rihanna. Govan, *Rihanna*, 21; McCammon, "Rihanna Is the Sexiest"; Van Meter, "Living Out Loud."

25. Roach, *It*, 1.

26. Ibid., 3.

27. Wilson, "Star Power" (italics added).

28. Ibid.

29. Strachan, *Paradise and Plantation*, 1.

30. Ibid., 81.

31. Bestdestination, "Rihanna Promoting Barbados Tourism"; RihannaVEVO, "Rihanna—If It's Loving." The song is from her first album, *Music of the Sun*, and reappears as a remix on her second album, *A Girl like Me*.

32. For more on sexuality and tourism, see Kempadoo, *Sexing the Caribbean*; Nixon, *Resisting Paradise*; Sheller, *Consuming the Caribbean*; Krista Thompson, *Eye for the Tropics*; and Erica Williams, *Sex and Tourism*.

33. Krista Thompson, *Eye for the Tropics*, 3.

34. Ibid., 108.

35. Dwane Husbands sang on "Dem Haters" on the *Girl like Me* album. See Luigi Marshall, "7 Questions."

36. Rupert "Rupee" Clarke, interview by the author. At the time of the interview, 2009, all of these Barbadian-born or Barbadian-descended artists were signed to major U.S.-based record labels, mainly in the genres of pop, rock, and neo-soul. Shontelle, Hal Linton, and Vita Chambers were signed to Motown Records, Jaicko was signed to Capitol Records, and Livvi Franc was on Jive Records' roster.

37. C.L.R. James, *Artist in the Caribbean*, 3.

38. McCammon, "Rihanna Is the Sexiest"; Russell, "Whose Rihanna?," 300. Such differences were also a cause of bullying. Govan, *Rihanna*, 10.

39. Early racial hybridity discourses varied according to each thinker's politics and intellectual background. Some decried racial mixing, while others posited mixed-race women as the most desirable, and still others concluded that "white" men were inherently attracted to women of "lesser races." Faith Smith, "Introduction," 3; Young, *Colonial Desire*, 107.

40. Hill, "Rihanna Talks," 324.

41. Hilary Beckles notes the ways in which Rihanna's neighborhood of Westbury both taught her and celebrated her "badness." Thus the good girl gone bad can be read as the good girl gone home, not to the Barbados of tourist ideals but to the specific neighborhood that shaped her. Beckles, "Westbury Writes Back," 29.

42. "Worldwide Album Sales Chart."

43. Dyer, *Only Entertainment*, 67.

44. See Griffin, *If You Can't Be Free*; and Dove, "Canary."

45. Hill, "Rihanna Talks," 324.

46. Fenty, interview by Diane Sawyer.

47. Arjan, "Rihanna Works."

48. Henwood, *Rihanna*, 12; arjan, "Rihanna Works."

49. Fleetwood, "Case of Rihanna," 424.

50. Ibid., 425.

51. Fenty, interview by Diane Sawyer.

52. See also Fleetwood, "Case of Rihanna." Such a stance mirrors Farah Jasmine Griffin's reading of Billie Holiday. Griffin presents Holiday as the "kind of woman who is simply too complex to be contained by the tragic victim narrative that has predominated in

even some of the most sophisticated representations of her life." Griffin, *If You Can't Be Free*, 7.

53. Fenty, interview by Diane Sawyer.

54. Ibid.

55. Bierria, "'Where Them Bloggers At?,'" 114 (italics in the original).

56. In the same interview, Sawyer asks Rihanna whether the decision to leave or stay was actually hers. There had been rumors that her corporate sponsors would not support her if she publicly stayed in an abusive relationship. Rihanna did not comment on the wishes of her sponsors except to say that if she were a corporate sponsor, she would not support such a move either. Fenty, interview by Diane Sawyer.

57. Eells, "Queen of Pain," 44.

58. Hine, "Rape," 380.

59. Ibid., 382.

60. See, for example, Paule Marshall's depictions of Silla in *Brown Girl, Brownstones*, 200.

61. Hill, "Rihanna Talks," 324.

62. Many of the objections are to Rihanna's discussions, images, and usage of marijuana and how, as a cultural ambassador, her Twitter feed may reflect on the island as a whole. In one instance, Rihanna tweeted an image of marijuana, and subsequently on the CBS morning show *The Talk*, Sharon Osbourne said, "It is understandable because she is from Barbados and everyone there smokes marijuana." Natanga Smith, "Bajans Upset."

63. Van Meter, "Living Out Loud," 260.

64. Eells, "Queen of Pain," 80.

65. Fleetwood, "Case of Rihanna," 430.

66. See Eells, "Queen of Pain," 45; Hill, "Rihanna Talks," 329; Long, "Forever Strong," 307; Fenty, interview by Diane Sawyer; and Van Meter, "Living Out Loud," 262.

67. Rihanna, "G4L," on *Rated R*; Rihanna, "Wait Your Turn," on *Rated R*.

68. Henwood, *Rihanna*, 9.

69. This critique would grow when, years later, she released the video to "Man Down," which begins with her shooting a man who had sexually assaulted her. See Bascomb, "Rude Girl, Big Woman."

70. Curwen Best, *Roots to Popular Culture*, 224.

71. Rihanna's grandmother used to call her a rebel flower. Her scent Reb'l Fleur, which was launched around the same time as the *Loud* album, is named after the nickname.

72. See the covers and liner notes of Lady Saw's *Passion*, and Betty Davis's *Nasty Gal*.

73. Ricky Jordan, "Rihanna Pushing Envelope."

74. Gmelch, *Behind the Smile*, 23.

75. Howard, *Economic Development of Barbados*, 138–141.

76. Luigi Marshall, "Bling Style Taking Over."

77. The 2003 Barbados Economic and Social Report states, "An examination of the annual statistics reveals that more young people are becoming involved in crime" (114). In 2010 *Nation-News* released articles about the decrease in crime in Barbados ("New Crime Culture Emerging") and the perception of a more aggressive culture on the island ("Too Much Violence"). A year later, the newspapers reported that crime rates had slightly increased ("Crime Rate Increased").

78. Evanson, "Killer Owns Up."

79. Between 2002 and 2014 the rate of enrollment of Barbadian students at the University of the West Indies rose 167 percent before a sharp drop-off in 2015. Barbados Economic and Social Reports 2002–2015.

80. This paradox of being a "fucking lady" is one that both adopts and discards any normative politics of respectability. See Finley, "Raunch and Redress."

81. Cooper, *Noises in the Blood*, 11.

82. RihannaVEVO, "Rihanna—What's My Name?"

83. Sheller, *Consuming the Caribbean*, 13; Strachan, *Paradise and Plantation*, 81–85; Krista Thompson, *Eye for the Tropics*, 108; Young, *Colonial Desire*, 31–32.

84. Kempadoo, *Sexing the Caribbean*; Nixon, *Resisting Paradise*; Sheller, *Consuming the Caribbean*; Faith Smith, "Introduction."

85. See Young, *Colonial Desire*.

86. See Torgovnick, *Gone Primitive*.

87. Van Meter, "Living Out Loud," 260.

88. Strachan, *Paradise and Plantation*, 89.

89. Fleetwood, "Case of Rihanna," 427.

90. Vasquez, "Rihanna AMA's."

91. "NIVEA Kicks Off."

92. "Rihanna Deemed Too Sexy."

93. Brathwaite, "Blanche," in *Words Need Love Too*, 11.

94. Wilson, "Star Power."

95. Gilroy, *Black Atlantic*.

96. Patrick Ward, "Too Rude."

97. Thomas, *Modern Blackness*, 11–12.

98. Wilson, "Star Power."

99. Kadooment is a carnival road march that occurs as one of the last events of Barbados's Crop Over Festival. It is held on the first Monday of August. Participants are organized into bands, and each band has a number of costumes representing it.

100. "Well That Didn't Last."

101. While the title of queen has many usages within Caribbean culture and within carnival culture worldwide, in the context of Barbados's Crop Over, it is reserved for the most productive female cane cutter of the season, who is crowned at the opening of the festival known as the ceremonial cutting of the canes. The 2011 Queen of the Crop was Judy Cumberbatch. See "Barbados Crop Over Festival."

102. Luigi Marshall, "No Tying Ri Ri Down."

103. Nessif, "Which Singer?"

104. Ibid.

105. Ibid.

106. Ibid.

107. I say *arguably* because the Crop Over Festival of the seventeenth- and eighteenth-century Barbadian plantations often included parades, though these precursors took a drastically different form, and the Crop Over Festival is part of a worldwide carnival tradition also drawing on European, New World, and West and Central African celebratory practices.

108. Wekker, *Politics of Passion*, 226.

109. Although the overwhelming majority of the nation identifies as Christian, more specifically Protestant, there are a number of Christian denominations and several other religions practiced on the island. See "Barbados Churches."

110. Enam, comment on Nessif, "Which Singer?"

111. Thomas, *Modern Blackness*, 11–12.

112. Rivera-Rideau, *Remixing Reggaetón*, 11.

113. Ibid., 10.

114. Ibid., 36–37.

115. Thomas, *Modern Blackness*, 77.

116. Ibid., 191.

117. Edmondson, "Trinidad Romance," 57; Thomas, *Modern Blackness*, 115–116.

118. See Torgovnick, *Gone Primitive*; Gilroy, *Black Atlantic*.

119. Bourdieu, "Forms of Capital."

120. Wayne, "Celebrity Focus," 24.

121. See Edmondson, "Public Spectacles."

122. Eells, "Queen of Pain," 80.

123. This could be interpreted as what Thomas terms "ghetto feminism," which is the active assertion of the power of female sexuality in ways that challenge respectability and patriarchy. Thomas, *Modern Blackness*, 252–257.

124. Rosamond King, *Island Bodies*, 127.

125. Mallett, "'Project Runway' Designer."

126. "Anya Ayoung-Chee Dishes."

127. Ibid.

128. O'Connor, "Sex-Scandal Beauty Queen."

129. Rihanna would go on to launch her own fashion line a few years later, in 2013.

130. There were similar concerns over the cost of the tickets and whether they would be affordable to the average Barbadian or target the upper classes on the island and wealthy visitors.

131. Martindale, "Rihanna Local Concert"; Luigi Marshall, "No Tying Ri-Ri Down." Rihanna had not done a big show on the island since leaving to become a star.

132. C.L.R. James, *Artist in the Caribbean*, 7.

133. Yvette Best, "Stage Is Set."

134. Barry Alleyne, "Tourism Minister Pushing Culture." $8.6 million in Barbadian dollars converts to roughly $4.3 million in U.S. dollars. The BTA had expected to attract four thousand visitors and spent $4 million Barbadian on the concert. "Barbados Gets Loud!"; Luigi Marshall, "Show a Success."

135. "Darling Nikki" is about a woman who is a "sex fiend," and it chronicles the singer's encounter with her, beginning with meeting her while she masturbates in a hotel lobby, continuing with a night at a castle, and ending with a goodbye note. Prince, "Darling Nikki."

136. Pauline Kael in the *New Yorker*, quoted in Lisa Taylor, "'Baby I'm a Star,'" 162.

137. The video to Rihanna's 2010 song "Te Amo," released for a European audience, explores a budding relationship between two women, one of whom is wary of the sexual overtones. The chorus presents the confusion of a woman reacting ambiguously to the sexual advances of another woman, advances that are disconnected by a language gap between English and Spanish. The video depicts the conflicted attraction and features French model Laetitia Casta. Rihanna and Casta enact a slow cat-and-mouse chase in an ornate old church. Each exerts a very physical presence over the other, but the solo shots of Casta show her longing, while the solo shots of Rihanna show a more complicated search for control. The dark-red lighting, the use of a blazing fireplace as a background, and the capoeiristas who perform for them all frame this desire in a cloud of danger. Such danger is highlighted at the end of the video with a montage of all of the previous scenes that leads to the two sitting down for dinner outside. They sit at either side of a long table that is ablaze between them. The song and the video openly explore same-sex desire without expressing a definitive sexual identity, and they contrast the clear heterosexual longing of "Rude Boy" on the same album, 2010's *Rated R*. RihannaVEVO, "Rihanna—Te Amo."

138. Eells, "Queen of Pain," 42.

139. Such a performance would be akin to what Uri McMillan calls Nicki-aesthetics. In analyzing Nicki Minaj's aesthetics, he notes how she is able to recenter what had often been seen as a white, gay performance aesthetic onto her own black, female, sexually ambiguous public self. McMillan, "Nicki-Aesthetics."

140. Rihanna said, "The song can be taken very literally, but it's actually a very metaphorical song. It's about the love-hate relationship with the media and how sometimes the pain is pleasurable. We feed off it, you know—or I do. And it was a very personal message that I was trying to get across. I wanted the video to say that but still play off the theme of S&M. And I mean, *wow*, people went crazy. They just saw sex. And when I see that video, I don't see that at all. I wanted it to be cheeky. There's no other way to take it." Van Meter, "Living Out Loud," 265.

141. Roach, *It*, 22. Savannah Shange notes similar though not identical issues with Nicki Minaj. She calls attention to the ways in which Minaj appears to perform heterosexuality in some instances and queerness in others but often strategically refuses both. Shange seeks to "examine the distance between provocation and transgression, and how queer practice and commodification interact in the discursive flows of black popular culture." She notes that such discursive flows contain "currents that are both strategic and static, essentialist and ambiguous, coerced and agentic, coursing through the same narrative." Shange, "King Named Nicki," 30.

142. Yvette Best, "Stage Is Set."

143. Martindale, "Rihanna Thanks the Crowd." Although this is presumably a heartfelt gesture, it is also part of the show, as Rihanna sat on the edge of the stage and talked to and thanked each audience on the Loud Tour.

144. Martindale, "Loud Concerns."

145. Ibid.

146. Tanyarespect, comment on ibid.

147. D'Souza, "Rihanna Rocks," 254 (italics in the original).

148. Annetta Worrell and En Dee, comments on Martindale, "Rihanna, Shut Up and Sing."

149. Kay, comment on Rodrigo, "Rihanna Covers British Vogue."

150. Spencer, "C-Word for the Publicity?"; comments on Martindale, "Rihanna's Love."

151. Spencer, "C-Word for the Publicity?"

152. Martindale, "Rihanna, Shut Up and Sing."

153. Stevia.arthur, comment on ibid.

154. Padmore, "Barbados Labour Party"; "William Duguid Loses It!"

155. Holder, "Rihanna Hospitalized in Sweden."

156. Holder, "Rihanna Ordered"; Martindale, "What's Trending."

157. Martindale, "Pastor Concerned"; Mike King, "Rihanna 'Not Fit.'"

158. Long, "Forever Strong," 302 (italics in the original).

159. Ibid., 307.

160. Visit Barbados, "Are you a tourist or a traveler? Find out at http://touristortraveler .visitbarbados.org/," Facebook, January 24, 2013, https://www.facebook.com/VisitBarbados /photos/a.198104150206872.64441.135470743136880/589142681103015/?type=3&theater.

161. Rihanna, "Navy! River Island wants to hook you up with a trip to Visit Barbados and a week long stay The SoCo Hotel! Enter here for a chance to win: http://bddy.me/RFVdPo," Facebook, September 19, 2013, https://www.facebook.com/rihanna/photos/a.207477806675 /10151868761151676/?type=3&theater.

162. Amina Taylor, "Bajan Beyoncé," 61.

163. C.L.R. James, *Artist in the Caribbean*, 6.

164. Walcott, "Caribbean," 10.

165. Ibid., 9.
166. Amina Taylor, "Bajan Beyoncé," 65.

CONCLUSION

1. "Rihanna for Barbados 50"; "Rihanna to Perform."
2. "Prince Harry Joined Rihanna."
3. Pettis and Marshall, "*MELUS* Interview," 119.

DISCOGRAPHY

Davis, Betty. *Nasty Gal*. MPC Entertainment, 2003, compact disc. Originally released 1975.

Gabby. *Gabby 'til Now*. Ice Records, 1996, compact disc.

———. *Well Done*. Ice Records, 1999, compact disc.

Hinds, Alison. *Caribbean Queen*. Black Coral, 2010, MP3 album.

———. *Soca Queen*. Black Coral, 2007, compact disc.

Lady Saw. *Passion*. VP Records, 1997, compact disc.

Marley, Bob, and the Wailers. *Catch a Fire*. Island Records, 1973, vinyl.

Merrymen. *The Merrymen Story Live!* Recorded December 1, 1996, at Sir Garfield Sobers's Gymnasium, Barbados. CRS Music and Media, 2006, 2 compact discs.

Mr. Dale. "W. I. Cultuh." On *Soka Tite Choonz Vol. 4*. Smokyn Vybz Musik, 2009, compact disc.

Prince. "Darling Nikki." On *Purple Rain*. Warner Brothers, 1990, compact disc. Originally released 1984.

Queen Latifah. "Just Another Day." On *Black Reign*. Motown Records, 1993.

Red Plastic Bag. "Caribbean Music." *Unlimited*. 1998.

Rihanna. *A Girl like Me*. Def Jam Recordings/SRP Records, 2006, compact disc.

———. *Good Girl Gone Bad*. Island Def Jam Music Group, 2007, compact disc.

———. *Loud*. Def Jam/SRP Music Group, 2010, compact disc.

———. *Music of the Sun*. Def Jam Recordings/SRP Records, 2005, compact disc.

———. *Rated R*. Island Def Jam Music Group, 2009, compact disc.

———. *This Is Rihanna*. Def Jam Music, 2005, not released for sale.

Rupee. *Blame It on the Music*. Self-produced, 2001, compact disc.

———. *Leave a Message*. Self-produced, 2002, compact disc.

———. *1 on 1*. Atlantic Recording Corporation, 2004, compact disc.

———. *Thisisrupee.com*. Self-produced, 2003, compact disc.

Square One. *In Full Bloom*. Self-produced,1998, compact disc.

WORKS CITED

"About the NCF." National Cultural Foundation Barbados. Accessed July 12, 2018. http://www .ncf.bb/about-the-ncf/.

Alexander, M. Jacqui. "Not Just (Any) *Body* Can Be a Citizen: The Politics of Law, Sexuality and Postcoloniality in Trinidad and Tobago and the Bahamas." *Feminist Review*, no. 48 (1994): 5–23.

Allen, Caroline, Roger McClean, and Keith Nurse. "The Caribbean, HIV/AIDS and Security." In *Caribbean Security in the Age of Terror: Challenge and Change*, edited by Ivelaw L. Griffith, 219–251. Kingston: Ian Randle, 2004.

Alleyne, Barry. "Tourism Minister Pushing Culture." *NationNews*, March 16, 2012. http://www .nationnews.com/nationnews/news/33785/tourism-minister-pushing-culture.

Alleyne, Mike. "Globalization and Commercialization of Caribbean Music." *Popular Music History* 3, no. 3 (2008): 247–273.

Andaiye. Foreword to *Conversations: Essays, Addresses and Interviews, 1953–1990*, by George Lamming, 7–16. Edited by Richard Drayton and Andaiye. London: Karic, 1992.

Anderson, Benedict. *Imagined Communities: Reflections on the Origins and Spread of Nationalism*. New York: Verso, 1983.

Anderson, Mark. "When Afro Becomes (like) Indigenous: Garifuna and Afro-Indigenous Politics in Honduras." *Journal of Latin American and Caribbean Anthropology* 12, no. 2 (2007): 384–413.

"Anya Ayoung-Chee Dishes on Project Runway, Her Passion for Design & Overcoming Scandal." *Oh No They Didn't!* (blog), September 22, 2011. http://ohnotheydidnt.livejournal.com /62934351.html.

Appadurai, Arjun. "Disjuncture and Difference in the Global Cultural Economy." In *Theorizing Diaspora*, edited by Jana Evans Braziel and Anita Mannur, 25–49. Malden, Mass.: Blackwell, 2003.

Arjan. "Rihanna Works with Simon Henwood on Creative Direction for 'Rated R.'" *Arjan Writes* (blog), December 4, 2009. http://www.arjanwrites.com/arjanwrites/2009/12 /simon-henwood-rihanna.html.

Austin, J. L. *How to Do Things with Words*. Cambridge, Mass.: Harvard University Press, 1962.

Babb, Davandra. "Musical Icons: Alison Hinds." *NationNews*, January 16, 2018. http://www .nationnews.com/nationnews/news/119722/musical-icons-alison-hinds.

Bailey, G. "Destra Denise and Alison at Soca Monarch 2009 Live—Obsessive Winers (Deh Cyar Wine like We)." Posted February 22, 2009. Video, 7:09. http://www.youtube.com /watch?v=EPGdiIYzuUM.

Bailey, Wilma, Clement Branche, Gail McGarrity, and Sheila Stuart. *Family and the Quality of Gender Relations in the Caribbean*. Mona, Jamaica: Institute of Social and Economic Research, University of the West Indies, 1998.

Banet-Weiser, Sarah. *Authentic™: The Politics of Ambivalence in a Brand Culture*. New York: New York University Press, 2012.

Barbados Annual Report. Department of Labour, Barbados Government. 1969. Barbados National Library.

"Barbados Churches." Go Barbados. Accessed March 20, 2019. http://www.barbados.org /churches.htm.

"Barbados Crop Over Festival." Go Barbados. Accessed April 27, 2019. https://barbados.org/cropover.htm.

Barbados Economic and Social Reports. Economic Planning and Research Unit, Ministry of Finance and Economic Affairs, Barbados Government. 2002–2015. http://www.economicaffairs.gov.bb/archive.php?cid=10.

"Barbados Gets Loud!" *Barbados Advocate,* August 5, 2011. Accessed August 5, 2011. http://www.barbadosadvocate.com/newsitem.asp?more=local&NewsID=19123 (no longer available).

Barriteau, V. Eudine. "Liberal Ideology and Contradictions in Caribbean Gender Systems." In *Caribbean Portraits: Essays on Gender Ideologies and Identities,* edited by Christine Barrow, 436–456. Kingston: Ian Randle, 1998.

———. *The Political Economy of Gender in the Twentieth-Century Caribbean.* New York: Palgrave, 2001.

Barrow, Christine. "Caribbean Masculinities, Marriage and Gender Relations: Ideologies and Contradictions." In *Gender and the Family in the Caribbean,* edited by Wilma Bailey, 32–52. Mona, Jamaica: Institute of Social and Economic Research, University of the West Indies, 1998.

———. "Caribbean Masculinity and Family: Revisiting 'Marginality' and 'Reputation.'" In *Caribbean Portraits: Essays on Gender Ideologies and Identities,* edited by Christine Barrow, 339–358. Kingston: Ian Randle, 1998.

———. "Introduction and Overview: Caribbean Gender Ideologies." In *Caribbean Portraits: Essays on Gender Ideologies and Identities,* edited by Christine Barrow, xi–xxxviii. Kingston: Ian Randle, 1998.

Barrow, Errol. *Speeches by Errol Barrow.* Edited by Yussuff Haniff. London: Hansib, 1987.

Barrow, Jennifer V., and Sherma Roberts. "Market Positioning: The Case of Barbados." In *Marketing Island Destinations: Concepts and Cases,* edited by Acolla Lewis-Cameron and Sherma Roberts, 53–64. Amsterdam: Elsevier, 2010.

Barrow-Giles, Cynthia, and Albert Branford. "Edna Ermyntrude 'Ermie' Bourne: Breaking the Ice—Barbadian Pioneer." In *Women in Caribbean Politics,* edited by Cynthia Barrow-Giles, 29–36. Kingston: Ian Randle, 2011.

Barthes, Roland. *Image, Music, Text.* Translated by Stephen Heath. New York: Hill and Wang, 1977.

———. "Myth Today." In *Mythologies,* translated by Annette Lavers, 109–146. New York: Hill and Wang, 1972.

Bascomb, Lia T. "Rude Girl, Big Woman: Power and Play in Representations of Caribbean Women." *Palimpsest: A Journal on Women, Gender, and the Black International* 3, no. 2 (October 2014): 191–213.

Baudrillard, Jean. *Simulacra and Simulation.* Ann Arbor: University of Michigan Press, 1994.

Beckles, Hilary. *Afro-Caribbean Women and Resistance to Slavery in Barbados.* London: Karnak House, 1988.

———. *A History of Barbados: From Amerindian Settlement to Nation-State.* Cambridge: Cambridge University Press, 1990.

———. "Independence and the Social Crisis of Nationalism in Barbados." In *Caribbean Freedom: Economy and Society from Emancipation to the Present,* edited by Hilary Beckles and Verene Shepherd, 528–539. Kingston: Randle, 1993.

———. *Natural Rebels: A Social History of Enslaved Black Women in Barbados.* London: Zed Books, 1989.

———. "Radicalism and Errol Barrow in the Political Tradition of Barbados." In *The Empowering Impulse: The Nationalist Tradition of Barbados,* edited by Glenford D. Howe and Don D. Marshall, 221–231. Barbados: Canoe, 2001.

———. "Westbury Writes Back: Rihanna Reclaimed." In *Rihanna: Barbados World-Gurl in Global Popular Culture*, edited by Hilary Beckles and Heather D. Russell, 14–37. Kingston: University of the West Indies Press, 2015.

———. "Why Nelson Must Fall." *NationNews*, September 12, 2017. http://www.nationnews.com/nationnews/letters_to_editor/100433/nelson-fall.

Benítez-Rojo, Antonio. *The Repeating Island: The Caribbean and the Postmodern Perspective*. 2nd ed. Durham, N.C.: Duke University Press, 1996.

Best, Curwen. *Barbadian Popular Music and the Politics of Caribbean Culture*. Rochester: Schenkman Books, 1999.

———. *The Politics of Caribbean Cyberculture*. New York: Palgrave Macmillan, 2008.

———. "Popular/Folk/Creative Arts and the Nation." In *The Empowering Impulse: The Nationalist Tradition of Barbados*, edited by Glenford D. Howe and Don D. Marshall, 232–255. Barbados: Canoe, 2001.

———. *The Popular Music and Entertainment Culture of Barbados: Pathways to Digital Culture*. Toronto: Scarecrow, 2012.

———. *Roots to Popular Culture: Barbadian Aesthetics: Kamau Brathwaite to Hardcore Styles*. London: Macmillan Education, 2001.

Best, Yvette. "The Stage Is Set." *NationNews*, August 5, 2011. http://www.nationnews.com/nationnews/news/39038/stage-set.

Bestdestination. "Rihanna Promoting Barbados Tourism." Posted March 19, 2010. Video, 0:31. http://www.youtube.com/watch?v=-7TtY_kTbD8.

Bhabha, Homi. *The Location of Culture*. New York: Routledge, 1994.

Bierria, Alisa. "'Where Them Bloggers At?' Reflections on Rihanna, Accountability, and Survivor Subjectivity." *Social Justice* 37, no. 4 (2011): 101–125.

"Biography—Alison Hinds." Alison Hinds's official website. Accessed May 9, 2010. http://alisonhinds.com/biography.

BlastRadiusInc. "NIVEA Augmented Reality Campaign by Blast Radius." Posted October 31, 2011. Video, 0:39. http://www.youtube.com/watch?v=GijFCzWLEco.

Borges, Jorge Luis. "Del Rigor en la Ciencia." In *El Hacedor*, 103. Buenos Aires: Emecé Editores, 1971.

Bourdieu, Pierre. "Forms of Capital." In *Readings in Economic Sociology*, edited by Nicole Woolsey Biggart, 46–58. Malden, Mass.: Blackwell, 2002.

Brathwaite, Kamau. *The Arrivants*. Oxford: Oxford University Press, 1973.

———. "Golokwati Conversations: An Interview with Kamau Brathwaite." By Marcia P. A. Burrowes. *World Literature Written in English* 39, no. 1 (2001): 9–26.

———. *Words Need Love Too*. Philipsburg, Saint Martin: House of Nehisi, 2000.

Brodber, Erna. *Perceptions of Caribbean Women: Towards a Documentation of Stereotypes*. Cave Hill, Barbados: Institute of Social and Economic Research, University of the West Indies, 1982.

Brown, Jacqueline Nassy. "Black Liverpool, Black America, and the Gendering of Diasporic Space." *Cultural Anthropology* 13, no. 3 (1998): 291–325.

Brown, J. Dillon. *Migrant Modernism: Postwar London and the West Indian Novel*. Charlottesville: University of Virginia Press, 2013.

Browning, Barbara. *Infectious Rhythm: Metaphors of Contagion and the Spread of African Culture*. New York: Routledge, 1998.

Bryant, Melissa. "Barbados to Maintain Laws on Death Penalty, Prostitution and Homosexuality." SKN Vibes, December 5, 2008. http://www.sknvibes.com/News/NewsDetails.cfm/7663.

Burgie, Irving. *Day-O!!! The Autobiography of Irving Burgie*. Bloomington, Ind.: Xlibris, 2007.

Burrowes, Marcia P. A. "The Cloaking of a Heritage: The Barbados Landship." In *Contesting Freedom: Control and Resistance in the Post-Emancipation Caribbean*, edited by Gad Hauman and David V. Trotman, 215–234. Warwick University Caribbean Studies. Oxford: Macmillan Caribbean, 2005.

Butler, Judith. *Gender Trouble: Feminism and the Subversion of Identity*. New York: Routledge, 1990.

Bynoe, Kenmore. "Women's Day Celebration." *NationNews*. March 20, 2010. Accessed March 10, 2010. http://www.nationnews.com (no longer available).

Campbell, Kofi Omononiyi Sylvanus. *The Queer Caribbean Speaks: Interviews with Writers, Artists, and Activists*. New York: Palgrave Macmillan, 2014.

Carpenter, Karen, and Gavin Walters, "A So Di Ting Set: Conceptions of Male and Female in Jamaica and Barbados." *Sexuality and Culture* 15 (2011): 345–360.

Carter, Anthony "Gabby." Interview by the author. Wildey, Barbados, August 20, 2009.

Carter, Gercine. "Pride Sprung from National Anthem Lyrics." *NationNews*, May 15, 2016. http://www.nationnews.com/nationnews/news/81236/pride-sprung-national-anthem -lyrics.

Chamberlain, Mary. *Empire and Nation-Building in the Caribbean: Barbados, 1937–66*. Manchester: Manchester University Press, 2010.

———. *Narratives of Exile and Return*. New York: St. Martin's, 1997.

Charles, Jacqueline. "Soca's Blend of Soul and Calypso Is Making a Splash on Radio, MTV." *Seattle Times*, last updated October 25, 2004. http://seattletimes.com/html/musicnightlife /2002070527_soca25.html (no longer available).

Chase, Barbara. *Who Gabby Think He Is? The Story of the Mighty Gabby*. With Valerie Clarke and Anthony "the Mighty Gabby" Carter. Oistins, Barbados: Caribbean Chapters, 2015.

Chude-Sokei, Louis. *The Last "Darky": Bert Williams, Black-on-Black Minstrelsy, and the African Diaspora*. Durham, N.C.: Duke University Press, 2006.

Clark, VèVè A. "Developing Diaspora Literacy and *Marasa* Consciousness." In *Comparative American Identities: Race, Sex, and Nationality in the Modern Text*, edited by Hortense J. Spillers, 40–61. New York: Routledge, 1991.

Clarke, Kamari. *Mapping Yorùbá Networks: Power and Agency in the Making of Transnational Communities*. Durham, N.C.: Duke University Press, 2004.

Clarke, Richard L. W. "Roots: A Genealogy of the 'Barbadian Personality.'" In *The Empowering Impulse: The Nationalist Tradition of Barbados*, edited by Glenford D. Howe and Don D. Marshall, 301–349. Barbados: Canoe, 2001.

Clarke, Rupert "Rupee." Interview by Andre C. Y. Choo Quan. August 13, 2006. Video, 4:58. http://www.trinijunglejuice.com/interviews.html#rupee.

———. Interview by Maya Trotz. Newk's Cafe Tampa, Fla., May 31, 2003. Accessed July 23, 2009. http://www.jouvay.com (site discontinued).

———. Interview by Maya Trotz. Hard Rock Cafe, Orlando, Fla., May 29, 2005. Accessed July 23, 2009. http://www.jouvay.com (site discontinued).

———. Interview by the author. Oakland, Calif., September 19, 2009.

Collins, Merle. "'Sometimes You Have to Drink Vinegar and Pretend You Think Is Honey': Race, Gender, and Man-Woman Talk." In *Caribbean Portraits: Essays on Gender Ideologies and Identities*, edited by Christine Barrow, 377–390. Kingston: Ian Randle, 1998.

Comissiong, David. "Re-defacing of Nelson Statue in Bridgetown." *Barbados Underground* (blog), November 29, 2017. https://barbadosunderground.net/2017/11/29/re-defacing-of -nelson-statue-in-bridgetown/.

Connell, Neville. "Prince William Henry's Visits to Barbados in 1786 & 1787." *Journal of the Barbados Museum and Historical Society* 25, no. 4 (August 1958): 157–164.

Conniff, Michael L. *Black Labor on a White Canal: Panama, 1904–1981.* Pittsburgh: University of Pittsburgh Press, 1985.

Cooper, Carolyn. *Noises in the Blood: Orality, Gender and the "Vulgar" Body of Jamaican Popular Culture.* London: Macmillan, 1993.

———. *Sound Clash: Jamaican Dancehall Culture at Large.* New York: Palgrave Macmillan, 2004.

"Crime Rate Increased by 2.3% in 2010." *Barbados Advocate,* January 7, 2011. http://www .barbadosadvocate.com/newsitem.asp?more=local&NewsID=14981 (no longer available).

Cropoverbarbados. "DJ Tricky Trick Cold Crop Over Top 10." Posted June 4, 2010. Video, 3:27. http://www.youtube.com/watch?v=3wcWFIpNCWE.

Crop Over Festival Magazine. Barbados: Letchworth, 1988. National Cultural Foundation Archives, Barbados.

Crop Over 1993. Barbados: Paperchase Publications, 1993. National Cultural Foundation Archives, Barbados.

Daniel, Yvonne. *Caribbean and Atlantic Diaspora Dance: Igniting Citizenship.* Urbana: University of Illinois Press, 2011.

Dann, Graham. *The Barbadian Male: Sexual Attitudes and Practices.* London: Macmillan, 1987.

Davis, N. Darnell. *The Cavaliers and Roundheads of Barbados, 1650–52: With Some Account of the Early History of Barbados.* Georgetown, British Guiana: Argosy, 1887.

De Certeau, Michel. *The Practice of Everyday Life.* Translated by Steven Rendall. Berkeley: University of California Press, 1984.

DeShong, Halimah A. F., and Tonya Haynes. "Intimate Partner Violence in the Caribbean: State, Activist and Media Responses." *Global Public Health* 11, no. 1–2 (2016): 82–94.

Dikobe, Maude. "Bottom in de Road: Gender and Sexuality in Calypso." *Proudflesh: A New Afrikan Journal of Culture, Politics, and Consciousness,* no. 3 (2004). https://www .africaknowledgeproject.org/index.php/proudflesh/article/view/211.

———. "Doing She Own Thing: Gender, Performance and Subversion in Trinidad Calypso." PhD diss., University of California, Berkeley, 2003.

Dove, Rita. "Canary." In *Grace Notes: Poems,* 64. New York: W. W. Norton, 1989.

Downes, Aviston D. "Boys of the Empire: Elite Education and the Construction of Hegemonic Masculinity in Barbados, 1875–1920." In *Interrogating Caribbean Masculinities: Theoretical and Empirical Analyses,* edited by Rhoda Reddock, 105–136. Kingston: University of the West Indies Press, 2004.

D'Souza, Christa. "Rihanna Rocks: In Fashion's New Glamour." *British Vogue,* November 2011, 167–173, 254.

Du Bois, W.E.B. *The Souls of Black Folk.* New York: Signet Classic Penguin Books, 1969.

Duke, Eric D. *Building a Nation: Caribbean Federation in the Black Diaspora.* Gainesville: University Press of Florida, 2016.

Dyer, Richard. *Only Entertainment.* New York: Routledge, 2002.

EBUZZTT. "Archived: Even with T&T Carnival in Sight, Bajan Star, Rupee Signs Major International Music Deal with ULTRA." EBUZZTT.com, January 14, 2017. https://ebuzztt.com /barbados-rupee-signs-major-international-deal-ultra/.

Edmondson, Belinda. "The Caribbean: Myths, Tropes, Discourses." In *Caribbean Romances: The Politics of Regional Representation,* edited by Belinda Edmondson, 1–11. Charlottesville: University Press of Virginia, 1999.

———. "Public Spectacles: Caribbean Women and the Politics of Public Performance." *Small Axe* 7, no. 1 (March 2003): 1–16.

———. "Trinidad Romance: The Invention of Jamaican Carnival." In *Caribbean Romances: The Politics of Regional Representation,* edited by Belinda Edmondson, 56–75. Charlottesville: University Press of Virginia, 1999.

Edward, Geralyn. "Banks Holdings Limited (BHL) Is No Longer a Barbadian-Owned Company." Guyanese Online, December 8, 2015. https://guyaneseonline.wordpress.com/2015/12/11/banks-holding-limited-bhl-is-no-longer-a-barbadian-owned-company/.

Edwards, Brent Hayes. Practice of Diaspora: Literature, Translation, and the Rise of Black Nationalism. Cambridge, Mass.: Harvard University Press, 2003.

Eells, Josh. "Queen of Pain." Rolling Stone, April 2011, 40–45, 80.

Ellis, Nadia. Territories of the Soul: Queered Belonging in the Black Diaspora. Durham, N.C.: Duke University Press, 2015.

Evanson, Heather-Lynn. "Killer Owns Up." NationNews, June 2, 2011. http://www.nationnews.com/nationnews/news/38738/killer-owns.

———. "Nelson Part of Our History." NationNews, July 7, 2011. http://www.nationnews.com/nationnews/news/23035/nelson-history.

Fanon, Frantz. Black Skins, White Masks. New York: Grove, 1967.

———. The Wretched of the Earth. New York: Penguin Books, 2001.

"Fast Food Music." Barbados Today, April 12, 2013. http://www.barbadostoday.bb/2013/0f4/12/fast-food-music-2/.

Fenty, Robyn Rihanna. Interview by Diane Sawyer. 20/20. ABC News, November 7, 2009.

Finley, Jessyka. "Raunch and Redress: Interrogating Pleasure in Black Women's Stand-Up Comedy." Journal of Popular Culture 49, no. 4 (2016): 780–798.

Finneran, Niall. "'This Islande Is Inhabited with All Sorts': The Archaeology of Creolisation in Speightstown, Barbados, and Beyond, AD 1650–1900." Antiquaries Journal 93 (2013): 319–351.

Fleetwood, Nicole R. "The Case of Rihanna: Erotic Violence and Black Female Desire." African American Review 45, no. 3 (Fall 2012): 419–436.

———. On Racial Icons: Blackness and the Public Imagination. New Brunswick, N.J.: Rutgers University Press, 2015.

Forbes, Curdella. From Nation to Diaspora: Samuel Selvon George Lamming and the Cultural Performance of Gender. Mona, Jamaica: University of the West Indies Press, 2005.

Foss, Richard. Rum: A Global History. London: Reaktion Books, 2012.

Foster, Cecil. Island Wings: A Memoir. Toronto: HarperCollins, 1998.

Freeman, Carla. High Tech and High Heels: Women, Work, and Pink-Collar Identities in the Caribbean. Durham, N.C.: Duke University Press, 2000.

Fuentes, Marisa. "Buried Landscapes: Enslaved Black Women, Sex, Confinement and Death in Colonial Bridgetown, Barbados and Charleston, South Carolina." PhD diss., University of California, Berkeley, 2007.

———. Dispossessed Lives: Enslaved Women, Violence, and the Archive. Philadelphia: University of Pennsylvania Press, 2016.

———. "Power and Historical Figuring: Rachael Pringle Polgreen's Troubled Archive." Gender and History 22, no. 3 (November 2010): 564–584.

Fuss, Diana. "Inside/Out." In Inside/Out: Lesbian Theories and Gay Theories, edited by Diana Fuss, 1–10. New York: Routledge, 1991.

Gill, Lyndon K. Erotic Islands: Art and Activism in the Queer Caribbean. Durham, N.C.: Duke University Press, 2018.

Gillespie, Carmen. "'Nobody Ent Billing Me': A U.S./Caribbean Intertextual, Intercultural Call-and-Response." In Sex and the Citizen: Interrogating the Caribbean, edited by Faith Smith, 37–52. Charlottesville: University of Virginia Press, 2011.

Gilroy, Paul. The Black Atlantic: Modernity and Double Consciousness. Cambridge, Mass.: Harvard University Press, 1993.

———. Small Acts: Thoughts on the Politics of Black Cultures. London: Serpent's Tail, 1993.

Glissant, Édouard. *Caribbean Discourse.* Charlottesville: University of Virginia Press, 1989.

———. *The Poetics of Relation.* Ann Arbor: University of Michigan Press, 1997.

Gmelch, George. *Behind the Smile: The Working Lives of Caribbean Tourism.* Indianapolis: Indiana University Press, 2003.

———. *Double Passage: The Lives of Caribbean Migrants Abroad and Back Home.* Ann Arbor: University of Michigan Press, 1992.

Gmelch, George, and Sharon Bohn Gmelch. *The Parish behind God's Back: The Changing Culture of Rural Barbados.* Ann Arbor: University of Michigan Press, 1997.

Goffman, Erving. *The Presentation of Self in Everyday Life.* New York: Anchor Books, 1959.

Goldberg, Vicki. *The Power of Photography: How Photographs Changed Our Lives.* New York: Abbeville, 1991.

Gottschild, Brenda Dixon. *Digging the Africanist Presence in American Performance: Dance and Other Contexts.* Westport, Conn.: Praeger, 1996.

Govan, Chloe. *Rihanna: Rebel Flower.* London: Omnibus Press, 2011.

Greene, Oliver, and Brian Castillo, dirs. *Play, Jankunú, Play: The Garifuna Wanáragua Ritual in Belize.* Watertown, Mass.: Documentary Educational Resources, 2007, DVD.

Greenfield, Sidney. *English Rustics in Black Skin: A Study of Modern Family Forms in a Pre-industrial Society.* Saint Ann's Garrison: Barbados Museum and Historical Society, 2010.

Griffin, Farah Jasmine. *If You Can't Be Free, Be a Mystery: In Search of Billie Holiday.* New York: Free Press, 2001.

Griffith, Alana, and Peter Wickham. "Tolerance, Acceptance, or Ambivalence? Changing Expressions of Attitudes towards Homosexuals in Barbados." *Sexuality Research and Social Policy* 16 (2018): 1–12.

Griffith, Ezra E. H. *I'm Your Father, Boy.* Tucson: Hats Off Books, 2004.

Griffith, Ezra E. H., George E. Mahy, and John L. Young. "Barbados Spiritual Baptists: Social Acceptance Enhances Opportunities for Supporting Public Health." *Mental Health, Religion and Culture* 11, no. 7 (November 2008): 671–683.

Grossberg, Lawrence. "History, Politics, and Postmodernism: Stuart Hall and Cultural Studies." In *Stuart Hall: Critical Dialogues in Cultural Studies,* edited by David Morley and Kuan-Hsing Chen, 151–172. New York: Routledge, 1996.

Guilbault, Jocelyne. "Music, Politics, and Pleasure: Live Soca in Trinidad." *Small Axe* 14, no. 1 (March 2010): 16–29.

GuyanaLive. "Don't Dis Me Concert—Rupee's Tribute to His Parents." Posted December 1, 2007. Video, 6:40. http://www.youtube.com/watch?v=yYJVqoqKneE.

Hall, Clifford. "Nelson a Fact of Our History." *NationNews,* April 25, 2017. http://www.nationnews.com/nationnews/letters_to_editor/96102/nelson-history.

Hall, Stuart. "Cultural Identity and Diaspora." In *Theorizing Diaspora,* edited by Jana Evans Braziel and Anita Mannur, 233–246. Malden, Mass.: Blackwell, 2003.

———. Introduction to *Representation: Cultural Representation and Signifying Practices.* Edited by Stuart Hall, 1–12. London: SAGE, 1997.

———. "Race, Articulation, and Societies Structured in Dominance." In *Black British Cultural Studies: A Reader,* edited by Houston A. Baker, Manthia Diawara, and Ruth Lindeborg, 16–60. Chicago: University of Chicago Press, 1996.

———. "Representation, Meaning and Language." In *Representation: Cultural Representation and Signifying Practices,* edited by Stuart Hall, 13–74. London: SAGE, 1997.

———. "What Is This 'Black' in Black Popular Culture?" In *Black Popular Culture,* edited by Gina Dent, 21–33. Seattle: Bay, 1992.

Hamilton, Jill. *Women of Barbados: Amerindian Era to Mid 20th Century.* Barbados: Letchworth, 1981.

Harewood, Susan. "Calypso, Masquerade Performance and Post National Identities." PhD diss., University of Illinois at Urbana-Champagne, 2006.

——. "Masquerade Performance and the Play of Sexual Identity in Calypso." *Cultural Studies* ↔ *Critical Methodologies* 5, no. 2 (2005): 189–205.

——. "Policy and Performance in the Caribbean." *Popular Music* 27, no. 2 (2008): 209–223.

——. "Transnational Soca Performances, Gendered Re-narrations of Caribbean Nationalism." *Social and Economic Studies* 55, no. 1 (2006): 25–48.

Harewood, Susan, and John Hunte. "Dance in Barbados: Reclaiming, Preserving, and Creating National Identities." In *Making Caribbean Dance: Continuity and Creativity in Island Cultures*, edited by Susanna Sloat, 265–282. Gainesville: University Press of Florida, 2010.

Harris, David. "Divas." In *Crop Over Potpourri*, 23–27. 2001. National Cultural Foundation Archives, Barbados.

Hartman, Saidiya. *Lose Your Mother: A Journey along the Atlantic Slave Route*. New York: Farrar, Straus and Giroux, 2007.

Haynes, Tonya. "Sylvia Wynter's Theory of the Human and the Crisis School of Caribbean Heteromasculinity Studies." *Small Axe* 20, no. 1 (March 2016): 92–112.

Henwood, Simon. *Rihanna*. New York: Rizzoli International, 2010.

Hill, Logan. "Rihanna Talks: This Is *My* Story." *Glamour*, September 2011, 322–329, 401.

Hinds, Alison. Interview by ABC News Radio. Posted May 30, 2008. Video, 5:55. https://www.youtube.com/watch?v=DXopbijvDvg.

——. Interview by the author. Kensington Oval, Barbados, August 2, 2009.

Hine, Darlene Clark. "Rape and the Inner Lives of Black Women." In *Words of Fire: An Anthology of African American Feminist Thought*, edited by Beverly Guy-Sheftall, 380–388. New York: New Press, 1995.

"History: Banks Beer Barbados." Banks Beer Barbados. Accessed March 22, 2019. http://www.banksbeer.com/history.

Holder, Sherie. "Rihanna Hospitalized in Sweden." *NationNews*. October 31, 2011. http://www.nationnews.com/nationnews/news/10241/rihanna-hospitalized-sweden.

——. "Rihanna Ordered: Stop Partying." *NationNews*, November 2, 2011. www.nationnews.com/nationnews/news/10313/rihanna-stop-partying.

Hope, Donna. *Inna di Dancehall: Popular Culture and the Politics of Identity in Jamaica*. Kingston: University of the West Indies Press, 2006.

Howard, Michael. *The Economic Development of Barbados*. Kingston: University of the West Indies Press, 2006.

Hoyos, F. A. *Barbados: A History from the Amerindians to Independence*. London: Macmillan, 1978.

Huss, Hasse. "The 'Zinc-Fence Thing': When Will Reggae Album Covers Be Allowed out of the Ghetto?" *Black Music Research Journal* 20, no. 2 (Autumn 2000): 181–194.

"Independence Square." Barbados Pocket Guide, last modified February 10, 2012. http://www.barbadospocketguide.com/barbados-attractions/attractions-by-parish-location/bridgetown/independence-square.html.

Iton, Richard. *In Search of the Black Fantastic: Politics and Popular Culture in the Post-Civil Rights Era*. New York: Oxford University Press, 2008.

Jackson, John L., Jr. *Real Black: Adventures in Racial Sincerity*. Chicago: University of Chicago Press, 2005.

Jackson, Steven. "Alison Hinds Aim to Top Jamaica Chart." *Jamaica Observer*, March 21, 2010. Accessed 27 March, 2010. http://www.jamaicaobserver.com/entertainment/alison-Hinds-_7494035 (no longer available).

James, C.L.R. *The Artist in the Caribbean*. Mona, Jamaica: University College of the West Indies, 1960.

James, Winston. *Holding Aloft the Banner of Ethiopia: Caribbean Radicalism in Early Twentieth-Century America*. New York: Verso, 1998.

Johnson, E. Patrick. "'Quare' Studies, or (Almost) Everything I Know about Queer Studies I Learned from My Grandmother." In *Black Queer Studies: A Critical Anthology*, edited by E. Patrick Johnson and Mae G. Henderson, 124–157. Durham, N.C.: Duke University Press, 2005.

Johnson, Jasmine Elizabeth. "Queen's Diaspora." *African and Black Diaspora: An International Journal* 9, no. 1 (2016): 44–56.

Jordan, Meena. *Physical Violence against Women in Barbados, 1977–1985*. Barbados: Bureau of Women's Affairs, Ministry of Employment, Labour Relations and Community Development, 1986.

Jordan, Ricky. "Rihanna Pushing Envelope with S&M." *NationNews*, February 9, 2011. http://www.nationnews.com/index.php/articles/view/rihanna-pushing-envelop-with-sm/ (no longer available). Now available at Martindale, Carol. "Rihanna Pushing Envelope with S&M." *NationNews*, February 9, 2011. http://www.nationnews.com/nationnews/news/36099/rihanna-pushing-envelop-amp-amp.

Kamugisha, Aaron. "The Survivors of the Crossing and the Impossibility of Late Colonial Revolt." Introduction to *The Survivors of the Crossing*, by Austin C. Clark, 7–22. Leeds: Peepal Tree Press, 2011.

Kasinitz, Philip. *Caribbean New York: Black Immigrants and the Politics of Race*. Ithaca, N.Y.: Cornell University Press, 1992.

Kelley, Robin D. G. "The Rest of Us: Rethinking Settler and Native." *American Quarterly* 69, no. 2 (June 2017): 267–276.

Kempadoo, Kamala. *Sexing the Caribbean: Gender, Race, and Sexual Labor*. New York: Routledge, 2004.

King, David. "Lord Nelson Statue Stands like a Colossus in Heroes Square." *Barbados Underground* (blog), November 16, 2008. https://barbadosunderground.wordpress.com/2008/11/16/independence-lord-nelson/.

King, Mike. "Rihanna 'Not Fit.'" *NationNews*, November 21, 2011. http://www.nationnews.com/nationnews/news/289/rihanna-fit.

King, Rosamond. *Island Bodies: Transgressive Sexualities in the Caribbean Imagination*. Gainesville: University Press of Florida, 2014.

———. "New Citizens, New Sexualities: Nineteenth Century *Jamettes*." In *Sex and the Citizen: Interrogating the Caribbean*, edited by Faith Smith, 214–223. Charlottesville: University of Virginia Press, 2011.

Knight, Franklin W. *The Caribbean: The Genesis of a Fragmented Nationalism*. New York: Oxford University Press, 1990.

LaBennett, Oneka. *She's Mad Real: Popular Culture and West Indian Girls in Brooklyn*. New York: New York University Press, 2011.

Lambert, David. "'Part of the Blood and Dream': Surrogation, Memory and the National Hero in the Postcolonial Caribbean." *Patterns of Prejudice* 41, nos. 3–4 (2007): 345–371.

Lamming, George. *Coming, Coming Home: Conversations II*. Philipsburg, Saint Martin: House of Nehisi, 2000.

———. *In the Castle of My Skin*. Foreword by Sandra Pouchet Paquet. Ann Arbor: University of Michigan Press, 1991.

———. "Nationalism and Nation." In *The George Lamming Reader: The Aesthetics of Decolonisation*, edited by Anthony Bogues, 110–120. Kingston, Ian Randle, 2011.

———. *The Pleasures of Exile.* Foreword by Sandra Pouchet Paquet. Ann Arbor: University of Michigan Press, 1992.

———. "Portrait of a Prime Minister." In *Conversations: Essays, Addresses and Interviews, 1953–1990,* by George Lamming. Edited by Richard Drayton and Andaiye, 176–182. London: Karic, 1992.

———. *Season of Adventure.* London: Allison and Busby, 1979.

Lewis, Arthur. "The Agony of the Little Eight." *Journal of Eastern Caribbean Studies* 23 (1998): 6–26.

Lewis, Gordon. "The Challenge of Independence in the British Caribbean." In *Caribbean Freedom: Economy and Society from Emancipation to the Present,* edited by Hilary Beckles and Verene Shepherd, 511–518. Kingston: Randle, 1993.

Lewis, Linden. "The Contestation of Race in Barbadian Society and the Camouflage of Conservatism." In *New Caribbean Thought: A Reader,* edited by Brian Meeks and Folke Lindahl, 144–195. Kingston: University of the West Indies Press, 2001.

Ligon, Richard. *A True and Exact History of the Island of Barbados.* Edited with an introduction by Karen Ordahl Kupperman. Indianapolis: Hackett, 2011.

Lipsitz, George. *Dangerous Crossroads: Popular Music, Postmodernism and the Poetics of Place.* New York: Verso, 1994.

"'Live Up' Media Campaign a Positive Approach to HIV-AIDS." *St. Croix Source,* March 9, 2007. https://stcroixsource.com/2007/03/09/live-media-campaign-positive-approach-hiv-aids/.

Long, April. "Forever Strong." *Elle,* May 2012, 300–313, 347.

Lorde, Audre. *Sister Outsider.* Berkeley: Crossing, 1984.

Lynch, Louis. *The Barbados Book.* New York: Taplinger, 1964.

Mallet, Renee. "'Project Runway' Designer Anya Ayoung-Chee Is Scandal Ridden Former Beauty Queen." July 13, 2011. Accessed January 16, 2013. http://www.examiner.com/article/project-runway-designer-anya-ayoung-chee-is-scandal-ridden-former-beauty-queen (site discontinued).

Manley, Michael. Introduction to *Speeches by Errol Barrow,* by Errol Barrow, 13–15. Edited by Yussuff Haniff. London: Hansib, 1987.

Marshall, Luigi. "Bling Style Taking Over." *NationNews,* October 31, 2011. http://www.nationnews.com/nationnews/news/10229/-bling-style-taking.

———. "Gay Man Cries Foul." *NationNews,* October 6, 2011. http://www.nationnews.com/nationnews/news/15467/gay-cries-foul.

———. "No Tying Ri-Ri Down." *NationNews,* November 5, 2011. http://www.nationnews.com/nationnews/news/10412/tying-ri-ri.

———. "Rihanna Video Pushes Barbados." *NationNews,* August 28, 2011. http://www.nationnews.com/nationnews/news/27899/rihanna-video-pushes-barbados.

———. "7 Questions for Dwane Husbands." *NationNews,* May 24, 2011. http://www.nationnews.com/nationnews/news/10716/questions-dwane-husbands.

———. "Show a Success." *NationNews,* August 7, 2011. http://www.nationnews.com/nationnews/news/39091/success.

Marshall, Paule. *Brown Girl, Brownstones.* New York: Feminist Press, 1981.

———. *Daughters.* New York: Atheneum, 1991.

Marshall, Trevor G. "The Facts about 'Nelson.'" *NationNews,* April 20, 2017. http://www.nationnews.com/nationnews/letters_to_editor/95902/about-nelson.

———. *Notes on the History and Evolution of Calypso in Barbados.* Cave Hill, Barbados: University of the West Indies, 1986.

Marshall, Trevor G., Peggy McGeary, and Grace Thompson. *Folk Songs of Barbados.* Kingston: Ian Randle, 1981.

Marshall, Trevor G., and Elizabeth F. Watson. "Barbados." In *Music in Latin America and the Caribbean: An Encyclopedic History*, edited by Malena Kuss, 2:345–58. Austin: University of Texas Press, 2007.

Marshall, Wayne. "'Bling-Bling' for Rastafari: How Jamaicans Deal with Hip-Hop." *Social and Economic Studies* 55, no. 1/2 (March 2006): 49–74.

Martindale, Carol. "Loud Concerns about Rihanna Show." *NationNews*, August 10, 2011. http:// www.nationnews.com/nationnews/news/39167/loud-concerns-about-rihanna.

———. "Pastor Concerned about Rihanna." *NationNews*, March 12, 2002. http://www .nationnews.com/nationnews/news/25651/pastor-concerned-about-rihanna.

———. "Rihanna Local Concert Long Overdue." *NationNews*, April 15, 2011. http://www .nationnews.com/nationnews/news/44185/rihanna-local-concert-overdue.

———. "Rihanna, Shut Up and Sing." *NationNews*, October 6, 2011. http://www.nationnews .com/nationnews/news/15479/rihanna-shut-sing.

———. "Rihanna's Love for the 'C-Word.'" *NationNews*, October 4, 2011. http://www .nationnews.com/nationnews/news/4043/rihanna-8217-love-8216-word-8217.

———. "Rihanna Thanks the Crowd." *NationNews*, August 6, 2011. http://www.nationnews .com/nationnews/news/39069/rihanna-thanks-crowd.

———. "What's Trending: Rihanna Lights Up." *NationNews*, January 17, 2012. http://www .nationnews.com/nationnews/news/34245/-8217-trending-rihanna-lights.

McCammon, Ross. "Rihanna Is the Sexiest Woman Alive." *Esquire*, November 2011, 110–122.

McMillan, Uri. "Nicki-Aesthetics: The Camp Performance of Nicki Minaj." *Women and Performance: A Journal of Feminist Theory* 24, no. 1 (2014): 79–87.

Meredith, Sharon. "Barbadian *Tuk* Music: Colonial Development and Post-independence Recontextualization." *British Journal of Ethnomusicology* 12, no. 2 (2003): 81–106.

"The Merrymen: Calypso Pioneers." In *Crop Over Potpourri*, 20–21. 2001. National Cultural Foundation Archives, Barbados.

Miller, Billie A. Foreword to *Women of Barbados: Amerindian Era to Mid 20th Century*, by Jill Hamilton, i–ii. Barbados: Letchworth, 1981.

Miller, Daniel, and Don Slater. *The Internet: An Ethnographic Approach*. New York: Berg, 2000.

Miller, Monica L. *Slaves to Fashion: Black Dandyism and the Styling of Black Diasporic Identity*. Durham, N.C.: Duke University Press, 2009.

Millington, Janice. "Barbados." In *The Garland Encyclopedia of World Music*, vol. 2, *South America, Mexico, Central America, and the Caribbean*, edited by Dale A. Olsen and Daniel E. Sheehy, 813–821. New York: Garland, 1998.

Mohammed, Patricia, and Althea Perkins. *Caribbean Women at the Crossroads: The Paradox of Motherhood among Women of Barbados St. Lucia and Dominica*. Mona, Jamaica: Canoe Press, University of the West Indies, 1999.

Mounsey, Colville. "Nelson Defaced." *Barbados Today*, November 29, 2017. https:// barbadostoday.bb/2017/11/29/nelson-defaced/.

Muñoz, José Esteban. *Disidentifications: Queers of Color and the Performance of Politics*. Minneapolis: University of Minnesota Press, 1999.

Murray, David A. B. *Flaming Souls: Homosexuality, Homophobia, and Social Change in Barbados*. Toronto: University of Toronto Press, 2012.

Musa, M. "Rupee Opens Up about Losing Both Parents to HIV/AIDS." The Source, April 11, 2018. http://thesource.com/2018/04/11/rupee-parents-hiv-aids/. Video, 17:03.

National Cultural Foundation. *25 Years of Crop Over*. [Saint James], Barbados: National Cultural Foundation, 1998.

"National Emblems of Barbados." Go Barbados. Accessed March 21, 2019. http://www.barbados .org/emblems.htm.

Negrón-Muntaner, Frances. "Jennifer's Butt." *Aztlán: A Journal of Chicano Studies* 22, no. 2 (1997): 181–194.

Nessif, Bruna. "Which Singer Is Rocking a Teeny Bikini and Feathers?" E! News, August 1, 2011. http://www.eonline.com/news/which_singer_rocking_teeny_bikini/255643 #ixzz1e2csUBgz.

"New Crime Culture Emerging." *NationNews*, January 9, 2010. Accessed January 10, 2010. http://www.nationnews.com (no longer available).

Newton, Melanie. *The Children of Africa in the Colonies: Free People of Color in Barbados in the Age of Emancipation*. Baton Rouge: Louisiana State University Press, 2008.

———. "Race for Power: People of Colour and the Politics of Liberation in Barbados, 1816–c. 1850." In *Contesting Freedom: Control and Resistance in the Post-emancipation Caribbean*, edited by Gad Hauman and David V. Trotman, 20–38. Warwick University Caribbean Studies. Oxford: Macmillan Caribbean, 2005.

———. "Returns to a Native Land: Indigeneity and Decolonization in the Anglophone Caribbean." *Small Axe* 41 (July 2013): 108–122.

Newton, Velma, Kathleen Drayton, and Woodville Marshall, eds. *The Barbados-Panama Connection Revisited: 2004 Lectures Commemorating Migration from Barbados to Panama, 1904–1914*. Saint Michael, Barbados: Barbados Museum and Historical Society, National Cultural Foundation, and the Department of History and Philosophy, University of the West Indies, Cave Hill campus, 2014.

"NIVEA Kicks Off Skincare for Life Campaign." Electronic press release, July 29, 2011. Accessed February 15, 2012. http://www.blastradius.com/2011/07/29/nivea-launches-skincare-for -life/ (no longer available).

Nixon, Angelique V. *Resisting Paradise: Tourism, Diaspora, and Sexuality in Caribbean Culture*. Jackson: University of Mississippi Press, 2015.

"Not Much Love for Trini Takeover in Barbados Cohobblopot." Fire Online Radio, June 29, 2015. Accessed July, 12 2018. https://fireonlineradio.com/not-much-love-for-trini-takeover -in-barbados-cohobblopot/ (no longer available).

Nurse, Keith. "Masculinities in Transition: Gender and the Global Problematique." In *Interrogating Caribbean Masculinities: Theoretical and Empirical Analyses*, edited by Rhoda Reddock, 3–37. Kingston: University of the West Indies Press, 2004.

———. "Popular Culture and Cultural Industry: Identity and Commodification in Caribbean Popular Music." In *Globalisation, Diaspora, and Caribbean Popular Culture*, edited by Christine G. T. Ho and Keith Nurse, 324–340. Miami: Ian Randle, 2005.

O'Connor, Maureen. "Sex-Scandal Beauty Queen Now a Contestant on *Project Runway*." Gawker, July 13, 2011. https://gawker.com/5820972/sex-scandal-beauty-queen-now-a -contestant-on-project-runway.

Orderson, J. W. *Creoleanna: Or, Social and Domestic Scenes and Incidents in Barbados in the Days of Yore and the Fair Barbadian and Faithful Black*. Edited by John Gilmore. Oxford: Macmillan, 2002.

Padmore, Branford. "Barbados Labour Party Member of Parliament, William Duguid, Uses the 'C' Word in Parliament." Posted November 21, 2012. Video, 1:24. https://www.youtube.com /watch?v=dRM_7OmtNSA.

Paquet, Sandra Pouchet. *Caribbean Autobiography: Cultural Identity and Self-Representation*. Madison: University of Wisconsin Press, 2002.

———. Foreword to *The Pleasures of Exile*, by George Lamming, vii–xxvii. Ann Arbor: University of Michigan Press, 1992.

Petrini, Benjamin. "Homicide Rate Dataset." World Bank, January 2010. http://siteresources .worldbank.org/EXTCPR/Resources/407739-1267651559887/Homicide_Rate_Dataset.pdf.

Pettis, Joyce, and Paule Marshall. "A *MELUS* Interview: Paule Marshall." *MELUS* 17, no. 4 (Winter 1991–1992): 117–129.

Pfleiderer, Martin. "Soul Rebels and Dubby Conquerors: Reggae and Dancehall Music in Germany in the 1990s and Early 2000s." *Popular Music* 37, no. 1 (2018): 81–99.

Pinckney, Warren R., Jr. "Jazz in Barbados." *American Music* 12, no. 1 (Spring 1994): 58–87.

"Prince Harry Joined Rihanna on Stage at a Barbados Independence Concert." Independent.ie, December 1, 2016. https://www.independent.ie/entertainment/music/music-news/prince -harry-joined-rihanna-on-stage-at-a-barbados-independence-concert-35259489.html.

Puckrein, Gary A. *Little England: Plantation Society and Anglo-Barbadian Politics, 1627–1700*. New York: New York University Press, 1984.

Rashbaum, Alyssa. "Rupee Educating People about the Temptations of Soca." MTV. November 16, 2004. Accessed June 22, 2009. http://www.mtv.com/news/yhif/rupee/ (no longer available).

Reddock, Rhoda. Introduction to *Interrogating Caribbean Masculinities: Theoretical and Empirical Analyses*, edited by Rhoda Reddock, xiii–xxxiv. Kingston: University of the West Indies Press, 2004.

Reed, Ishmael. *Mumbo Jumbo*. New York: Simon and Schuster, 1972.

Regis, Louis. *The Political Calypso: True Opposition in Trinidad and Tobago*. Barbados: University of the West Indies Press, 1999.

Reichelt, Lisa. "Ambient Intimacy." *Disambiguity* (blog), March 1, 2007. http://www .disambiguity.com/ambient-intimacy/.

"Rihanna Deemed Too Sexy for Nivea by New CEO (Photo)." Huffington Post, August 8, 2012. http://www.huffingtonpost.com/2012/08/07/rihanna-nivea-video-stefan-heidenreich _n_1753414.html.

"Rihanna for Barbados 50." *NationNews*, October 18, 2016. http://www.nationnews.com /nationnews/news/88175/rihanna-barbados50.

"Rihanna to Perform at Barbados' 50th Independence Celebration." *RJRNews*, October 19, 2016. http://rjrnewsonline.com/arts-entertainment/rihanna-to-perform-at-barbados-50th -independence-celebration.

RihannaVEVO. "Rihanna—Cheers (Drink to That)." Posted August 27, 2011. Video, 4:41. https://www.youtube.com/watch?v=ZRovoi63PQ4.

———. "Rihanna—If It's Loving That You Want." Posted August 21, 2011. Video, 3:36. https:// www.youtube.com/watch?v=hD5MRBzY1uM.

———. "Rihanna—Te Amo." Posted June 14, 2010. Video, 4:08. https://www.youtube.com /watch?v=Oe4Ic7fHWf8.

———. "Rihanna—What's My Name? Ft. Drake." Posted November 12, 2010. Video, 4:23. https://www.youtube.com/watch?v=UoCGsw6h6ok.

Rivera-Rideau, Petra. *Remixing Reggaetón: The Cultural Politics of Race in Puerto Rico*. Durham, N.C.: Duke University, 2015.

Roach, Joseph. *It*. Ann Arbor: University of Michigan Press, 2007.

Robertson, Carol E. "Myth, Cosmology, and Performance." In *Music in Latin America and the Caribbean: An Encyclopedic History*, edited by Malena Kuss, 1:7–23. Austin: University of Texas Press, 2004.

Rodrigo. "Rihanna Covers British Vogue." October 2, 2011. Accessed October 3, 2011. http:// rihannadaily.com/2011/10/02/rihanna-covers-british-vogue/ (no longer available).

Rollock, Melissa. "The Face of HIV/AIDS." *Barbados Today*. Accessed April 15, 2011. http:// www.barbadostoday.bb (no longer available online).

———. "Lady Ann Born to Sing." *Barbados Today*. Accessed July 15, 2011. http://www .barbadostoday.bb (no longer available online).

Rosenberg, Leah Reade. *Nationalism and the Formation of Caribbean Literature*. New York: Palgrave Macmillan, 2007.

Rudder, P. Antonio "Boo." *Marching to a Different Drummer: Elements of Barbadian Culture*. Saint Peter, Barbados: Caribbean Chapters, 2010.

"Rupee for GDF War on HIV/AIDS Concert." *Guyana Lime* (blog), November 7, 2008. http:// guyanalime.blogspot.com/2008/11/rupee-for-gdf-war-on-hiv-aids-concert.html.

"Rupee to Set Up AIDS Foundation." *Daily Herald*. May 31, 2010. http://www.thedailyherald .info/index.php?option=com_content&view=article&id=4181:rupee-to-set-up-aids -foundation-&catid=2:news&Itemid=5.

Russell, Heather D. "Whose Rihanna? Diasporic Citizenship and the Economies of Crossing Over." In *Archipelagos of Sound: Transnational Caribbeanities, Women and Music*, edited by Ifeona Fulani, 299–320. Kingston: University of the West Indies Press, 2012.

Sandoval, Chela. *Methodology of the Oppressed*. Minneapolis: University of Minnesota Press, 2000.

Saunders, Patricia. *Alien-Nation and Repatriation: Translating Identity in Anglophone Caribbean Literature*. New York: Lexington Books, 2007.

———. "Is Not Everything Good to Eat, Good to Talk: Sexual Economy and Dancehall Music in the Global Marketplace." *Small Axe* 7, no. 1 (March 2003): 95–115.

Saxeous. "Wendy Alleyne.. 'Off the Cuff.'" Posted May 19, 2011. Video, 11:33. http://www.youtube .com/watch?v=vTExnflvFuw.

Schechner, Richard. *Between Theater and Anthropology*. Philadelphia: University of Pennsylvania Press, 1985.

Scott, James. *Domination and the Arts of Resistance: Hidden Transcripts*. New Haven, Conn.: Yale University Press, 1990.

"Shame on You Mara for 'Childless' Remark!" *Barbados Today*, March 25, 2017. https://www .barbadostoday.bb/2017/03/25/shame-on-you-mara-for-childless-remark/.

Shange, Savannah. "A King Named Nicki: Strategic Queerness and the Black Femmecee." *Women and Performance* 24, no. 1 (2014): 29–45.

Sharpley-Whiting, T. Denean. *Pimps Up, Ho's Down: Hip Hop's Hold on Young Black Women*. York: New York University Press, 2007.

Sheller, Mimi. *Consuming the Caribbean: From Arawaks to Zombies*. New York: Routledge, 2003.

———. "Demobilizing and Remobilizing Caribbean Paradise." In *Tourism Mobilities: Places to Play, Places in Play*, edited by Mimi Sheller and John Urry, 13–21. New York: Routledge, 2004.

Sheppard, Jill. *The "Redlegs" of Barbados: Their Origins and History*. Millwood, N.Y.: KTO, 1977.

ShontelleOnline. "vBlog: Shontelle and Vita Chambers @ Hilton Beach (Barbados)." Posted January 10, 2010. Video, 9:23. https://www.youtube.com/watch?v=vSFZCK6WbXs.

Shyguy974. "Rupee—Tempted to Touch." Posted September 15, 2006. Video, 3:38. http://www .dailymotion.com/video/xeacl_rupee-tempted-to-touch_news?start=210.

Sloat, Susanna, ed. *Caribbean Dance from Abakuá to Zouk: How Movement Shapes Identity*. Gainesville: University Press of Florida, 2002.

Smith, Faith. "Introduction: Sexing the Citizen." In *Sex and the Citizen: Interrogating the Caribbean*, edited by Faith Smith, 1–17. Charlottesville: University of Virginia Press, 2011.

———, ed. *Sex and the Citizen: Interrogating the Caribbean*. Charlottesville: University of Virginia Press, 2011.

Smith, Natanga. "Bajans Upset by Bad Image." *NationNews*, January 19, 2013. http://www .nationnews.com/nationnews/news/5012/bajans-upset-by-bad-image.

Smith, Shawn Michelle. *Photography on the Color Line: W.E.B. Du Bois, Race, and Visual Culture.* Durham, N.C.: Duke University Press, 2004.

"Speightstown." Barbados Pocket Guide, last modified February 7, 2012. http://www .barbadospocketguide.com/our-island-barbados/towns/speightstown.html.

Spencer, Gina. "C-Word for the Publicity?" *NationNews,* October 10, 2011. http://www .nationnews.com/index.php/letters/view/c-word-for-the-publicity/ (no longer available). Now available at Marshall, Luigi. "C-Word for the Publicity?" *NationNews,* October 10, 2011. http://www.nationnews.com/nationnews/letters_to_editor/5448/-word-publicity.

Spliffietv. "Alison Hinds Interview—Pt. 1." Posted March 11, 2008. Video, 10:03. http://www .youtube.com/watch?v=CaAhGzUDHko.

———. "Alison Hinds Interview—Pt. 2." Posted March 11, 2008. Video, 10:17. http://www .youtube.com/watch?v=_YXlTfiflyw.

———. "Alison Hinds—Pt. 3." Posted March 11, 2008. Video, 9:30. http://www.youtube.com /watch?v=-KdrZbGFupM.

Springer, Jennifer Thorington. "'Roll It Gal': Alison Hinds, Female Empowerment and Calypso." *Meridians: Feminism, Race, Transnationalism* 8, no. 1 (2008): 93–129.

Stafford, Patricia. "The Growth and Development of the Brown and Black Middle Class, 1838–1988, and Its Role in the Shaping of Modern Barbados." PhD diss., University of the West Indies, 2005.

Stanley Niaah, Sonjah. *Dancehall: From Slave Ship to Ghetto.* Ottawa: University of Ottawa Press, 2010.

Stephens, Michelle A. "Babylon's 'Natural Mystic': The North American Music Industry, the Legend of Bob Marley, and the Incorporation of Transnationalism." *Cultural Studies* 12, no. 2 (1998): 139–167.

———. *The Black Empire: The Masculine Global Imaginary of Caribbean Intellectuals in the United States, 1914–1962.* Durham, N.C.: Duke University Press, 2005.

Stolzoff, Norman. *Wake the Town and Tell the People: Dancehall Culture in Jamaica.* Durham, N.C.: Duke University Press, 2000.

Strachan, Ian. *Paradise and Plantation: Tourism Culture in the Anglophone Caribbean.* Charlottesville: University of Virginia Press, 2002.

Stuart, Freundel. "Prime Minister's Independence Message." Barbados Government Information Services, November 30, 2016. http://gisbarbados.gov.bb/blog/prime-ministers -independence-message/.

Sturken, Marita, and Lisa Cartwright. *Practices of Looking: An Introduction to Visual Culture.* New York: Oxford University Press, 2001.

Taylor, Amina. "The Bajan Beyoncé." *SHE Caribbean,* March/April 2006, 60–65.

———. "Rupee: The Reluctant Romeo." *SHE Caribbean,* November/December 2005, 32–36.

Taylor, Lisa. "'Baby I'm a Star': Towards the Political Economy of the Actor Formerly Known as Prince." In *Film Stars: Hollywood and Beyond,* edited by Andy Willis, 158–173. New York: Manchester University Press, 2004.

Taylor, Ula. *The Veiled Garvey: The Life and Times of Amy Jacques Garvey.* Chapel Hill: University of North Carolina Press, 2002.

Theman35z. "Pat and Crank New Single by Peter Ram 2010." Posted January 3, 2011. Video, 3:01. https://www.youtube.com/watch?v=bd4P_VwKufU.

Thomas, Deborah A. *Modern Blackness: Nationalism, Globalization, and the Politics of Culture in Jamaica.* Durham, N.C.: Duke University Press, 2004.

Thompson, Krista. *An Eye for the Tropics: Tourism, Photography, and Framing the Caribbean.* Durham, N.C.: Duke University Press, 2006.

————. *Shine: The Visual Economy of Light in African Diasporic Aesthetic Practice.* Durham, N.C.: Duke University Press, 2015.

Thompson, Rhonda. "Artistes Best for HIV Message." *NationNews*, May 22, 2011. http://www.nationnews.com/nationnews/news/33678/artistes-hiv-message.

Tölölyan, Khachig. "Rethinking Diaspora(s): Stateless Power in the Transnational Movement." *Diaspora: A Journal of Transnational Studies* 5, no. 1 (1996): 3–36.

"Too Much Violence." *NationNews*, January 27, 2010. Accessed January 27, 2010. http://www.nationnews.com (no longer available).

Torgovnick, Marianna. *Gone Primitive: Savage Intellects, Modern Lives.* Chicago: University of Chicago Press, 1990.

Trilling, Lionel. *Sincerity and Authenticity.* New York: Harcourt Brace Jovanovich, 1972.

Trouillot, Michel-Rolph. "The Caribbean Region: An Open Frontier in Anthropological Theory." *Annual Review of Anthropology* 21 (1992): 19–42.

————. *Global Transformations: Anthropology and the Modern World.* New York: Palgrave Macmillan, 2003.

Turino, Thomas. *Nationalists, Cosmopolitans, and Popular Music in Zimbabwe.* Chicago: University of Chicago Press, 2000.

Van Meter, Jonathan. "Living Out Loud." *Vogue*, April 2011, 258–267.

Vasquez, Robert. "Rihanna AMA's 2010 Performance." Posted November 22, 2010. Video, 7:33. https://www.youtube.com/watch?v=n38Qe9sJuOY.

Vickerman, Milton. *Crosscurrents: West Indian Immigrants and Race.* New York: Oxford University Press, 1999.

Von Eschen, Penny. *Race against Empire: Black Americans and Anticolonialism, 1937–1957.* Ithaca, N.Y.: Cornell University Press, 1997.

Walcott, Derek. "The Caribbean: Culture or Mimicry?" *Journal of Interamerican Studies and World Affairs* 16, no. 1 (February 1974): 3–13.

Ward, Alicia. "Rupee Speaks Out about HIV/AIDS." *Antigua Observer*, June 26, 2012. http://www.antiguaobserver.com/rupee-speaks-out-about-hiv-aids-2/.

Ward, Patrick. "Too Rude." *NationNews*, March 14, 2010. Accessed March 14, 2010. www.nationnews.com (no longer available).

Wartofsky, Alona. "Island in the Song: Kevin Lyttle Took a Soca Tune and Made a World-Beating Hit." *Washington Post*, September 25, 2004, C1.

Waters, Mary C. *Black Identities: West Indian Immigrant Dreams and Black American Realities.* Cambridge, Mass.: Harvard University Press, 1999.

Watson, Elizabeth F. "Cultural Heritage and the Knowledge Economy: The Role and Value of Sound Archives and Sound Archiving in Developing Countries." Paper presented at the Stellenbosch University Library Symposium, Stellenbosch, South Africa, February 18–19, 2010. http://hdl.handle.net/10019.1/394.

Watson, Hilbourne A. "Errol Barrow (1920–87): The Social Construction of Colonial and Postcolonial Charismatic Political Leadership in Barbados." In *Caribbean Charisma: Reflections on Leadership, Legitimacy, and Populist Politics*, edited by Anton Allahar, 33–71. Boulder, Colo.: L. Rienner, 2001.

Wayne, Rick. "Celebrity Focus: Alison Hines [*sic*]—Doin' What Comes Naturally!" *SHE Caribbean*, September–November 2000, 24–25.

Wekker, Gloria. *The Politics of Passion: Women's Sexual Culture in the Afro-Surinamese Diaspora.* New York: Columbia University Press, 2006.

"Well That Didn't Last Long . . . Rihanna Goes Back to Her Rude Girl Ways Getting Raunchy as a Scantily Clad Carnival Queen." *Daily Mail* (U.K.), August 1, 2011. http://www.dailymail

.co.uk/tvshowbiz/article-2020977/Rihanna-goes-rude-girl-ways-getting-raunchy
-scantily-clad-carnival-queen.html#ixzz1e2TkQwVf.

"Wendy Alleyne Show." Boyce Voice (blog). November 29, 2009. Accessed December 14, 2010. http://www.boycevoice.com/blog/2009/11/29/the-wendy-alleyne-show/ (site discontinued).

"Where in the World Is Matt Lauer?" *Today Show*. MSNBC, November 11, 2011. Accessed January 30, 2012. http://allday.today.msnbc.msn.com/_news/2011/11/11/8751752-matt-basks-in-the-barbados-sun-to-end-where-in-the-world-trip (no longer available).

Whitney, Malika Lee, and Dermott Hussey. *Bob Marley: Reggae King of the World*. Kingston: Kingston Publishers, 1984.

Will, Jay. "King and Queen." Black Coral, 2009. Posted July 31, 2009. Video, 4:18. http://www.youtube.com/watch?v=i_r-6K6nEAE.

"William Duguid Loses It!" *Barbados Underground* (blog), November 20, 2012. https://barbadosunderground.wordpress.com/2012/11/20/william-duguid-loses-it/.

Williams, Erica. *Sex and Tourism in Bahia: Ambiguous Entanglements*. Urbana: University of Illinois Press, 2013.

Williams, Marie-Claire. "Oh No, Mara! Thompson and Bradshaw Lock Horns in Parliament over 'Childless' Comment." *Barbados Today*, March 18, 2017. https://www.barbadostoday.bb/2017/03/18/oh-no-mara/.

Wilson, Julie. "Star Power." *NationNews*, April 23, 2006. Accessed April 23, 2006. http://www.nationnews.com (no longer available).

"Worldwide Album Sales Chart: Rihanna Outsells Beyonce & Alicia Keys." *Fresh and Fab* (blog). September 30, 2008. http://freshandfab.blogspot.com/2008/09/.

Worrell, Rodney. *Pan-Africanism in Barbados: An Analysis of the Activities of the Major 20th-Century Pan-African Formations in Barbados*. Washington, D.C.: New Academia, 2002.

Yates, Ann Watson. *Bygone Barbados*. Saint Michael, Barbados: Black Bird Studios, 1999.

Young, Robert J. C. *Colonial Desire: Hybridity in Theory, Culture and Race*. London: Routledge, 1995.

INDEX

ABOUT THE AUTHOR

LIA T. BASCOMB is an assistant professor of African American studies at Georgia State University.